Under the Patronage of Her Royal Highness
Princess Margriet of the Netherlands

This exhibition has been made possible by generous grants from Shell Oil Company Foundation and Smithsonian Institution Special Exhibition Fund.

Support has also been gratefully received from Dutch American West-India Company Foundation, Inc.; Sotheby's; British Airways; KLM Royal Dutch Airlines; NMB Bank; Kay Jewelers, Inc.; Koppers Co., Inc.; Estate of Jane Negbaur; Morgan Guaranty Trust Company of New York; Lloyds Bank; and Adrian C.R. Verwey; and, through the Netherlands American Amity Trust, from AMEV Holdings, Inc.; Nationale-Nederlanden U.S. Corp.; Rabobank Nederland; Dutch Institutional Holding Company, Inc.; The Ian Woodner Family Collection, Inc.; Driggs Corporation, John Driggs, Executive Director; Netherlands Foreign Investment Agency; Mrs. John Murray Begg; The Honorable J. William Middendorf II, and Thomas H. Wysmuller.

Courts and Colonies

The William and Mary Style in Holland, England, and America

Reinier Baarsen

Gervase Jackson-Stops

Phillip M. Johnston

Elaine Evans Dee

Cooper-Hewitt Museum, The Smithsonian Institution's National Museum of Design, New York

The Carnegie Museum of Art, Pittsburgh

Distributed by University of Washington Press, Seattle and London

Cooper-Hewitt Museum
2 East 91st Street
New York, New York 10128

Cover: Tile (No. 165)
Delft, c. 1690
Probably the Greek A factory
Tin-glazed earthenware
62 × 62
Rijksmuseum, Amsterdam
Lent by KOG

LC 88-71757
ISBN 0-295-96804-4

Edited by Nancy Aakre with Joanna Ekman
Designed by Nathan Garland Graphic Design and Film
Typeset by Trufont Typographers
Printed in the United States by Meriden-Stinehour Press

Library of Congress Cataloging-in-Publication Data
Courts and colonies.
Bibliography: p.
Supt of Docs. no.: SI 1.3:C83
1. Decoration and ornament—William and Style—Exhibitions.
2. Art—Exhibitions. 3. Art, Modern—17th–18th
centuries—Exhibitions. I. Baarsen, Reinier. II. Cooper-Hewitt Museum
NK1352.C6 1988 709'.03'2 88-600273

Contents

Ambassadors' Statements

Being a member of the International Committee of Honor of this major exhibition, *Courts and Colonies: The William and Mary Style in Holland, England, and America*, is both thought-provoking and rewarding for a Dutch ambassador in the United States.

As the United States, the United Kingdom, and the Netherlands commemorate in 1988 and 1989 the tercentenary of the accession to the throne of Great Britain by a Dutch prince, William of Orange, and his Scots wife Mary Stuart, we cannot but marvel at the tortuous ways of history that have led to the strong bonds in every field of human endeavor that join our three nations together today.

It is this insight into our common heritage in the political, cultural, and economic domains, culminating in our shared trust in democracy and freedom, that underlies this important exhibition.

His Excellency
Richard H. Fein
Ambassador of the Kingdom
of the Netherlands to the
United States of America

I am delighted to be a member of the International Committee of Honor of this imaginative and important exhibition.

This year the United States, the Netherlands, and the United Kingdom commemorate the tercentenary of the British Parliament's invitation to William of Orange and his wife Mary, to assume the throne of Great Britain as cosovereigns. The momentous events that led to William and Mary's accession in 1689 had a deep and lasting effect on the histories and relationships of our three countries.

The common theme that these events produced in the political history of our three countries is reflected in a common artistic style, now known simply as William and Mary. An international team has selected many fine works of art for this exhibition, a fascinating symbol of the shared history and love of democracy of three nations. The links that were created three centuries ago are still strengthening, and the exhibition represents a celebration we can all enjoy.

His Excellency
Antony Acland
British Ambassador to the
United States of America

Foreword

A traveling clock with an alarm, a wine cooler from the household of a British prime minister, silver furniture from Windsor Castle, an inkstand for a royal governor of two North American colonies, and a ceramic plate with a popularized portrait likeness of a youthful Dutch prince, England's future King William III: dissimilar objects which nevertheless speak the native language they have always shared.

The rhetoric of such forms is perhaps now too quiet, too foreign, too fragmented in its syntax, idioms, and individual inflections, to command the attention of a hurried American audience or to gain its understanding easily. Unless, as we have attempted to do, we trap them in the benevolent captivity of a modern museum. Trap them, of course, for examination, for interpretation, for comparison, and even for exaltation of a kind.

These objects, and the others selected for *Courts and Colonies: The William and Mary Style in Holland, England, and America*, are precious survivors. We value them as we do—in part—because by some miracle they survived and so can represent today their makers, their owners, and other realities of their age.

For our own purposes, then, we lift them carefully from their rightful contexts and marshal them into roles never dreamed of by their creators. With no intention to create period rooms or settings, we nevertheless note the masterfully concerted effects of their original architectural environments while we examine them as individual embodiments of a distinctive visual style. In response, they speak freely of very specific economic and political conditions, of intimate personal relationships, and of broad cultural continuities. As we admire their rarity and aged beauty, we therefore ought not overlook their intrepidity as unwitting but resourceful ambassadors from the world which was theirs to our own.

The idea for this exhibition was first suggested by Lisa Taylor, Director Emeritus of the Cooper-Hewitt Museum, in the belief that it would constitute a worthwhile commemoration of the historical events of 1688. John R. Lane, then Director of The Carnegie Museum of Art, agreed not only to lend expertise from his staff for the curatorial team but also to have the museum share in the project's funding and administration as an organizational partner with the Cooper-Hewitt. The collaboration has proven fruitful and entirely happy, for which we have the professional staffs of both organizations to thank.

David Revere McFadden recruited and continuously encouraged the entire curatorial team with sensitivity and unfailing enthusiasm. His initial vision and belief in the significance of the style's international character has had much to do with the exhibition's final form.

As a personal aside, it is gratifying to both of us, as former students of the late Benno Forman at The Henry Francis du Pont Winterthur Museum, to see his passionate scholarship in American decorative arts, as well as the continuing work of several museum professionals whom he helped to train, informing an exhibition in which European, British, and American artifacts are juxtaposed for the simultaneous analysis they deserve. We are deeply indebted to Gervase Jackson-Stops and Reinier Baarsen for agreeing to consult so carefully with the other members of the curatorial team in the deployment of their individual expertise in order that this innovative approach to the material might succeed.

Our greatest debts, of course, are to the lenders and patrons upon whose generosity the entire project has completely depended. Particular gratitude must be expressed to Her Majesty Queen Elizabeth II for the presence in New York of the magnificent silver furniture sent from Windsor Castle, and other items from the royal collection. And we are similarly honored by the gracious extension of the patronage of Her Royal Highness Princess Margriet of the Netherlands for the project as a whole. Their participation is truly a distinction of which we have tried to make the exhibition worthy.

Harold F. Pfister
Acting Director
Cooper-Hewitt Museum

Phillip M. Johnston
Director
The Carnegie Museum of Art

Acknowledgments

We wish to acknowledge with gratitude the many different contributions of numerous individuals in the Netherlands, Great Britain, the United States, and France without whose assistance this project would not have been possible. Among these persons are:

Michael Archer
John Austin
David L. Barquist
Linda R. Baumgarten
Suzanne Boorsch
Yvonne Brunhammer
Emmanuelle Brugerolles
Elizabeth Burke
Jacqueline Calder
Randall Cherry
Mr. and Mrs. I. W. Colburn
Edward S. Cooke, Jr.
Donna Corbin
Tammis K. Croft
Prof. W. H. Crouwel
John Davis
Peter Day
M. D. Drury
Jonathan L. Fairbanks
Donald L. Fennimore
Martha Gandy Fales
Andrew Fisher
Hank Fisher
William H. Florkowski
Beatrice B. Garvan
Marie-Noël de Gary
Cora Ginsburg
Dorothy Twining Globus
Mr. and Mrs. Dudley J. Godfrey, Jr.
Margaret Grieve
Susan D. Guiser
Stephen V. Hartog
Andrew Henderson
Jan Hesseling
Kathryn Hiesinger
Graham Hood
William N. Hosley, Jr.
Sarah Towne Hufford
Jethro Hurt
Kate Hutchins
Colta Ives
Annie Jacques
Elizabeth Jarvis
Françoise Jestaz
Brock W. Jobe
William Johnston
M. Jonker
Dr. C. J. A. Jörg
Patricia E. Kane
Dean Lahikainen

Patrick Laharie
Wade Lawrence
Michael Legnasky
Joseph Leonetti
Jack Lindsay
Charles R. Longsworth
Dwight P. Lanmon
William Lyman
Jessie McNab
J. V. G. Mallet
Christine Miles
John Morley
George Nichols
J. W. Niemeijer
Jane C. Nylander
Richard Nylander
Jeffery J. Pavelka
Marion Pennink-Tijsseling
Dianne Pilgrim
Laurence R. Pizer
Cynthia B. Plaut
Anne Poulet
Jane Preger
Ian M. G. Quimby
Dr. Olga Raggio
Elizabeth N. Redmond
William Reider
Cordelia Rose
Frances Gruber Safford
Cheryl Saunders
Peter Schatborn
Jan G. Schouten
Helga Schouten-Werner
Arlene Palmer Schwind
Michael Snodin
Mrs. Stanley Stone
Kevin Stayton
Robert F. Trent
Johannes van de Pol
Mr. and Mrs. Fred Vogel III
Monica Vroon
Barbara McClean Ward
Gerald W. R. Ward
Deborah D. Waters
Gillian Wilson
Drs. M. I. E. van Zijl
Philip D. Zimmerman

Lenders to the Exhibition

The Netherlands:
Amsterdams Historisch Museum,
 Amsterdam
Museum Boymans-van Beuningen,
 Rotterdam
Cannenburch Castle, Vaassen
Centraal Museum, Utrecht
Bestuur Godshuizen, Den Bosch
Dordrechts Museum, Dordrecht
Gemeentearchief, The Hague
Gemeentemuseum, Arnhem
Gemeentemuseum, The Hague
Groningen Museum, Groningen
Hannema–De Stuers Foundation, Heino
Lodewijk Houthakker Collection
Museum Mr. Simon van Gijn, Dordrecht
Rijksmuseum, Amsterdam

Great Britain:
Her Majesty Queen Elizabeth II
The Duke of Buccleuch and Queensberry,
 K.T.
The Burghley House Collection, Stamford
The Duke of Devonshire and The Trustees
 of the Chatsworth Settlement
The Lord Egremont
Provost and Fellows of Eton College,
 Windsor
Hopetoun House Preservation Trust, West
 Lothian, Scotland
Mr. Gervase Jackson-Stops
Lady Lever Art Gallery, Port Sunlight
The Viscount de L'Isle, V.C., K.G.,
 Penshurst Place
The National Trust (Knole and Dunham
 Massey)
The Royal Institute of British Architects,
 London
St. Paul's Cathedral, London
Mr. L. G. Stopford Sackville
The Victoria and Albert Museum, London
The Worshipful Company of Goldsmiths,
 London
The Worshipful Company of Pewterers,
 London
Private Collection

France:
Archives Nationales, Paris
Bibliothèque Nationale, Paris
Ecole Nationale Supérieure des Beaux-Arts,
 Paris
Musée des Arts Décoratifs, Paris

United States:
Albany Institute of History and Art,
 Albany, New York
The Brooklyn Museum, Brooklyn,
 New York
The Carnegie Museum of Art, Pittsburgh,
 Pennsylvania
Colonial Williamsburg Foundation,
 Williamsburg, Virginia
Cooper-Hewitt Museum, New York
The Corning Museum of Glass, Corning,
 New York
The Essex Institute, Salem, Massachusetts
The J. Paul Getty Museum, Malibu,
 California
Mr. Richard L. Gray
Mr. and Mrs. George M. Kaufman
Mrs. Richard Koopman
Emily Fisher Landau
The Metropolitan Museum of Art,
 New York
Museum of the City of New York,
 New York
Museum of Fine Arts, Boston
Philadelphia Museum of Art, Philadelphia,
 Pennsylvania
The Pierpont Morgan Library, New York
Pilgrim Hall Museum, Plymouth,
 Massachusetts
Mr. and Mrs. Glenn C. Randall
Society for the Preservation of New
 England Antiquities, Boston,
 Massachusetts
The J. B. Speed Art Museum, Louisville,
 Kentucky
Mr. Peter A. Tcherepnine
Wadsworth Atheneum, Hartford,
 Connecticut
The Walters Art Gallery, Baltimore,
 Maryland
Professor N. R. Weiss
The Henry Francis du Pont Winterthur
 Museum, Winterthur, Delaware
Yale Center for British Art, New Haven,
 Connecticut
Yale University Art Gallery, New Haven,
 Connecticut
Private Collections

Introduction

Circumspection is always in order when proposing connections between political events and artistic developments, particularly in the analysis of events that appear to have affected stylistic changes in different countries. Yet, within the decorative arts, such changes often reveal themselves with unusual clarity.

The era of William and Mary was a time of important stylistic change in architecture and the decorative arts. The new style, which flourished in France, had far-reaching impact on Holland, England, and America, three regions that shared political affinities and cultural ties.

Traditionally, the style has been named for William and Mary, both for reasons of expediency and simplicity, as well as in acknowledgment of the monarchs' roles in its promotion. As the works selected for the exhibition demonstrate, however, the artistic sources of this style predate the reign of William and Mary and take inspiration from geographical areas as far removed from their court as the Orient.

The monarchs provided an imprimatur for artists, artisans, and their works in the new and highly ornamental style; royal patronage assured that the style was effectively promoted. At the same time, the William and Mary style was also embraced by a wider segment of society. In Holland, a powerful and influential merchant class provided patronage for both native and foreign artisans and architects, while across the Channel, in England, the court style was enthusiastically buttressed by aristocrats building or renovating their elegant dwellings. In America, colonial governors and affluent individuals who wished to project an image of urbanity and sophistication adopted a similar vocabulary of ornament, furnishing their houses with textiles, ceramics, glass, silver, and furniture in the new style.

The significant role of interior decoration in this period remains one of the noteworthy features of the William and Mary style. Clearly, the architectural foundations of the style are of critical importance to any analysis of the decorative arts; without structures such as Het Loo in Holland, Hampton Court in England, and the Governor's Palace in Virginia as points of reference, our appreciation of the style would be diminished. Notably, however, architecture was sometimes conservative in comparison to interior design and decoration in all three countries. It was inside palaces and houses that the William and Mary style flourished with vigor, in the richly gilded and inlaid surfaces of furniture, in the brilliant tonality and textures of fabrics and hangings, in the boldly dramatic forms and sculptural ornaments of silver for display and use, and in the sophisticated blue-and-white ceramics (both exotic imports and indigenous wares) that garnished mantelpieces, walls, and cabinets.

International exchange in the field of decoration and decorative arts during the period reflected improved communications, most notably in the area of printed designs for architecture and ornament. Cultural exchange was also fostered by increased travel, sometimes by choice and sometimes out of political or religious necessity. Daniel Marot, the pivotal figure of this exhibition, stands as a singular example of the mobility of talent in the period. Born in France, he lived in both Holland and England. The impact of his designs, however, reverberated as far as the American colonies.

What are the pertinent characteristics of the William and Mary style? And which of these characteristics can be said to represent a new chapter in the history of the decorative arts?

The authors of this catalogue consistently underline the importance of a unified scheme of interior decoration. This unity of structure and ornament, which may be viewed as a legacy of the remarkable artistic choreography of Versailles, was embraced by a wide circle of the fashionable and wealthy throughout Europe. The domestic interior, a symbol of personal status and taste, took on added significance, both for the owner and for the interior architect responsible for its plan and decoration.

Teams of specialists such as upholsterers, carvers, gilders, and painters, were able to achieve a memorable *mise-en-scène* within the domestic setting.

A vocabulary of decorative motifs—flutes, gadroons, shells, ornamental masks, and scrollwork—flourished as surface decoration on silver wine coolers and fountains, side chairs, candlestands, and lighting fixtures. Motifs popularized in France by silversmiths and cabinetmakers appeared in Holland and England with astonishing rapidity. Even more striking, however, is the appearance of the same motifs and forms in the silver and furniture of craftsmen in the colonies. The complicated routes of stylistic transmission in the period have been suggested by the authors of this catalogue: direct knowledge of the newest styles gained by travel in foreign countries; the movement and relocation of artists and artisans from one country to another; the importation of fashionable objects that served as prototypes for native designs; and access to printed books of architecture and ornament that made the style easily accessible.

The emphasis on unification of the interior through ornament can be seen in furniture and upholstery of the period. Large and impressive suites of seating furniture are known from all three countries. Special importance was given to "triads" consisting of a table, paired candlestands, and a framed mirror. Such sets are well documented in both Holland and England, but the appearance of such sophisticated refinements in colonial America in the latter years of the seventeenth century adds to our growing awareness of the truly international character of the William and Mary style.

Refinements in both techniques and materials during the William and Mary era also had an impact on the decorative arts. Potters in Holland and England created earthenwares that imitated the expensive oriental porcelains that were avidly collected in Europe. Glass also took on a new importance in the architecture and decoration of the period. Improved skills in production encouraged the use of glass in buildings, thereby placing emphasis on landscape vistas. Inside, mirrors and looking glasses reflected both natural and artificial light. Looking glasses played an especially important role in Dutch, English, and American

interiors and, like silver, signified sophistication and wealth.

A style is defined by distinct and recognizable characteristics that are repeated or varied in many different settings or contexts. This exhibition demonstrates the national and regional variations in materials, techniques, forms, and motifs to be found in Holland, England, and America during this period of political and cultural change. It also offers special insights into the ways in which ornament and design are transmitted, adopted, and shared among artists and artisans internationally.

Neither this exhibition nor this catalogue would have been possible without the spirit of close cooperation that existed among our guest curators: Reinier Baarsen of the Rijksmuseum in Amsterdam; Gervase Jackson-Stops of the National Trust in Great Britain; Phillip M. Johnston of The Carnegie Museum of Art in Pittsburgh; and Elaine Evans Dee of the Cooper-Hewitt Museum in New York. To them we offer our sincere appreciation. Other colleagues in the Netherlands, Great Britain, and America contributed expertise and important loans, and we hope they share our pride in the final result.

At the Cooper-Hewitt Museum, Linda Shulsky and Deborah Sampson Shinn admirably managed the immense task of coordination and preparation of the exhibition and catalogue. Nancy Aakre has once again guided the catalogue with consummate skill from its inception to publication. To them, and to the many other staff members of both the Cooper-Hewitt Museum and The Carnegie Museum of Art, we extend our sincere gratitude.

David Revere McFadden
Curator of Decorative Arts

The Court Style in Holland

by Reinier
Baarsen

The court style of the late seventeenth century is the style of Versailles. Louis XIV, the Sun King (1638–1715), began enlarging this small hunting lodge immediately upon assuming complete power after the death of Cardinal Mazarin in 1661, and he was to continue adding to the château and enriching it all his life. His architect was Louis Le Vau (1612–1670), his garden designer was André Le Nôtre (1613–1700), and his decorator for the interior was the painter Charles Le Brun (1619–1690). This famous team had already worked together for Nicolas Fouquet (1615–1680), the minister of finance, at his Château de Vaux-le-Vicomte, with such brilliant success that the result had excited the envy of the young king, thereby precipitating Fouquet's fall. At Vaux, all the arts combined to create a splendid ensemble proclaiming the glory of the owner of the house and of his king. Painting, sculpture, garden design, furniture making, every form of art lost its independence to take its place in a unified scheme governed by the architecture. This idea of an all-embracing artistic unity was developed even further by the king. He wished every element of his palace to be supremely magnificent and in full accord with its surroundings; thus the building would testify in the most forceful way to the reigning, animating spirit of the sovereign.

To achieve this aim, the best craftsmen were attracted from within France, as well as from Italy and Northern Europe, and in 1662, a large court workshop, the Manufacture Royale des Meubles de la Couronne, was set up at the Gobelins, where these artists worked under the guidance and after the designs of Le Brun. The famous tapestry depicting Louis XIV's visit to the workshops in 1667 shows some of the foremost craftsmen presenting a choice of the luxurious objects they made: various kinds of furniture, marquetry floors, tapestries, and silver vessels (Fig. 2). These various works reveal the main source of ornamentation to be classical antiquity and its Renaissance interpretations. Motifs such as rams' heads, acanthus scrolls, and elements from the architectural orders like columns, friezes, and pediments occur frequently. Le Brun's work is baroque in its dramatically orchestrated use of the classical vocabulary to achieve an effect of greater tension. Compared to its Italian models it is often heavy and somewhat rigid. All the works executed at the Gobelins are characterized by the use of the richest possible materials and by a great refinement of workmanship, which together relieve the sometimes rather ponderous quality of the design.

Like the architecture and the decorative arts, life itself was highly organized at Versailles. A strict etiquette, where almost every act and movement carried a specific meaning, was prescribed. As each action was formalized into a ceremony, the objects involved acquired new importance as well. A well-known example is the significance attached to the various kinds of seating. The right of a duchess to sit on a *tabouret*, or stool, in the presence of the queen was thought to be so important a distinguishing mark that the famous diarist the duc de Saint-Simon tells us that ladies of that rank were often referred to simply as *tabourets*.

Both the mode of life and the decorative idiom of Versailles became the model for every court in Europe. Visitors to the palace eagerly noted everything they saw and sent their reports home. Works of art were ordered in Paris by foreign princes, and French architects and artists were invited to work abroad. Engravings showing either Le Brun's works or new inventions in his manner (No. 32) were a most important means of spreading his style. Even the stadholder-king William III (1650–1702), Louis XIV's most powerful and tenacious opponent, felt no hesitation in following the lead of his enemy where architecture and decoration were concerned. In fact, there was a long tradition of French influence in these matters at the court of the stadholders. William III's grandfather, Frederik Hendrik (1584–1647), whose mother was the French-born Louise de Coligny and who had been raised partly at the French court, had employed the French architect Jacques de la Vallée at the castle of Honselaarsdijk.[1] His son , William II (1626–1650), in 1650 ordered a costly suite of bedroom furniture in Paris for the birth of his first child, who was to be William III. This suite was not used for the occasion, however, as the father died shortly before the birth of the son, so that the bedchamber had to be draped in black for mourning.[2] After this there was to be no stadholder until William III was appointed in 1672, but other connoisseurs and patrons remained interested in developments in France, and ornamental engravings from Paris were avidly sought in The Hague and elsewhere.

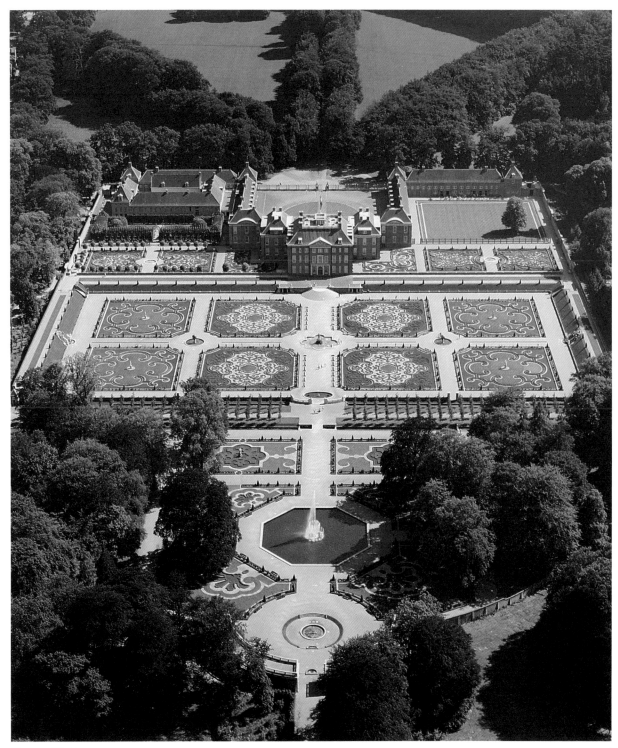

Figure 1. Het Loo
Palace and Gardens,
Apeldoorn

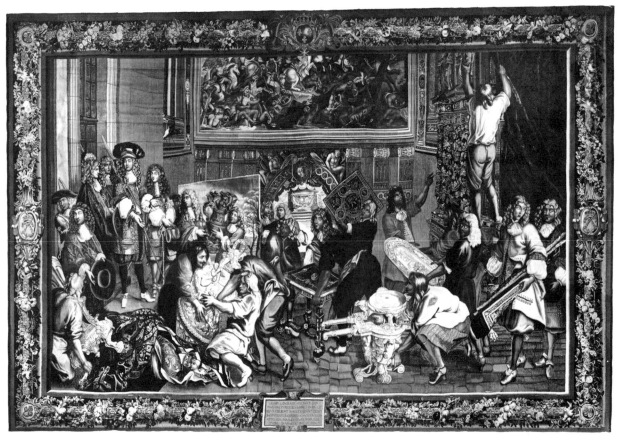

Figure 2. Tapestry depicting Louis XIV visiting the Manufacture des Gobelins; France, 1667; Manufacture des Gobelins, after a design by Charles Le Brun (1619–1690); Château de Versailles

Figure 4. Layette basket; The Hague, 1666; Adriaen van Hoecke (1636–1716); silver; Museum of Fine Arts, Boston, John H. and Ernestine A. Payne Fund

Figure 3. Design for two tables in the auricular style; Amsterdam, 1655; Gerbrandt van den Eeckhout (1621–1674); engraving; Rijksprentenkabinet, Rijksmuseum, Amsterdam

In what artistic climate were these impulses from France received? In the Netherlands, the second quarter of the seventeenth century had witnessed the birth of the Dutch classicist style in architecture. Closely based on Italian Renaissance prototypes, this style was both plainer and purer than the later Louis XIV court style. Dutch classicism was influential in the decorative arts as well, but they were also swept by another current of equal importance and great originality: at the beginning of the century the Utrecht silversmiths Paul (c. 1570–1613) and Adam (1569?–1627) van Vianen had introduced the fantastic, so-called auricular ornament, reminiscent of ears and bones. Although created in silver, it gradually affected furniture and the other decorative arts (see Fig. 3). Surprisingly, elements in this anticlassical manner were employed even in the most severe, imposing surroundings and they retained their popularity well into the 1670s. By this time, the prevailing architectural and decorative style had acquired distinctly baroque features. There was a new love of strongly three-dimensional forms, richly worked surfaces, and costly, exotic materials. Realistic floral ornament—either embossed, carved, or woven—enjoyed great popularity. The play of light and shade was enhanced by the employing of lustrous materials, the application of high relief, and the use of bold shapes (see Fig. 4).

No survey of Dutch seventeenth-century interior decoration, however summary, could fail to mention the highly important role played by oriental works of art. Following the founding of the Dutch East India Company, many artifacts from China and Japan found their way to Holland, with blue-and-white porcelains and lacquers foremost among them. Seventeenth-century inventories testify to the astonishing number of oriental objects to be found in many Dutch houses—not only lacquer cabinets with porcelain arranged on top of them, but also smaller lacquer objects and innumerable cups and saucers, plates, and other chinaware stored away in cupboards. Naturally, the taste for things oriental was not restricted to Holland: in France, England, Germany, and elsewhere, Far Eastern curiosities were collected with zeal. The craze was nowhere as strong nor as widespread throughout the social orders, however, as in the Netherlands. From an early date, oriental objects were imitated: the Delft potters strove to copy Chinese porcelain as closely as possible, and japanned furniture was produced in imitation of real lacquer, which was made from the sap of the *rhus vernicifera* tree, which did not grow in Europe. It will be seen that in the Netherlands, throughout the period dominated by the Louis XIV style, this love of Far Eastern wares lost none of its strength.

If the artistic climate created around Louis XIV began to exert its influence in Holland almost from the moment it came into being, and if this current was strengthened after 1672, the year in which William III became stadholder, it only really gathered momentum in the 1680s. This was partly owing to Louis XIV's hostile attitude toward the Huguenots, culminating in the revocation of the Edict of Nantes in 1685. After eighty-seven years of freedom, Protestants in France were once again forbidden to exercise their faith. Many thousands of them fled the country, in addition to the great numbers who had already done so in the years before the revocation. Among the refugees were many excellent craftsmen who naturally brought the current French style with them. Little research has been done on those who came to the Netherlands. We know many names, and some of the work of a small number of artists has been identified, but there is as yet no reliable picture of their importance as a group. One figure stands out: the designer, architect, and engraver Daniel Marot (1661–1752), who fled Paris for The Hague in 1684 or 1685.

Immediately upon arriving in the Netherlands, Marot found employment for his manifold talents. He published several engravings in The Hague in 1686 and in the same year designed a number of interiors for the Slot Zeist, near Utrecht, for Willem Adriaan, count of Nassau-Odijk.[3] Even more important, at about the same time he entered the service of Nassau-Odijk's cousin, William III, who was starting to build a house near the old castle of Het Loo, near Apeldoorn. Marot was to be connected with the building and decorating of Het Loo for the next fifteen years, up to the death of William III in 1702. This palace, recently completely restored, remains his most important work, in which the evolution of his early style can be traced through the succeeding phases of construction. At Het Loo, as at Slot Zeist and the other dwellings for William III and his entourage where Marot was employed—such as the exquisitely beautiful De Voorst, built for Arnold Joost Keppel, earl of

Albemarle, from 1697 to 1700[4]—he was not the actual architect of the house. Indeed, at the three houses just mentioned he worked with the architect Jacob Roman (1640–1716). Marot's responsibility lay in the decoration of the interior and possibly the arrangement of the various rooms and staircases. He was also involved in the design of the gardens with their ornamental pavilions and decorative vases; both those at Het Loo and De Voorst appear largely to have been his work.

Apart from the States-General of the Republic, for whom he decorated the Trèves-zaal and other rooms in the Binnenhof in The Hague, Marot's Dutch clientele was, as far as we know, confined to the court circle of his foremost patron, William III. Although the stadholder demanded neither the same splendor nor the same formality as Louis XIV, it was a matter of course that he and his consort, Princess Mary Stuart (1662–1695), whom he married in 1677, should be surrounded by a considerable amount of ceremony, with etiquette and conventions reflecting those at Versailles. After William and Mary were crowned king and queen of England in 1689, life at court naturally assumed an even grander and more stately tone. In 1688 the couple had gone to England, where Queen Mary stayed, never to return to the Netherlands. The king did come back periodically, however, and work on the palaces in Holland continued as before. During the ensuing decade Marot, who after a brief interlude had followed his royal patrons across the Channel, probably divided his time between the two countries before returning to Holland in about 1700.[5]

Marot, who through his training in France had a firsthand knowledge of customs and fashions at Versailles, was ideally suited to fulfill the desires of the stadholder-king and his courtiers. For them he designed great staircases with allegorical decorations, painted ceilings, unified schemes for rooms of state, elaborate beds, magnificent furniture, and other objects, many of which were executed by Huguenot craftsmen. He gave proof of having learned the lessons of Le Brun's work well. His proposals for fully integrated ensembles in the new style encompassed all the various arts involved; no detail was deemed unworthy of his attention, and he used the same decorative motifs in each medium. His designs for gardens are again in the same idiom. The unity of house and garden, a concept so dear to the spirit of the baroque, was achieved by Marot in terms not only of spatial relationships but ornament as well.

William III and the noblemen of his court, however, represented only a very small section of art patronage in the Netherlands. The great majority of wealthy Dutchmen belonged to merchant families living in Amsterdam and other cities. Members of this class also held most of the offices of local and national government. The French style did not penetrate this milieu as quickly as it did the court, since the formal manner was less suitable for canal houses or relatively simple country residences, where life was not so geared toward display. Works by Huguenot craftsmen reflecting French fashions did find their way into these houses, but the spreading of the new style was less systematic. Also, it is less well documented.

The dissemination of the newly fashionable manner was greatly stimulated by the publication of a large series of engraved decorative designs by Marot himself. His range of subjects was much broader than that of any other designer of the period. These published designs have ensured Marot's lasting fame, while many of the other artists and craftsmen who worked alongside him have been underestimated or forgotten, an imbalance that can only be rectified by continuing research into the period. In the meantime Marot's work has to be our principal guide in surveying the various elements of fashionable Dutch interior decoration in the late seventeenth century.

Most of Marot's early designs for ceilings were meant to be executed by painters. Following a popular baroque formula, he usually created an illusionistic effect of various balustrades and other architectural features beyond which the sky is perceived (No. 27). In the central block of Het Loo, built and decorated in the 1680s, all the ceilings are painted. In the pavilions that were added from 1691, however, they are of stucco. This change is symptomatic: only from the very end of the seventeenth century was plasterwork employed at all regularly in the Netherlands.[6] In Marot's later buildings stucco ceilings were to replace painted ones almost entirely. Some of his engraved designs clearly are for ceilings in this

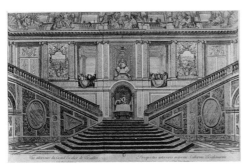

Figure 5. *Vue interieure du Grand Escalier de Versailles;* France, c. 1715; Louis Surugue (1686–1762), after drawings by Jean-Michel Chevotet (1698–1772); engraving; Bibliothèque Nationale, Paris, Cabinet des Estampes

Figure 6. *Italian Landscape;* The Netherlands, c. 1730–40; Isaac de Moucheron (1667–1744); oil on canvas; Wadsworth Atheneum, Hartford, Anonymous Gift

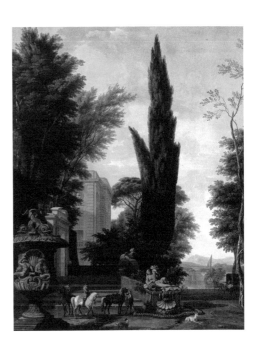

Figure 7. Lacquer paneling, detail of a room from the residence of Hendrik Casimir II; Leeuwarden, c. 1695; Chinese incised lacquer, painted and gilded wood; Rijksmuseum, Amsterdam

medium. They are usually entirely ornamental. The ceiling in the Trèves-zaal, which was decorated in 1697, is a rare instance of painting and stucco being combined and integrated.

In this room the walls, articulated by Ionic pilasters with the rusticated bands so typical of Marot, are inset with large painted portraits of the first four stadholders. In other room schemes Marot employed large illusionistic canvases of landscapes set in the paneling. In some of his grand staircases, notably those at Het Loo (No. 12) and De Voorst (No. 13), the walls were entirely painted with great vistas of landscapes with figures leaning over balustrades in the foreground. These splendid staircases, based on the famous Escalier des Ambassadeurs at Versailles (Fig. 5), were to remain a somewhat isolated phenomenon in the Netherlands. To have a room fitted with huge landscapes painted on canvas, however, became one of the most characteristic types of decoration in Holland, lasting throughout the eighteenth century. A painter who specialized early on in idealized, classical landscapes of the type seen in some of Marot's engravings was Isaac de Moucheron (1667–1744) (Fig. 6).

This kind of decoration was not invented by Marot; in adopting it he followed a tradition that had already been established in Holland. To some extent the same can be said of his designs for chinoiserie rooms fitted with lacquer panels (see No. 171). Amalia van Solms (1602–1675), the wife of Stadholder Frederik Hendrik, already had a room at Huis ten Bosch, near The Hague, the walls of which were enriched with Japanese lacquer panels taken from chests and boxes and arranged in decorative patterns. It had probably been decorated before 1660. When large lacquer screens, either Japanese or Chinese, became readily available at a somewhat later date, their tall leaves were seen to be ideally suited for the paneling of rooms. Small rooms decorated in that manner were installed for Princess Mary at the Binnenhof in The Hague and at the castle of Honselaarsdijk, presumably between 1685 and 1686. The exotic character of the cabinet at Honselaarsdijk—thought to be one of the first works designed by Marot for the stadholder—was enhanced by a ceiling inset with mirrors, a feature also occurring in a cabinet at Het Loo. A room paneled with Chinese incised lacquer screens (the so-called coromandel) and installed, probably in 1695, in the Leeuwarden residence of Hendrik Casimir II (1657–1697), the Frisian stadholder, survives in the Rijksmuseum (Fig. 7).[7] Here, the ornament of the carved dado and frieze does not yet show the influence of the French style, suggesting that this was not immediately adopted outside The Hague, even in a commission for one of the stadholder's close relatives who himself was a governing prince.

The oriental atmosphere of these rooms adorned with lacquer paneling was continued in their furniture, which at Honselaarsdijk was japanned and at Leeuwarden was of lacquer and amber. Furthermore, there was an abundance of oriental porcelain in these rooms—arranged on the chimneypiece at Honselaarsdijk, on shelves and tables at Leeuwarden. Marot's engraving shows how in the hands of an architect, the porcelain could be fully integrated within the treatment of the walls, with strings of cups and saucers becoming moldings or pilasters and massed groupings of vases turning into structural features, giving rooms an almost unreal, fairy-tale quality. Another engraved design shows the porcelain arranged on brackets all over the walls and even serving as a kind of extra cornice (No. 144). Again, the fashion for porcelain rooms existed in Holland before the arrival of Marot, and may even have originated there in the first half of the seventeenth century;[8] he merely reinterpreted it, bringing a more structured aspect to the genre.

Rooms entirely paneled with lacquer screens must have been rare outside court circles, but the widespread craze for Far Eastern objects in Holland resulted in many houses having at least one room where the dominant theme was oriental. If the entire paneling was rarely covered with china, the chimneypiece frequently was. Its form could be extremely elaborate (Fig. 8), but many comparatively simple examples were also installed, with tiered arrangements for the display of porcelain. Arrangements like these would usually be found in small, luxurious rooms, where they were ideally suited to the upper stages of corner chimneypieces.

As seen in Marot's designs for chinoiserie rooms, his chimneypieces often have a narrow looking glass panel set directly above the fireplace opening—below the main decorative feature, which was either a picture or a panel decoratively carved en suite with the paneling of the walls in the room. In a few examples the chimneybreast is faced with a taller glass panel, creating a much lighter effect and reflecting the latest French developments (No. 18).

Among Marot's most typical creations are his proposals for richly appointed bedchambers (No. 154). In accordance with the international model, the residences of the stadholders and their courtiers were divided into apartments for the individual members of the household. The bedchamber was the culmination point of the apartment, the last and grandest room to be reached, with only private cabinets and closets beyond. Its central feature was the state bed, which, more than any other piece of furniture, symbolized the status of the owner. It comes as no surprise, therefore, that Marot devoted so much attention to this type of room and to individual beds.

The walls of the bedchamber might be hung with tapestries, but at this time they were often hung with the same silk damask or velvet as the bed. Complete unity could thus be achieved within the room, with chairs ranged against walls upholstered to match and with window curtains made of the same material. The appearance of such a room was to a great extent dictated by the textiles; it was the preserve of the upholsterer. This craftsman was responsible for the elaborate valances, the fringes and tassels, and above all the state beds, which were the greatest test of his virtuosity. Marot's designs for beds are of astounding elaboration; these extraordinary confections employ his entire decorative vocabulary (Fig. 11). By proposing highly decorated beds with flying testers for the most formal surroundings, Marot probably intended somewhat to "show off" the French style, although in fact bedsteads of this type were never used in French state rooms, where an unadorned, boxlike shape was always preferred. More fanciful variants were probably only used there in informal surroundings and carried distinctly frivolous connotations. For instance, some beds installed in the Trianon de Porcelaine, a small pleasure pavilion in the gardens of Versailles, in 1672, closely resemble those illustrated by Marot (Figs. 9 and 10). It is surprising that these forms were accepted for state bedchambers by the most exalted patrons both in Holland and England, at least some of whom must have been aware of the discrepancy. The idea of flying testers was not often adopted in Holland, where nearly all the surviving state beds have four posts. The decoration could, however, be quite as extravagant as in Marot's engravings (Fig. 12). For Dutch upholsterers the new designs must have presented a great challenge, one that they could not always face with confidence. Marot probably relied on Huguenots from

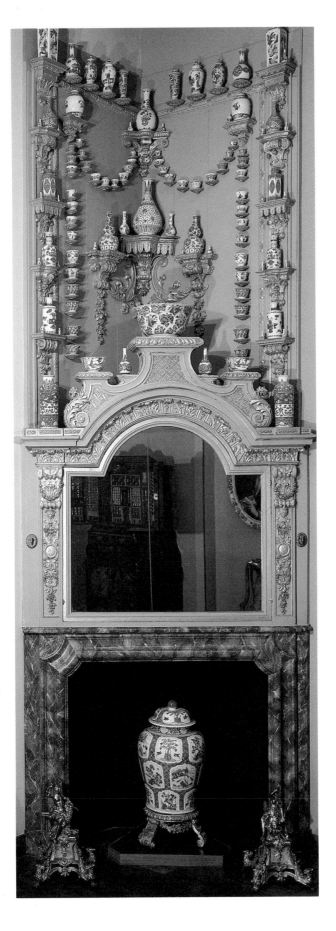

Figure 8. Corner chimneypiece with Chinese blue-and-white porcelains; probably The Hague, c. 1700; painted and gilded wood; Rijksmuseum, Amsterdam

Figure 9. Design for state bed; France, c. 1687; Nicodemus Tessin the Younger (1654–1728); graphite; Nationalmuseum, Stockholm, Tessin-Hårleman Collection

Figure 10. Design for state bed; France, c. 1687; Nicodemus Tessin the Younger (1654–1728); graphite, watercolor; Nationalmuseum, Stockholm, Tessin-Hårleman Collection

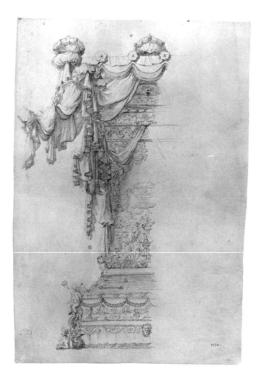 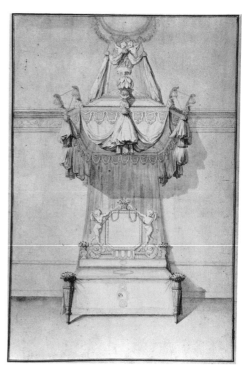

Figure 11. Design for a state bed; The Netherlands, c. 1700; Daniel Marot (1661–1752); pen and ink with gray wash; Biblioteca Comunale degli Intronati, Siena

Figure 12. Bed from Kasteel Rosendael, Gelderland; The Netherlands, first quarter 18th century; wood, cut velvet; Rijksmuseum, Amsterdam

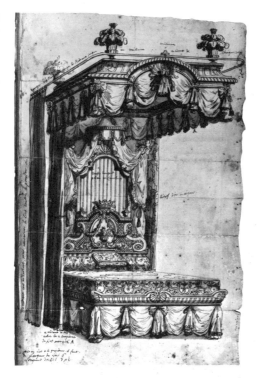 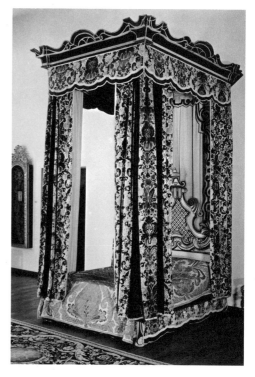

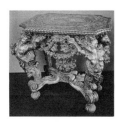

Figure 13. Table; possibly The Hague, c. 1700; carved and gilded oak; Rijksmuseum, Amsterdam

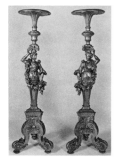

Figure 14. Pair of candlestands; possibly The Hague, c. 1700; carved and gilded limewood; Rijksmuseum, Amsterdam

France for the execution of many textile furnishings after his designs; and indeed the name of one of them, Pierre Courtonne (active 1696–1714), figures prominently among those working for the stadholder.

No complete scheme devised by any of the upholsterers of this period survives in the Netherlands, where there were comparatively few large country houses and where, as in France, the system of primogeniture did not obtain. After a death, collections were often dispersed—which greatly complicates the study of Dutch furniture, as the origin of individual pieces is hardly ever known. Inventories, descriptions, and illustrations show that most of the types of furniture that can still be found in England existed in Holland as well. Thus we must often turn there to try to find out more about Dutch practices.

The wooden frames of the state beds were entirely covered with textiles, so no special care was bestowed on their finish. Carvers were engaged on many other types of furniture, however, notably the side table. Marot published a few proposals for such tables among his designs for silver (No. 98), inspired by the magnificent silver furniture made at the Gobelins that he must have seen proudly displayed at Versailles. When Louis XIV was forced to have this furniture melted down in 1689 to pay for his military campaigns, replacements were made in carved and gilded wood. William III and members of his court also possessed a certain amount of silver furniture, but Dutch tables of this type were mostly made in wood. In fact, we know that Marot's well-known drawing of 1701 for a table, candlestand, and looking glass for Het Loo was executed in gilt wood, with the table frame supporting a marble top (No. 86). Other such tables made in Holland have wooden tops decorated with carved and gilded gesso (Fig. 13), but these remained rare, as compared with England, where they became very fashionable.

Marot's designs for tables introduced an entirely French type, closely based on models by Le Brun and Jean I Berain (1640–1711). The four legs take the form of herms or even full caryatid figures, or alternatively of tapering columns with carved embellishments. This imposing form of table was new to the Netherlands, but the concept of a richly carved side table was not. Highly sculptural examples had been made from at least the middle of the century, with legs formed of bold scrolls linked by swags of flowers and with elements of auricular ornament (see Fig. 3). Sometimes figures of children or animals were included. This more indigenous type survived in the late seventeenth century when a straightening of forms and a much clearer separation of the various elements making up the piece occurred (No. 97). In the Netherlands, tables of this kind probably continued to be made in larger quantities, and at more centers of production, than the totally French-inspired ones. The way in which Marot's French ornament, designed for palatial settings, filtered downward and was combined with native forms can be observed in the development of many of the decorative arts.

Marot's drawing for the Het Loo suite shows the table as part of an ensemble, in truly baroque fashion—flanked by a pair of stands, and with a looking glass hung above it, all carved en suite. Candlestands and mirrors occur frequently among Marot's engraved designs, and some pieces executed after his proposals survive (Fig. 14). Dutch gilt-wood mirrors in the Louis XIV style often have a rounded top, which is sometimes crowned by a domed section with lambrequins. This feature, perhaps introduced only after 1700, does not appear on French or English examples but does have its source in Marot's work (No. 41). The frames often have recessed panels with decoration in relief in the French fashion (Fig. 15).[9]

Chandeliers formed another class of furniture frequently supplied by wood-carvers. In France at this time, gilt-bronze chandeliers became the height of fashion. Some of the published designs by the famous *ébéniste* and *bronzier* André-Charles Boulle (1642–1732) are for such gilt-bronze pieces, and they also occur among Berain's engraved work. In the Netherlands no gilt bronze was produced, so French-style chandeliers were generally made of gilt wood; traditional Dutch examples continued to be made in brass. In one of his sets of engravings, entitled *Nouveaux Livre d'Orfevrerie*, Marot published some designs for chandeliers of a more massive character than those by Boulle or Berain. Surviving gilt-wood examples always have a heavy central feature from which the arms spring (Fig. 16).

No designs appear among Marot's known work for two characteristically Dutch types of carved furniture, hall benches and chairs, but the large surfaces of their backs offered

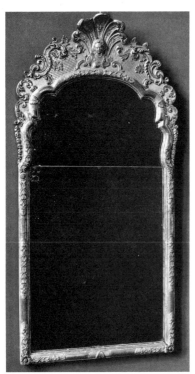

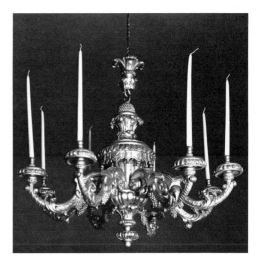

Figure 16. Chandelier;
The Netherlands, first
quarter 18th century;
carved and gilded
limewood; Rijks-
museum, Amsterdam

Figure 15. Mirror; The
Netherlands, early
18th century; carved
and gilded wood,
glass; Rijksmuseum,
Amsterdam

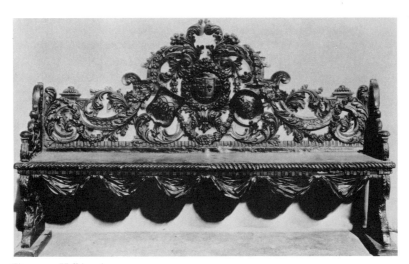

Figure 17. Hall bench;
The Netherlands, first
quarter 18th century;
carved wood; Philadel-
phia Museum of Art,
Purchased: Temple
Fund

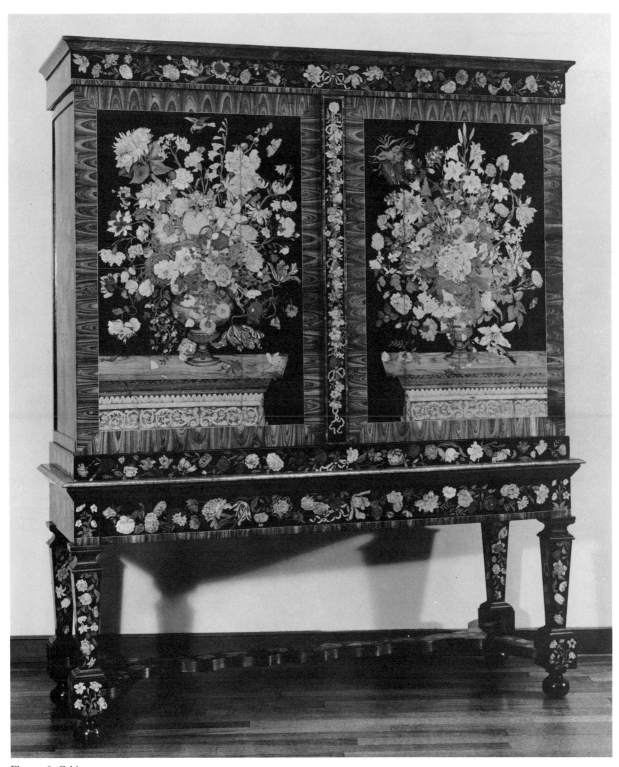

Figure 18. Cabinet;
Amsterdam, c. 1700;
attributed to Jan Van
Mekeren (1658–1733);
oak veneered with
rosewood and other
woods; Rijksmuseum,
Amsterdam

sculptors scope for the display of the latest decorative inventions, and French features quickly made their appearance there. Inventories show hall benches to have been a feature of nearly every well-appointed Dutch house. Highly uncomfortable and not meant to be sat upon for any length of time, their function was primarily decorative. Often the carving of the back included the arms of the owner of the house (Fig. 17). It is likely that these benches were introduced in England as a result of Dutch influence.[10]

Chairs with carved backs were very popular in both England and the Netherlands. A fair number of Dutch examples survive (Nos. 110 and 111)—a fact that may have given us an unbalanced picture of chair production at the time, for, apart from caned examples, which were common in every household, those with upholstered backs were greatly in the majority. When an entirely upholstered chair became worn and outmoded, however, there was little to justify its being preserved, and consequently, very few remain.

We know little about wood-carvers working in Holland at this time. Huguenot names are recorded as well as names of other nationalities,[11] but little of their work has been recognized, especially in the field of furniture. One Huguenot carver and gilder, Jean Pelletier, was already in Amsterdam by 1681 and later followed William III to England (No. 89). It may be surmised that the gilt-wood furniture in a completely French style was often executed by Huguenot carvers, while more typically Dutch pieces were the work of native craftsmen.[12]

As opposed to carvers, cabinetmakers were solely concerned with the production of furniture. Among those whose names are known to us are fewer Huguenots, but French influence was again strong both in Holland and in England, and in some cases it is difficult to ascribe pieces of veneered furniture dating from between 1680 and 1710 to a specific country (No. 102). The international character of cabinetmaking in this period, when *ébénistes* from Northern European countries were often employed in France itself, cannot be overstressed. For instance, the Dutch-born Pierre Gole (c. 1620–1684) came to Paris early in his life and rose to a position of preeminence among the cabinetmakers working for Louis XIV. In Paris he was first apprenticed to the *ébéniste* Adriaan Garbrand, again of Northern origin, whose eldest daughter he married in 1645. Two of Pierre's brothers, Gerrit and Adriaan, also came to work as cabinetmakers in Paris. Adriaan Gole married another of Adriaan Garbrand's daughters, Marguerite, and their daughter Catherine married the architect-designer Daniel Marot, who has figured so prominently in these pages and whose mother was another of Garbrand's daughters! Pierre Gole's son, Corneille, also became an *ébéniste*. After the revocation of the Edict of Nantes he, like Daniel Marot, came to The Hague and likewise went on to London, working for William III. In about 1686, Pierre's brother Adriaan returned to Amsterdam, where he possibly worked for Princess Mary.[13] With such close links between craftsmen working in the various centers, and with their frequent movement from one country to another, it is not surprising to find that pieces produced in different cities have certain elements in common. Rather, it is remarkable that local characteristics emerged as often as they did.

A typically Dutch piece of furniture is the tall cabinet with two large doors, on four legs linked by a stretcher. The smaller cabinets of an earlier period—from which these developed—usually had interiors with numerous drawers and compartments, but the doors of the later pieces open to reveal only a small number of shelves, often used for the storage of linen, above a single tier of low drawers. Soon after 1700 this kind of cabinet was to acquire a full range of drawers below the doors; this was the origin of one of the most common types of Dutch eighteenth-century furniture.

All sorts of veneers could be employed to great advantage on the large doors of the cabinets, but the most highly prized was floral marquetry. Perhaps the finest group of Dutch marquetry cabinets is that convincingly attributed to the Amsterdam maker Jan Van Mekeren (1658–1733) (Fig. 18).[14] Five cabinets of the early variety, with a single drawer below the doors, are thought to be his work. They show little variation, though one example recently acquired by the Victoria and Albert Museum in London has a light ground rather than the dark palisander of the other four. The crowded arrangements of many different flowers in vases, shown standing on plinths or tables, remind one of the floral marquetry of André-

Figure 19. Cabinet; The Netherlands, c. 1700; oak veneered with ivory and other woods; Rijksmuseum, Amsterdam

Charles Boulle as seen, for instance, on his great armoires.[15] The two makers may have been inspired by the same kinds of sources, such as the engravings of the flower painter Jean-Baptiste Monnoyer (1634–1699). Although the work of Boulle shows an even greater refinement and elegance, Van Mekeren's attains a quality that comes very close to that of the great Parisian master and is hardly equaled elsewhere in Europe. The Dutch must have had a natural gift for this type of work. We have seen that Pierre Gole, Boulle's predecessor as the principal cabinetmaker and *marqueteur* in France, came from Holland. The family of Boulle himself originated from the Spanish Netherlands. Moreover, only a few years after Gole introduced floral marquetry to France, a cabinetmaker by the name of Leonard van der Vinnen brought this technique to the grand-ducal court in Florence; he, too, probably came from the Netherlands.[16] On the other hand, there is little indication that floral marquetry was practiced in Holland before the 1680s, and artistic inspiration must have come from Antwerp or Paris.

Another group of floral marquetry cabinets is even more richly decorated than that attributed to Van Mekeren (Fig. 19). The striking polychrome effect of these pieces is enhanced by the use of strongly figured burled wood veneers, reminiscent of colored marbles or even tortoiseshell, for structural details such as arches and tables, and by the introduction of details in white or green-stained ivory. These features can already be found on pieces made in Paris in the 1650s and 1660s,[17] but they do not occur on Van Mekeren's work. This group of floral marquetry cabinets has been tentatively attributed to the cabinetmaker Philippus van Santwyck (1632–1712) from The Hague,[18] but several of his colleagues in Amsterdam, The Hague, and Rotterdam are also known to have specialized in floral marquetry, so more definite attribution must await fresh evidence.

Floral marquetry contained in reserves, on an oyster-veneer ground, has usually been associated with England and is found, for instance, on a large number of English long-case clocks. A small number of cabinets of typically Dutch form decorated in this way show that this idea also found favor in the Netherlands (No. 105). Less elaborate cabinets could also be veneered with oyster patterns disposed in a flowerlike manner (Fig. 20) or with star patterns (Fig. 21).

Dutch cabinets entirely decorated with intricate ornamental patterns are rare, and again, marquetry of this kind is normally regarded as English; the famous London cabinetmaker Gerrit Jensen (active 1680–1715) excelled in it. However, a cabinet of this type at Kingston Lacy in Dorset (Fig. 22) was recently found to bear two Dutch signatures on its interior: Jan Roohals and I. Hoogeboom.[19] Nothing is known about these men, who were probably journeymen or assistants in a cabinetmakers' workshop, but the inscriptions indicate that the piece must have a Dutch origin. Similar motifs occur on a rare cabinet inlaid with Japanese lacquer panels that call to mind the little "cabinet" rooms and closets decorated in that manner (Fig. 23).

A considerable amount of Dutch furniture japanned in imitation of oriental lacquer must have been made, but few examples can be safely attributed to the Netherlands.[20] An even more exotic type of decoration was the adaptation of parts of a Chinese screen—decorated with relief in soapstone—for the doors and sides of a cabinet at Kasteel De Cannenburch in Gelderland (Fig. 24).

Contemporary documents show that such large cabinets were sometimes surmounted by a tiered stand or platform for the display of porcelain.[21] Since these were probably never decorated, they do not survive, but the practice may have been quite widespread, and it even found its way to America.[22]

Cabinets could also be integrated into an ensemble by being decorated to match a set of a table, stands, and a looking glass. In that way the same complete unity achieved within the textile furnishings might be attained within the veneered furniture in a room. A study of inventories of the period suggests that complete sets of this kind were somewhat exceptional, however. Often a cabinet is described with "its" table and candlestands, but combined with a looking glass in a different material. In the residences of William III, on the other hand, where the looking glasses were usually en suite with tables and stands, there were very few cabinets.

Figure 20. Cabinet; The Netherlands, c. 1700; oak veneered with rosewood and other woods; Rijksmuseum, Amsterdam

Figure 21. Cabinet; The Netherlands, c. 1700; oak veneered with ivory, rosewood, and other woods; Rijksmuseum, Amsterdam

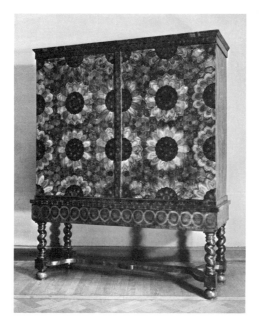
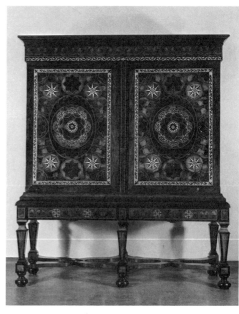

Figure 22. Cabinet; The Netherlands, c. 1700; signed by Jan Roohals and I. Hoogeboom; oak veneered with rosewood and other woods; The National Trust, Kingston Lacy

Figure 23. Cabinet; The Netherlands, c. 1700; oak veneered with various woods and Japanese lacquer panels; Rijksmuseum, Amsterdam

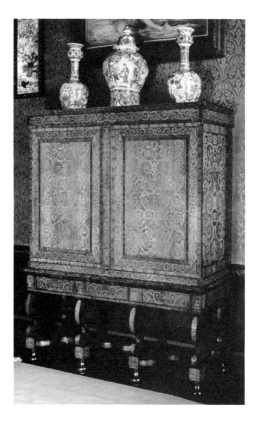
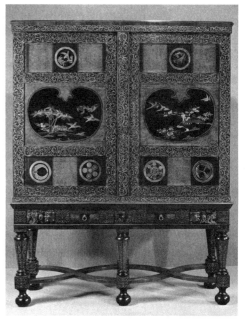

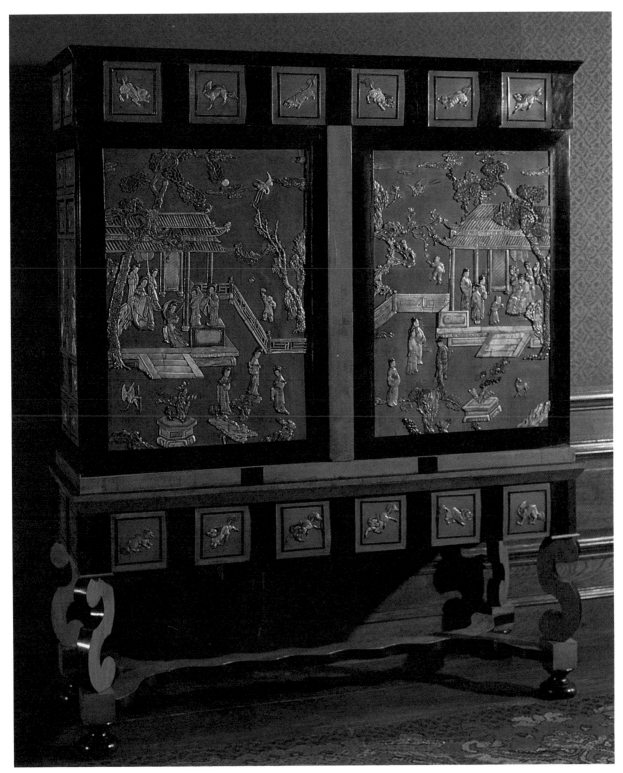

Figure 24. Cabinet;
The Netherlands,
c. 1700; oak veneered
with ebony, other
woods, and Chinese
panels with soapstone
figures; Stichting
Vrienden der
Geldersche Kasteelen,
Arnhem; Kasteel De
Cannenburch, Vaassen

There are examples of individual tables, stands or looking glasses decorated en suite with Van Mekeren cabinets (Figs. 25 and 25a), but only one complete set survives, at Kasteel Amerongen near Utrecht.[23] Further pieces also exist in most of the other styles previously mentioned.

Was the so-called boulle furniture—veneered with marquetry of tortoiseshell, brass, and pewter—ever made in Holland? No proof of this has yet been found in contemporary documents, but pieces like the cabinet for an Amsterdam dolls' house, with marquetry of pewter on a tortoiseshell ground (Fig. 26), and the extremely fine case of a clock by the Amsterdam clockmaker Andries Vermeulen (active first half of the eighteenth century; Fig. 27), both in the Rijksmuseum, are tantalizing indications that metal inlay could have been carried out in the Netherlands. If these two splendid examples are indeed Dutch, other pieces of boulle furniture made in Amsterdam or The Hague may as yet have gone unrecognized. Another way to achieve powerful polychrome effects was the use of embroidered panels, not only for chair covers or fire-screen panels, but in rare instances on the doors and sides of cabinets as well (Fig. 28).

The costliest and most ostentatious furniture of the period was, of course, that made of, or entirely covered with, silver. Such furniture had been a feature of several residences of the stadholders during the first part of the seventeenth century,[24] and William III had a number of pieces made for his palaces, following the example both of his predecessors and of Louis XIV. Some of this furniture came from Paris. In 1679 two large tables, two large mirrors, and four tall candlestands—that is, two "classic" sets—were brought from the French capital by the silversmith Adam Loofs (master in 1682–1710), who was to become William III's court goldsmith in the following year. These pieces were the work of an unknown Parisian silversmith, but Loofs had presumably collaborated on them. Probably born in The Hague, he had worked in Paris for many years before returning to his native country and entering the stadholder's service. From France he brought the Louis XIV style of metalwork to The Hague, where among other things he made several silver chandeliers and sets of wall sconces for William III. The fact that there were no Dutch makers of gilt bronze not only meant that the Dutch turned to gilt-wood chandeliers, but also, at the other end of the scale, that silver ones remained in fashion longer than in France; as late as 1749 we find the Hague silversmith Albert de Thomese (master in 1708–1753), who probably was of French descent, delivering two chandeliers to Stadholder William IV (1711–1751). No seventeenth- or eighteenth-century Dutch examples are known to survive, however, and even sconces are very rare compared with English ones (No. 127). In 1683 Loofs made a large and heavy pair of andirons representing the Four Elements. These have disappeared, it is sad to say, like the other andirons made by Loofs for the stadholder, but at Kasteel Duivenvoorde, near Leiden, there is a fine pair of silver andirons that is probably Dutch that must have been made shortly after 1700 (Fig. 29).

Naturally, Loofs's output was not confined to silver furniture; he made many more ordinary objects as well. Vessels for eating and drinking were at this time usually displayed on buffets, often in tiered arrangements like those used for porcelain (Nos. 34 and 36). For large, princely buffets great pieces were needed, such as wine coolers, ewers with their basins, dishes, bottles (Fig. 30), and standing cups (No. 52). Wine coolers could be accompanied by wine-fountains (Nos. 45 and 46), but this seems to have been rare in Holland, although it was fairly common practice in England. In most well-to-do Dutch households the wine cooler was the largest piece of silver; it heads many inventories of the plate of both noblemen and merchants.

Another focus of attention for the silversmith was the tea table. The habit of drinking tea became more widespread toward the end of the seventeenth century, creating a need for new silver utensils, such as teapots, teakettles (No. 62), and tea caddies. These were usually in a conventional European style, but in some rare instances they had the distinct character of chinoiserie—appropriate for objects associated with such an exotic beverage. Their form and decoration could be based on Chinese prototypes in stoneware, lacquer, or silver (No. 210), but new, fanciful inventions with Chinese subjects are also encountered (No. 209).

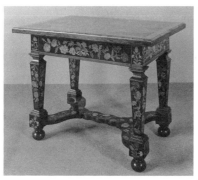

Figure 25. Table; Amsterdam, c. 1700; attributed to Jan Van Mekeren (1658–1733); oak veneered with rosewood and other woods; Rijksmuseum, Amsterdam

Figure 25a. Top of the table in Fig. 25.

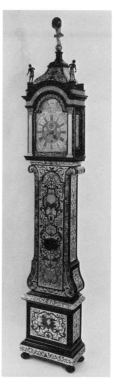

Figure 26. Detail of a side of the cabinet for the dolls' house of Petronella Oortman; The Netherlands (Amsterdam?), c. 1700; oak, veneered with tortoiseshell and pewter; Rijksmuseum, Amsterdam

Figure 27. Long-case clock; Amsterdam, first quarter 18th century; works by Andries Vermeulen (c. 1680–after 1742); oak veneered with ebony, tortoiseshell, brass, pewter, and mother-of-pearl; Rijksmuseum, Amsterdam

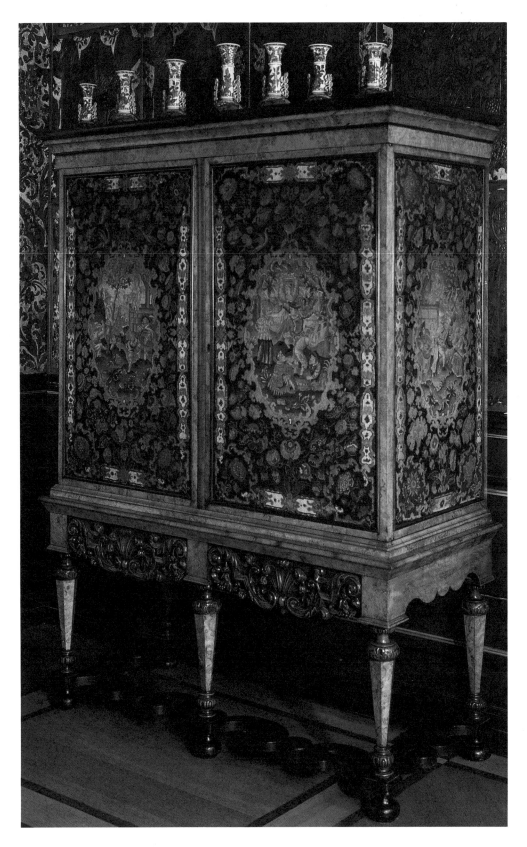

Figure 28. Cabinet
with needlework pan-
els; The Netherlands,
c. 1720; walnut, wool,
silk, linen; Centraal
Museum, Utrecht

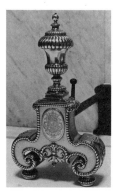

Figure 29. One of a pair of andirons with the arms of Van Wassenaer and Bentinck; The Netherlands (?), c. 1701–10; silver; Kasteel Duivenvoorde, Voorschoten

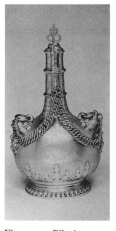

Figure 30. Pilgrim bottle; The Hague, 1688; Adam Loofs (c. 1645–1710); silver gilt; The Duke of Devonshire and The Trustees of the Chatsworth Settlement

Chinoiserie decoration in silver was not restricted to objects for use at the tea table: a circular Dordrecht box of 1700 (No. 208) probably must be regarded as a toilet-box; perhaps it even formed part of a larger toilet service. Services of this kind evolved in the course of the seventeenth century, when the formerly heterogeneous utensils for the dressing table began to be treated as an ensemble decorated in a single manner, again conforming to the unifying spirit of the baroque. What appears to be the earliest of all surviving European toilet services was made in The Hague and dates from 1651 to 1658.[25] Queen Mary possessed an extremely fine French toilet service, made in Paris between 1669 and 1671, with the cipher of William and Mary probably added at the time of their marriage in 1677.[26] A number of Dutch toilet services in the Louis XIV style are known; they are usually very plain.[27]

Because silver is almost always hallmarked, one can form a picture of the local styles in various Dutch cities—which is not possible in the case of furniture or other decorative arts. It has already been noted that the Hague silversmith Loofs worked in a purely French style. His work is usually very restrained, with plain surfaces being relieved by moldings, gadrooned borders, and cut-card ornament. Some pieces are more sculptural, following the ambitious creations made in France under the influence of Le Brun (No. 67). Loofs's work was highly influential in The Hague, and his particular version of the Louis XIV style remained in fashion over a long period. The French element in that city, which was the stadholder's seat, was strengthened by a number of Huguenot silversmiths working there. Little is known about them, but their few surviving works (No. 68) are again in a fully French manner. Interestingly, the stadholder-king seems not to have patronized the Huguenot silversmiths, but remained loyal to Loofs, just as he employed the English Garthorne brothers working in the French style rather than any of the highly competent Huguenot silversmiths working in London.[28]

No Huguenot silversmiths of any note seem to have worked in Amsterdam either at the end of the seventeenth century or at the beginning of the eighteenth. There the French style did not make itself felt until well into the eighteenth century, and then probably only as a result of direct imitation of models from The Hague.[29] Soon afterward, a highly individual Amsterdam style was evolved, mainly by Dutch-born silversmiths, in which Louis XIV motifs were employed in a new manner, cast and applied to bold, strong shapes (No. 61).

At Leeuwarden, where the Frisian stadholders had their court, the French style was not adopted as quickly as in The Hague, but when it reached this northern outpost of court life, it was followed more literally than in Amsterdam. It was very long-lived, not only in Leeuwarden, but in the whole of Friesland; soon it began to reflect Daniel Marot's ornamental designs, which indeed appear to have exerted an appreciable influence on silver design only in Friesland (No. 78).

Stylistic developments in other branches of the decorative arts probably paralleled that seen in silverwork, with a strong and direct influence from France in The Hague, centered on the stadholder and his courtiers; a somewhat later adoption of this style in Leeuwarden and Friesland generally, again centered on the court, and often displaying a rather provincial exaggeration; and a slow acceptance of the French manner in Amsterdam, soon followed by a strongly individual interpretation. At the same time, the situation was much more complex than this summary might suggest: patrons and craftsmen traveled from one place to another, the nobility in The Hague had their country houses in the various provinces, and there were many more centers of creative activity than the three compared here.

The best known manifestation of the Dutch taste for chinoiserie is of course blue-and-white Delft. In the last part of the seventeenth century, Delft, harboring a great number of factories, was firmly established as the most famous of all European centers for the production of faience. Many pieces copying Chinese originals were still made, by this time usually reflecting the styles of the Kangxi period (1662–1722) (No. 178); free interpretations of Chinese models were also produced, however, as were pieces in an entirely European style (No. 189). Next to blue-and-white, polychrome wares were popular (No. 203), and the small group with dark grounds—black or olive green, for instance—has always been highly prized (Nos. 201 and 202). The variety of objects made was great. Among the most striking were the

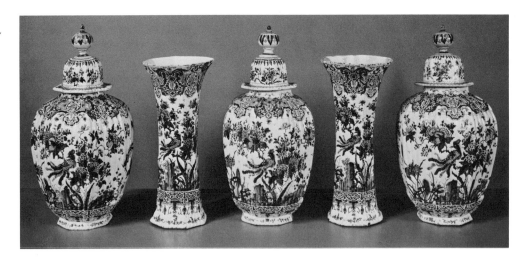

large garnitures of vases, often consisting of beaker-shaped vessels and globular ones with covers (Fig. 31), made to stand on cabinets or tables.

Toward the end of the century some impressive flower vases and other objects were produced at Delft for the king and his consort—many of them designed by Daniel Marot. A number were specially commissioned for the palace at Hampton Court, where a splendid series still survives (Fig. 33). Some large tiles closely following designs by Marot—now dispersed among various collections—served to decorate the walls of one of Mary's newly furnished rooms in the Water Gallery at the palace (Nos. 164–168). Fragments of Delft objects, recently excavated at Het Loo, have demonstrated that there were similar pyramid vases in the queen's apartments there, which continued to be enriched after she had gone to England in 1688. During the time she lived in Holland, she formed a splendid collection of Chinese porcelain and she was already buying flower vases and other large objects made at Delft. These did not yet reflect the influence of the French style, however. She mainly bought from De Grieksche A (The Greek A) factory, which until 1685 was owned by Samuel van Eenhoorn, and later by his brother-in-law, Adriaen Kocks.[30]

For the gardens at Het Loo, Marot designed a set of vases to be executed in marble; two of his most attractive series of engravings show these and other examples (Fig. 34), including one for the Earl of Albemarle's house at De Voorst. Some of the vases made for Het Loo survive (Fig. 35) and display striking similarities to some of the Delft vases at Hampton Court, again demonstrating how the same decorative vocabulary was applied to different media.

Queen Mary died in 1694 and William III in 1702, but Marot lived on for another half-century, until 1752. Only after the death of his great patron, and possibly as an endeavor to compensate for the loss of royal commissions, did he publish the first collected editon of his prints. As a result of this action, the influence of his style spread wider, throughout the Netherlands and even into Germany and Scandinavia. Curiously, during a long life spent working in Amsterdam and The Hague, his style hardly evolved at all. At a time when France saw the light-hearted Régence style develop into the full-blown rococo and when in England the Palladian manner prevailed in architecture, Marot continued to work in his personal version of the Louis XIV manner, which gradually became more ponderous and in some cases more sculptural, with swelling forms perhaps attempting to adapt to the strongly three-dimensional Régence and Louis XV styles (Fig. 36). At least until the 1730s this somewhat modified Louis XIV style remained dominant in all branches of Dutch decorative art, especially with regard to architectural elements, such as paneled rooms, marble chimney surrounds, and carved furniture. It was only fully superseded with the advent of the rococo, which was again French-inspired. There are rooms of the 1730s that from a stylistic point of view might almost have been created twenty-five years earlier (Fig. 32)—testimony to the enduring effect of a style created for Louis XIV and developed under William and Mary, but in either of its manifestations part of the same international movement in the decorative arts.

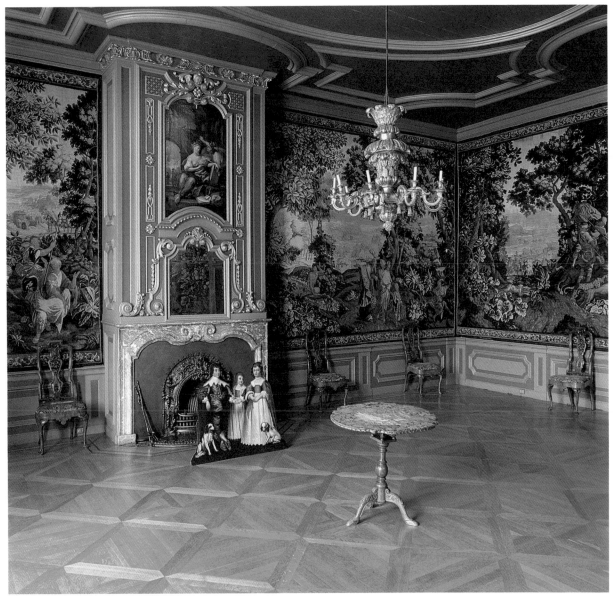

Figure 32. Tapestry
room in the house at
Nieuwehaven 29; Dor-
drecht, 1730; Brussels
tapestries; painted
decoration by Adriaen
van den Burg; Mu-
seum Mr. Simon van
Gijn, Dordrecht

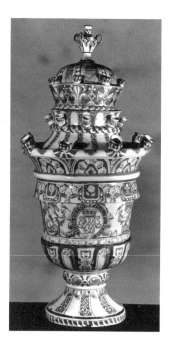

Figure 33. Flower vase with royal arms; Delft, c. 1700; the Greek A factory (signed AK for Adriaen Kocks); tin-glazed earthenware; Royal Collection, copyright reserved to Her Majesty Queen Elizabeth II

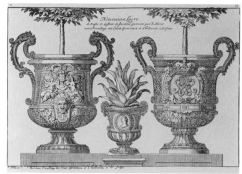

Figure 34. Design for garden urns; The Netherlands; Daniel Marot (1661–1752) (reproduced from P. Jessen, *Das Ornament des Daniel Marot*, facsimile edition [Berlin, 1892], pl. 187); Cooper-Hewitt Museum, New York, Gift of the Council, 1921-6-540

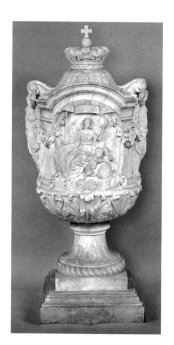

Figure 35. Garden urn made for Het Loo Palace; The Netherlands, c. 1690; Jan Ebbelaar (active from 1679); marble; National Museum, Het Loo Palace, Apeldoorn

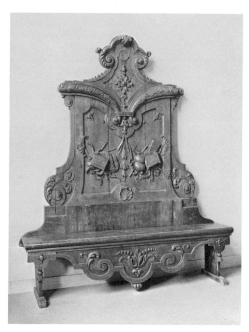

Figure 36. Garden bench; The Netherlands, second quarter 18th century; probably designed by Daniel Marot (1661–1752); pine; Rijksmuseum, Amsterdam

Notes

Much of the information in this essay is based on the following general publications, to which no specific references are given: P. Jessen, *Das Ornamentwerk des Daniel Marot* (Berlin, 1892); M. D. Ozinga, *Daniel Marot, de schepper van den Hollandschen Lodewijk XIV-stijl* (Amsterdam, 1938); Th. H. Lunsingh Scheurleer, *Van haardvuur tot beeldscherm* (Leiden 1961); S. W. A. Drossaers and Th. H. Lunsingh Scheurleer, *Inventarissen van de inboedels in de verblijven van de Oranjes en daarmede gelijk te stellen stukken 1567–1795*, 3 vols. (The Hague, 1974–76); P. K. Thornton, *Seventeenth-century Interior Decoration in England, France and Holland* (New Haven 1978).

1. D. F. Slothouwer, *De paleizen van Frederik Hendrik* (Leiden, 1945), 39–88.
2. Th. H. Lunsingh Scheurleer, "Meubles français importés en Hollande 1650–1810," in *Actes du XIXe Congrès International d'Histoire de l'Art* (Paris, 1959), 326–29.
3. G. Jackson-Stops, "Slot Zeist—Netherlands," *Country Life* 160 (1976): 534–37 (I); 594–97 (II).
4. H. W. M. van der Wijck, "De Voorst," *Bulletin van de Koninklijke Nederlandse Oudheidkundige Bond*, 6th series, 16 (1963): 149–66; C. A. Baart de la Faille, "De geschiedenis en restauratie van het Huis de Voorst," ibid., 167–91; Th. H. Lunsingh Scheurleer, "Het Huis de Voorst in zijn glorietijd," ibid., 193–220.
5. G. Jackson-Stops, "Daniel Marot and the 1st Duke of Montagu," *Nederlands Kunsthistorisch Jaarboek* 31 (1980): 244–62.
6. G. W. M. Jager and C. W. Fock, *Italiaans stucwerk in Den Haag en Leiden 1700–1800* (Delft, 1984), 19–23.
7. Th. H. Lunsingh Scheurleer, "Stadhouderlijke lakkabinetten," in *Opstellen voor H. van de Waal* (Amsterdam and Leiden, 1970), 164–73.
8. H. Börsch-Supan, "Die Chinamode in brandenburgisch-preussischen Residenzen," in *China und Europa*, exh. cat., Schloss Charlottenburg (Berlin, 1973), 37–47.
9. Cf. also the picture frame, No. 96.
10. J. Hardy and G. Jackson-Stops, "The Second Earl of Warrington and the 'Age of Walnut,'" *Apollo* 108 (1978): 12–23.
11. See No. 91.
12. Cf. No. 97.
13. Th. H. Lunsingh Scheurleer, "Pierre Gole, ébéniste du roi Louis XIV," *Burlington Magazine* 122 (1980): 380–94.
14. Th. H. Lunsingh Scheurleer, "Jan van Mekeren, een Amsterdamsch meubelmaker uit het einde der 17de en begin der 18de eeuw," *Oud-Holland* 58 (1941): 178–88.
15. See for example D. Alcouffe, "Dal Rinascimento al Luigi XIV," in *Il mobile francese dal Medioevo al 1925* (Milan, 1981), 40–41.
16. A. González-Palacios, "Limiti e contesto di Leonardo van der Vinne," *Paragone* 333 (1977): 37–68.
17. See Alcouffe, "Dal Rinascimento al Luigi XIV."
18. Th. H. Lunsingh Scheurleer, "Een Hollands kabinet versierd met 'blomwerk,'" *Bulletin van het Rijksmuseum* 3 (1955): 85–90.
19. I wish to thank Anthony Mitchell for drawing this cabinet to my attention.
20. An example was recently acquired by the Rijksmuseum, *Bulletin van het Rijksmuseum* 34 (1986): 256, 258, fig. 1.
21. See, for example, Th. H. Lunsingh Scheurleer, C. W. Fock, and A. J. van Dissel, *Het Rapenburg, geschiedenis van een Leidse gracht* (Leiden, 1987), 2: 293, where the 1737 inventory of the house Rapenburg 4 is quoted, mentioning in the dining room a cabinet with a *trap* (literally, steps) stacked with porcelain.
22. See page 72.
23. Th. H. Lunsingh Scheurleer, "Amerongen Castle and Its furniture," *Apollo* 80 (1964): 360–67.
24. Th. H. Lunsingh Scheurleer, "Silver Furniture in Holland," in *Opuscula in honorem C. Hernmarck* (Stockholm, 1966), 141–58.
25. *Haags zilver uit vijf eeuwen*, exh. cat., Gemeentemuseum (The Hague, 1967), no. 38a–c. The looking glass belonging to this service was subsequently also acquired by the Gemeentemuseum, The Hague.
26. C. Hernmarck, *The Art of the European Silversmith, 1430–1830* (London and New York, 1977), figs. 700, 700a.
27. Cf. two boxes from a Delft silver toilet service of 1705 in the Toledo Museum of Art, *Nederlands zilver/Dutch silver 1580–1830*, exh. cat., Rijksmuseum (Amsterdam, 1979), no. 93.
28. J. Hayward, *Huguenot Silver in England 1688–1727* (London, 1959), 10.
29. *Meesterwerken in zilver, Amsterdam zilver 1520–1820*, exh. cat., Museum Willet-Holthuysen (Amsterdam, 1984–85); R. J. Baarsen, K. A. Citroen, and J. Verbeek, "Enkele nabeschouwingen bij de Amsterdamse zilvertentoonstelling," *Antiek* 19 (1984–85): 548–51.
30. A. M. L. E. Erkelens, "Delfts aardewerk op Het Loo," *Nederlands Kunsthistorisch Jaarboek* 31 (1980): 263–72.

The Court Style in Britain

by Gervase
Jackson-Stops

Political and cultural movements in history are not always easy to reconcile. It might, for instance, seem paradoxical that Dutch influence was at its strongest in England after the Restoration of 1660, when the two countries were almost permanently at war, and that after the Glorious Revolution of 1688, when they were united in their opposition to France, both were dominated by the fashions of the French court in the fine and decorative arts. But war, like a vast game of chess played with pawns in the shape of mercenaries, was then regarded more as a civilized pursuit than as an expression of ideological hatred. Much of the architect John Vanbrugh's captivity in France was spent looking at Sebastien Vauban's forts and the architecture of Louis Le Vau and Jules Hardouin-Mansart,[1] while much of Marshal Tallard's confinement in a comfortable house in Nottingham was spent laying out a formal parterre with the aid of the royal gardeners George London and Henry Wise.[2] Even the great Duke of Marlborough was not averse to having the saloon at Blenheim painted by Louis Laguerre (Louis XIV's godson) on the model of the Escalier des Ambassadeurs at Versailles.[3]

The baroque style was indeed a truly international movement in the arts, with Versailles as its epicenter. Above all, it was also a court style, clearly identified in a secular context with the ceremonials and rituals of kingship, whether employed in a palace or in a lesser country house, whose owner "kept state" as the king's representative. Despite Macaulay's idealized picture of William III as the first constitutional monarch,[4] there is every reason to think that the stadholder-king envied the power of his great rival and wished to express a very similar philosophy of centralized government in his own buildings and their settings. His identification with Hercules, so vividly portrayed in the gardens at Het Loo and the interiors of Hampton Court,[5] seems to have been a conscious alternative to Louis XIV's Apollo, and his ambitions can be judged by Celia Fiennes's description of the throne room at Windsor Castle in 1698: ". . . the cannopy was so rich and curled up and in some places so full it looked very glorious and was newly made to give audience to the French Embassadour to shew the grandeur and magnificence of the British Monarch—some of these foolerys are requisite sometimes to create admiration and regard to keep up the state of a Kingdom and nation."[6]

The real watershed, culturally and politically, was to come only with the death of Queen Anne and the rout of the Tories in 1714. The Whig oligarchs, who then looked back to Inigo Jones and Palladio for new sources of inspiration, identified the court style with absolutism, and in their patriotic fervor put Britain on a different course from the rest of Europe. In this sense, the idea that there were separate "William and Mary" and "Queen Anne" styles in Britain remains little more than auctioneer's jargon—inspired by the emergence of the cabriole leg in early eighteenth-century furniture, but hardly reflecting any major change of outlook. The idea of the court style as predominantly French in inspiration has its origins in the reigns of Charles II (1660–85) and James II (1685–88), despite the fact that the predominant influences at this period came from the Low Countries. For the moment, Dutch and Flemish portrait painters such as Lely and Soest, Huysman and Wissing, certainly held sway; the seascapes of the van de Veldes were appreciated by those whose growing wealth was based on maritime power and overseas trade; while the trompe l'oeils of Leemans and Hoogstraeten, and the carvings of Arnold Quellin and Grinling Gibbons, fed a new appetite for illusionism, allied to the scientific experiments of the newly founded Royal Society. The new "double-pile" houses made popular by Hugh May and Roger Pratt (and shown in the bird's-eye views of Danckerts, Griffier, and Siberechts) were just as indebted to the architecture of the Low Countries, and Dutch influence can also be seen in the marquetry furniture and tall caned chairs of the Restoration period, or in the heavy embossing of Caroline silver, imitating the work of the van Vianens.

On the other hand, many of the Royalist emigrés who had gathered in the Netherlands during the Commonwealth (1649–53) also took the opportunity of visiting Paris. The diarist John Evelyn, who in 1664 translated Roland Fréart's *Parallèle* into English, bought a number of cabinets as well as architectural books during his stay;[7] the fifth Earl of Dorset's mementos include "une montre de Guillaume Martinott au Galleries du Louvre";[8] while the engraver William Faithorne not only acquired quantities of "cutts," or prints, to resell in London, but also took time to study under the artist Philippe de Champaigne.[9] The

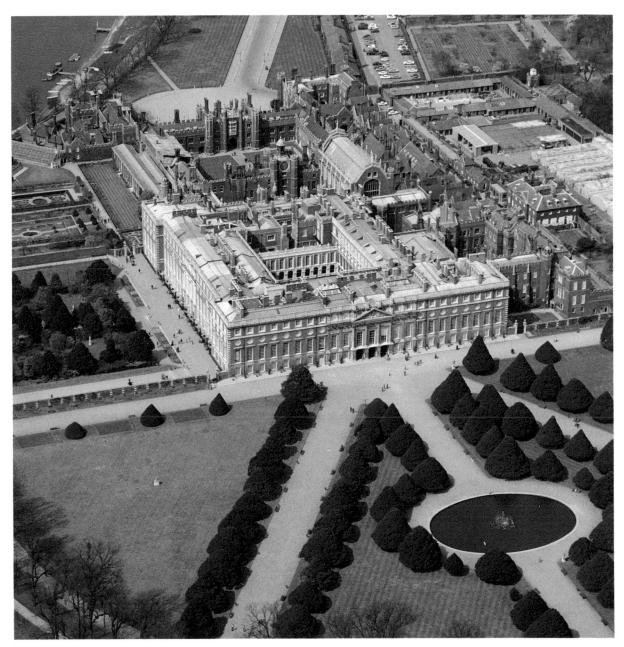

Figure 37. Hampton
Court Palace and
Gardens, Middlesex

importance of engravings in spreading the Louis XIV style to Northern Europe is already implicit in Christopher Wren's letter to a friend, written during his own visit to Paris in 1665: "I have purchased a great deal of *Taille-douce* [copperplate engravings] that I might give our Countrymen Examples of Ornaments and Grotesks, in which the Italians themselves confess the French to excell."[10] Nor was it long before London booksellers like Robert Pricke were publishing pirated editions of Pierre Le Muet's *Art of Fair Building* (1670) or compilations of prints by Jean Barbet, Jacques Le Pautre, and others, with titles like *The Architect's Store House* (1674).[11] The elaborate alcove and balustrade in the state bedchamber at Powis Castle, fitted up in the same decade, may well be based on such engravings, and show how powerful was their influence.

The rebuilding of London after the Great Fire in 1666 gave special impetus to the spread of these ideas, although as early as 1663 the author of the pamphlet *England's Interest and Improvement* also drew attention to the way in which immigrant French craftsmen "have introduced new modes and new tastes and set us all agog, and have increased among us considerable trades, witness the vast multitude of broad and narrow silk weavers, makers of looking glasses, paper, fringes and gilded leather."[12] Cosimo III of Tuscany, visiting England five years later, commented that "there does not pass a day in which the artisans do not indulge themselves in going to the public-houses, which are exceedingly numerous . . . hence it is, that the French make fortunes in London, for being more attentive to their business, they sell their manufactures at a lower price than the English."[13]

It was of course difficult for foreigners to avoid the restrictions imposed by the City's guild system, but an important loophole was the Great Wardrobe, which supplied the wants of the court and was of enormous importance in establishing an identifiable court style. A document of 1671 among the Sackville papers talks of the "power . . . given to the Keeper of the Great Wardrobe to let the houses, ships, tenements, cellars, etc. thereunto belonging, to any artificer or tradesman native or foreign, and [these are] . . . exempted from paying all taxes and duties."[14] Thus a Frenchman like John Casbert could become Chief Upholsterer to the Royal Household as early as 1660,[15] while the Queen Mother, Henrietta Maria, could employ a whole team of her fellow countrymen in the alterations to Somerset House from 1661 to 1662[16]—including the sculptor Pierre Besnier, the carpenter John Augier, and the "French joyners" under "Monsieur Ambrey," responsible for the earliest recorded parquet floors in England.

Foreign craftsmen were also allowed to work from premises in Westminster, Southwark or the "liberty of Blackfriars," areas that were not under the jurisdiction of the City companies, and this may explain the sudden expansion of Covent Garden and Soho as commercial centers toward the end of the seventeenth century; the concentration of upholsterers (including Guillotin, Jean Paudevin, and Francis Lapierre) in Pall Mall,[17] conveniently near St. James's Palace; or the development of still more distant colonies like Portugal Row, off Hyde Park Corner, where the blacksmiths Jean Tijou, Thomas Robinson and Thomas Goff, the sculptors Jan van Nost and Andries Carpentière, and the painter Louis Laguerre, all had their workshops.[18]

In the end, however, it was the great influx of Huguenots before and after Louis XIV's revocation of the Edict of Nantes in 1685 that undermined the more reactionary tendencies of the old guild system and encouraged the spread of the Francophile court style on a much wider scale. The refugees, likely to have numbered around forty to fifty thousand, constituted easily the largest group of peacetime immigrants before Queen Victoria's reign,[19] and it is important to remember that a large proportion of them came from the higher professional or skilled artisan classes—the French king having barred Protestants from any higher rank. Most of them arrived destitute, but with meager grants from regular public appeals (or from the King's Privy Purse between 1690 and 1702), they were soon able to make ends meet, especially since their "papers of denization" entitled them to apprenticeship, and ultimately to the freedom of the city, like their native counterparts. Whether in insurance or the law, medicine or science, watch- or gun-making, they tended to be as successful as they were hardworking: in the eighteenth century it became a popular saying that a drop of Huguenot blood in the veins was worth £1000 a year.[20]

Figure 38. The court-
yard facade, Drayton
House, Northamp-
tonshire, designed by
William Talman
(1650–1719), 1702

One of the particular strengths of the Huguenot community was the system of intermarriage, which bound certain groups of specialized craftsmen together. Daniel Marot's relationship to the Gole and Garbrand dynasties of *ébénistes* has already been mentioned (see page 24), but it can be paralleled by any number of other tangled family trees: the goldsmith David Willaume senior, to take one typical example, married the sister of another celebrated smith, Louis Mettayer; his daughter married a third, David Tanqueray; and his sister-in-law, Marie Mettayer, married the engraver Simon Gribelin.[21] Willaume's role as a banker—an obvious extension of the goldsmith's function—must also have been important in raising loans for less affluent members of the clan, or those who had only recently arrived.

Links between craftsmen in London, Paris, and The Hague or Amsterdam evidently remained strong despite religious differences—and this too gave the court style an international baroque character, often transcending native traditions and making it difficult to tell the exact nationality of undocumented pieces (see No. 104). It is interesting, for instance, that at his death in 1683, Pierre Gole owed 400 livres for English glue to "Sieur Janson, ebeniste a Londres"[22]—undoubtedly the cabinetmaker Gerrit Jensen. In the same way, the signature of the Parisian engraver Blaise Gentot (b. 1658–d. after 1701) appears not only on a splendid silver tabletop featuring the Cavendish arms at Chatsworth, made between 1694 and 1710,[23] but also on the title page of the French edition of the blacksmith Jean Tijou's *New Booke of Drawings* dated 1693.[24] Nor should one forget the career of the painter Pierre Berchet, who began to work for Louis XIV in the late 1670s, came to England in 1682 or 1683, returned to decorate Marly, was in England again after 1685, was at Het Loo in the 1690s, and ended up as one of the competitors for St. Paul's.[25]

What exactly were the characteristics of the court style in Britain, and how far can it be said to have dominated the arts under William and Mary? In the field of architecture—where Hugh May (1621–1684) had pointed the way with his remodeling of Windsor for Charles II—the international baroque was only successful in a limited way, thanks to the idiosyncratic genius of Sir Christopher Wren (1632–1726), and of his successors Sir John Vanbrugh (1664–1726) and Nicholas Hawksmoor (c. 1661–1736). It is not hard to find French influences either in Wren's work or that of his Scottish contemporary Sir William Bruce (c. 1630–1710). One can point to Wren's plans for a palace at Winchester based on Le Vau's Versailles or to echoes of the Invalides in his great naval hospital at Greenwich,[26] or to Bruce's Palace of Holyroodhouse in Edinburgh recalling François Mansart's Orléans wing at Blois, or to his own house at Kinross with its little *pavillons* in the manner of Salomon de Brosse's Château de Blérancourt.[27] Vanbrugh's entrance front at Castle Howard equally looks back to Le Vau's Collège de Quatre Nations, while Hawksmoor's Easton Neston owes much to Marly.[28] But French sources were seldom the mainspring of these architects' designs, and a more empirical approach, using just as many Italian baroque and Renaissance prototypes—and even, in Vanbrugh's case, memories of Elizabethan "prodigy houses"—was the order of the day.

Discounting the Dutchman Jacob Roman (1640–1716), who came to England in 1689 or 1690 and almost certainly designed the King's Gallery and Clock Court at Kensington Palace,[29] or the Prussian Jean de Bodt (1670–1745), whose designs for Greenwich and for Wentworth Castle in Yorkshire (built in 1709–14) are entirely French in their sources,[30] only one major architect of the period, William Talman (1650–1719), the Comptroller of the King's Works, can be said to embody the court style. Talman's revolutionary south front of Chatsworth, with its roof concealed behind a heavy balustrade, its lack of central emphasis, and its giant order of pilasters (again based on Marly), is a wonderfully assured essay in the French manner—like his orangery at Dyrham, which is almost a straight copy of Hardouin-Mansart's at Versailles.[31] But, above all, his designs for a trianon for William III at Hampton Court (Nos. 220 and 221) and his courtyard facade at Drayton in Northamptonshire[32] (Fig. 38) come from the world of Daniel Marot and suggest a close relationship between the two men.

Drayton was built for the Duchess of Norfolk and her second husband, the courtier and soldier Sir John Germaine, who was reputedly William III's half-brother. Close relationships with the court account for another group of three houses that have markedly French

characteristics, and which seem to bear signs of Marot's involvement. Boughton House in Northamptonshire and Montagu House in Bloomsbury (on the site of the present British Museum) were both built by Ralph, later first Duke of Montagu, Master of the Wardrobe, and several times ambassador to France, who also played a major role in opposing James II. The arcaded north front of Boughton (Fig. 39), again with a markedly French lack of central emphasis, is based on an engraving by Jean Marot that his son Daniel later republished in his own *Nouveau Livre des bâtiments*, while Montagu House, rebuilt after a fire in 1686 (Fig. 40), had a central squared dome (recalling Hardouin-Mansart's Château de Clagny), close to Marot's later Paleis Wassenaar-Obdam at The Hague.[33]

Petworth House in Sussex, the seat of the Duke and Duchess of Somerset, originally had the same type of squared dome, mansard roofs, and heavily bracketed frieze (Fig.41), and it is interesting to find that the Duchess was not only Ralph Montagu's stepdaughter, but also acted as Chief Mourner at Queen Mary's funeral. The panels above the windows of the end "pavilions," with busts on tapering plinths (Fig.42), recall those at Drayton and are constant features of Marot's engraved designs (see No. 17). While he may well have been involved at Petworth in 1693 (when his name is briefly mentioned in two documents),[34] there is the added complication of the mysterious "Mr. Pouget," given in Colen Campbell's *Vitruvius Britannicus* (1715) as the architect of Montagu House, and probably the same "Boujet," whose signature appears on three architectural drawings very much in Marot's style (Nos.19 and 20).[35]

The sculptor Honoré Pelle, whose signature appears on a bust of William III at Petworth (No. 4) and on another of Charles II in the Victoria and Albert Museum, may well have carved the wonderful baroque trophies of arms for the forecourt gates at Petworth (Fig. 41)[36] and may have been a member of Marot's immediate circle. The Huguenot Jean Nadauld was another stonecarver working very much in the Louis XIV style, first at Hampton Court and Kensington, and later in Yorkshire—notably at Castle Howard—with his compatriots Jonathan Goodyear (or Godier) and Daniel Harvey (or Hervé).[37] As opposed to the extreme naturalism of Grinling Gibbons, festoons of fruit and flowers carved both in wood and stone by native followers like Samuel Watson at Chatsworth, William Thornton at Beningbrough (Fig. 43), and John Selden at Petworth tend to be more robust and architectural in character, with stylized acanthus ornament, putti, birds and animals based on engravings by Jean and Pierre Le Pautre.

The coming of the "court style" under William and Mary on the whole affected the interiors of English palaces and country houses more than their exteriors. In planning terms, Robert Hooke's Ragley (of 1679 to 1683) already shows the French idea of *appartements* (each consisting of a bedchamber, dressing room, and closet) housed in separate pavilions flanking the main "state center."[39] But the trend toward the end of the century was to extend the sequence of state rooms, linked by one continuous enfilade, so as to provide a setting for the processions and elaborate ceremonies of a nobleman's daily life. Although many of its customs were drawn from Versailles, the ritual of court life in England was actually more hierarchical and antiquated than it was in France, with far less easy access to the monarch.[40] This in itself tended to lengthen the usual suite of rooms and to increase the importance of those at the far end: the closets or cabinets that were the sovereign's private inner sanctum. At Hampton Court, the enfilade began with the guard chamber at the head of the King's Stairs, and progressed through two anterooms, the dining room or "Room of State" (in the center of the Privy Garden façade), the withdrawing room, bedchamber, dressing room, and cabinet, the room that first gave its name to William III's inner circle of ministers.

Country houses took their cue from this arrangement, with central halls flanked by "apartments" of five or six rooms on each side, with the doors all aligned so as to give views from one end of the building to the other; and the bolection chimneypieces all carved in different colored marbles. The hall itself would be architectural in treatment, with much use of stone or plaster, to provide a transition from exterior to interior. The Marble Hall at Petworth (Fig.44) is a case in point, with its overscaled doorcases, huge bracketed frieze, and two overmantels crowned by segmental pediments, with the Duke of Somerset's arms and supporters. The room is closely comparable with Daniel Marot's Trèves-zaal in the Binnenhof

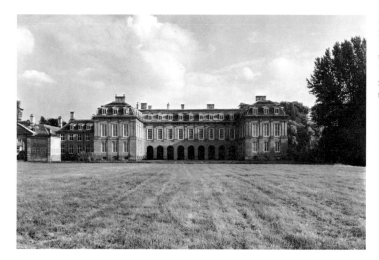

Figure 39. The north front of Boughton House, Northamptonshire, built for Ralph Montagu (later first Duke of Montagu), c. 1690–94

Figure 40. The south elevation of Montagu House, Bloomsbury, from *Vitruvius Brittanicus* (London, 1715), vol. 1, pl.36

Figure 41. View of Petworth House, Sussex (detail); England, c. 1700; oil on canvas; The Duke of Rutland and the Trustees of Belvoir Estates

Figure 42. One of the west front "pavilions" at Petworth House, Sussex, c. 1690, with carved stone ornaments by John Selden, (active 1688–1715), possibly after designs by Daniel Marot (1661–1752)

Figure 43. Overdoor at Beningbrough Hall, Yorkshire, with carving by William Thornton, c. 1714

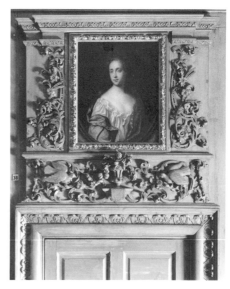

Figure 44. The Marble Hall at Petworth House, Sussex, with carving by John Selden (active 1688–1715), c. 1692

Figure 45. The staircase at Boughton House, Northamptonshire, with ceiling and wall paintings by Louis Chéron (1660–1723), c. 1695

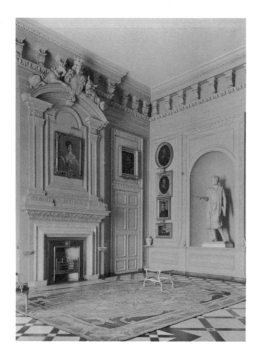

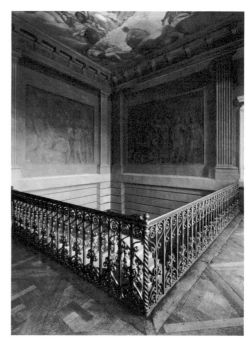

Figure 46. The Balcony Room at Dyrham Park, Gloucestershire, designed by Samuel Hauduroy, c. 1690

at The Hague, completed only a year or two earlier,[41] and shows all the hallmarks of the court style.

The saloon, or parlor, which succeeded the hall, would probably be paneled, though grained in imitation of walnut or cedar, or painted to resemble marble. The Balcony Room at Dyrham Park, designed by the Huguenot architect Samuel Hauduroy for William III's secretary-at-war, William Blathwayt, is known to have been decorated in 1694, with its Ionic pilasters and entablature painted to look like porphyry and gilded, and the panels between made to look like orange-pink marble.[42] Interestingly, the scheme closely follows C. A. D'Aviler's advice on marbling in his *Cours complet d'architecture*, published in Paris in 1691 and a book that Hauduroy may have known. D'Aviler also gives parquet patterns that may have been copied for staircase landings (Fig 45) and designs for wrought-iron balustrades that guided at least one smith, Jean Montigny, whose spectacular ironwork for a staircase at Cannons in Middlesex, made in 1721, is now in the Metropolitan Museum.[43] In Charles II's reign, plasterers like Edward Goudge, Robert Bradbury, and James Pettifer were called in to ornament the ceilings of country houses with the fat wreaths of fruit and flowers, the palm branches, and the cartouches familiar from Wren's City churches. At the accession of William and Mary, however, the vogue for decorative painting was already well established, and by 1702 Goudge, described by the architect William Winde as "ye beste master in England in his profession,"[44] had to resort to a begging letter to his patron, Thomas Coke of Melbourne, explaining that "by the use of ceiling painting the employment which hath been my chiefest pretence hath been always dwindling away, till now its just come to nothing."[45]

Ralph Montagu was again the catalyst in this development, for it was he who first brought the painter Antonio Verrio (1639–1707) back from Paris in 1672 (initially to make designs for the Mortlake tapestry factory) and who later brought a whole team of French artists over to decorate Montagu House in the early 1690s (Nos. 22 and 23).[46] Louis Laguerre and Louis Chéron, who followed Verrio to England, had also been star pupils at the Academy of Painting and Sculpture in Paris, founded by Jean-Baptiste Colbert, and these three—with lesser figures like Jacques Rousseau and Jacob Rambour, who had both worked at Versailles and Marly—brought the classical baroque style of Le Brun with its complex mythological references to the world of the country house.[47] Thus, Brutus (personifying the first Duke of Devonshire) becomes the hero of Laguerre's scenes from the life of Caesar at Chatsworth, and the wedding of Hercules and Hebe (the legitimate heiress of the gods) symbolizes the marriage of William and Mary in Chéron's hall ceiling at Boughton.[48] The feigned architecture, assuming particular importance on staircases and where walls as well as ceilings were painted (as in Verrio's Heaven Room at Burghley), is often close to Le Brun's own schemes, worked out at the Hôtel Lambert, Vaux, and Versailles, and there are also parallels with the stage sets of Berain and Le Pautre. One device that found particular favor was the ceiling in the form of an open balcony, with a view to the heavens beyond—ultimately deriving from René-Antoine Houasse's Salon de l'Abondance at Versailles.[49] Most of Daniel Marot's ceiling designs are variations on this theme, and their influence can particularly be felt in the work of James Thornhill (1676–1734), the most distinguished native artist working in the manner of Verrio and Laguerre.

The colors used by the baroque painters—deep crimsons, dark blues, purples, and grays, made still warmer by the use of an umber or red-brown undercoat—are especially noteworthy, for they indicate the rich tones of the baroque interior that have so seldom survived in textiles or plain paint surfaces. In the damp English climate, the oils that these artists used (in the French manner) have also lasted better than the Italian technique of *fresco secco*.

Overdoor paintings assumed a special importance at this date. These were often framed in a continuation of the doorcase molding so as to balance the chimneypiece and overmantel, and to give a rhythmic articulation to the room, emphasizing its verticality in the French manner. Favorite subjects were series of architectural capriccios like Rousseau's at Hampton Court (almost exactly like those he had painted at the Hôtel Lambert),[50] birds and animals by the Hungarian-born Jakob Bogdany (Fig. 46), and above all flower-pieces by Jean-Baptiste Monnoyer (No. 106). Family portraits could also be used in oval fitted frames like

Figure 47. Corner chimneypiece at Beningbrough Hall, Yorkshire, with stepped ledges for porcelains, c. 1714

those at Beningbrough in Yorkshire, designed by the carpenter-architect William Thornton of York, whose extraordinarily elaborate cornices, here and at Wentworth Castle, are sometimes literal borrowings from Daniel Marot's engravings (Fig. 43).[51] In this context it is interesting to find another Yorkshire architect, John Etty, corresponding with Sir Godfrey Copley of Sprotborough (a house with remarkably French features) about the loan of a copy of "Marrot's book" in 1700.[52]

Mirrors were increasingly used as fixtures in the baroque interior, particularly in long rectangular panels above the chimneypiece, described as "landskip glasses" in early inventories, presumably because of their "landscape" shape. The very large mirrors over the chimneypieces in the Queen's Gallery at Kensington Palace, matching the pier glasses on the opposite wall, were achieved by joining a whole grid of panes together with gilt moldings like sash bars—an arrangement that may have been inspired by the overmantel in the King's Bedchamber at Versailles. At almost exactly the same time, in 1692, the cabinetmaker Gerrit Jensen supplied " a large door of looking glass in great pannells all diamond cutt"[53] for the State Dining Room at Chatsworth; this device was apparently intended to reflect the enfilade on the other side and to suggest the existence of a pair of state apartments flanking a central saloon.[54]

Corner chimneypieces may have been an English invention, for Marot specifically calls them "cheminées a l'angloise" (No. 18), and they can be found early on in drawings by Wren and Hooke. As well as allowing three fireplaces (usually in the bedchamber, dressing room, and closet) to share the same flue and increasing warmth by bringing the hearth further into the room, they accommodated the arrangement of oriental porcelain on stepped ledges above (Fig. 47). Designs by Le Pautre and Jean Lassurance show the decorative effect of pots on brackets developing in France in the 1670s,[55] but Marot's crowded arrangements (No. 171) took the idea much further—perhaps, as Defoe suggests, at Queen Mary's own insistence.[56] One of Grinling Gibbons's designs for an overmantel at Hampton Court, made about 1693, clearly shows Marot's influence in this respect.[57]

Perhaps the greatest contribution Daniel Marot made to the English interior in the 1690s was his idea of each room as a complete decorative unity, an innovation sometimes attributed to the Adam brothers over half a century later. The same vocabulary of ornament—tapering plinths, tasseled cloths-of-estate, masks with feathered headdresses, and pierced shells—can be found on anything from a state bed to a Delft vase, from a clock case to a doorknob, even extending outside the windows to the urns and flower beds of the parterre. This unity of the interior was achieved particularly through the art of the upholsterer, who was responsible for wall hangings and portieres, bed and window curtains, chairs and settees, all likely to be en suite. It is virtually unknown for all these components to have survived, but a remarkable set of wall hangings, daybed, armchair, and six single chairs with matching red-and-yellow appliqué covers survives at Penshurst Place in Kent (Fig. 48), to give an idea of the splendor of such interiors.[58] One of the family, Henry Sidney, Earl of Romney, was Groom of the Stole at the time of William III's death in 1702 and could well have acquired these items as perquisites from the royal collection. They can also be attributed to Philip Guibert, an upholsterer with premises in Jermyn Street who is mentioned in the royal accounts for supplying furniture of this type in 1697 to 1698 and who probably made a similar suite for the Duchess of Leeds at Kiveton in 1703 (now at Temple Newsam).[59]

The greatest status symbol of the day, coming as a climax near the end of the enfilade, was the state bed, for although only rarely used by the most honored guest, it would be permanently on show as a mark of a family's wealth and power. Firsthand knowledge of French beds may have stimulated their development in England: in 1672 to 1673 the Parisian upholsterer Jean Peyrard made two trips to London with no fewer than six beds supplied for Charles II, while Simon Delobel, maker of the king's bed at Versailles, brought several more which were laid out to be "viewed by their Majesties in the Banqueting House" at Whitehall in 1685.[60] It now seems likely that the great state bed in the King's Room at Knole (Fig. 49) could be one of those acquired from Peyrard, and that the emblems of love carved on the chair frames celebrate the marriage of the future James II and Mary of Modena during the same year. If so, it is instructive to compare it with the bed in the Venetian

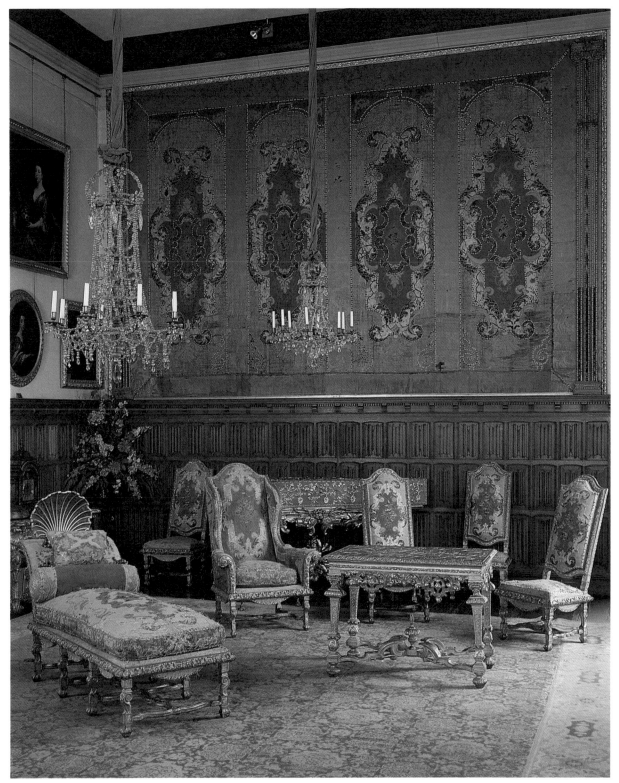

Figure 48. A set of
seat furniture and
wall-hangings en suite
at Penshurst Place,
Kent, c. 1690–1700.
The contemporary
chandeliers are
thought to have been
made for William III
and acquired as a per-
quisite after his death.
The Viscount De
L'Isle, V.C., K.G.

Figure 49. The King's
Bed at Knole, Kent;
probably France,
c. 1682; carved,
gilded, and silvered
wood; gold and silver
brocade, pink satin
lining; The National
Trust, Knole

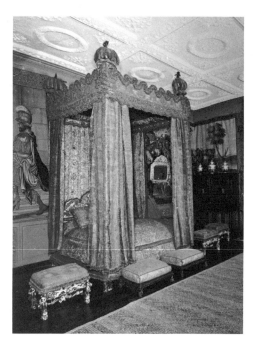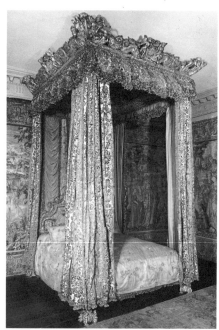

Figure 50. The Vene-
tian Ambassador's Bed
at Knole, Kent;
England, 1688; Jean
Poitevin (upholstery);
Thomas Roberts
(active 1687–c. 1714)
(carving); carved and
gilded wood, blue-
green Genoa velvet;
The National Trust,
Knole

Figure 51. Armchair
from the King's Room
at Knole, Kent; proba-
bly France, c. 1682;
carved, gilded, and sil-
vered wood; gold and
silver brocade; The
National Trust, Knole

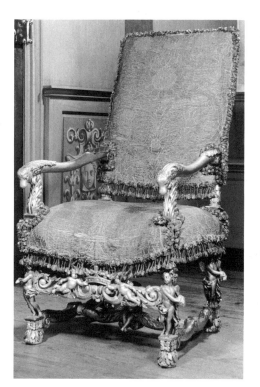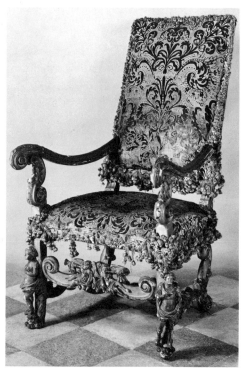

Figure 52. Chair from
the Venetian Ambas-
sador's Room at
Knole, Kent; England,
1688; Jean Poitevin
(upholstery); Thomas
Roberts (active
1687–c. 1714) (carv-
ing); carved and gilded
wood, blue-green
Genoa velvet; The Na-
tional Trust, Knole

Ambassador's Room at Knole (Fig. 50), made for James II in England only a few months before he was deposed in 1688, and also acquired by the sixth Earl of Dorset as a perquisite early in the reign of William III.[61] The upholstery here was almost certainly by Jean Paudevin, who had succeeded Jean Casbert as Chief Upholsterer to the Royal Household in 1677, while the carving of the bed and chair frames (Fig. 52) was by Thomas Roberts. The carved figures on the legs of these chairs seem like a conscious imitation of the earlier seat furniture in the King's Room (Fig. 51), although the scrolling arms and "horsebone" ornaments on the stretchers remain more Dutch than French in origin.

Daniel Marot was of course the guiding spirit behind the great state beds of the 1690s, and there is reason to think that he had a special relationship with the most celebrated of all Huguenot upholsterers, Francis Lapierre (1688–1717), who apparently succeeded to Paudevin's business early in 1689. In one of Lapierre's bills at Boughton, dated 1706, concerning an elaborate bed of "striped Tapestry needlework, lined with satin," there occur two small but highly significant items: "paid to Marot for drawing the cornishes £1.15s. / paid for drawing the Cupps £1.5s."[62] Although there is no other record of Marot's visiting England at this time, the striking similarities between Marot's engravings and Lapierre's documented work make it virtually certain that the two collaborated on such projects as the great state bed made for the first Duke of Devonshire at Chatsworth in 1697, whose tester miraculously survives as a canopy in the Long Gallery at Hardwick.[63] With its original seat furniture covered in the same crimson damask, this set cost the then vast sum of £470. Other beds that are particularly close to Marot engravings and that can be attributed to Lapierre are those at Blair Castle in Scotland and at Dyrham (Fig. 53), the celebrated Melville bed now in the Victoria and Albert Museum, and two from Hampton Court in Herefordshire, now in storage at the Metropolitan Museum.[64] All these were, significantly, made for highly placed courtiers: the first for the Marquess of Tullibardine's apartments at Holyroodhouse; the second for William Blathwayt; the third for the first Earl of Melville, an ardent Williamite who was exiled in Holland between 1685 and 1688; and the fourth for Thomas, Lord Coningsby, said to have saved the king's life at the Battle of the Boyne.

Beds like these were on the whole more elaborate than their French counterparts (see page 18), particularly the flying or "angel" testers, which dispensed with the need for end posts. These seem to have made an appearance only toward the end of the decade, for Celia Fiennes commented that one of the bedchambers she saw at Windsor in 1698 had "a half bedstead as the new mode."[65] It is particularly interesting, therefore, to find William III instructing the Earl of Portland to look for beds during his embassy to Paris in the same year and receiving the answer, "la façon des licts comme on les faire icy ne luy plaira pas, n'approchant pas de ceux que l'on fait en angleterre."[66] Portland was equally unable to find the damasks, brocades, and brocatelles that the king had requested, and with the War of Spanish Succession starting in 1701, the French weavers at Lyons were to be still more seriously challenged by their Huguenot rivals established in the London suburb of Spitalfields. The collection of Spitalfields designs at the Victoria and Albert Museum, many of them by James Leman, unfortunately only go back as far as 1707, but their range is truly amazing, and the large number described as "French patterns" or "taken from a French brocaded damask" show how efficiently spies at Lyons and Tours had procured the latest designs to copy.[67] For this reason alone it is extremely difficult to be sure of the nationality of furnishing fabrics at this date, and even some of the cut velvets thought to be Genoese may have originated in London.

Tapestry weaving in England could, by contrast, never rival the vast output of the Gobelins, where the expenses were formidable and could only have been achieved with government backing. Ralph Montagu, who purchased the Mortlake factory in 1674, may have dreamed of this, and as ambassador to Louis XIV (and later in exile in France during James II's reign) he seems to have lured a number of *tapissiers* to work first under Thomas Poyntz and later under John Vanderbank.[68] The set of portieres at Boughton woven with the Montagu arms and Vanderbank's series of the Elements after Le Brun, woven for the state bedchamber at Burghley, show a high degree of skill developing, and it is interesting to compare the latter with the earlier set of Gobelins Bacchanals that Lord Exeter had specially

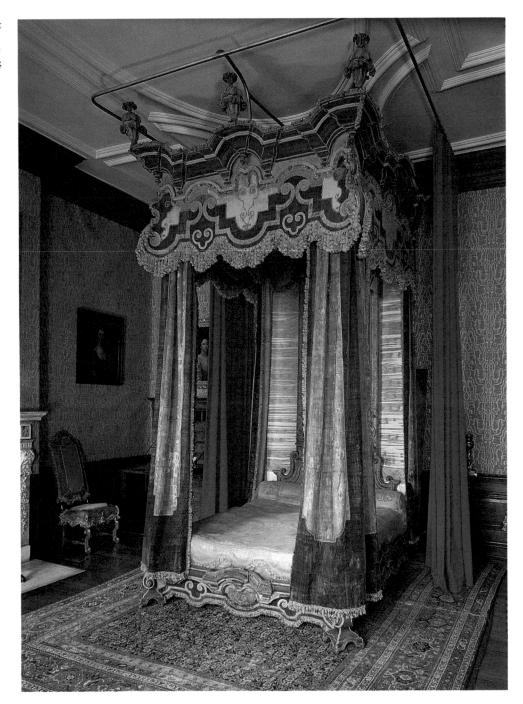

Figure 53. State bed at
Dyrham Park in
Gloucestershire, made
for William Blathwayt;
England, 1690–1700;
attributed to Francis
Lapierre (d. 1717);
velvet and silk uphol-
stery; The National
Trust, on loan from
the Lady Lever Art
Gallery

Figure 54. State bed at Drayton House, Northamptonshire; England, 1700; Guillotin (upholstery); Rebekah Dufee and Elizabeth Vickson (embroidery); green velvet with embroidered panels, yellow taffeta lining; Mr. L. G. Stopford Sackville

commissioned for the house while he was in Paris in 1680.[69] Vanderbank's later "Soho" tapestries, actually produced in Great Queen Street, Covent Garden, are equally indebted to France for their delicate grotesques in the manner of Berain.[70]

Embroidery was another area in which the Huguenots seem to have taken the lead. The floral hangings of the state bed at Clandon in Surrey are virtually indistinguishable from contemporary French needlework, and it is interesting to find that the spectacular curtains and valances of the one at Drayton in Northamptonshire (Fig. 54) were the work of two needlewomen named Rebekah Dufee and Elizabeth Vickson, with an upholsterer called Guillotin of Castle Street in Soho supplying the bedstead and yellow taffeta lining.[71] The bed itself has the simpler, more architectural outline of contemporary French examples, and this description also applies to the recently discovered state bed from Calke Abbey, with its outstanding Chinese embroideries.[72] Queen Mary evidently possessed something similar, for her "Chamber of State" at Windsor had a bed of "Indian Embroidery on white sattin being presented to her by the [East India] Company, on it great plumes of white feathers".[73] The Erddig state bed of 1720, with the same kind of "Indian" (in fact, of course Chinese) embroideries on a white satin ground, shows how long this fashion lasted, and its gilt-gesso decoration by John Belchier is also old-fashioned in feeling, with strapwork in the manner of Berain.[74]

The upholstered seat furniture that accompanied the state bed often consisted of an armchair or settee as well as six chairs and two stools. Inventories of the period also mention "squabb frames," or the low *porte-carreaux* used at the French court, but virtually the only English examples to survive are a pair at Ham,[75] which originally had two large cushions each—one to match the outer, and one the inner, hangings of the bed. In general the backs of the chairs and settees grew taller and more exaggerated in England, often with an arched cresting like those found on pier glasses, while the legs took the form of tapering pillars, raked at the back at an ever-increasing angle, and with prominent curving stretchers. Walnut continued to be used, but there was also an increase in gilding or japanning; a set at Burghley, probably supplied by Lapierre, has a combination of both.[76]

Carved and so-called case furniture, the realm of the cabinetmaker rather than the upholsterer, was equally influenced by the French characteristics of the court style, though Huguenot craftsmen may not have been quite so numerous in this sphere. The vogue for polychrome floral marquetry, already established in Charles II's reign, is usually thought to be Flemish in origin, but its confinement within a more architectural framework goes back to the Gobelins workshops, and particularly to Aubertin Gaudron, who was responsible for training a whole new generation of *marqueteurs*.[77] Oak was still generally used for the carcasses of cabinets, tables and mirror frames, but it was veneered with a bewildering variety of other woods—walnut, yew, mulberry, laburnum, chestnut, olive, holly, beech and fruitwoods—as well as white and green-stained ivory, so that the richness of color must have vied with the brilliance of textiles and ceiling paintings. Once again, the unity of the interior was enhanced by sets of furniture, like the "fine Cabonett, looking glass frame, Table & Stands Suitable" that Peter Pavie made for Queen Mary in 1690.[78] A similar set attributed to Pierre Gole was bought by Lord Exeter in Paris in 1680 and still survives at Burghley,[79] but hardly any English suites including a cabinet now survive, and it is far more common to find the standard mirror, table, and candlestands placed between the windows of a seventeenth-century interior—painted, gilded, or ebonized, in floral or "seaweed" marquetry, brass-mounted or even entirely covered in silver. A particularly splendid example at Hopetoun (No. 87), with carved figures supporting the table and stands very close to Marot in style (see No. 86), is probably by John Guilbaud, whose name occurs in the accounts for 1703[80]—presumably the same John Guilliband who made "two scrutores [or escritoires] inlaid with flowers" for Queen Mary in 1692.[81]

By far the most important London cabinetmaker in the reigns of William and Mary and Queen Anne was Gerrit Jensen (active 1680–1715), who has with reason been called "the English Boulle."[82] Jensen's earlier pieces dating from the 1680s often employ the intricate "seaweed" marquetry of arabesques—possibly derived from Antwerp cabinets, and not unlike the engraving of watchcases and gun stocks of the period. The technique is also found

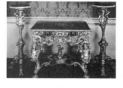

Figure 57. Table and candlestands at Petworth House, Sussex, made for the sixth Duke of Somerset; England, c. 1695; possibly Gerrit Jensen (active c. 1680–1715); carved and gilded wood, pewter, brass, ebony; The Lord Egremont

in a little writing table made for William III's use at Kensington in 1690 and in a "glass case of fine markatree" of 1693, apparently used to house some of the Queen's porcelain.[83] On the other hand the forms of these pieces are increasingly French, and indeed, the "beuro" or "scrutore" made with "drawers to stand on the top" (like a cartonnier) may be a type that Jensen introduced to England, together with the narrow gateleg table with a folding top. He undoubtedly had French craftsmen working for him, including one Peter Berew, who signs a receipt on his behalf at Drayton in 1693,[84] and his business dealings with Pierre Gole in Paris (see page 39) suggest a close relationship both with Pierre's brother Cornelius, who was in London making marquetry furniture for the Crown from 1689 to 1691,[85] and the Gole's nephew by marriage, Daniel Marot.

Jensen's work often shows remarkable similarities to Marot's engraved furniture designs, and this resemblance particularly applies to his metal-inlaid pieces, like the magnificent chest of drawers at Windsor with the *WMR* cipher (Fig. 55) and a very similar pair inlaid with pewter and brass with mirrors en suite at Boughton (Fig. 56).[86] The quality of these is quite as high as French work of the period, but although Jensen is thought to be the only exponent of the boulle technique in England at this time, the existence of some far less accomplished pieces—like a table and stands at Petworth (Fig. 57) on caryatid supports very close to Marot (see No. 86)—suggests that other cabinetmakers were also working in this field.[87] The treatment of the frieze on the Petworth table almost suggests that the maker bought a French panel of brass-and-tortoiseshell inlay and cut it up to use as an exotic veneer like lacquer or coromandel. Boulle bureaus were certainly imported from France at this date, and at Petworth and Erddig they are known to have been used early on as dressing tables[88]— like the one seen in an engraving by Jean de Saint-Jean. The possibility must remain that Gerrit Jensen not only made his own boulle furniture, but also retailed French pieces, and farmed out work to other specialists, like the smiths who worked on the famous silver furniture at Knole, now known to have been supplied by him in 1680.[89] The remarkable quality of the gilt-bronze mounts on the Windsor chest of drawers and on some of Thomas Tompion's more elaborate clock and barometer cases indicates the hand of just such a specialist, and the comparatively large number of boulle cases for English bracket clocks again suggests that there were other cabinetmakers capable of using this technique.

The profession of carver and gilder grew more specialized towards the end of the seventeenth century. René Cousin (d. 1694), who came over from France with Verrio and carried out all the gilding for him at Windsor and Burghley,[90] must have introduced new standards of matte and burnished gold leaf for use on furniture as well as in wall paintings, and Peter Cousin, probably his brother or son, supplied picture and mirror frames for Petworth and Hampton Court respectively in 1690 and 1701.[91] But the outstanding craftsmen in this métier were Jean, Thomas, and René Pelletier, who sent in bills either jointly or separately for very large quantities of furniture at the royal palaces, and at Montagu House and Boughton between 1690 and 1710.[92] The Pelletiers' large torchères, or candlestands, at Windsor and Hampton Court (No. 89) are among the purest Louis XIV forms of furniture ever made in England, and their fire screens (No. 90), with strapwork and acanthus carving also belong to the mainstream of French ornamental carving. It is indeed quite possible that they received their training at the Gobelins workshops, for there is an uncanny likeness between some of their carved and gilded tables, now at Windsor, supported by large scrolling brackets, and a table and stands in the Cartoon Gallery at Knole (Fig. 58), known to have been made by the carver Mathieu Lespagnandelle at the Gobelins in 1671 and probably given by Louis XIV to the then English ambassador, Lord Dorset.[93] This Knole set was also gilded and silvered by David Dupré to match the gold and silver of Pierre Gole's tops, inlaid with brass and pewter. Many of the Pelletiers' bills also refer to silvering, both for picture and mirror frames, and although few examples survive, this was of course almost as popular as gilding in the late seventeenth-century. One of the Pelletiers' most significant innovations was the use of gilt gesso, barely known before their time and suggesting a knowledge of French prototypes such as the magnificent royal daybed now in the Rijksmuseum. A particularly good example is the center table at Boughton (Figs. 59 and 59a) which bears Ralph Montagu's monogram and earl's coronet, and thus dates from before 1705:[94] both the ornament of the top

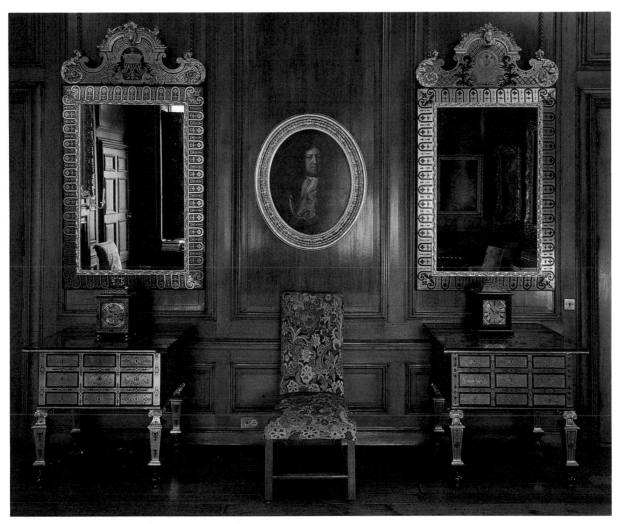

Figure 56. The Low
Pavilion Antechamber
at Boughton House,
Northamptonshire,
showing Kneller's por-
trait of Ralph, Duke of
Montagu, flanked by
chests of drawers and
mirrors made for him
by the royal cabinet-
maker Gerrit Jensen
(active c. 1680–1715),
c. 1694

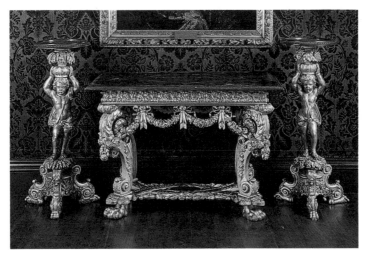

Figure 58. Table and
candlestands at Knole,
probably a gift from
Louis XIV to the
Ambassador Charles
Sackville, later sixth
Earl of Dorset; Paris,
c. 1680; Mathieu
Lespagnandelle (carv-
ing); Pierre Gole (mar-
quetry); carved,
gilded, and silvered
wood, inlaid with
brass and pewter; The
National Trust, Knole

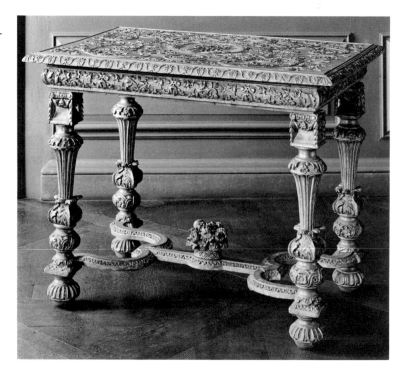

Figure 59. Table at Boughton, Northamptonshire; England, c. 1695; Jean Pelletier (active 1701–10); carved and gilded wood and gesso; The Duke of Buccleuch and Queensberry, K.T.

Figure 59a. Top of the table in Fig. 59.

Figure 60. One of a pair of pier glasses at Hampton Court Palace, Middlesex; England, c. 1715; John Gumley (active 1694–1715); carved and gilded wood, glass; Royal Collection, copyright reserved to Her Majesty Queen Elizabeth II

and the tapered Ionic columns of the legs are strongly influenced by Marot, but the punching of the gesso background and the striated bands (almost imitating straw) look forward to the later work of John Gumley (d. 1727) and James Moore (d. 1726).

John Gumley was one of the pioneers of mirror production in England, setting up a new manufactory at Hungerford Market, Lambeth, in 1705 to compete with the older glasshouses at Southwark and Vauxhall (Fig. 60).[95] Despite the Duke of Buckingham's earlier attempts to produce large glass plates by casting instead of blowing, Colbert's foundries by the Porte Saint-Antoine in Paris (later moved to Normandy) had always been far more successful at this complicated technique, and they were to remain so until the end of the eighteenth century. Nevertheless the *Postman* was able to announce that "large looking-glass plates, the like never seen in England before" were available at the Vauxhall works in 1700,[96] and a sudden expansion in the size of pier glasses and sash windows coincided with this improvement. Many of the former were made with borders of *verre églomisé*, a method of engraving in gold under glass, against a bright red or blue background, somewhat confusingly named after a later Parisian framemaker, Jean-Baptiste Glomy. Robert Hooke "saw a curious way of back-painting on the backside of a looking glasse at Mr. Bartue chamber in Pump Street" as early as 1674, adding "it was done by one Monsr. Tués lying at the Smiths by the green dragon in the Pall Mall."[97] But the frames usually seen, with grotesques derived from Berain including *commedia dell'arte* figures under canopies, the signs of the zodiac, or family crests and coats of arms, seem to date from after 1690, and many of the later ones catch the lighter spirit of the Régence.

A small group of mirrors with putti, floral garlands, and masks painted in oil on the surface of the plate can be found at the Victoria and Albert Museum, at Melbourne in Derbyshire, and at Dalkeith Palace near Edinburgh. The latter was the work of the painter Jakob Bogdany, but the other two are probably by the flower painter Jean-Baptiste Monnoyer, for Vertue records that he was responsible for such a looking glass at Kensington Palace, describing it as "the most curious of all his works . . . painted for the late Q Mary of Glorious Memory, her Majisty sitting by him almost all the while."[98] Once again there may have been a French precedent, for an entry in Louis XIV's *Comptes des bâtiments* for 1676 records a payment to "le peintre Boulongne ayant peint des glaces de miroir dans un appartement des attiques à Versailles."[99]

The Worshipful Company of Glass-Sellers, first set up in 1664, employed George Ravenscroft in 1673 to produce a substitute for Venetian clear glass. After many vicissitudes, Ravenscroft began to produce jugs, bowls, and drinking glasses from 1676, and the operation continued after his death in 1681, copying some French models as well as Flemish and Italian ones.[100] On the whole the English glass engravers' repertoire remained conservative, however, with old-fashioned auricular cartouches and acanthus decoration surviving well into the eighteenth century. Glass chandeliers were more affected by the court style, though few of this period now survive. A series of five at Penshurst, with a highly sophisticated design of drops imitating rock crystal and culminating in a royal crown, one of them adorned with orange leaves (Fig. 48), almost certainly belonged to William III and would have been acquired by the Earl of Romney as a perquisite after the king's death.[101]

Of all the areas in which Huguenot craftsmen came to hold sway, the production of silver and gold plate came nearest to being a monopoly, and the pieces that they produced are among the most beautiful and best adapted to their material in the history of English metalwork. One of the reasons for their success was the economic boom that accompanied the formation of the joint stock companies in the 1690s and early 1700s, for many of the landowners who benefited would invest the extra capital they earned in plate. A typical example is the second Earl of Warrington, who began buying silver in 1701 and whose notebook records purchases almost every year thereafter until his death in 1759, when he owned over 26,500 ounces (Nos. 43 and 44).[102] The development of the baroque buffet display, a tiered arrangement of plate shown on the sideboards of the saloon or dining parlor when guests were being entertained, was also central to the evolution of large-scale, architectural pieces like the great ewers and basins, wine fountains and cisterns, for which the Huguenot makers became celebrated.

Despite its earlier Italian origins, the idea of the buffet itself came from France, as the name implies, and its ceremonial aspect had (like so many other aspects of court life) a religious equivalent: even today silver and gold alms dishes and flagons are piled high on the altar of Westminster Abbey for coronations and feast days. Drawings by Berain for the buffets at Marly, and Desportes's overdoor paintings,[103] intended to continue the theme of the sideboards in trompe l'oeil, give an idea of their splendor, and also the decorative unity that was considered essential. In the same way, ladies' toilet sets of forty or fifty pieces, laid out on the dressing table of a state bedchamber, and tea or coffee services set up on tables in the dressing room beyond, fulfilled the baroque passion for symmetry and for objects made en suite. Indeed, it is quite common to find a buffet or toilet service made by several different makers over a long period, yet all conforming in style to the earliest dated pieces.

French influence on silver in Charles II's reign should not be underestimated, but so little survived being melted down to pay for Louis XIV's wars that it is hard to find French examples for comparison. Certainly the techniques of embossing, with loose floral ornament, and flat chasing (including chinoiserie scenes) are Dutch legacies, particularly from the van Vianens. Nevertheless, the "engraver extraordinary" to the Crown from 1668 was a Frenchman, John Destach, and there are a number of examples of so-called cut-card work, generally considered French in origin, dating from the 1660s and 1670s.[104] Several important Huguenot smiths, like Anthony Nelme and Philip Rollos, also arrived before the revocation of the Edict of Nantes—during the time of the *dragonnades*—and their influence can be traced early on in gadrooned borders of salvers by native smiths like Ralph Leeke.[105] Mostly this decoration was a matter of applying new ornament to old forms like the porringer, the tankard, or the standing cup, but it was also well suited to the monteith—a bowl with a notched brim to hold the feet of cooling wine glasses—invented in 1683, according to the Oxford diarist Anthony à Wood, and taking its name from "a fantastical Scot called 'Monsieur Monteigh' who, at that time or a little before, wore the bottom of his cloake or coate so notched."[106] One purely French form introduced by Charles II was the *cadenas*, or caddinet (No. 77), used at Versailles only by the king and princes of the blood: one was quickly made for Charles's coronation banquet, and another was included in the service he gave to the Duchess of Portsmouth in 1672[107]—though perhaps intended for his own use.

The greatest of the Huguenots' innovations generally adopted by the 1690s was the method of casting and chasing separate applied ornaments, enabling them to replace the lobate forms of the earlier Dutch baroque with bolder and more sculptural detail—whether gadrooned, fluted, scalloped, or in cut-card. The new emphasis on pieces primarily intended for display also encouraged new forms of French origin like the helmet-shaped ewer with basin en suite (No. 37), the ice pail, and the flat salver. This last is often referred to as a "table" in contemporary inventories and could indeed have a tripod stand with notches cut out for its feet, when used for serving tea or coffee. Cruet frames were also devised to give more weight and importance to the bottles and casters on the buffet, and to the inkstands that were centerpieces for a gentleman's chamber plate. Older forms were also rethought: the porringer was replaced by the ecuelle; the standing cup was given two handles and a domed cover; and the old pilgrim bottles with chained caps (medieval in origin) became wine flagons (No. 38). Above all, the wine cooler or cistern, and wine fountain (Nos. 45 and 46), placed in the middle of the buffet arrangement, assumed the static magnificence of garden urns and vases, worthy of their axial positions. Twenty-two great wine coolers still survive, many of them of gigantic size (Philip Rollos's at Burghley weighs almost 3,700 ounces),[108] but their fountains tended to be melted down when they later grew unfashionable, and few survive. As at Burghley, there was often a large and small cooler en suite, and an early nineteenth-century engraving of the dining room there shows how the three pieces were always arranged one above the other. One of Sarah, Duchess of Marlborough's early wills refers to "the little cistern for the sideboard and the fountain to hold the water that goes into it,"[109] so the smaller was evidently used to rinse the glasses while the larger contained the wine bottles packed in ice.

Silver furniture had been popular since Charles II's reign, and John Evelyn, visiting the Duchess of Portsmouth (Charles II's French mistress, Louise de Kerouaille) in 1683, was

Figure 61. Chandelier at Chatsworth, Derbyshire; made for the fourth Earl of Devonshire just before his elevation to the Dukedom; probably Leeuwarden, c. 1694; Johannes van der Lely (1673–after 1749), after a design by Daniel Marot (1661–1752); silver; The Duke of Devonshire and The Chatsworth House Trust

amazed by the "huge Vasas of wrought plate, Tables, Stands, Chimny furniture, Sconces, branches, Braseras &c they were all of massive silver & without number."[110] Most of this plate would have been of thin silver sheet, embossed, and applied to a wooden core like the Knole furniture (see page 50), but solid silver pieces became commoner with the advent of casting— and it is significant that the great table and mirror frame at Windsor (No. 85), presented to William III, are almost entirely of solid metal, like the later Portland tea table.[111] Andirons were still popular (No. 134) but began to go out of fashion because of the increasing use of coal and grates, and it should be noted that the last known pair, at Welbeck, are dated 1704.[112] Sconces (Nos. 126, 128–130) continued to be made in large sets into the reign of George I, however, gradually abandoning the cartouche shapes popular in the Restoration period and adopting Marotesque ornament, like the Ionic capitals and shell motif of a pair by Anthony Nelme dated 1704.[113] Marot himself could have designed the magnificent silver chandelier at Chatsworth (Fig. 61), which bears an earl's coronet and can thus be dated before 1694 when the Earl of Devonshire was raised to a dukedom. Very close to a plate in Marot's *Nouveaux Livre d'Orfèvrerie*, it appears to bear the Leeuwarden marks, and thus to have been made in Holland. But equally splendid examples were made in England, like the one at Hampton Court, made for William and Mary by George Garthorne about 1690.[114]

It is perhaps surprising to find the designs of the Huguenot smiths so assured and metropolitan in character, when almost all of these craftsmen came from provincial centers rather than Paris: David Willaume, from Metz; Isaac Mettayer, from Poitou; Pierre Harache, from Rouen; and Pierre Platel, from Lorraine.[115] They were, however, able to rely not only on the engravings of the great masters of ornament like Jean Berain and Jacques du Cerceau (c. 1520–c. 1584), but also on a host of specialized pattern books for metalworkers, such as the *Livre de desseins pour toute sorte d'ouvrages d'orfèvrerie* published by M. P. Mouton of Lyons, or Masson's *Nouveaux dessins pour graver sur l'orfèvrerie*. Others were published in English editions, like Jean Le Pautre's *New Book of Fries Work* and Jean Mussard's *A Book of Divers Ornaments . . .*, or even originated in London, as did the prints of de Moelder (Nos. 73 and 207) or Simon Gribelin (No. 40). Gribelin, a Huguenot from Blois, was one of the most accomplished silver engravers in England in the 1690s (see No. 39), working very much in the Marot style and foreshadowing the young Hogarth's later work for Paul de Lamerie.

De Moelder's chinoiserie designs show that, although the fashion for flat-chasing subjects had passed by the 1690s, oriental subjects were still the rage. Imports of porcelain and lacquer through the Dutch and English East India Companies were in fact reaching new heights, and many dealers stocked both: thus John van Colma who sold Queen Mary a substantial section of her vast china collection, also supplied "a fine right Japan chest" in 1694.[116] "Right" was used in this sense to signify genuine lacquer, as opposed to the japanned imitations produced in quantity, by amateurs as well as professionals, after the publication of John Stalker and George Parker's *Treatise of Japanning and Varnishing* in 1688. Appreciated first for their exoticism, these oriental wares came to be increasingly integrated in a thoroughly "Westernized" architectural setting. A "Japan closet" like those portrayed by Marot (No. 171), using sections of lacquer or coromandel screens cut up without any regard to their logical sequence, still exists at Drayton.[117] A large cushion mirror surround at Boughton is typical of this cavalier attitude, for the lacquer is used simply as a veneer, with figures on their sides or upside down. Yet it must have been a highly prized piece, for it bears Ralph Montagu's monogram in silver in the cresting.[118] In the same way a Javanese lacquer tea table at Ham acquired between 1679 and 1683 (and comparable with one in the Balcony Room at Dyrham) was too low to use with the Duchess of Lauderdale's japanned backstools, and was thus given a large stand of its own, completely altering its appearance.[119] It should also be remembered that garnitures of porcelain to place on the tops of cabinets or on chimneypieces were unknown in the East, and were manufactured purely for the export market. As early as 1697, John Pollexfen records artificers being sent out to introduce patterns for the Chinese craftsmen to copy.[120]

Delft pottery, imitating Chinese blue-and-white, was much admired in England, and the arrival of the Dutch potter Jan Ariensz van Hamme (1636–d. after 1676) in 1671 marks the beginning of a radical change in the old native majolica types.[121] Tin-enameled ware had

begun to be produced at Bristol two years earlier, and Edward Ward of Brislington, who started his factory in 1683, greatly improved the quality of this type of pottery. Lambeth, however, remained the principal source of large armorial plates, drug and posset pots—which are sometimes hardly distinguishable from those made at Delft, where English potters are also known to have been employed. It might be thought that "English Delft" was little affected by the court style, as seen in the great tulip vases, tiles, and milk pans made in Holland by Adriaen Kocks and imported to England by Queen Mary and many of the leading courtier families (Nos. 161–68), but a curious advertisement placed in the *Hague Friday Courant* in 1710 suggests that this was not entirely the case: "Louis du Pré of Amsterdam has several fine quality vases and pots at the Municipal Sculpture Ware House, which were made by Daniel Marot. They have the resonance of a bell, and have just come from England. Among these are vases which are five feet high. . . ."[122] Marot could well have designed such vases, to judge by the celebrated Kocks orange-tree pot at Erddig, but it comes as a surprise to find them apparently being made in England. Large blue-and-white vases of this type, containing clipped trees, can be seen lining the parterre in one of the Stoke Edith hangings (Fig. 62), the remarkable appliquéd scenes of a baroque garden, dating from about 1700, now at Montacute.

Gardening in England at the time of William and Mary is a huge subject that cannot adequately be discussed here, save to say that French and Dutch influences are so intertwined as to be virtually inseparable. Purely Dutch compartmented water gardens, like that at Westbury Court in Gloucestershire,[123] are rare, however, compared with the *parterres de broderie* (named after the embroidery patterns they resembled), the great axial vistas, the *pattes-d'oie* (or "goose feet" of converging avenues), and the groves and bosquets of pleached trees made popular by Le Nôtre. The latter never actually visited England, though he made designs for Greenwich in Charles II's reign and was consulted about Windsor in William III's—sending over his nephew Claude Desgots to superintend the planting of the Maestricht garden there in 1698.[124] The royal gardener George London was twice sent to France, while his younger partner Henry Wise was responsible for the design of Melbourne in Derbyshire, sending "drafts to form and plant the ground . . . to suit with Versailles."[125] The Earl of Portland, who acted as superintendent of Willam and Mary's gardens in England and Holland, was an avowed Francophile in horticultural matters, and as Stephen Switzer was to write of gardening at this period, "the Nobility and Gentry of Great Britain . . . were all this while very busie in Imitation of the Royal Examples of the then King and Queen."[126] French or Huguenot garden designers were also prominent: Daniel Marot himself laid out the great parterre at Hampton Court; Guillaume Beaumont worked at Levens, where he made the first recorded "ha-ha" (or sunk fence) in England;[127] while the mysterious "Monsieur Grillet" was responsible for the Cascade at Chatsworth (Fig. 63),[128] and perhaps the similar one at Dyrham. If Dutch influence can be found in such gardens—as at Boughton where the gardener was named Vandermeulen—it is in the greater emphasis on planting and the ribbons of bulbs mixed with annuals and exotic herbaceous plants (many of them brought from the Far East) that softened the strict symmetry of the French parterre.

Lead garden sculpture was far more popular in England than in France, where the stone was generally of better quality and the climate less harsh. The great exponents of the court style in England were the Flemish-born sculptors Jan van Nost (d. 1729) and his successor Andries Carpentière (d. 1737), whose urns and vases are often close to Marot's engravings and to the work of the sculptors like Jan van Baurscheit in the Netherlands. Their statues tended to be based on famous antiques like the Venus de Medici, or Italian prototypes like Giambologna's *Samson and the Philistine*, but they could also produce ambitious work in a thoroughly French manner like van Nost's superb *Vase of the Seasons* at Melbourne with its monkey supporters or Carpentière's *Fame* at Powis Castle, based on a celebrated group by Antoine Coysevox now in the Tuileries.[129] Contemporary bills and accounts, and the bird's-eye view paintings of Knyff and Siberechts (Fig. 63), show that these lead sculptures were invariably painted to resemble stone or marble, or even given naturalistic colors, just as wrought-iron gates and screens would be painted bright blue or green, with much gilding.[130]

Baroque wrought-ironwork reached greater heights in England than in France at the

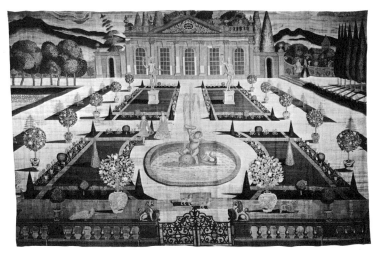

Figure 62. One of a set of embroidered hangings formerly at Stoke Edith, Herefordshire, now at Montacute, Somerset, showing a French-inspired garden; England, c. 1700; The National Trust, Montacute House

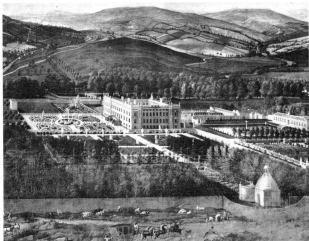

Figure 63. A view of Chatsworth, Derbyshire (detail); England, after 1699; attributed to Jan Siberechts (1627–after 1699); oil on canvas; Private Collection

Figure 64. Part of the fountain garden screen, Hampton Court Palace, Middlesex, England, 1692; Jean Tijou (active 1689–1712); iron; Department of the Environment

end of the seventeenth century, owing partly to the country's vast increase in iron production and to the damp climate (which made it a preferable material to wood), but above all to the genius of one blacksmith, Jean Tijou (active 1689–1705). It is doubtful whether Tijou was a Huguenot, for his daughter married the painter Laguerre, who had initially been trained for the Catholic priesthood, but he may have been one of the many French craftsmen brought to England by Ralph Montagu. He is first recorded working at Hampton Court in 1689, and the Fountain Garden screen there (Fig. 64) remains one of his finest achievements, but he also worked at Burghley, Chatsworth, Kiveton, and, almost certainly, Drayton—all of them "courtier houses" where William Talman was involved as architect.[131] The designs in Tijou's *New Booke of Drawings* (1693) (later published in Paris by Louis Fordrin under the title, *Nouveau Livre de serrurerie de composition angloise. . .*) are now known to be a working-up of much earlier French engravings (see page 84), yet the assurance of his dense repoussé work, the delicacy of his scrolls and uprights, and the daring of his seemingly unsupported overthrows mark him as one of the greatest craftsmen of the period.

The vast expense of Tijou's ironwork—he was paid £4,500 for the gardens at Hampton Court alone between 1691 and 1700[132]—and his close association with the Office of Works under Wren and Talman, meant that he was to some extent an isolated phenomenon. Thomas Robinson (active 1696–1715), his official successor, was to revert to a much simpler arrangement of plain bars and scrolls, and Tijou's real heirs were the provincial smiths of the next generation: the Davies brothers of Wrexham, the Edneys of Bristol, and Robert Bakewell of Derby, who worked in areas where the hybrid English baroque still lingered as an architectual and artistic force.[133] Of all these smiths, only Bakewell adopted a French style more advanced than Tijou's own. His famous arbor at Melbourne, carried out between 1707 and 1711, is close to the elaborate wooden *treillages* at De Voorst and Rosendael, seen in Marot's engravings, and the pierced shells and cloths-of-estate he favored can be found in the work of French smiths like Nicolas de Poilly (1626–1696) and Nicolas Guérard (1680–1719).[134]

Why was the French-influenced court style so decisively rejected by the Whigs at the time of the Hanoverian Succession? The replacement of Tijou by Robinson at Saint Paul's, the dismissal of Wren and Hawksmoor from the Office of Works in favor of the incompetent Palladians, William and Benjamin Benson, and the rejection of Thornhill's designs for murals at Kensington Palace in favor of William Kent's—all these events, combined with the publication in 1715 of Colen Campbell's *Vitruvius Britannicus*, urging the superiority of "Antique Simplicity" over the "affected and licentious forms" of the baroque, can certainly be seen as aspects of a revolution in taste as well as politics. The famous letter from the third Earl of Shaftesbury to Lord Somers, written in 1712[135] and hailed from an early date as a Whig manifesto, may mark the first open association of the baroque with political absolutism. But as early as 1708 to 1709, the arrival of the artists Pellegrini and Ricci, and the plasterers Bagutti and Plura,[136] foreshadowed the mania for all things Italian that was to be so strenuously promoted by Lord Burlington. Echoes of Berain and Marot lingered in some of the detailed ornament of Kent's furniture, in the masks with feathered headdresses on Gumley and Moore's gilt-gesso mirrors, and in the tureens and épergnes of Paul Crespin and Paul De Lamerie. But the overall forms of the objects underwent a radical change after 1714, as Marot, the ornament-designer, yielded in importance to Kent, the painter-decorator. At the same time there was a corresponding change in France with the death of Louis XIV and the emergence of the Régence style, toward the more sculptural forms of Oppenord.

The final expression of the court style of William and Mary is not to be found in fashionable London circles, but in the provinces (where architects like the Smiths of Warwick and the Townesends of Oxford moved only slowly with the times), in Holland (where the Frisian stadholders presided over an increasingly conservative and inward-looking society), and in the colonies. As Princess Elizabeth Charlotte of Orléans (the indomitable "Liselotte") wrote from Versailles in 1715, asking a friend to think of a present she could give the Princess of Wales, "one can no longer send fashions, because the English have their own, which are followed here now."[137]

Notes

1. Kerry Downes, *Vanbrugh* (London, 1977), 75.

2. "The Plan of M. Tallard's Garden at Nottingham," in George London and Henry Wise, *The Retir'd Gard'ner* (London, 1706); reproduced in John Dixon Hunt and Peter Willis, *The Genius of the Place* (London, 1975), 109, fig. 55.

3. Edward Croft-Murray, *Decorative Painting in England 1537–1837* (London, 1962), 1:64.

4. Thomas Babington Macaulay, *History of England, from the Accession of James II* (London, 1849–1861), 3:1–127; for a more up-to-date view of William III's reluctance to be governed by the dictates of parliament, see David Ogg, *England in the Reigns of James II and William III* (Oxford, 1955), 319–21, 488–92.

5. Edgar Wind, "Julian the Apostate at Hampton Court," *Journal of the Warburg and Courtauld Institutes* 3 (1939–40): 127–37.

6. Christopher Morris, ed., *The Journeys of Celia Fiennes* (London, 1947), 280.

7. John Evelyn, *The Diary of John Evelyn*, ed. E. S. de Beer (Oxford, 1955), 3:3.

8. Sackville papers, Kent Record Office; F5.

9. Basil Gray, *The English Print* (London, 1937), 21; E. Croft-Murray and P. Hulton, *Catalogue of British Drawings in the XVIth and XVIIth Centuries* (London, 1960), 1:315.

10. Stephen Wren, *Parentalia, or Memoirs of the Family of the Wrens* (1750; reprinted London, 1965), 162.

11. Reprinted London, 1967.

12. The anonymous author is now thought to be Samuel Fortrey; see *National Union Catalog* (London and Chicago, 1971), 160:283.

13. *Travels of Cosimo the Third, Grand Duke of Tuscany, through England, during the Reign of Charles the Second* ([1669], reprinted London, 1821), 398.

14. C. Phillips, *History of the Sackville Family* (London, 1929), 2:446.

15. Public Record Office, London; Wardrobe Accounts LC5/39.

16. H.M. Colvin, ed., *The History of the King's Works* (London, 1976), 5:255.

17. Gervase Jackson-Stops, "Huguenot Upholsterers and Cabinet-Makers in the Circle of Daniel Marot," in I. Scouloudi, ed., *Huguenots in Britain and Their French Background 1550–1800* (London, 1987), 115, 117.

18. Van Nost's first workshop was in the Haymarket, but he later moved to Hyde Park Corner, where Carpentière became his assistant; Laguerre was Tijou's son-in-law. See Horace Walpole, *Anecdotes of Painting in England*, R. N. Wornum, ed. (London, 1862), 2:645–48.

19. Robin D. Gwynn, "The Number of Huguenot Immigrants in England in the Late Seventeenth Century," *Journal of Historical Geography* 9:4 (1983): 384–95.

20. Robin D. Gwynn, "Patterns in the Study of Huguenot Refugees in Britain," in *Huguenots in Britain*, 218.

21. J. F. Hayward, *Huguenot Silver in England, 1688–1727* (London, 1959).

22. Th. H. Lunsingh Scheurleer, "Pierre Gole, ébéniste du roi," *Burlington Magazine* 122 (June 1980): 394.

23. International Exhibitions Foundation, *Treasures from Chatsworth: The Devonshire Inheritance*, exh. cat., Virginia Museum of Fine Arts (1979), no. 157.

24. Gentot's name also occurs on the engraving of the fountain screen at Hampton Court in the English edition of Tijou's book: see John Harris, *English Decorative Ironwork 1610-1836* (London, 1960), pl. 25; see also Arthur Grimwade, "The Master of George Vertue," *Apollo* 127 (February 1988): 83–89.

25. Croft-Murray, *Decorative Painting*, 1:243.

26. Alan Cook, "Wren's Design for Winchester Palace," in Howard Colvin and John Harris, eds., *The Country Seat* (London, 1970), 60, fig. 37 (the drawing here attributed to Nicholas Hawksmoor).

27. Hubert Fenwick, *Architect Royal* (Kineton, 1970); John Dunbar, "Kinross House," in *The Country Seat*, 65–68.

28. James Lees-Milne, *English Country Houses: Baroque, 1685–1715* (London, 1970), 143.

29. W. Kuyper, *Dutch Classicist Architecture* (Delft, 1980), 123–124.

30. Nikolaus Pevsner, "John Bodt in England," *Architectural Review* 130 (July 1961): 29–43.

31. Gervase Jackson-Stops, "French Ideas for English Houses: The Influence of Pattern Books, 1660–1700," *Country Life* 167 (January 29, 1970): 261.

32. Gervase Jackson-Stops, *Drayton House* (London, 1978), 8–9, 34.

33. M. D. Ozinga, *Daniel Marot: De Schepper van den Hollandschen Lodewijk XIV-Stijl* (Amsterdam, 1938), pl. 39A.

34. Gervase Jackson-Stops, "The Building of Petworth," *Apollo* 105 (1977): 328.

35. John Hardy and Gervase Jackson-Stops, "The Second Earl of Warrington and the 'Age of Walnut,'" *Apollo* 108 (1978): 13–17.

36. Jackson-Stops, "Building of Petworth," fig. 4, 330.

37. Rupert Gunnis, *Dictionary of British Sculptors 1660–1851*, 2nd ed. (London, 1968), 190–191, 269.

38. The team also worked in Yorkshire at Aldby and Wentworth Castle; see Lees-Milne, *English Country Houses*, 236–39, 258–59.

39. Mark Girouard, *Life in the Country House* (London and New York, 1978), 135, fig. 8.

40. Hugh Murray Baillie, "Etiquette and the Planning of the State Apartments in Baroque Palaces," *Archaeologia* 101 (1967): 182–84.

41. Gervase Jackson-Stops, "Petworth and the Proud Duke," *Country Life* 153 (June 26, 1973): 1872–73, figs. 8–9.

42. Ian Bristow, "The Balcony Room at Dyrham," *National Trust Studies* (1980), 140–146.

43. Gervase Jackson-Stops, "English Baroque Ironwork— II," *Country Life* 149 (1971): 266.

44. Geoffrey Beard, "Edward Goudge: 'The Beste Master in England,'" *National Trust Studies* (1979), 21–27.

45. Geoffrey Beard, *Decorative Plasterwork in Great Britain* (London, 1975), 49.

46. George Vertue *Note Book* (The Walpole Society, 1931–32) 20: 21.

47. Croft-Murray, *Decorative Painting*, 1:61–68.

48. Gervase Jackson-Stops, "A British Parnassus: Mythology and the Country House," *The Fashioning and Functioning of the British Country House*, National Gallery of Art, Center for Advanced Study in the Visual Arts, forthcoming.

49. Gérald Van der Kemp, *Versailles* (London, 1978), 39–42.

50. Margaret Whinney and Oliver Millar, *English Art 1625–1714* (Oxford, 1957), 273.

51. Gervase Jackson-Stops, *Beningbrough Hall* (The National Trust, London, 1980), 29–30.

52. Manuscript in a letter book at Sheffield City Library; H. M. Colvin, *Biographical Dictionary of British Architects* (London, 1978), 300.

53. Manuscript at Chatsworth.

54. Girouard, *Life in the Country House*, 152, fig. 11, pl. 89.

55. Peter Thornton, *Seventeenth-Century Interior Decoration in England* (New Haven, Ct., 1978), fig. 236.

56. Daniel Defoe, *A Tour Thro' the Whole Island of Great Britain* (London, 1724), ppTK.

57. David Green, *Grinling Gibbons* (London, 1964), pl. 85.

58. Gervase Jackson-Stops, "Huguenot Upholsterers," 117–18, pl. 12, fig. 1.

59. Marcus Binney, "Penshurst Place, Kent—III," *Country Life* 151 (1972): 998, suggests as an alternative that the set may have been bought by Lord Romney's elder brother, the fourth Earl of Leicester, during his remodeling and refurnishing of Leicester House in London in 1698–1700; for the Kiveton set, see Christopher Gilbert, *Furniture at Temple Newsam and Lotherton Hall* (Leeds, 1978), 2:265, fig. 322.

60. Public Record Office, London, Wardrobe Accounts LC9/273, 21 and LC5/42, 42, and *Calendar of Treasury Books* 1685–89, 1040, 1151, 1153; for Delobel, see also Henri Havard, *Dictionnaire de l'ameublement . . .* (Paris, 1887–90), 3:383–384, and Jules Guiffrey, *Comptes des Bâtiments du Roi sous le Règne de Louis XIV* (Paris 1881–1901), 1:1152, 1314; 2:342.

61. Gervase Jackson-Stops, "Purchases and Perquisites: The 6th Earl of Dorset's Furniture at Knole," *Country Life* 161 (June 1977): 1622, figs. 6–9.

62. First discovered by Mr. John Cornforth; Gervase Jackson-Stops, "Marot and the 1st Duke of Montagu," *Nederlands Kunsthistorisch Jaarboek* (1981), 255.

63. Manuscript, "Mr. Whildon's Account Book," drawn up for the 1st Duke of Devonshire, Chatsworth.

64. The Blair bed is the only one of these that has been reupholstered at a later date; for the Hampton Court beds, see L. White, "Two English State Beds in the Metropolitan Museum of Art," *Apollo* 116 (1982): 84–88.

65. Morris, ed., *The Journeys of Celia Fiennes* (London, 1947), 277.

66. Gervase Jackson-Stops, "William III and French Furniture," *Furniture History* 7 (1971): 125.

67. Peter Thornton, *Baroque and Rococo Silks* (London, 1965), 23.

68. H. C. Marillier, *English Tapestries of the Eighteenth Century* (London, 1930), xiii–xxiii.

69. Christopher Hussey, "Burghley House—V," *Country Life* 114 (1953): 2166.

70. M. A. Havinden, "The Soho Tapestry Makers," *Survey of London* 34 (The Parish of St. Anne, Soho), App. 1, (London, 1966), 515–20, 542–43.

71. Jackson-Stops, *Drayton House*, 31.

72. Gervase Jackson-Stops, ed., *The Treasure Houses of Britain: Five Hundred Years of Private Patronage and Art Collecting* (New Haven and London, 1985), no. 375.

73. Morris, ed., *Journeys of Celia Fiennes*, 279.

74. John Hardy, Sheila Landi, and Charles D. Wright, *A State Bed from Erthig* (London: Victoria and Albert Museum, 1972).

75. Peter Thornton and Maurice Tomlin, "The Furnishing and Decoration of Ham House," *Furniture History* 16 (1980): fig. 125.

76. Glyn Mills Bank (Child's), Exeter account, records payments to Lapierre in the 1690s.

77. Pierre Verlet, *French Furniture and Interior Decoration of the 18th Century* (London, 1967).

78. Robert Symonds, *Furniture Making in Seventeenth- and Eighteenth-Century England* (London, 1955), 108.

79. I am indebted to Professor Th. H. Lunsingh Scheurleer for this information, which he is to publish in the *Burlington Magazine* in due course.

80. Manuscript at Hopetoun House; Jackson-Stops, "Huguenot Upholsterers," 120–21, pl. 14, fig. 2.

81. Public Record Office, London, Wardrobe Accounts LC9/124, 53; the two desks together cost £30.

82. R. W. Symonds, "Gerrit Jensen, Cabinet-Maker to the Royal Household," *Connoisseur* 95 (1935): 268–74.

83. Ibid., 271, fig. 4.

84. Manuscript at Drayton.

85. Public Record Office, London, Wardrobe Accounts, LC9/280, 27.

86. Anon., "French Furniture in the Duke of Buccleuch's Collection," *Country Life* 71 (1932): xxv–xxvii.

87. Gervase Jackson-Stops, "Furniture at Petworth," *Apollo* 105 (1977): 360, fig. 7.

88. 1748 inventory, Petworth House Archives 6263; Martin Drury, "Early Eighteenth-Century Furniture at Erddig," *Apollo* 108 (1978): 48, fig. 1.

89. Kent Record Office, Sackville papers, A192/10; I am indebted to Dr. Eric Till for this discovery.

90. Croft-Murray, *Decorative Painting*, 1:246.

91. Gervase Jackson-Stops, "Picture Frames at Petworth— I," *Country Life* (September 4, 1980), 800; Public Record Office, S/32; *Wren Society* 18 (1941): 160–61.

92. Jackson-Stops, "Huguenot Upholsterers," pl. 16, fig. 1.

93. Jackson-Stops, "Furniture at Knole," 1496, fig. 3, cover illustration.

94. Tessa Murdoch, ed., *The Quiet Conquest, The Huguenots 1685–1988* (Museum of London, 1985), no. 285.

95. Geoffrey Wills, *English Looking-Glasses* (London, 1965), 46.

96. Anthony Coleridge, "England 1660–1715," in Helena Hayward, ed., *World Furniture* (London and New York: Hamlyn, 1965), 89, 95.

97. H. W. Robinson and W. Adams, eds., *The Diary of Robert Hooke*, London, 1935), 113.

98. George Vertue, *Note Book* (The Walpole Society: London 1955), 30:180; the mirror at Melbourne may be the one Vertue refers to, since Thomas Coke, the builder of the house, was Vice-Chamberlain to Queen Anne and could well have received it as a perquisite; the example in the Victoria and Albert is inv. no. W-36-1934. For the documentation of the Bogdany painted mirror at Dalkeith, see John Cornforth, "Moor Park," *Country Life* 182 (1988): 139.

99. Henri Havard, *Dictionnaire de l'ameublement . . .*, (Paris, 1887–90), 2:993.

100. W. B. Honey, *English Pottery and Porcelain*, 5th ed. (London, 1962), 42–43.

101. Binney, "Penshurst," 998, calls the chandeliers rock crystal and suggests they were imported "as there are no records of rock-crystal cutters in England at this date"; however, it seems certain that the drops are of blown glass.

102. J. F. Hayward, "The Earl of Warrington's

Plate," *Apollo* 108 (1978): 32–33.

103. Thornton, *Seventeenth-Century Decoration*, figs. 13, 229.

104. Charles Oman, *English Engraved Silver 1150 to 1900* (London, 1978), 59, 71.

105. Ibid., 39–40.

106. Quoted in ibid., 45.

107. The list of the service (including "1 gilt Cadanett with knife & spoon & fork") is in the Public Record Office, London, LC5/107: 159.

108. N. M. Penzer, "The Great Wine Cisterns," *Apollo* 66 (1957): 39–46.

109. Hayward, *Huguenot Silver*, 35.

110. Evelyn, *Evelyn Diary*, 4:343.

111. Made shortly after 1724; E. A. Jones, *Catalogue of the Plate belonging to the Duke of Portland at Welbeck Abbey* (London, 1935), 124, pl. 17.

112. Ibid., 41 and pl. 8

113. Hayward, *Huguenot Silver*, pl. 72A.

114. Ibid., pl. 77; Carl Hernmarck, *The Art of the European Silversmith 1430–1830* (London, New York, 1977), 1:218; 2:202, fig. 531.

115. Ibid., 8.

116. Coleridge, *World Furniture*, 89.

117. John Cornforth, "Drayton House, Northamptonshire— IV," *Country Life* 164 (1965): fig. 2; John Cornforth, "Honington Hall, Warwickshire—I," *Country Life* (September 21, 1978), fig. 6.

118. Percy Macquoid and Ralph Edwards, *Dictionary of English Furniture*, rev. ed. (London, 1924–27), 2:318, fig. 21.

119. Thornton and Tomlin, *Ham House*, fig. 88.

120. John Pollexfen, *A Discourse of Trade, Coyn and Paper Credit* (London, 1697); quoted in Coleridge, "England 1660–1715," 89.

121. Honey, *English Pottery and Porcelain*, 42–43.

122. Michael Archer, "Pyramids and Pagodas for Flowers," *Country Life* 159 (1976): 166–69.

123. Gervase Jackson-Stops, "A Formal Garden Reformed: Westbury Court, Gloucestershire," *Country Life* 154 (1973): 864–66.

124. Colvin, ed., *King's Works*, 5:332.

125. David Green, *Gardener to Queen Anne—Henry Wise and the Formal Garden* (Oxford, 1956), 25.

126. Stephen Switzer, *Ichnographia Rustica* (London, 1718); quoted in Green, *Gardener to Queen Anne*, 48.

127. Annette Bagot, "Monsieur Beaumont and the Garden at Levens," *Garden History* 3:4 (1975): 66–78.

128. Francis Thompson, *A History of Chatsworth* (London, 1949), 80, 86.

129. Jonathan Marsden, "Carpentière's 'Fame' at Powis Castle," *Country Life*, forthcoming.

130. Gervase Jackson-Stops, "New Deities for Old Parterres: The Painting of Lead Statues," *Country Life* 181 (January 29, 1987): 92–94.

131. Harris, *English Ironwork*, 4.

132. Jackson-Stops, "English Baroque Ironwork— II," 262.

133. Maxwell Ayrton and Arnold Silcock, *English Decorative Wrought Iron in the 17th and 18th Centuries* (London, 1929), 99–140.

134. Jackson-Stops, "English Baroque Ironwork— II," 264.

135. Anthony Ashley Cooper, 3rd Earl of Shaftesbury, *Letters* (London, 1750), 139–56.

136. Croft-Murray, *Decorative Painting*, 2:13–24; Beard, *Decorative Plasterwork*, 53–55.

137. Maria Kroll, ed., *Letters from Liselotte* (London, 1970), 171.

The William and Mary Style in America

by Phillip
M. Johnston

Although distant from the seat of royalty, the American colonies in the late seventeenth century were not outside the monarchy's sphere of influence. Indeed, with the ascension of William III and Mary II to the English throne, the colonies were drawn even closer into this sphere as William pursued a policy of increased unification of the empire that had begun with the Restoration of the Stuarts and the appointment by James II in 1686 of royal governors for the colonies. This policy was not his alone; it was consistent with the general movement toward centralized control of power from the capital or seat of government that spread from France to all of seventeenth-century Europe.

Louis XIV of France unquestionably set the essential patterns of power that monarchs, even the relatively democratic William and Mary, strove in varying degrees to emulate. Consequently, as Louis surrounded himself with ultimate splendor at Versailles, so William and Mary established themselves appropriately at Het Loo and at Kensington Palace. In turn, great noble families in Europe modeled their household arrangements after those of their respective monarchs, the aim always being first and foremost to advance their power and status. As one moved down the social scale, so the splendor of household arrangements decreased. Nevertheless, the standards of behavior and taste set by the ruling families were recognized by all, and people adopted them as best they could, according to their means.[1]

In America, especially with the assertion of royal authority by the king's governors, the pattern applied, as well. The little courts of these governors established new role models for colonial merchants who were becoming wealthy and for America's affluent country gentry.[2] Moreover, evidence found in inventory records and in objects with verified histories of ownership supports the conclusion that the terms "provincial" and "cultural lag" do not apply to certain style-conscious colonists, in relation to their economic and social peers in England.

Surviving visual records of the most important American buildings of this era, long since demolished, demonstrate that some American colonists consciously emulated the Anglo-Dutch classicism that characterized contemporary English architecture. One of these was John Foster, a wealthy Boston merchant, who from 1689 to 1692 built a grand brick house elaborated with Ionic pilasters of Portland stone. Rising through the three stories of the house on its street front, these pilasters were topped with garlanded capitals. Stoughton Hall at Harvard, built from 1698 to 1699, was as classical as the Foster House. The Clarke-Frankland House, built twenty years later on Garden Court Street—on land adjoining the Foster-Hutchinson property—was a three-story brick mansion with alternating round and triangular pediments over its dormers, as well as a broken-scroll pediment over its door. It was destroyed, along with the Foster-Hutchinson House, around 1832 or 1833, but two painted wall panels from the house survive, as well as a section from its remarkable parquetry wood parlor floor (No. 136).[3] In Philadelphia, the best-known house from the era was the so-called Slate Roof House. Its hipped roof, Flemish-bond brickwork, and pedimented doorway followed current London building practices.

The Governor's Palace at Williamsburg—named for William III—was, however, the preeminent baroque building in America. Built from 1706 to 1720, the palace, like the Foster and Slate Roof houses, introduced bilateral symmetry about a central axis, a classical concept in the organization of space that was new to the colonies (Fig. 66). It also stood at the end of an extensive green as one of three public buildings that commanded long, open vistas—an arrangement devised by Governor Francis Nicholson that was very much in keeping with current concepts of city planning in baroque Europe. There monarchs and designers cleared away disorderly medieval neighborhoods in order to create visually comprehensible cities with wide, straight streets, open areas, and classical structures.

The baroque style in the decorative arts, which in America we have called William and Mary, actually predates their reign and continues afterward as well. It is possible, however, to look at the full period of the baroque in America and identify an earlier phase of the style that is more Dutch-inspired and a later phase that may be specifically associated with these monarchs, for it relates to the French-inspired baroque brought by the Huguenot designer Daniel Marot to the Dutch court of William and Mary, and in turn to England when Marot followed the monarchs there in 1689 or 1690.

Figure 65. The
Governor's Palace
and Gardens,
Colonial Williamsburg
Foundation

Figure 66. Public
buildings at
Williamsburg, Virginia;
England, 1732–47;
engraving; Colonial
Williamsburg Foun-
dation, Williamsburg,
Virginia, Gift from
the Bodleian
Library, Oxford

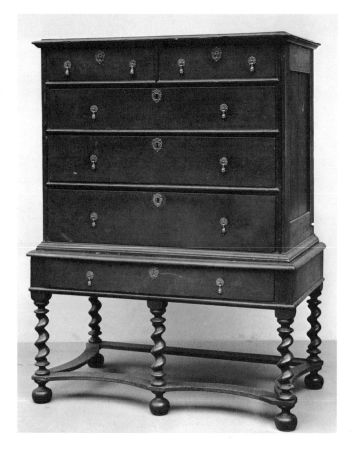

Figure 67. Chest on frame; New York, Kings County or Queens County, 1690–1720; gumwood, tulip, pine, and oak; The Metropolitan Museum of Art, New York, Rogers Fund, 1936

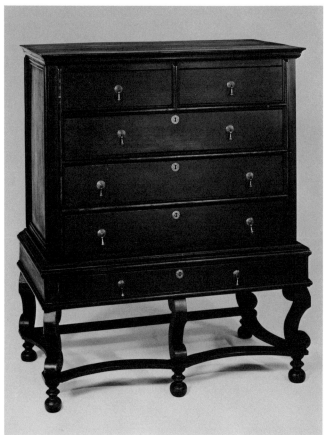

Figure 68. Chest on frame; Massachusetts, Essex County, 1710–25; oak, maple, white pine, sycamore; Wadsworth Atheneum, Hartford, Wallace Nutting Collection, Gift of J. Pierpont Morgan

Both aesthetically and technically, the baroque style in case furniture was abruptly different from the preceding fashion. It represents a complete rejection of ornament applied to surfaces in favor of an aesthetic in which the surface itself is rich. To achieve this newly preferred surface, craftsmen needed a different set of skills: the ability to fashion furniture of large boards held together by dovetails and to ornament the resulting flat surfaces with richly grained veneers. In short, with the baroque style the age of the joiner ended and the era of the cabinetmaker began.

When did this age of the cabinetmaker begin in America? An examination of seventeenth-century Boston estate inventories reveals that the high chest of drawers—the signature case-furniture form for the baroque style—was certainly present in Boston by 1690, when the first unambiguous reference to one appears listed among the belongings of Thomas Scudder as a "Chest of Drawers & frame."[4] Whether this chest was English- or American-made, we cannot tell. The second Boston reference comes in the June 1693 inventory of "Chirurgeon" Richard Kennett, in whose chamber stood "1 Chest of drawers 1 Table and 1 Dressing box," valued together £6.10.0. When Dr. Thomas Pemberton, also a "chirurgeon" and a friend of Sir William Phips, the second royal governor of Massachusetts, died one month later, in July 1693, his possessions included a "chest of drawers and table" in his chamber. Both these 1693 references presumably describe not only a high chest of drawers but also a high chest of drawers with a matching dressing table—a combination that was a new, important phenomenon for this period.[5] A fourth reference, dated May 10, 1695, records the remarkable furnishings of Captain Andrew Cratey's Marblehead, Massachusetts, house. Captain Cratey had come from London in 1688 and furnished his house with the finest London furniture, including "an olive wood Case of Draws and table."[6] Cratey, being a part of the new royal-appointed government of Massachusetts and, thereby, like Dr. Pemberton, a member of the new social elite, must have been aware of his power and influence and presumably, therefore, would have brought to the colonies household furnishings in the current taste. Certainly his high chest with matching dressing table would suggest as much.

Similar early documentation for America's other principal cities, Philadelphia and New York, cannot be cited. Although in Philadelphia a clear record of this form does not come until 1711, the "Stand Chest of Drawers" in Margaret Beardsley's 1701 inventory may be an earlier instance.[7] Unfortunately, New York's probate records were destroyed by fire in 1911, making impossible a search for documentation comparable to the one Benno Forman accomplished for Boston and that which Cathryn J. McElroy completed for Philadelphia.

Turning from written records to an examination of surviving baroque high chests of drawers known to have been made in America, we see that the ones that are stylistically earlier have rather square proportions and incorporate a single drawer in the lower case. Indeed, many could be accurately described as chests on stands or chests on frames:[8] the well-known New York chest in the Metropolitan Museum of Art fits this description (Fig. 67). Moreover, its spiral turned legs suggest familiarity with French Huguenot or Anglo-Dutch furniture. Anglo-Dutch traditions are reflected in the flat S-scroll legs of a chest signed by Edmund Titcomb of Newbury, Massachusetts, and a similar, unsigned chest in the Wadsworth Atheneum, Hartford, Connecticut (Fig. 68). The stylistically earlier veneered high chests from Massachusetts generally have a single drawer in the lower case and rather flat arching patterns in the skirt below. More numerous, however, are those stylistically later high chests showing the influence of English chests that must post-date the arrival of Daniel Marot and his introduction to England of the French-inspired classicist baroque. Noticeably taller, they stand on legs turned into forms clearly derived from classical baluster shapes as interpreted in the Renaissance and later by French baroque designers, such as Jean Berain, and their follower, Daniel Marot. The chests are enlivened by a distinctive polyarched pattern in the center of their skirts, accommodated by an arrangement of three or more drawers of varying sizes. Such chests were made in Boston (No. 109), New York (Fig. 70), and Philadelphia, and variations of this pattern, not specifically Marot-like in outline, appear in Pennsylvania high chests (Fig. 69). These high chests, consequently, cannot be dated earlier than 1689 to 1690, the time of Marot's arrival in London, and probably began to be made in America soon thereafter. They, therefore, can most appropriately be termed William and Mary style high chests.

Figure 69. High chest of drawers; Philadelphia, 1700–25; black walnut, yellow pine, cedar; Philadelphia Museum of Art, Gift of Lydia Thompson Morris

How did this style of case furniture reach America? Certainly, inventory records indicate that American colonists owned imported chests. Regrettably, however, I am unaware of an English or a Dutch one with an American provenance from the late seventeenth century. A second possible means by which the new style could have reached America is by way of printed designs. Only, however, in the instance of "1 paper book of dutch draughts" in the "Joyners Roume" at William Penn's residence, Pennsbury Manor, in 1687, is there evidence of the presence of a pattern book in America during this period.[9] A third means of style transmission is by way of trained artisans immigrating to the colonies and bringing with them knowledge of the current style and skills to produce it. The first four woodworking craftsmen who immigrated to Philadelphia identified themselves on the ship passenger lists of 1682 as "cabinetmakers."[10] (Thereafter, however, it seems that in Philadelphia, unlike Boston, the term *joiner* was preferred, even for craftsmen with cabinetmaking skills.) As one would suspect, given the 1682 date of Philadelphia's settlement, case furniture in the baroque style was being made there from its first days.

In Boston the earliest baroque style furniture may have originated in the shop of cabinetmaker John Clarke, who became a resident of Boston in 1681 but about whom nothing else is known. More important is the arrival of John Brocas (d. 1740), who purchased land in Boston on May 11, 1696, for he is the first English cabinetmaker known to have immigrated to Boston and continued in residence there.[11] He worked until his death in 1740 and trained the second, third, and fourth cabinetmakers known to have made furniture in the Boston area: John Damon, Jr. (b. 1679), George Thomas (b. 1684), and John Maverick (b. 1687), all native born. We cannot yet ascribe particular pieces of furniture to specific individual craftsmen in this group. Nevertheless, these men must account for the particular appearance of William and Mary furniture for almost twenty years, since not until 1714, when the English cabinetmakers William Howell (d. 1717) and William Price arrived, could a new strain have been introduced.[12] Furthermore, it would seem that it cannot be coincidental that the preponderance of baroque high chests made in Boston postdates Marot's influence in London and that the cabinetmaker responsible for the look of Boston William and Mary case furniture arrived in 1696. Clearly, John Brocas must have brought the true William and Mary style to Boston.

Also identifiable with the arrival of the baroque style in America is the appearance of cane seating furniture. Cane chairs offered the advantages of "durableness, Lightness and cleanness from dust, worms and moths which inseparably attend Turkey-work, Serge, and other stuff-Chairs and Couches," according to contemporary advocates. Beginning in 1664 and continuing well into the late seventeenth century as many as a quarter of a million cane chairs were exported annually.[13] Benno Forman's recently published *American Seating Furniture 1630–1730* admirably sets forth the origins of cane furniture. Inspired by Italian designs of the sixteenth century, Hispanic chairmakers by the mid-seventeenth century developed a leather upholstered chair, which before the end of the century, in the Netherlands, was translated into the turned, molded, and carved chair with cane seat and back: "This brilliant Netherlandish adaptation repeats, note for note, the themes of the earlier Spanish chair: the outline of the crest and bottom rails of both gently undulate, sometimes complementing, sometimes echoing each other; the cast iron and gilt or brass finials atop the stiles [of the Spanish chair] are replaced by turned wooden ones; both chairs have turned, ogival balusters on their legs and massive, carved stretchers rich in shape and ornament; the 'great heels' of the back legs are likewise common to both; so, too, are the strongly molded arms terminating in architectural volutes and the famous 'Spanish foot.'" Forman goes on to delineate clearly the stylistic sequence that pertains to the type in England and America, concluding: "The introduction of chairs with cane bottoms and backs in Northern Europe and America is one of the high points in the story of the seventeenth-century decorative arts as an international phenomenon. In no other form of furniture and at no other time do so many crosscurrents of political and commercial history and the history of taste come together to create so vividly a new style."[14] Because cane chairs were mass-produced products in an age of mercantilism, they brought fashionable urban-style chairs within the economic reach of a great number of people. They also were so popular that they

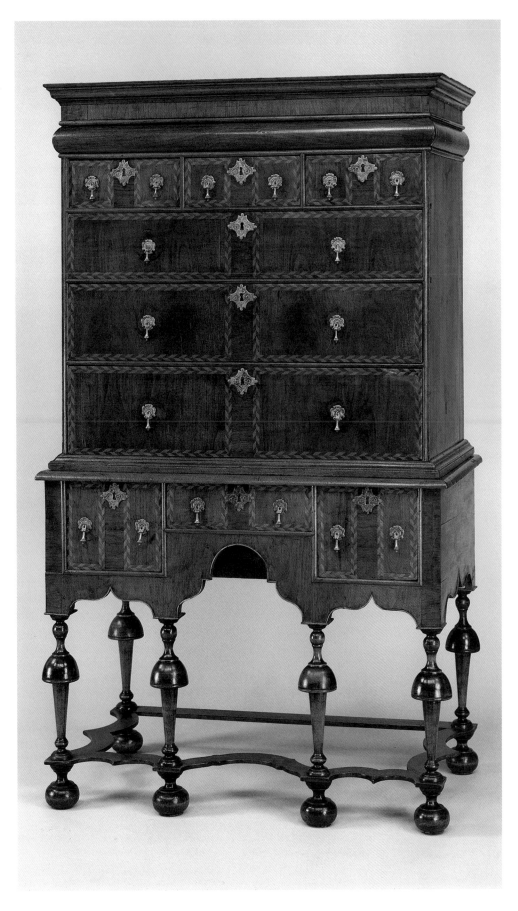

Figure 70. High chest of drawers; probably New York City, 1700–30; maple, walnut, walnut veneer, maple and cedar banding; The Metropolitan Museum of Art, New York, Gift of Mrs. J. Insley Blair, 1950

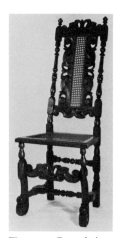

Figure 71. Cane chair, owned by Robert Sanders; probably England, c. 1700; beechwood; Historic Cherry Hill, Albany, New York

were produced, early on, in the shops of both joiners and turners. This caused a blurring in the distinctive characteristics of each of these specialists; the result was the emergence of a new specialist craftsman, the chairmaker.[15]

The first London probate-record reference to cane chairs occurs in 1674 in the inventory of a Cambridge gentleman, Robert Mannynge, who owned "2 elboe chairs canne botham." By 1683 cane chairs begin to turn up frequently in inventories, and such descriptions as those of Captain Francis Digby's "12 cane chairs with 12 cushions and backs of Damask" in 1676 to 1677 indicate that cushions were used on the seats and backs of cane chairs and that even at this early date cane chairs were purchased in sets of a dozen.[16]

Likewise, in the 1680s, during the first days of settlement in Pennsylvania, cane chairs appeared. Christopher Taylor of Philadelphia owned "five cane chairs" when he died in 1685. The 1687 inventory of William Penn's house, Pennsbury, listed cane chairs as well. In Boston, the earliest inventory reference to cane chairs comes on July 9, 1688, with the recording of "six cane chairs" in the estate of Giles Masters, the King's attorney. Dr. Thomas Pemberton, whose high chest of drawers and dressing table have already been mentioned, also owned six cane chairs, and the lavishly furnished home of Andrew Cratey contained a dozen cane chairs plus a dozen "Lackered cane chears" and a matching couch.[17]

Prior to the 1690s, cane chairs present in the colonies were predominantly imported, with 2,000 dozen a year being exported annually by English cane chairmakers. They continued to be imported even into the first decades of the eighteenth century, but in decreasing numbers. Cane chairs with abruptly reversed scroll crests, stretchers, and front legs were made in England from the late 1670s, and a number of these with American histories of ownership survive, including one that descended in the Sanders family of Albany, New York (Fig. 71). This style of cane chair was followed by ones having higher and often narrower backs; their arching crest rails composed of scrolls were repeated in their front stretchers. The less expensive versions had turned front legs. The rear stiles, instead of a series of baluster forms, became almost exclusively architectonic columns. Chairs of this style dominated the last decade of the seventeenth century; they were undoubtedly imported to the colonies in some quantity. This decade, however, was also the time when cane chairs began to be made in America. A cane armchair of this style in the Wadsworth Atheneum (No. 113) is stamped with the initial *I* with cross-serif, thought to be the mark of a caner working in Boston. In the shaped outline of the frame for its caned back and in its columnar stiles, this chair suggests the presence of French, classicist baroque influence. However, the American chairs that look most like Marot's designs are two that were probably made in Philadelphia (No. 116) and a later group made in Boston between 1717 and 1730, when cane chairs reached the height of their popularity (No. 115). They share simple, molded stiles and molded rails that incorporate polyarched patterns. An English chair that makes an especially interesting comparison with these from Boston is one from a set that belonged to Hezekiah Wyllys (1672–1741) of Hartford and descended in his family (No. 113).[18]

Unquestionably, cane was the popular, new upholstery material in this era. However, most American chairmakers chose to produce banister-back or leather-upholstered chairs. The accounts and letters of Thomas Fitch (active 1689(?)–1736), a Boston upholsterer, prove invaluable in studying the production of upholstered chairs at this time. Fitch, born in 1669, established himself as an upholsterer around 1690. In Boston a chair industry had already existed for at least twenty years with chairmakers producing leather-upholstered Cromwellian type chairs both for local consumption and for export to other colonies.[19] However, from Fitch's records it appears that around 1696 a new, high-back leather chair became desirable. On April 8, 1695, the Trustees of Harvard College voted to purchase for the library "six leather chairs." Then on December 22, 1697, they paid Thomas Fitch for "6 Russia [leather] chairs had of him last Commencement . . . 4.10." At this price, these chairs were twice as expensive as the Cromwellian type listed in inventories, and presumably were of the new, high-back style.[20] Interestingly, this is precisely the time when, with the arrival of an English cabinetmaker, we can confirm the production of William and Mary case furniture in Boston.

The first leather chairs in the new style seem to have taken their form from

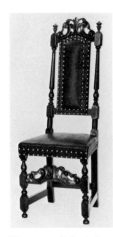

Figure 72. Side chair, owned by George Wilhelmus Mancius of Albany; Boston, 1695–1710; maple, oak, leather upholstery; Private Collection

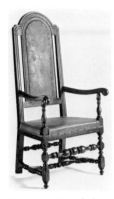

Figure 73. Armchair; probably Philadelphia, possibly Delaware or New Jersey, 1725–46; black walnut, leather upholstery; The Henry Francis du Pont Winterthur Museum, Winterthur, Delaware

contemporary English cane chairs and probably were made to rival them. The Boston armchair from the Winterthur Museum (No. 117) and a privately owned side chair made for the Mancius family of Albany (Fig. 72) are the sort Fitch would have called "carv'd Russia leather" chairs.[21] Such chairs were not, however, less expensive alternatives to cane ones. Russia leather[22] was imported and expensive, and the chair frame cost roughly twice as much as a competitive cane chair imported from England.[23] Nevertheless, Boston chairmakers in the early eighteenth century supplied leather-upholstered chairs in great quantity to customers not only in Boston and throughout New England, but in New York, Philadelphia, and the South.

In Philadelphia, leather chairs were second only to cane chairs in popularity (Fig. 73).[24] Even though no carved-top leather chairs of the early Boston-made type seem to survive from Philadelphia chairmakers' shops, intriguing connections between Boston and Philadelphia makers exist. Thomas Fitch learned the upholsterer's trade from Edward Shippen (d. 1715), who had immigrated to Boston in 1669. Shippen then moved to Philadelphia in 1693 and became mayor there in 1701. A second Boston craftsman who left for Philadelphia in the 1690s was Thomas Stapleford. He, too, had connections with Fitch, for his former Boston shop by 1696 was in Fitch's "Tenure."[25] Beyond this documentary connection, however, no correspondences between surviving pieces have yet been established. The best known of the records indicating that Boston's export trade was significant in Philadelphia comes much later. It is a September 1742 advertisement in the *Philadelphia Gazette* in which Philadelphia chairmaker Plucket Fleeson offers "several sorts of good chair frames, black and red leather chairs, finished cheaper than any made here or imported from Boston."[26]

Thomas Fitch's New York orders, however, were large early on, and presumably his chairs were being bought for resale to customers who wanted English-looking chairs.[27] Leather chairs were also made in New York, sometimes in imitation of Boston ones (No. 119). Others are distinctly different, especially in their more complex turnings, and have been compared to Dutch chairs (No. 118). The scrolled arms with carved foliage both at the ends and at the juncture with the rear stiles, seen in the New York chair, can be found on English cane chairs that appear to derive from Dutch prototypes.[28] No arms of this type were made in Boston. Furthermore, what becomes clear in comparing Boston and New York chairs is that New York chairmakers, unlike those in Boston, offered their clients chairs that were distinctly unlike imported London chairs and that were indeed more conservative in taste. It is important to recall that in 1664, when the Dutch were forced to surrender to the English, New Amsterdam had become New York. With this abrupt change in government, an English tradition was overlaid upon an already-existing Dutch heritage, and a long period of cultural transition ensued. Presumably, these more conservative chairs were preferred by New Yorkers who wished to ignore the English ascendancy in New York and attempted, in their choice of furniture, to retain their distinctive cultural identity.[29]

Similar cultural diversity can easily be seen in American baroque silver made in New York. A group of bowls (Fig. 74) made from the 1690s and well into the eighteenth century retains a kind of repoussé floral decoration characteristic of early Dutch baroque decoration that was also popular in England in the 1660s and 1670s but that was supplanted in stylish silver by French-inspired classical decoration by the 1690s. These bowls are similar to oval, two-handled Dutch bowls from Groningen and Friesland made from the mid-seventeenth century to the nineteenth. That these bowls with their robust floral decoration continued to be made in New York as long as they did is evidence of a persistent Dutch influence in this colony; that they did not remain a traditional form in New York as similar ones did in parts of the Netherlands is evidence that, indeed, English culture ultimately supplanted Dutch traditions.[30]

Interesting in this context is a small group of two-handled cups ornamented with repoussé vertical leaves (Fig. 75), made from the 1690s until 1720, although they are like English cups of the 1670s and 1680s. It is noteworthy that these typically English cups were made in America only in New York,[31] all apparently for prominent Dutch and French families in New York—the Van Cortlandts, Bayards, Brockholsts, and Philipses.[32] Perhaps they appealed to some Dutch clients because they were so English; perhaps they appealed to

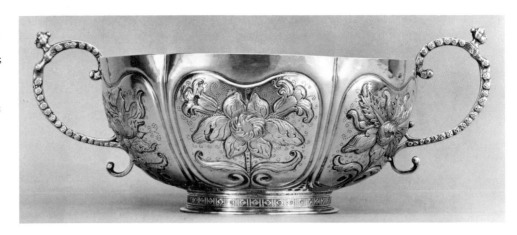

Figure 74. Two-handled bowl; New York, 1700–10; Cornelius Kierstede (1675–1757); silver; The Metropolitan Museum of Art, New York, Samuel D. Lee Fund, 1938

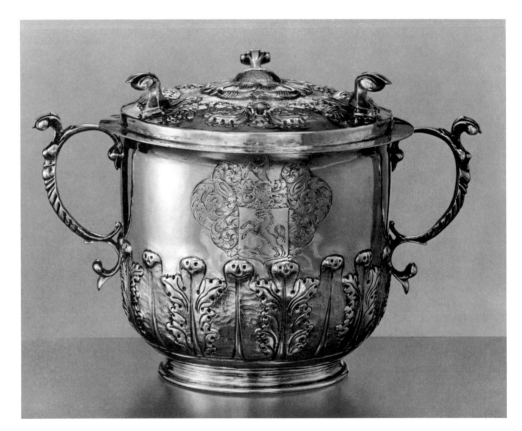

Figure 75. Covered caudle cup; New York, 1690–1700; Gerrit Onckelbag (c. 1670–1732); silver; Yale University Art Gallery, New Haven, Connecticut, The Mabel Brady Garvan Collection

others because the decoration, in its robustness, had a Dutch sensibility that offered an appealing compromise in taste.

The ornament most characteristic of later baroque silver of the William and Mary style is gadrooning. A type of classical ornament revived in the Renaissance, gadrooning is prominent in baroque decoration. The earliest dated American object enriched with this ornament is a standing cup made by Jeremiah Dummer (1645–1710) (No. 54). It is dated 1700, the year it was given to the church in Eastham, Massachusetts, by Joseph and Hanna Bangs. The cup is also typically baroque in its alternation of fully decorated and plain surfaces and in its use of a generous vasiform stem. Once established, gadrooning became omnipresent in silver from both Boston and New York. In New York, as on the Jacob Boelen teapot (No. 63), the Cornelius Kierstede candlestick (No. 72), and the Bartholomew Le Roux caster (No. 79), gadrooning played a subservient role to engraving and other decorative patterning. In Boston, gadrooning was often the primary decoration (Nos. 55 and 66). Even on the most elaborate objects made in Boston, gadrooning plays a major role in the overall decorative program. Certainly among the most sumptuous objects of this era are the sugar boxes (No. 75) of John Coney (1656–1722) and Edward Winslow (1669–1753). As Graham Hood has observed, "In their intricate patterns these boxes convey the same effects that cabinetmakers might in their rich burl veneering and japanning, both popular in this period." The Winslow box is fully baroque in "its subtle use of point and counterpoint, smooth and elaborate, naturalistic and geometric form, the infinite variations on the scroll and the oval, the capricious highlights, its intricate rhythms."[33]

The single American silver object that most completely embodies the phase of the baroque specifically identified with William and Mary is a monteith by John Coney (No. 50). The shape of the rim (made up of a combination of scrolls), the applied gadrooned urns that punctuate the upper border beneath this rim, and the lambrequins to which the lion masks and handles are applied all recall Daniel Marot's designs. The monteith is of up-to-the-minute style and fully equivalent to English contemporary work in both design and execution. In fact, we should not be surprised that such a bowl was made in Boston. Prior to this period a strong tradition of silversmithing had already been established there. Then the coming of English officials in the late 1680s and early 1690s "jarred the Boston social elite and created a large demand for stylish objects which would meet London standards," and Boston silversmiths responded.[34] According to Barbara Ward's study of Boston silversmiths, eleven men operated independent shops in the 1680s, but in the 1690s, in response to the new demand, the number of practicing silversmiths almost doubled, making Boston by 1700 the undisputed center of the craft in New England and, arguably, in all the colonies.[35]

How, specifically, did the new style in silver reach Boston and the other colonies? In a sense the most direct contact between the American colonists and their English monarchs came in the gifts of silver from William and Mary to the newly favored Anglican congregations such as Saint Anne's Parish in Annapolis, Maryland, Trinity Church in New York City, and, perhaps most significantly, to King's Chapel in Boston, founded in 1686 in a colony whose earlier leadership had maintained a specifically non-Anglican bias. To these congregations, William and Mary presented simple but boldly formed chalices, alms basins, and flagons devoid of ornament save for their engraved arms and tributes. They were wrought by George or Francis Garthorne in 1694 and 1695. In no specific way, however, can we point to these ecclesiastical objects as conveyors of the new style.

Certainly, however, English domestic silver objects were also imported at the time, and these could have conveyed the style. It is also true that from 1695 to about 1710 most of the immigrant goldsmiths for whom we have records entered Boston, where they worked either as journeymen or as independent masters.[36] These newcomers, like John Brocas, the cabinetmaker, could very well have brought knowledge of the current style and the skills necessary to produce it. Barbara Ward has conjectured that Henry Hurst, who arrived in Boston on March 1, 1699 or 1700, working at first for Richard Conyers but operating independently after June 6, 1701, played a significant role in the transmission of the William and Mary style to Boston.[37] One of the very few surviving objects by him is a tankard with cast dolphin-and-mask thumbpiece and a cast cherub's-mask handle terminal. Could he have

introduced these baroque elements, which after 1700 become characteristic of Boston tankards?

Printed sources of design also may have spread the new style, but this theory cannot be verified. Engraved baroque coats of arms on silver from Boston, New York, and Philadelphia share an essential period character—which certainly suggests the presence in the colonies of printed manuals for these details. Perhaps future research will establish their specific sources. The most Marot-like engraving on a piece of American silver may be the Wynkoop arms on a tankard from about 1710, made by New York silversmith Benjamin Wynkoop (1675–1728) for his own use (Fig. 76).

It has been stressed earlier in this catalogue that the William and Mary style as codified in England by Daniel Marot is more than a set of design characteristics that appear in individual objects. With this style came the concept of a fully unified interior. Since no interiors survive from this era in America, we must turn to documentary sources, namely estate inventories, to learn to what degree the unified interior prevailed in America.

Without question, Americans owned suites of chairs. Cane and leather chairs were bought in sets of six or a dozen, sometimes with an accompanying couch. Early in the period, as has been mentioned, Captain Andrew Cratey owned a dozen cane chairs in his great hall and a dozen "Lackered cane chears" with a matching couch; and in Philadelphia suites of seating furniture, including couches or stools, were fairly common in inventories after 1715.[38] However, in seating furniture, ownership of suites of chairs had begun earlier with Cromwellian turned chairs; such references, therefore, do not suggest in and of themselves a new concept in interior design during the era of William and Mary. The presence of new furniture forms and, in particular, of distinctive combinations of furniture associated with the William and Mary style, however, do indicate the arrival of a new concept of interior furnishings.

One such combination is that of the high chest of drawers with matching dressing table, examples of which have been noted earlier in the discussion of high chests of drawers as a new form in this era. From associated references we also see that American colonists displayed ceramics and glass atop their high chests of drawers. Since they had done the same in earlier days on their court cupboards, however, it is hazardous to draw hasty comparisons with Queen Mary's elaborate arrangements of ceramics. Nevertheless, a few later, cabriole-leg high chests survive with their original stepped shelves on top—no doubt of the same type as Captain William Warner's "1 case of Draws Steps & Table"[39] inventoried in 1745—suggesting more specifically that this baroque concept, fully expressed in European buffets, did find expression in America and persisted for some years into the eighteenth century.

Likewise, the combination of a table, a pair of candlestands, and a looking glass—the principal fashionable furnishing unit of the baroque period—does appear, if rarely, in American inventories. Among the exceptional furnishings of Captain Andrew Cratey's great hall were "1 Looking Glass, 1 Inlaid table & pr. stands," and in the 1697 inventory of Philadelphians John and Elizabeth Tatham appeared "One rich Ollave inlaid Table & 2 Stands."[40] Regrettably, none of these "triads," as Peter Thornton calls these combinations, survive.

The era abounds in new furniture forms that not only are known from inventories but also survive. Tables specifically for the taking of tea first made their appearance both in European and in American interiors during this period. Two walnut tea tables are listed in Philadelphia as early as 1686.[41] Dr. Thomas Pemberton's inventory of 1693 included a "slate table,"[42] perhaps a tea table like the one in the Wadsworth Atheneum (No. 175).

In this era the gateleg table replaced the earlier trestle table or heavy, stretcher-based, stationary table. Lighter-weight, easily movable gateleg tables were ideal for creating various dining situations. Their tops, when opened, are almost invariably oval (No. 101), unquestionably a significant shape in this era. In baroque architecture, the oval is most forcefully expressed in molded ceilings that dominate rectangular rooms. In ornament of both architectural woodwork and decorative arts, it appears prominently in patterns of applied moldings and of marquetry banding, in reserves for coats of arms or other enrichments, and in the shapes of boxes, wine cisterns, or other functional objects. In household objects the oval is perhaps most strongly expressed in gateleg dining tables, which, when opened and placed in the center of a room, altered entirely the nature of that space.[43] Such tables also

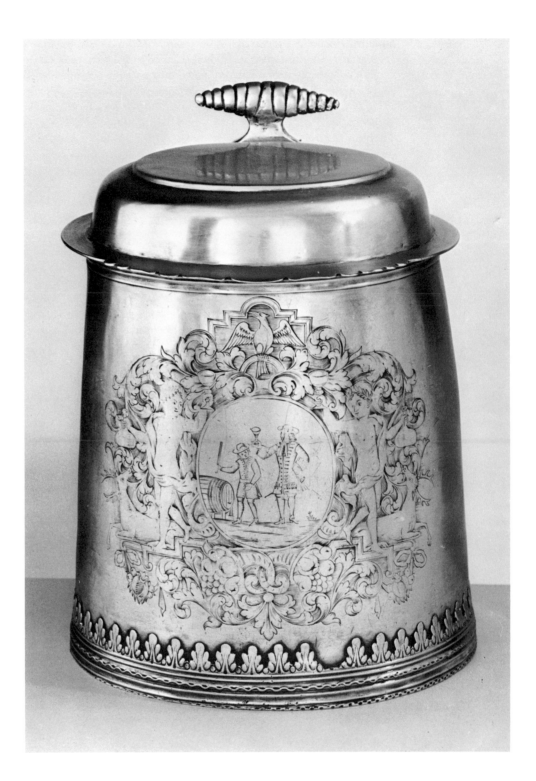

Figure 76. Tankard;
New York, 1710;
Benjamin Wynkoop
(1675–1728); silver;
Private Collection

brought to America the concept of more informal dining as it began to prevail in late seventeenth-century culture at all levels of society. At that time it became fashionable for family and close friends to dine in small dining rooms where the respective rank of those seated at table was not an issue; hence, oval (or round) dining tables came into use.

Desks also made a strong appearance in America for the first time in this era. New York and Philadelphia cabinetmakers made fall-front desks (No. 103). This form, which Thornton describes as the one most common for desks in Europe during the seventeenth century,[44] first evolved in Spain as a fall-front desk called an *escritorio*. (Interestingly, both the fall-front desk and the elaborate lacquer cabinets and Carolean chests-on-stands that led to the baroque high chests of drawers have their roots in the Spanish *vargueño*.) The earliest Philadelphia inventory reference to it may be the "scutore" among Philadelphia merchant James Claypoole's belongings in 1688.[45] Beatrice Garvan has published a detailed comparison of the 1707 Philadelphia writing cabinet by Edward Evans (Fig. 77)—the earliest signed and dated piece of American cabinetwork—and a nearly identical English desk by John Guilbaud of 1695.[46] In a more general sense, American fall-front desks are similar to the built-in writing cabinet of cedar in the 1670s library at Ham House.[47] Slant-top desks seem to be the formal result of affixing slant-top, portable desks—formerly placed on stands, tables, or chests—to chests of drawers. Richly veneered examples were made in Boston cabinet shops (Fig. 78). Much rarer in America is the full-desk-and-bookcase form. A Philadelphia example, by D. John, though late (c. 1720), is the most fully developed American expression of this baroque form, with its double-arch top and mirrored doors (No. 108). English japanned desks of very similar design were owned by the Bowdoin family of Boston and by Sir Danvers Osborn, royal governor of New York (Fig. 79).[48]

Setting mirror glass into architectural interiors was a startling innovation of French architecture in the 1600s. Daniel Marot helped to spread this fashion in rooms he created in Holland and England for the display of Queen Mary's oriental porcelain and in his designs published in the 1690s. In America the introduction of mirror glass in interiors seems to have been limited to the very occasional use of mirrored doors in bookcases and to the more prevalent occurrence, at least in wealthier households, of looking glasses, which were hung over dressing tables, over chests of drawers, and elsewhere.

The typical looking glass associated with the William and Mary style in America is a square, convex-molded frame surmounted by a half-round cresting, even though such frames actually belong to an earlier phase of the baroque. Taller molded frames with polyarched tops are more appropriately in the spirit of the true William and Mary style. Such looking glasses, however, appear to date no earlier than 1710 in America. An English looking glass undoubtedly influenced by designs of Daniel Marot was owned by Pieter Schuyler, first mayor of Albany and Indian Commissioner of New York (No. 93).[49] The presence of such a looking glass in American households testifies to the quality of stylish interiors possible in America and encourages us to consider what a complete William and Mary style interior in America must have been like.

These looking glasses were introduced into fashionable interiors newly adorned with fully wood-paneled walls, which would have glowed by day in the light shining through sash windows, larger than the mullioned, casement ones of earlier houses, or by night, in the softer, flickering light cast by candles. The looking glasses hung over or near furniture whose flat surfaces, whether of veneered or solid expensive woods, were similarly reflective. Along the walls, or variously dispersed in the middle of the rooms, were slender chairs and tables. Turned symmetrical patterns of vases, rings, and balls and, in the case of chairs, deeply carved scrolls caught the light and glistened at their high points and disappeared into the shadows at their edges. Into this chiaroscuro environment colonists introduced gadrooned silver, gadrooned or baluster-stemmed glasses (Fig. 80 and No. 58), white or polychromed Delft vessels with paneled decoration (No. 199), and fine colorful textiles (No. 157), all of which gave the American baroque interior its full drama.

Within this setting, perhaps the most dramatic furniture of the William and Mary style is decorated with japanning, a simplified imitation of oriental lacquerwork (No. 174) made not only in Holland and England but also in America, specifically Boston and New

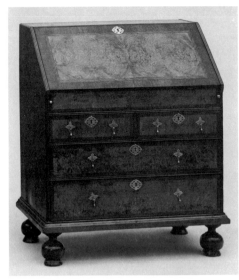

Figure 77. Fall-front writing cabinet; Philadelphia, 1707; Edward Evans (1679–1754); walnut, white cedar, white pine; Colonial Williamsburg Foundation, Williamsburg, Virginia

Figure 78. Desk; Eastern Massachusetts, 1700–30; olive wood veneer, walnut banding, walnut, poplar; The Metropolitan Museum of Art, New York, Gift of Mrs. Russell Sage, 1909

Figure 79. Desk and bookcase; England, c. 1700; japanned oak and pine; The Metropolitan Museum of Art, New York, Gift of James DeLancey Verplanck and John Bayard Rodgers Verplanck, 1939

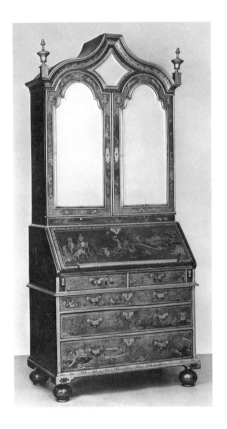

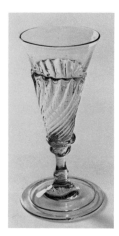

Figure 80. Wineglass, descended in the Sayward family of York Harbor, Maine; perhaps purchased originally by Joseph Sayward (1681–1741); England, 1690–1710; colorless lead glass; The Society for the Preservation of New England Antiquities, Boston, Massachusetts

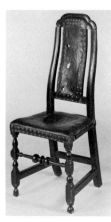

Figure 81. Leather side chair; Boston, 1725–40; maple, oak, original leather upholstery; Wilton House Museum, Richmond, Virginia; Property of the National Society of Colonial Dames of America in the Commonwealth of Virginia

York. Philadelphians certainly owned japanned objects, although no examples remain that seem to have been made there. Japanned furniture did not lose its popularity with the decline of the William and Mary style, but continued to enliven forms of the succeeding style.

As in Holland and England, the William and Mary style did not end in America with the reigns of these monarchs. Certain critical formal changes mark the passing of the baroque and the emergence of the early Georgian style in the decorative arts. In furniture such changes include replacement of the turned, trumpet-shaped leg with the cabriole leg and the introduction of the curved chair back in lieu of a straight one.

The accounts of Boston upholsterers Thomas Fitch and Samuel Grant once again provide specific dates for these critical formal changes in Boston. In 1722 Fitch began selling what he called crooked-back chairs.[50] These represented a new phase in the production of "Boston chairs," which Fitch and other Boston craftsmen continued to make and export during the next two decades (Fig. 81). In 1730 Grant sold a couch frame with "horsebone feet," presumably a cabriole leg with a notch near the bottom of its back resembling the indentation just above a horse's hoof. The previous year Grant had sold an upholstered chair with a "New fashion round seat,"[51] which would also denote the new style. Clearly, therefore, by the late 1720s, the William and Mary style had become outmoded in Boston. In England ten years earlier (1718) Richard Roberts had supplied "cane chairs with Bended backs" to the Lord Chamberlain. This new cane chair was undoubtedly exported to America and served as a model for new design elements.[52] Benno Forman has conjectured that this new style was slow in coming to Boston because of that city's entrenched woodworking establishment, which began with John Brocas. He also questions whether English furniture historians have dated objects in the new style too early.[53] The work of Edward S. Cooke, Jr., however, leads us to an earlier date for the appearance of a new style in Boston. Cooke has carefully documented a walnut-veneered chest-on-chest as the work of an English-trained cabinetmaker working in Boston (Fig. 82) perhaps as early as 1715. Three English cabinet-makers capable of making this chest-on-chest—William Howell, William Price, and Thomas Robinson—began work in Boston around this date. Just as in the 1690s such London-trained craftsmen as John Brocas brought the William and Mary style to Boston, so the appearance of these men provides a logical date for the introduction of the Georgian style. Cooke further reminds us: "There was another period of intense material Anglicization in the 1710s, probably brought about by the increased scale of Boston's commerce in the early eighteenth century and the alliance between Governor Dudley and the merchants. The perceived economic opportunities attracted numbers of English-trained craftsmen who answered the growing merchant class's desires for London-style objects."[54]

In silver, a new preference for unadorned forms marks the change in style. Three plain two-handled cups, two dated 1714 and one dated 1717, made by Boston silversmith John Dixwell for three Boston churches, may result from Dixwell's impression of the new plain style that he formed while in England in 1710. Faceted candlesticks fashioned by John Coney in 1716 for presentation to Harvard tutor Henry Flynt, Coney's plain two-handled covered cup (also with Flynt's arms and dated 1718), and his equally monumental but restrained monteith made for the Livingston family of New York (Fig. 83) all show that this great master silversmith of the baroque became a master of the new style. These documented silver objects demonstrate that by 1715 a new style had come to Boston—a style in which form took precedence over ornament. It is also noteworthy that Coney's clients for this new look were New Yorkers as well as Bostonians. Still to be pursued is further confirmation of the end of the baroque and the beginning of the Georgian style in New York and Philadelphia.

Clearly, however, the mid-1690s to about 1715 was a time of intense development in the New World. It was a period of rapid social and political adaptation when American colonists emulated the current English style, which connoted power and status. For their style-conscious clientele, American craftsmen produced furniture and silver equivalent in taste and quality to the designs made by London craftsmen for comparable English clients. Bold and orderly forms, rich surfaces, and robust ornament mark this era of assertive classicism in America.

Figure 82. Chest on chest; Boston, 1715–25; black walnut, burl walnut veneer, Eastern white pine; Museum of Fine Arts, Boston, Gift of a friend of the Department of Decorative Arts and Sculpture and Otis Norcross Fund

Figure 83. Monteith; Boston, 1705–10; John Coney (1655/6–1722); silver; Franklin Delano Roosevelt Library, Hyde Park, New York

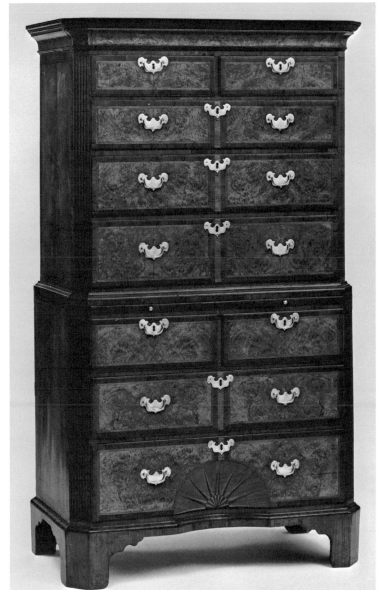

Notes

The readers of this essay will quickly discover my substantive indebtedness to the published scholarship of Benno Forman. His meticulous research into the furniture of this era and his analysis of it have laid the groundwork on which all future study must be based. I also am grateful to Patricia E. Kane, Robert F. Trent, and Edward S. Cooke, Jr., for their sound advice in this project.

1. Peter Thornton, *Seventeenth-Century Interior Decoration in England, France and Holland* (New Haven and London, 1978), 3.
2. Wayne Craven, *Colonial American Portraiture* (Cambridge, Mass., 1986), 107.
3. Abbott Lowell Cummings, "The Domestic Architecture of Boston," *Archives of American Art Journal* 9:4 (May 1971): 10.
4. Benno M. Forman, "The Chest of Drawers in America, 1635– 1730. The Origins of the Joined Chest of Drawers," *Winterthur Portfolio* 20:1 (1985) 20.
5. Benno M. Forman, "Furniture for Dressing in Early America, 1650-1730: Forms, Nomenclature, and Use." *Winterthur Portfolio* 22:2/3 (1987): 159.
6. Benno M. Forman, "Urban Aspects of Massachusetts Furniture in the Late Seventeenth Century," in John Morse, ed., *Country Cabinet Work and Sample City Furniture* (Charlottesville, Va., 1970), 25.
7. Cathryn J. McElroy, "Furniture in Philadelphia: The First Fifty Years, " in Ian M. G. Quimby, ed., *American Furniture and Its Makers, Winterthur Portfolio* 13 (1979): 69, 74.
8. Among the belongings of William Cox of New York City inventoried in 1689 was "a chest of drawers and frame." Unpublished manuscript by Peter Hammel, the Henry Francis du Pont Wintertur Museum Manuscript Library.
9. Forman, "The Chest of Drawers in America," 26.
10. Ibid.
11. To date only one object bearing the signature "Brocas" has appeared. It is a cabriole-leg, japanned high chest of drawers. The signature may be that of John Brocas, working 1696-1740, or his son John Brocas, Jr., working 1728-1751. See *Antiques* 127 (1985): 4.
12. Forman, "The Chest of Drawers in America," 21.
13. R. W. Symonds, "English Cane Chairs—Part I," *Connoisseur* 127 (March 1951), 13. Symonds cites a petition by the chairmakers to Parliament to add a clause to the Woolen Manufacturers' bill.
14. Benno M. Forman, *American Seating Furniture 1630–1730: An Interpretive Catalogue* (New York and London, 1988), 232.

15. Ibid., 229.
16. Ibid., 234.
17. Ibid., 241.
18. This chair, like the Philadelphia one and many of the Boston chairs, has what American furniture historians have called a "Spanish foot." Benno Forman did not believe this foot appeared in Northern Europe until late in the seventeenth or early in the eighteenth century, when the idea of a back whose crest rail symmetrically echoed the bottom back rail, as in the Spanish chair, became popular as well. No one has satisfactorily explained the origin of this foot, which is so closely identified with the William and Mary style in America and England. Perhaps, it "represents nothing more romantic than an architectural bracket of the type often illustrated in the engraving of such designers as Jean Le Pautre or Jean Marot or a refinement of the earlier termination, sometimes treated animalistically and sometimes as a florative scroll, already ubiquitous in trestle-footed Italian forms and Spanish furniture in the Italian idiom." Forman, *American Seating Furniture*, 232–23.
19. Jonathan L. Fairbanks and Robert F. Trent, *New England Begins: The Seventeenth Century*, exh. cat., Museum of Fine Arts (Boston, 1982), 288.
20. Forman, *American Seating Furniture*, 282, cites "Account-books of Treasures of Harvard College, 1669–1752," 353, and Thomas Brattle's Journal, 1673–1713, 50.
21. Quoted in Jonathan L. Fairbanks and Elizabeth Bidwell Bates, *American Furniture 1620 to the Present* (New York, 1981), 77.
22. Russia leather was "a specially treated calf or goat skin that was beaten and soaked in seal oil after it had been cured in vegetable distillates. The surface of Russia leather was scored in a faint diamond pattern, which helped the seal oil to penetrate the leather more effectively." Fairbanks and Trent, *New England Begins*, 288.
23. Forman, *American Seating Furniture*, 281.
24. McElroy, "Furniture in Philadelphia," 66.
25. Forman, *American Seating Furniture*, 295.
26. Patricia E. Kane, *300 Years of American Seating Furniture* (Boston, 1976), 56.
27. Forman, *American Seating Furniture*, 292.
28. Ibid., 289.
29. Ibid., 294.
30. A. L. den Blaauwen, ed., *Dutch Silver 1580–1830* (Amsterdam, 1979), 176.
31. This sort of decoration, however, does appear on a unique Boston tankard made by Timothy Dwight (1654–1691/2). Kathryn C. Buhler, in *Colonial Silversmiths, Masters & Apprentices* (Boston: Boston Museum of Fine Arts, 1956), 17, describes the ornament as "British-derived yet essentially Dutch."

32. Milo M. Naeve, "Dutch Colonists and English Style in New York City: Silver Syllabub Cups by Cornelius Kierstede, Gerrit Onckelbag, and Jurian Blanck, Jr.," *American Art Journal* 19:3 (1987): 40–53.

33. Graham Hood, *American Silver: A History of Style, 1650–1900* (New York, 1971), 65.

34. Barbara Ward, "The Craftsman in a Changing Society: Boston Goldsmiths, 1690-1730," Ph.D. diss., Boston University, 1983, 10.

35. Ibid., 16.

36. Ibid., 184.

37. Barbara McLean Ward, "Boston Goldsmiths, 1690-1730," in Ian M. G. Quimby, ed., *The Craftsman in Early America* (New York and London, 1984), 144.

38. Forman, "Urban Aspects of Massachusetts Furniture," 23–24; and McElroy, "Furniture in Philadelphia," 68.

39. Brock Jobe and Myrna Kaye, *New England Furniture, The Colonial Era* (Boston, 1984), 180.

40. Forman "Urban Aspects of Massachusetts Furniture," 24; and McElroy, "Furniture in Philadelphia," 68.

41. McElroy, ibid., 71.

42. Forman, "Urban Aspects of Massachusetts Furniture," 22.

43. I am indebted to Patricia E. Kane for this observation.

44. Thornton, *Seventeenth-Century Interior Decoration*, 312.

45. McElroy, "Furniture in Philadelphia," 75.

46. *Philadelphia: Three Centuries of American Art* (Philadelphia, 1976), 14–15.

47. Thornton, *Seventeenth-Century Interior Decoration*, 299.

48. Dean A. Fales, Jr., "Boston Jappaned Furniture," in *Boston Furniture of the Eighteenth Century* (Boston, 1974), 57, figs. 46, 47.

49. I am indebted to David Barquist for bringing this looking glass to my attention.

50. Forman, *American Seating Furniture*, 286.

51. Brock Jobe, "The Boston Furniture Industry 1720–1740," in *Boston Furniture of the Eighteenth Century* (Boston, 1974), 42.

52. R. W. Symonds, "English Cane Chairs–Part II," *Connoisseur* 127 (June 1951): 87.

53. Forman, *American Seating Furniture*, 302.

54. Edward S. Cooke, Jr., "The Warland Chest: Early Georgian Furniture in Boston," *Maine Antique Digest* 15:3 (March 1987): 11c–13c.

Printed Sources for the William and Mary Style

by Elaine
Evans Dee

The development of printmaking techniques in the Renaissance and the growing demand by a widespread audience for designs in the latest fashion encouraged the making of ornament prints that could serve as patterns for artisans to follow. Pattern designs of every conceivable type were passed from hand to hand or shop to shop and often traveled long distances from their place of origin. The seventeenth and eighteenth centuries saw a proliferation of such prints after works by leading designers or by artists wishing to achieve that status.

During Louis XIV's reign, as France rose to prominence in the arts, the publishing of prints kept pace with French artistic accomplishments, with the result that leadership in producing ornament prints passed from Italy to France. Jean-Baptiste Colbert (1619–1683), Louis XIV's able finance minister and superintendent of the royal building works, was aware that prints were the means of conveying to the world the splendors of his monarch's enterprises as well as recording them for future generations. Colbert issued the following instructions on behalf of the king: "It is necessary to set down in engraving for posterity . . . the emblems and medals for the King, the busts and statues of S.M., the pictures, the carrousels, tapestries, royal houses and generally everything else of the same nature. . . ."[1] It was Colbert's intention to assemble the engravings into an anthology for each year under the title "Cabinet du Roi." Every ten or twelve years the prints were to be gathered into volumes by subject. Through Colbert's influence, engravers were awarded an independent status as artists, under the protection of the king. Because royal patronage provided ample encouragement to the profession, printmaking flourished in France. With the nation's prosperity during the first thirty years of Louis XIV's reign and the brilliance of the court, the great projects of building and decoration were far too extensive to permit the engravers to achieve a complete record of all the palaces, gardens, monuments, and art treasures, but considerable progress was made. To be commissioned to contribute to the Cabinet du Roi indicated official recognition of artistic competence. Among those chosen, three artists in particular—Jean Le Pautre, Pierre Le Pautre, and Jean I Berain—are notable because through their prints they exerted the greatest influence on Northern European design.

Jean Le Pautre (1618–1682) was the eldest member of a family of printmakers. He is considered to be one of the most important figures in disseminating the Louis XIV style throughout Europe—to some extent, perhaps, because of his enormous output. More than two thousand prints are known from his hand on a broad range of subjects: chimneypieces, ceilings, wall decoration, furniture, trophies, vases, friezes, tapestry, and garden ornament. He was remarkably skillful as an etcher, reputedly incising his compositions directly onto the plate without benefit of preliminary drawings. His prints are characterized by the spirited and vivacious handling of line and the richness and precision of the detail. The sumptuousness of the etched engraved ornamentation suitably represents the grandeur of Louis XIV design.

Two of Jean Le Pautre's sons became printmakers; the elder, Pierre (1659–1716), achieved the greater success both as a printmaker and as a designer. He attended to many of the same subjects that had preoccupied his father and also produced a large number of prints that relate specifically to the architecture of Versailles and the accomplishments there of the chief architect, Jules Hardouin-Mansart. Pierre Le Pautre entered the regular employ of the buildings office in 1699 to work under Hardouin-Mansart, who had just been elevated to the role of superintendent. Le Pautre held the position of *dessinateur et graveur* until his death in 1716. His training under his father had equipped him with a variety of skills; according to the biographer Pierre-Jean Mariette, he was accomplished in "architecture, ornament, perspective, and generally all the different aspects of design."[2] Mariette characterized his facility at etching as "marvelous." Less elaborate and more focused on specific aspects of each subject, Pierre Le Pautre's compositions are easily distinguished from those of his father. The overall effect is lighter, the forms more slender in proportion, and the relief slighter.

Jean I Berain (1640–1711), one of the most brilliant and versatile designers of all time, was an obvious choice to receive commissions for the Cabinet du Roi. His extraordinary talents were rewarded even more when he was appointed the king's chief designer and the head of the office of the *menus plaisirs*, where the spectacles and ceremonies of the court were organized. He also designed costumes and stage settings for the opera. After assuming the

Figure 84. Design for
a clock, plate 4 from
*Nouveaux livre de boites
de pendulles de coqs et
etuys de montres et
autres necessaire au
Orlogeurs;* The Nether-
lands, 1705–1712;
Daniel Marot
(1661–1752); etching,
printed in red ink;
Cooper-Hewitt Mu-
seum, New York, Gift
of the Council,
1921-6-352 (77)

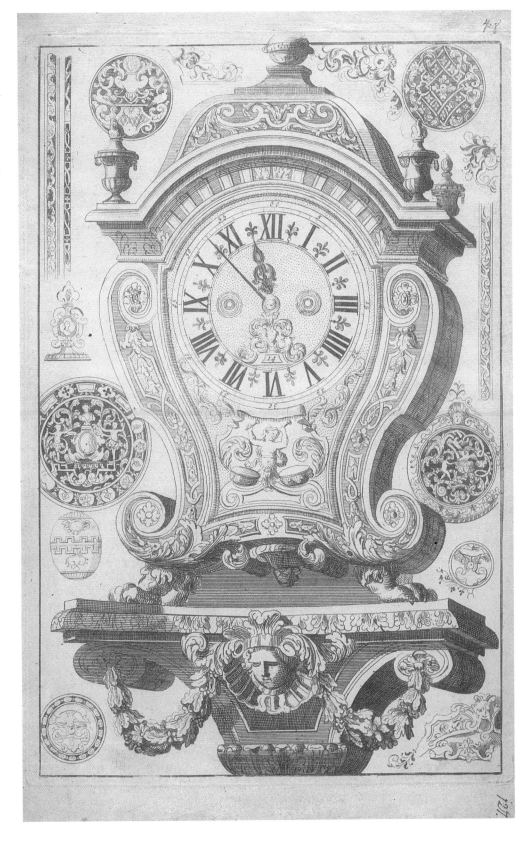

post of designer to the king, Berain turned over to others the task of engraving or etching his numerous designs. He had begun his career as a gunsmith, the profession practiced by his father and other relatives. In 1659, when he was just nineteen years old, he published his first series of prints, entitled *Diverses pièces très utiles pour les arquebuzières*. Designs for locks, silver tableware, furniture, tapestries, ceilings, chimneypieces, carriages, mausoleums, capitals, boats, and garden parterres followed. Most influential in the area of interior decoration, however, were the printed sheets of ornamental panels with graceful figures, animals, and grotesques—some playing music and dancing, moving rhythmically and joyfully within stylized vines, acanthus, palmettes, and trees. Patterns of bands or strapwork integrated and contained the diverse elements of the compositions that he developed in seemingly endless variations.

Out of this milieu emerged the printmaker and designer Daniel Marot, the central figure in both the creation and dissemination of the William and Mary style. He was born in Paris, the eldest son of Jean I Marot (1619?–1679), a well-established architect and engraver. Jean Marot had published a two-volume series of topographical prints on architecture, the first known as *Petit Marot*, published between 1654 and 1660, and the second, called the *Grand Marot* because of its larger format, published after 1670. (A 1751 edition of the *Grand Marot* published by Jombert incorporates prints by Daniel Marot, as well.) As his father's pupil and assistant, Daniel had not only the advantage of his father's tutelage, but also ready access to other Parisian printmakers. From his father, Daniel had learned a technique of etching characterized by accuracy and refinement, but in style his work was strongly influenced by Jean Le Pautre's prints. The exuberance and plasticity of Marot's etched lines recall Le Pautre's technique.

Marot was also familiar with the work of Pierre Le Pautre, who was roughly his contemporary. Fiske Kimball has pointed out that Marot drew upon Pierre Le Pautre's work for ideas.[3] The title of Marot's series *Nouvelles cheminees a panneaux de la glace de la manière de France* is derived from Le Pautre's *Nouvelles cheminés à panneaux de glace executées dan quelques hôtels de Paris.*

The work of Jean I Berain had a lasting influence on Marot. Before leaving France in about 1685 because of his religious beliefs, Marot had executed several prints after designs by Berain. The fact that he received the commission to make prints after the most important designer in France at that time indicates that Marot's reputation as a fine professional printmaker had already been established, in spite of his youth. After moving to Holland and England, Marot continued to keep informed of Berain's latest designs through the circulation of his prints all over Europe. Berain's flat, interlacing bandwork enlivened with crisply swirling arabesques and grotesques was adapted by Marot, but the motifs were more effusively combined under Marot's etching needle. The bandwork diminished and became part of the ornament within the composition rather than forming a framework around it.

In Holland, while expanding his activities as an interior designer and architect, Marot continued to make prints, apparently living in The Hague and in Amsterdam. One of his first prints to appear in Holland records a magnificent ball held in honor of the Prince of Orange's birthday in 1686, two years before the prince became William III of England (No. 8). It is significant that Marot was already employed by the house of Orange very soon after arriving from France. Another group of prints of a topical nature related to the fireworks display celebrating the success of the Dutch armies who had defended their country against the French and the Spanish. A large print dated 1702 showed the glorious event taking place, and a series of smaller prints recorded the appearance of the sides of the fireworks machine, decorated with scenes of individual battles. More consistent with Marot's orientation toward architecture and ornament were the prints he published of his architectural projects, particularly at Het Loo and De Voorst. Following the usual practice of the time, these were issued in folios of six plates.

In 1703, soon after the death of William III, the first large collection of Marot's prints was published by Pierre Husson in The Hague under the title *Oeuvres de Sr. D. Marot Architecte de Guillaume III / Roy de la Grande Bretagne contenant plusieurs pensez utile aux Architectes, Peintres, Sculpteurs, Orfevres, Jardiniers & autres. . . .* A broad range of topics was

Figure 85. Design for garden urn; The Netherlands; Daniel Marot (1661–1752) (reproduced from P. Jessen, *Das Ornament des Daniel Marot* facsimile edition [Berlin, 1892], pl. 194); Cooper-Hewitt Museum, New York, Gift of the Council, 1921-6-540

addressed in more than a hundred prints. Bound copies in existence today are not consistent in the total number; a copy in the Musée des Arts Décoratifs in Paris contains 162 plates. The collection encompassed architecture (buildings, gates, and triumphal arches), gardens (parterres, rooms, and vases), trelliswork, fountains, sculpture, tombs, stage designs, interiors (including carved or painted wall and stairwell paneling, and ceilings, chimneypieces, and moldings), furniture, metalwork, and textile and embroidery designs. Inventive, precise, and explicit in their wealth of detail, Marot's prints would certainly have been useful to craftsmen and designers seeking guidance in the court style of William and Mary.

The collection was republished in Amsterdam under Marot's own imprint in 1712 and expanded to include more than two hundred thirty plates. Copies were made—a testimonial to the popularity of Marot's designs. A version with a title page in Dutch (*Werken van D. Marot Opperboumeester van Zyne Maiesteit Willem den Derden . . .*) and Latin is not dated and is printed on paper of inferior quality; the images are less refined than in the original and the images and plate mark are slightly smaller. A copy in the reverse and also smaller in format was made by Jeremiah Wolff and Augustus Wind in Augsburg in the eighteenth century. In the following century there was again sufficient interest in the work of Marot for the publication of a catalogue raisonné of his prints (André-Denis Bérard, *Catalogue de toutes les estampes qui forment l'oeuvre de Daniel Marot architecte et graveur français*, Brussels, 1865). Bérard lists 290 prints altogether. A large facsimile volume of 264 plates with a text by Peter Jessen was published by Ernst Wasmuth in 1892 in Berlin (*Das Ornamentwerk des Daniel Marot*).

Some Marot plates of vases and clocks were printed in Paris in red as well as black ink by the printing firm of Bonnart au Coq (Fig. 84). The Bonnart firm was founded in 1678 and operated on the rue Saint-Jacques under the "rooster" insignia for over a century. While it seems likely that these plates were printed before Marot left Paris in 1685, the artist apparently retained the plates in his possession, as these subjects appear in the 1712 edition published by Marot in Amsterdam. That he continued the practice of printing in both red and black inks in Amsterdam is documented by his etching of Baron de Coehorn's tomb, which is printed in red ink in some impressions and in black ink in others and inscribed *Amsterdam 1705*. Marot seems not to have produced prints after about 1718; for the next twenty years architectural commissions presumably demanded his full attention. Moreover, a new style was developing in France—the rococo—and Marot's designs, no longer in the latest fashion, were not in as great demand.

While Daniel Marot's prints mainly document the environment in which William and Mary and their court moved, the Dutch artist Romeyn de Hooghe (1645–1708) was the official chronicler through engraving and etching of important events in the history of the court. He also made etched portraits of the king. De Hooghe's work can be categorized into four subject areas: historical scenes, portraiture, topography, and purely imaginary capriccios. He began to record the memorable feats of William III as early as 1672, when the future king was still in Holland. De Hooghe remained a loyal reporter of the court throughout the king's entire career, depicting William's military victories, his comings and goings between England and Holland, coronations, funerals, and other significant events. De Hooghe's contribution to the fame and immortality of William III was recognized, as the king granted the artist a stipend with the title of commissary and supervisor of a mining district in the Netherlands. Even though de Hooghe could not have been present at all of the occasions preserved in his compositions, the prints are extremely useful in their suggestions of how the king's surroundings might have looked. He must have based his prints relating the death and funeral of Queen Mary on drawings made by others, since he himself was not in England at the time, but the bed hangings, furniture, and ceiling painting of the room as he created it supply accurate information regarding the style of the period (No. 9).

De Hooghe was active as a book illustrator from as early as 1667. He was fascinated by all facets of life in the Netherlands and commented on them not only as an artist but as an author as well. His twenty-page book entitled *Mirror of State of the United Netherlands . . .*, published in Amsterdam in 1706, eulogizes the idea of equality as a wonderful and attractive principle for the people in these provinces. He lists what a substantial Dutch household

might contain—linens, porcelain, paintings and drawings, fine books, velvets, silver for table, tea and coffee services, brass and pewter—but indicates that flowers might be too expensive for most. His combination of talents as an accomplished artist, a master of etching techniques, an acute observer and a well-informed intelligence enabled him to supply posterity with a clear view of his world. De Hooghe's illustrations for the *Wondertoneel der Nature* describe a typical seventeenth-century collector's cabinet with its collections of natural specimens, tools, antiquities, and an ample variety of other objects of every sort (No. 211). Most collector's cabinets also included prints, usually divided between those by great masters and those that were desirable because of their subject matter.

Just as late seventeenth-century decorative arts and ornament prints traveled from one country to another, so did many printmakers themselves. Simon II Gribelin (1661–1733), a member of a family of goldsmiths, clockmakers, and engravers, emigrated in about 1680 from Blois to London, where he found that his special skills were in demand. In his career he combined decorative engraving on metal and print making. In 1682, he published *A Book of Sevrall Ornaments*, with twelve plates, and in 1697, *A Book of Ornaments Usefull to Jewellers, Watchmakers and all other Artists*, which was reworked and renumbered in 1700. These volumes were apparently popular in England; in 1704 Gribelin issued still another set of the designs compiled into fifteen plates titled *A New Book of Ornaments Useful to All Artists, dedicated to the Honourable Colonel Parsons*. The book was still being advertised and reprinted years after the artist's death (No. 40). The French tradition of goldsmith's ornament lingers in Gribelin's designs. Close parallels can be drawn between his work and the prints of Jean Vauquer (c. 1650–1670) who worked in Blois and in Paris, and Jean-Louis Durant (1654–1718). Intricate, elaborate, tightly interlaced vines and leaves around putti and herms against black backgrounds characterize the work of all three designers.

Jean Tijou (active 1689–1712), a designer of wrought-iron work who was not an engraver, emigrated to England from Saint-Germain-en-Laye, probably in the 1660s. He found a ready market for his work in England, where the damp climate made wood a less practical material for railings and gates than iron. Records of payments show that Tijou was supplying wrought-iron screens and gates at Hampton Court in the 1670s. He is credited with revolutionizing the design of wrought-iron work, which became much more ornamental than it had been previously in England. Although it has been demonstrated that most of his designs derive from earlier French sources, especially the work of Hugues Brisville engraved by Jean I Berain in 1663,[4] Tijou's own publication reveals the elegance, elaboration, and sheer beauty of his designs. The long title provides an excellent example of the purpose: *A new Booke of Drawings Invented and Desined by John Tijou Containing severall sortes of Iron worke as Gates, Frontispieces, Balconies, Staircases, Pannells etc. of which the most part hath been wrought at the Royall Building of Hampton Court and to severall persons of Qualityes Houses of this Kingdome all for the Use of them that will worke Iron in Perfection and with Art*.

Bernard Picart (1673–1733) journeyed even more extensively, working not only in his native France but also in Amsterdam, England, and Germany. Although not a Huguenot himself, he found Holland a stimulating environment for an engraver because of the influx of French Protestant designers and craftsmen who were noted for their industry. Picart's work included book illustration and prints after paintings, but his name appears most frequently as an engraver of decorative arts and ornament subjects (No. 36).

Picart was also involved as an engraver in a publishing project initiated by the Bonnart printing firm in Paris. Since dress as a symbol of social position was a major concern of seventeenth- and eighteenth-century society, there was a need to be informed of the latest fashion for every occasion, season, and time of day. As in other areas, the court of Louis XIV led the way. Henri Bonnart's innovative idea was to publish costume prints modeled by prominent personages of the court rather than by anonymous mannequins. Accessories and appropriate surroundings provided an added dimension. This practice proved to be extremely popular and the prints sold well. The work was carried on by Henri Bonnart's four sons—Henri, Nicolas, Jean-Baptiste, and Robert—and the prints of all four were published indiscriminately as a Bonnart family production. They employed several artists besides Picart, among them Jean de Dieu, called Saint-Jean, and F. Ertinger. Collections of the prints

Figure 86. Plate 3
from *A New Book of
Ornaments*; London,
1704; Simon Gribelin
(1661–1733); engrav-
ing; Cooper-Hewitt
Museum, New York,
Purchase in Memory
of Mrs. A. Murray
Young, 1946-31-1

appear under the title *Costumes de la Court Louis XIV, Personnages de Qualité*. The Bonnart idea was widely imitated, in particular by Nicolas Arnoult, Jean Mariette, and Antoine Trouvain in France, and in Holland as well (No. 142).

A number of prints by Jean de Saint-Jean cross the line from fashion print to genre. In these prints, the surroundings in which the fashionable lady washes her feet, drinks coffee, or plays cards are given as much importance as the figure (No. 146).

It is obvious how prints contribute to our knowledge and understanding of the development and characteristics of a particular style of ornament and decoration. Michel de Marolles (1600–1681), who formed a magnificent, comprehensive collection of prints that was purchased by Jean Colbert for Louis XIV in 1667, summarized their usefulness: "Prints, well selected and well ordered, will conveniently supply information, not only about all the sciences and all the fine arts, but about everything imaginable."[5]

Notes

1. Paris, Bibliothèque Nationale Cabinet des Estampes, pet. fol. Y 159–160, quoted in Jean-François Méjanès, "Le Cabinet du roi et la collection des planches gravés de Louis XIV," in *Collections de Louis XIV* (Paris: Orangerie, 1977–78), supplement, 2.

2. *Abecedario* (Paris, 1854–56), 188.

3. *The Creation of the Rococo Decorative Style* (New York, 1980), 57.

4. *Country Life* 149 (1971): 182–3.

5. Michel de Marolles, *Catalogue de livres, d'estampes et de figures en taille-douce* . . . (Paris, 1666), quoted in A. Thibaudeau, "Lettre à l'auteur sur la curiosité," in C. Blanc, *Le Trésor de la Curiosité* (Paris, 1857), 1:XXXIX.

Courts and Colonies

The William and Mary Style in Holland, England, and America

Authors of catalogue entries:

EED Elaine Evans Dee
PMJ Phillip M. Johnston
DSS Deborah Sampson Shinn
LRS Linda Rosenfeld Shulsky

Dimensions are given in centimeters; height precedes width precedes depth or diameter.

The following objects will be shown only in New York: 52, 85, 89, 145, 211.

The following object will be shown only in Pittsburgh: 50.

The following object is not presented in the exhibition: 152.

The William and Mary Style

The Glorious Revolution of 1688 that brought William of Orange and Mary Stuart to the English throne was also responsible for a renewed wave of artistic influences from the Continent. The court of Louis XIV at Versailles, with its extravagantly laid-out palace and gardens, its rich baroque furnishings, and its highly formal court etiquette, was the model for monarchs throughout the rest of Europe in the late seventeenth century.

Daniel Marot, the French Huguenot designer and architect to William III, was the most important link between the French court style and the William and Mary style. His plans for Het Loo, Hampton Court, and other royal residences in both Holland and England were based on the full baroque styles he had witnessed at Versailles. His oeuvre of more than two hundred prints, including designs for interiors, furniture, gardens, fountains, and pavilions, inspired craftsmen in England, Holland, and the colonies well into the first decades of the eighteenth century.

1 Tapestry with Arms of William and Mary

Brussels, c. 1694–1700
Designed by Daniel Marot (1661–1752), woven by Hieronymous Le Clerc (active 1676–1719)
Wool, silk, metal thread
297 × 231
The Metropolitan Museum of Art, New York, Samuel D. Lee Fund, 1936
References: Mulliner, 1923, pl. 181; Phillips, 1933, 136, no. 2; Pierpont Morgan Library, 1979, no. 58b

Emblazoned with the coat of arms of William and Mary as sovereigns of England, Scotland, and Ireland, this tapestry was originally part of a set of eight woven in Brussels after designs by Daniel Marot. Mars, god of war, and Hercules, William's favorite symbolic embodiment, hold aloft a royal crown against a backdrop of military trophies referring to the king's unceasing war campaigns. The lion and unicorn supporters, *W* and *M* cipher, and badges of the Order of the Garter are among other armorial motifs woven here in gold, silver, and colored threads. The motto of the house of Orange, *Je Maintiendray* (I will maintain), is inscribed on the banner furled under the arms. Other tapestries from this same series show Mars and Minerva seated, and some pieces are signed by Jacques van den Borght, Jan Cobus, and Jan Coenot. Two from the series are presently in the royal collection at Windsor Castle, and three others at the palace of Het Loo in the Netherlands.

The Brussels tapestry workshops, known earlier for their fine figural and floral patterns, followed the fashion for depicting armorial designs and scenes commemorating major battles after such subjects became popular at Louis XIV's tapestry works at the Gobelins. This set was probably based on designs created by Daniel Marot. Trained in the French royal ateliers before emigrating to Holland in 1685, he provided numerous comprehensive schemes of decoration for William and Mary's residences in both Holland and England.

DSS

2, 3 Pair of Portraits of King William III
 and Queen Mary II
 (see pages 92 and 93)

Probably the Netherlands, c. 1690
Unknown artist
Oil on canvas
131 × 105; 130 × 104
Trustees of the National Museums and Galleries on
Merseyside (Lady Lever Art Gallery, Port Sunlight,
England)
Reference: Lady Lever Art Gallery, 1983, 8

Although the artist responsible for this pair
of portraits of King William and Queen
Mary is unknown, the heads were probably
based on the state portraits painted by Sir
Godfrey Kneller in 1690–91 (now at Wind-
sor Castle). The frames that originally
housed the paintings are inscribed *W / Je
Maintiendray* and *M / Dieu et Mon Droit* and
include lion and unicorn supporters; now at
Windsor Castle, they are used as mirror
surrounds.

 Both William and Mary are shown
dressed in lace-trimmed and ermine-lined
raiment, against backgrounds of heavy drap-
ery and beside their crowns and scepters.
The king also wears the chain of the Order
of the Garter, and he rests his hand on his
bejeweled orb, a traditional symbol of royal
status. Such likenesses of the king and
queen were copied many times over and
sent with ambassadors, emissaries, and colo-
nial governors to posts throughout Europe
and the New World.

 DSS

4 Bust of William III

England, c. 1690
Honoré Pelle
Marble
129.5 × 106.6 × 68.5
The Lord Egremont
Reference: Jackson-Stops, 1973, fig. 12

Signed by Honoré Pelle, who also carved a
bust of Charles II in 1684 (now in the
Victoria and Albert Museum), this bust of
William III from Petworth House in Sussex
shows the lively drapery and pose charac-
teristic of French and Italian baroque sculp-
ture. Pelle may also have been responsible
for the massive carved trophies on the
entrance gates at Petworth, originally in the
west forecourt, the designs for which are
close in spirit to the engravings of Daniel
Marot (Jackson-Stops, 1973, 1872).

 DDS

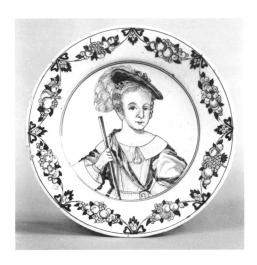

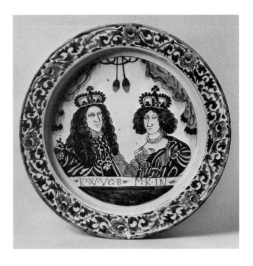

5 Plate with Portrait of William III
 as a Child

Delft, 1658
Tin-glazed earthenware
Diam. 20.5
Rijksmuseum, Amsterdam

The likeness on this plate of William as
Prince of Orange, in bonnet and feathered
hat, was copied from a print by A. de
Grebber, after Gerrit van Honthorst. Other
ceramics, engraved glass, and medals deco-
rated with this same image were especially
popular with Orangist supporters. Born the
posthumous son of Stadholder William II,
William was educated until the age of six-
teen by his mother, Princess Mary Stuart,
and his strong-willed grandmother, Princess
Amalia van Solms, widow of Stadholder
Frederik Hendrik. The fruit and floral
garlands ornamenting the border of this
plate were especially popular motifs during
the middle of the seventeenth century.

DSS

7 Plate with Portraits of William and Mary

Delft, c. 1690
Tin-glazed earthenware
Diam. 34
The Brooklyn Museum, New York, Museum
Collection Fund

Images of William and Mary were popular
decoration for both fancy and simple Delft-
ware pieces. Plates like this one, with its
chinoiserie border pattern and double por-
traits, were made in large quantities in both
Holland and England. The inscription
*KWVGB*MKIN*, for Koning Willem van
Groot Brittannien (King William of Great
Britain) and Maria Koningin (Queen Mary),
suggests a date between their coronation in
1689 and Mary's death in 1694.

DSS

6 Flute Glass

The Netherlands, c. 1670
Colorless nonlead glass, blown and diamond-engraved
45.3 × 11.1
The Corning Museum of Glass, Corning, New York,
Bequest of Jerome Strauss

The engraved ornament on this tall
Netherlandish flute glass, used for ale or
wine, includes a portrait of the Stadholder
William III, a coat of arms, and a wide band
of flowers, birds, and insects. In England,
Williamite glassware, inscribed with pic-
tures of the king and toasts celebrating his
victory at the Battle of the Boyne (1690),
continued to be popular long after his death.

DSS

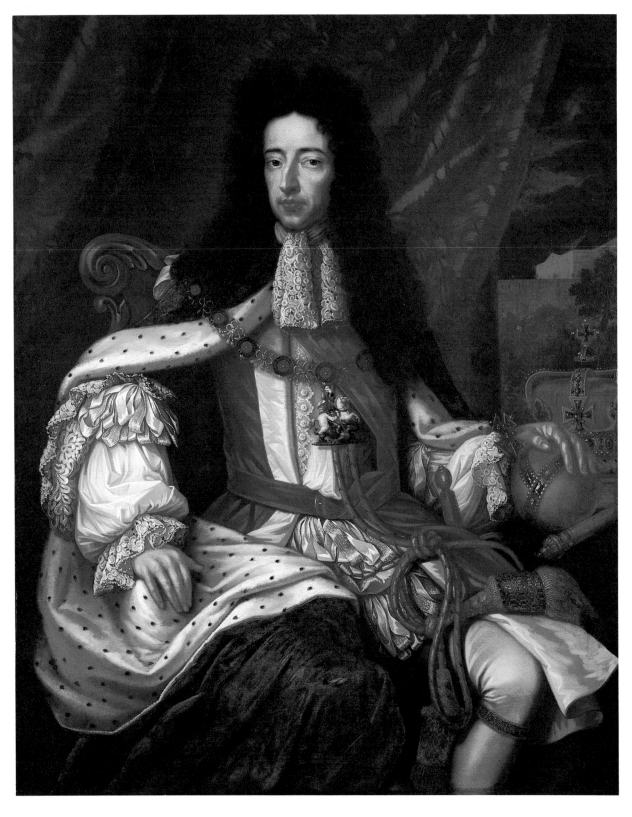

2 Portrait of King William III

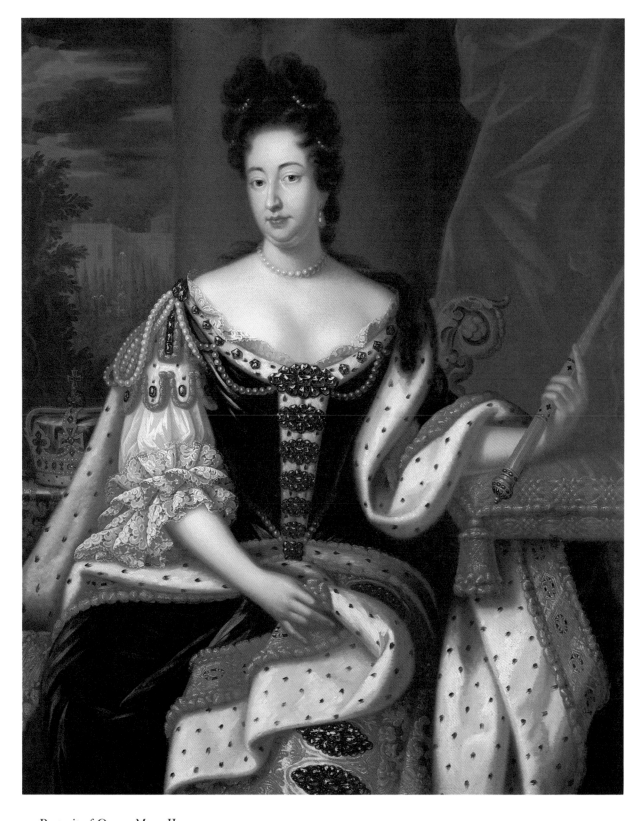

3 Portrait of Queen Mary II

9 Queen Mary Lying in State

The Netherlands, 1694
Romeyn de Hooghe (1645–1708)
Etching
46.4 × 54.6
The Metropolitan Museum of Art, New York, the
Elisha Whittelsey Collection, the Elisha Whittelsey
Fund, 1949
Reference: Landwehr, 1973, 174

8 The Birthday Ball

The Netherlands, 1686
Daniel Marot (1661–1752)
Engraving
81 × 55.9
The Metropolitan Museum of Art, New York, the
Elisha Whittelsey Collection, the Elisha Whittelsey
Fund, 1949

The celebrated Oranjezaal, the setting for
the ball given by Princess Mary in honor of
Stadholder William's birthday, is shown in
this print by Marot. The main hall of Huis
ten Bosch, built by Amalia van Solms near
The Hague in the 1640s, the Oranjezaal was
decorated with scenes from the life of
Stadholder Frederik Hendrik in paintings
by Jacob Jordaens, Caesar Boëtius van Ever-
dingen, and eight other Netherlandish art-
ists. Marot modernizes the composition of
the scene by surrounding it with a thick
classical frame, richly patterned drapes, and
a semicircular balustraded porch with two
figures of Music and a tasseled lambrequin
cartouche. A preliminary drawing for the
print, published by Ozinga, was lost during
World War II.
 DSS

When Queen Mary died suddenly of small-
pox at the age of thirty-two, only five years
into her reign, she was greatly mourned
both by William and by her English and
Dutch subjects. "It is impossible to describe
the desolation which this death has caused
to the whole nation . . . the love which
everyone had for the Queen is indescriba-
ble," wrote the Viennese envoy to London
at the time (Miller, 1974, 173). Her body lay
in state from February 21 until her funeral
on March 5, 1694. In this print by De
Hooghe, King William, who reigned for
another eight years, sits on a throne to the
left of Mary's funeral canopy while loyal
subjects pay their last respects.
 DSS

10 Portrait of Daniel Marot

The Netherlands, c. 1700
Jacob Gole (1660–1737), after James Parmentier
Engraving
17 × 14
Rijksmuseum, Amsterdam
Reference: Hollstein, 1949, 7:205

The French Huguenot designer Daniel
Marot, who had trained in Paris under the
ornemaniste Jean Berain, court designer to
Louis XIV, was the most important link
between the Louis XIV style and the court
style in Holland and England. His work for
William and Mary, first in the Netherlands
and later in England, helped spread French
taste in architecture, interior decoration,
and garden design. His published works,
which featured highly unified schemes of
decoration for state rooms and designs for
elaborate state beds and seating furniture,
continued to influence Dutch and English
interiors well into the eighteenth century.
Marot is shown here in typical baroque
portrait style, wearing a fashionable tall
peruke with flowing curls and surrounded
by an architectural framework draped with
a heavy curtain.
 DSS

11 Design for a State Coach or Sedan Chair
 (see page 96)

The Netherlands, probably before 1695
Daniel Marot (1661–1752)
Pen and black ink; red, yellow, and gray wash;
graphite
34.3 × 25.7
Inscribed at lower right in pen and black ink: *Daniel
Marot fecit*
Cooper-Hewitt Museum, Purchased in memory of the
Misses Hewitt, 1956-15-2
Reference: Smith, 1967, pl. 8

The state coach or sedan chair shown in
Marot's drawing was probably designed for
a member of the state council or for a
foreign ambassador. It is ornamented with a
seated figure of Peace surrounded by a
scrolled cartouche and the coat of arms of
the United Dutch Provinces displayed un-
der an ermine-lined baldachin. The arrange-
ment of allegorical motifs and decorative
female terms, putti, masks, and diapered
backgrounds is very similar to designs for
coaches from the French workshop of Jean
Berain—for example, a coach made for
Charles XII of Sweden (Dee and Walton,
1988, no. 69).
 DSS

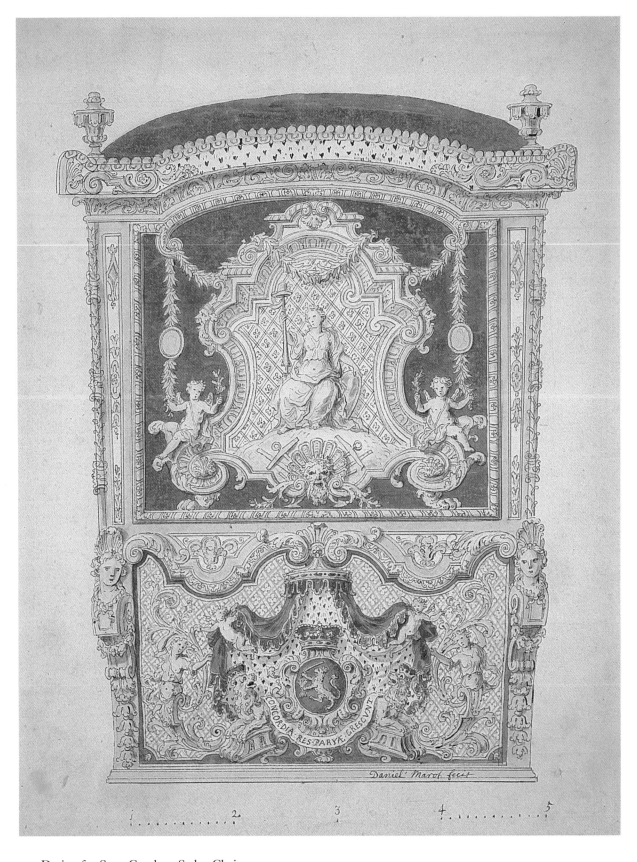

11 Design for State Coach or Sedan Chair

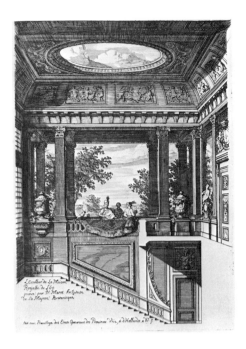

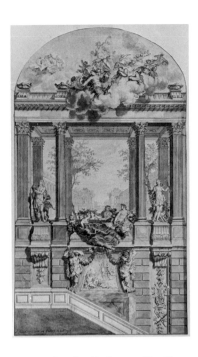

12 Design for Staircase, Het Loo Palace

13 Design for Staircase, De Voorst

The Netherlands, c. 1700
Daniel Marot (1661–1752)
Etching and engraving
27.7 × 19.4
Cooper-Hewitt Museum, Purchase, 1988-4-37
Reference: Pierpont Morgan Library, 1979, fig. 1

The Netherlands, 1700
Isaac de Moucheron (1667–1744) and Daniel Marot
(1661–1752)
Pen and black ink; gray wash; graphite
59.9 × 34.9
Inscribed at lower left in pen and brown ink: *I.
Moecheron inv. et fecit 22 oct 1700*
Cooper-Hewitt Museum, Gift of the Council,
1911-28-223
Reference: Wunder, 1962, no. 41

Started by William and Mary in 1685 on the
grounds of a medieval castle at Apeldoorn in
Gelderland, Het Loo rose under the super-
vision of the Dutch architect Jacob Roman
(1640–1716), with designs for the gardens
and decoration by Daniel Marot. Wishing to
expand the house into a more regal setting
after their coronation in England in 1689,
the king and queen added two new wings,
remodeled several rooms, and extended the
gardens. In addition to providing plans for
the enlargement and decoration of the gar-
dens, Marot supervised the renovation of the
interiors, drawing up detailed designs for
the main staircase and a new dining room
(No. 35).

Marot's design for the painted decora-
tion of the grand staircase at Het Loo,
inspired by the trompe l'oeil compositions
of Charles Le Brun (1619–1690) for the
Escalier des Ambassadeurs at Versailles
(Fig. 5), shows exotic figures peering over
balustrades draped with luxurious carpets.
Serving as a transition between exterior and
interior, and between architecture and deco-
ration, the design incorporates distant land-
scape vistas, giant columned porticoes, and
painted wall paneling.

DSS

De Voorst, located in Gelderland, was built
for Arnold Joost van Keppel, later Earl of
Albemarle, a favorite courtier of William
III. The house rose at about the same time
as Het Loo and under the supervision of the
same team of architect Jacob Roman and
designer Daniel Marot. Marot's scheme for
the painted trompe l'oeil wall decoration for
the main staircase at De Voorst, published
in his *Nouveaux livres de peintures de salles et
d'escaliers*, is closely related to his stairway
for Het Loo. Majestic columned porticoes,
punctuated here by sculptural figures of
Diana, Apollo, and Abundance, frame vis-
tas of distant backgrounds and views to the
heavens.

This drawing of the De Voorst stair-
case, which varies in several passages from
Marot's print of the same subject, is signed
by Isaac de Moucheron and indicates a close
working relationship between the two art-
ists. Trompe l'oeil wall decoration on such a
grand scale was rare in the Netherlands
during the William and Mary period; large
landscape paintings on canvas, however,
continued to be popular throughout the
eighteenth century.

DSS

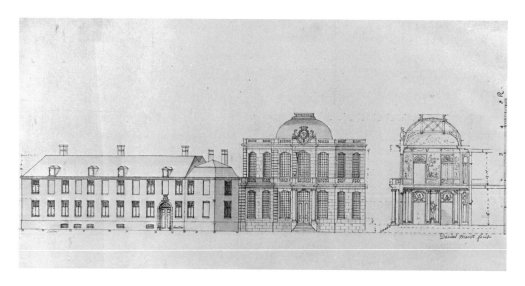

14 Design for the Wassenaer-van Obdam
 House, Kneuterdijk, The Hague

The Netherlands, c. 1715
Daniel Marot (1661–1752)
Pen and black ink; gray and pink wash; pencil
20.6 × 40.6
Inscribed at lower right in pen and black ink: *Daniel Marot fecit*
Gemeentearchief, The Hague
Reference: Ozinga, 1938, pl. 39

Several commissions for new buildings in The Hague, starting with the Schuylenburch House in 1715, provided Marot with an opportunity to design both interiors and exteriors. This preliminary design for the Wassenaer House shows his schooling in classical French architecture, combined with his own favorite decorative flourishes.

The facade is articulated by blocked pilasters, arched window surrounds, balustrades under the windows of the first storey and along the attic, a flat dome over the central section (also seen at Montagu House, London, and De Voorst), and a monumental carved coat of arms with supporters and crest crowning the middle bay. The interior decoration of the main hall, illustrated in the section at the right side of the drawing, includes giant pilasters and sculptural decoration on the ground floor and painted decoration on the walls of the floor above.

 DSS

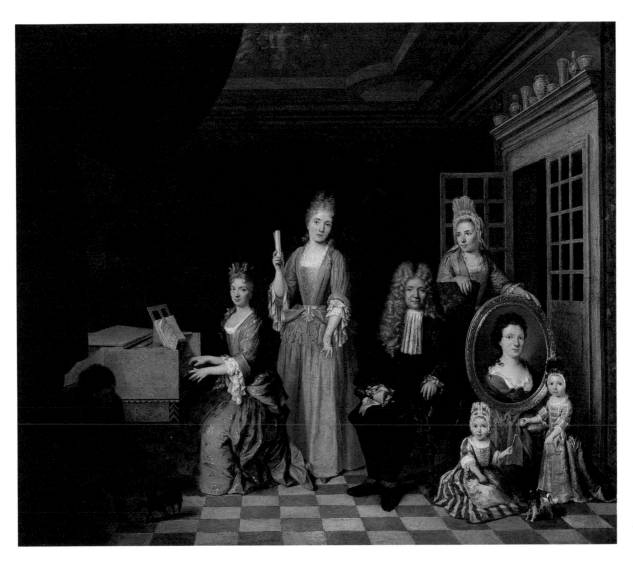

15 Portrait of a Family in an Interior

The Netherlands, c. 1690–1715
Attributed to Nicolas van Haeften (c. 1663–1715)
Oil on canvas
46.4 × 55.5
Museum of Fine Arts, Boston, Charles H. Bayley
Picture and Painting Fund

Interior furnishings typical of an upper
middle class Dutch household are shown in
this group portrait. Oriental porcelains or
Delftware jars, vases, and bowls, massed in
a symmetrical garniture on the projecting
cornice of the double doors, are similar to
arrangements included by Marot in his
designs for china closets. Other up-to-date
furnishings include the high-back uphol-
stered armchair with tapering column legs
and the oval carved frame of the portrait,
probably of a deceased wife (see No. 96).
The tall lace headresses worn here by the
women—and children—came into fashion
during the 1670s in France, where they were
called *fontanges* after one of Louis XIV's
mistresses.
 DSS

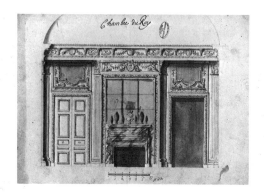

16 Design for the Chimney Wall of the Chambre du Roi at Versailles

France, 1684
Watercolor
23.6 × 37.5
Inscribed in pen and ink at upper center: *Chambre du Roy*; at lower center, beneath overlay: *remis faire en l'anée 1700*
Archives Nationales, Paris
References: Thornton, 1978, fig. 82; Kimball, 1980, fig. 20

This design for the chimney wall of the Chambre du Roi at Versailles shows several salient features of French interior design that were emulated by the Dutch and English. On a visit to Utrecht, Holland, in 1695, William Montague, the English traveler, wrote, "The better sort of people here affect the French Mode, and, in some measure, their way of living" (Montague, 1699, 197).

Mirrored glass was used above the mantel to add an element of luxury to a room. Silvered glass was expensive and difficult to produce in large sizes; therefore, several panes of glass were fitted to form large overmantel mirrors such as those that survive in the gallery at Kensington Palace.

Objects displayed were of porcelain or silver; both were used as garnitures. An unpublished inventory of the Dauphin's possessions at Versailles dated 1689 reveals that his porcelain was arranged "over the chimney," as was Queen Mary's at Kensington (*Agates, Crystaux, Porcelaines*, 1689).

This drawing was altered around 1700 by the addition of a hinged overlay section (not illustrated) that presents an alternative plan for a small, plainer mantelpiece and additional panes of mirrored glass. The scale at the bottom of the drawing shows that the mantel was over six feet wide.

LRS

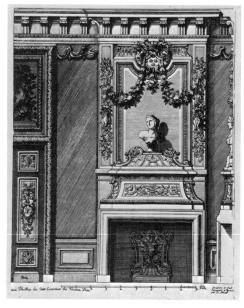

17 Design for a Room at De Voorst

The Netherlands, c. 1700
Daniel Marot (1661–1752)
Etching and engraving
24.7 × 19.3
Cooper-Hewitt Museum, Purchase, 1988-4-52

The curved and tapered plinths on the mantelpiece shown here are typical of the designs of Daniel Marot, as are the classical bust and the ornamented brackets at the cornice. The presence of the Albemarle arms indicates that the design was intended for De Voorst (see No. 13). The cappings, or festoons under the cornice, confirm the use of panels of luxurious fabric on the walls. The husk-and-blossom swags in high relief over the mantel would have required the services of a skilled wood carver such as Grinling Gibbons.

LRS

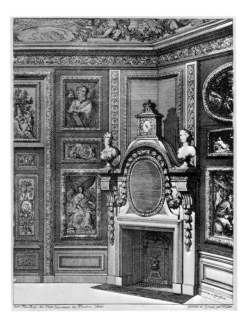

18 Design for Corner Chimneypiece

The Netherlands, c. 1700
Daniel Marot (1661–1752)
Etching
24.8 × 19.5
Cooper-Hewitt Museum, Purchase, 1988-4-51
Reference: Thornton, 1978, Fig. 74

Fireplaces were extremely important visual and practical elements of architecture during the seventeenth century. The fireplace, which provided the only means of heating a room, became a focal point in the interior. The words *cheminee a L'angloise* inscribed in the lower right-hand corner indicate that a corner fireplace may have been considered an English fashion. A description by John Evelyn in 1670 indicates that "the chimnies in the angles and corners" were "a mode now introduced by His Majesty" (Evelyn, 1850–52, July 22, 1670). The grandeur of the architectural elements used here—huge pendant husks, brackets, and acanthus leaves surrounding the paneling—add to the lavish effect, while classical busts enhance the baroque formality of the design.

Records of payments made to craftsmen during the building of Kensington Palace show that much attention was given to embellishments on the chimney: "paid to Nicholas Alcock, Carver, for shelf for a Chimney carved very rich in ye Queen's Bedchamber"; "large Italian picture frame for ye Chimneys, two members enriched, in ye Queen's Drawing Roome"; "large Impost Molding for a Chimney carved very rich in the Queen's Bedchamber" ("Kensington Palace," 130, 165).

LRS

19 Design for Overmantel at Dunham Massey
(see page 102)

England, c. 1700
Boujet
Pen and blank ink, gray wash
25.1 × 36.2
The British Architectural Library Drawings Collection, Smythson Collection, Royal Institute of British Architects, London

20 Design for Overmantel at Dunham Massey
(see page 102)

England, c. 1700
Boujet
Pen and black ink, gray wash
6.6 × 24
The British Architectural Library Drawings Collection, Smythson Collection, Royal Institute of British Architects, London
References: Girouard, 1962, 64, 181; Hardy and Jackson-Stops, 1978, fig. 2; Museum of London 1985, no. 273; Royal Institute of British Architects, 1972, vol. B, 98

The second Earl of Warrington's interest in heraldry and his support of Huguenot artists are both reflected in these two drawings for the decoration of the hall overmantel at Dunham Massey, his house in Cheshire. The earl's monogram and motto are incorported into one of the designs, along with his coat of arms and supporters of wild boars and lions. The second drawing shows a cartouche surmounted by a coronet, centered between putti and urn-topped plinths.

The drawings are signed by Boujet, probably one of the Huguenot artists patronized by the earl. Both the drawings and the actual chimneypiece are closely related to engraved designs published by Daniel Marot. Boujet, said to have been the architect of Montagu House and to have provided designs for Petworth and Boughton, may have worked with Marot at these houses, but little else is known about him. Another drawing of a design for a pediment, signed by Boujet, is in the collection of the Metropolitan Museum of Art, New York.

DSS

19 Design for Overmantel

20 Design for Overmantel

21 Designs for Painted Panels

England, c. 1690
Daniel Marot (1661–1752)
Pen and ink with traces of pencil
40 × 12.2; 40 × 14.6
The Board of Trustees of the
Victoria and Albert Museum, London
References: Jackson-Stops, 1981, fig. 6; Murdoch,
1985, no. 272; Stainton and White, 1987, no. 177

These designs for grotesques by Marot
served as the basis for a series of painted
panels for Montagu House, London, rebuilt
by Ralph, first Duke of Montagu, after a
fire there in 1686 (see No. 22). Although the
drawings are not signed, Marot's hand is
evident in the Berain-inspired arrangement
of figures and arabesques and in the many
instructional notes referring to colors, di-
mensions, and the identification of various
elements. The scenes in the central vi-
gnettes show two variations on the story of
Apollo and Daphne. The amorous my-
thological scenes in the other panels from
the same set show Diana and Endymion,
Venus and Adonis, Jupiter and Io, and the
Triumph of Galatea. Probably designed for
a cabinet, a small closet, or a dressing room,
they are important documentary evidence of
Marot's work during the 1690s for houses
other than the royal palaces in England.

DSS

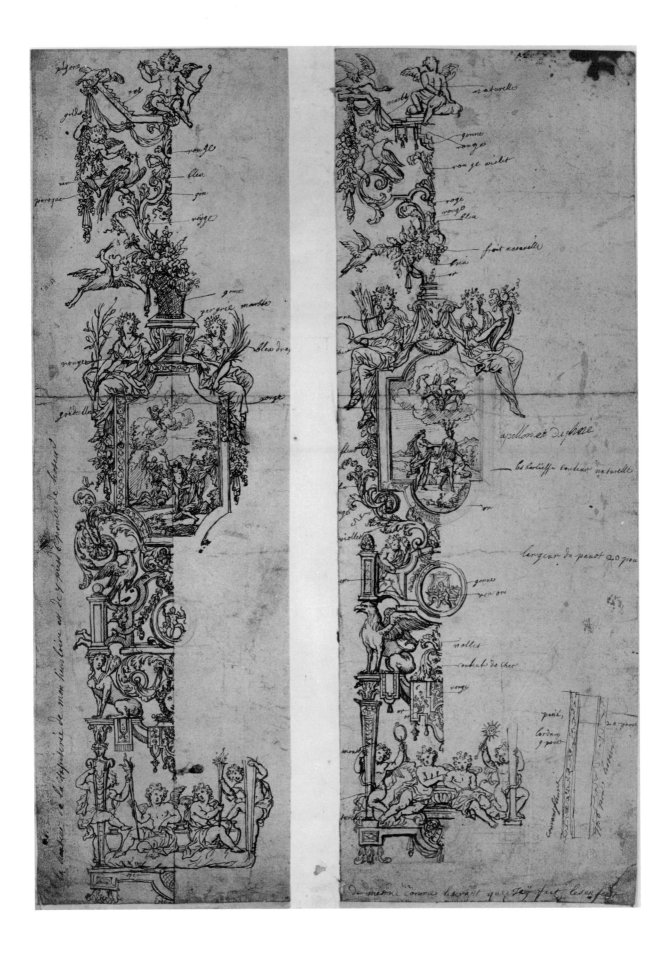

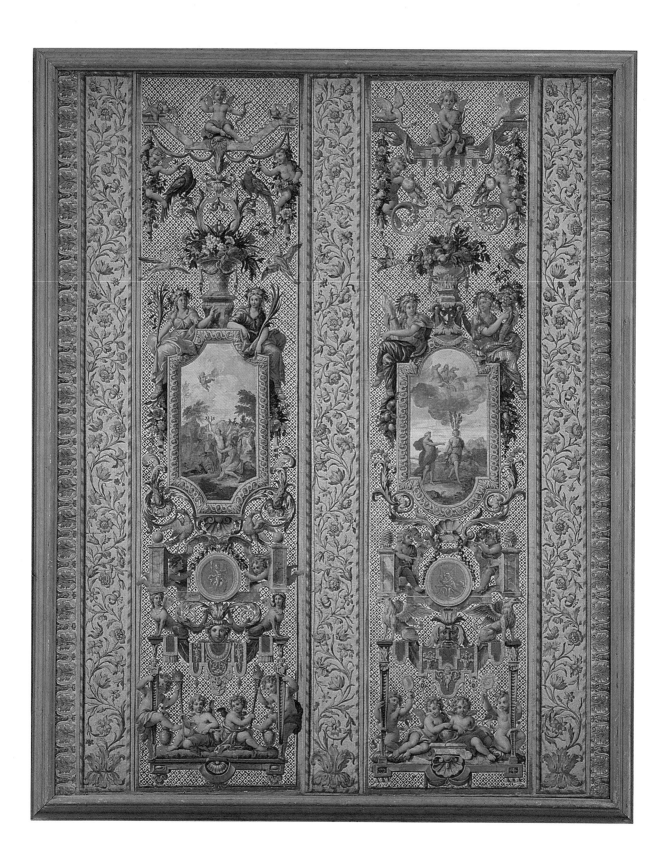

22 Painted Wall Panels with Scenes of Apollo and Daphne

England, c. 1690
Painted by Charles de Lafosse (1636–1716), Jacques
Rousseau (1630–1693), Jean-Baptiste Monnoyer
(1634–1699), and Jacques Parmentier (1658–1730), after
designs by Daniel Marot (1661–1752)
Oil on canvas
223.7 × 177.5
The Duke of Buccleuch and Queensberry, K.T.
References: Jackson-Stops, 1981, fig. 7; Museum of
London, 1985, no. 271

Two from a set of five painted wall panels
originally made for Montagu House, these
delightful polychromed paintings follow
closely the designs provided by Daniel
Marot (see No. 21). The first Duke of
Montagu, who had been ambassador to
France under Charles II and who had lived
in exile there from 1682 to 1685, was an
ardent Francophile and a great supporter of
Huguenot artists. Many French-inspired
elements of design were incorporated into
Montagu House, whose architect is re-
corded as Boujet, and into Boughton, the
duke's country estate in Northamptonshire
(see also Nos. 19, 20).

The antiquary George Vertue de-
scribed the team of French artists imported
by Montagu to execute these paintings and
other decorations at his London house: "The
late Duke Brought from France three excel-
lent painters to adorn & beautify [Montagu]
House. Monsieur [Charles de] Lafosse His-
tory painter. Monsieur [Jacques] Rousseau
for landskip & Architecture. [Jean-] Baptiste
[Monnoyer] for fruit & flowers. . . . These
three great masters have happily united their
thoughts & skill to a great perfection."
Vertue also mentioned that "Mr. [Jacques]
Parmentiere assisted in laying the dead
Colours for Monsr Lafosse and the Archi-
tecture & some bass relieves at bottom still
remain as painted by him" (quoted in
Jackson-Stops, 1980, 255). The panels were
eventually moved from Montagu House to
Boughton, possibly after the death of the
second Duke, or later.
DSS

23 Two Painted Wall Panels with Grotesque Ornament

England, c. 1720
Painting attributed to Mark Anthony Hauduroy, after
designs by Daniel Marot (1661–1752)
Oil on panel
300 × 75.3 (each)
The Duke of Buccleuch and Queensberry, K.T.
Reference: Jackson-Stops, 1981, 257–58

These panels come from a second set
painted for Montagu House but later moved
to Boughton (see No. 22). They were
installed around 1720, and they follow
Marot's engraved designs for grotesques.
Commissioned by the second Duke of
Montagu for a much larger room, they show
how the Marot style of decoration continued
to be popular well into the eighteenth
century. The panels are attributed to the
Huguenot painter Hauduroy on the basis of
their loose grisaille-like execution, similar to
works by the same artist at Knole.
DSS

24 Design for Grotesque Ornament

England or the Netherlands, c. 1690
Daniel Marot (1661–1752)
Pen and ink and black chalk
27.6 × 11.4
The Board of Trustees of the
Victoria and Albert Museum, London

Marot's design for a tall vertical panel of grotesque ornament peopled with musicians, a herm, and a bird supported by acanthus-sprayed strapwork reveals his training under the French *ornemaniste* Jean Berain. The drawing has recently been associated with a set of embroidered wall-hangings at the Palace of Holyroodhouse in Edinburgh, thought to have been made for Hampton Court (Howard Coutts, forthcoming article in *Country Life*, October 13, 1988). Similar designs by Marot were painted on a large set of Delft tiles made to line the walls of Queen Mary's Dairy at Hampton Court (see Nos. 164–168).
DSS

25 Designs for Cornice Moldings

The Netherlands, c. 1712
Daniel Marot (1661–1752)
Etching
27.7 × 19.4
Ecole Nationale Supérieure des Beaux-Arts, Paris, Collection Le soufaché
Reference: Jackson-Stops, 1973, fig. 5

The second of Marot's designs for cornice moldings on this print—with its large paired brackets and military trophy—relates closely to the central section of the west front of Petworth House, Sussex, which was probably executed after designs by him.
DSS

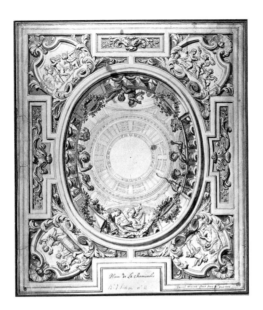

26 Design for Ceiling with the Four Seasons and the Four Continents

The Netherlands, c. 1712
Daniel Marot (1661–1752)
Pen and brown and black ink, gray wash
37.6 × 31.8
Inscribed in pen and black ink at lower center: *Plan de la cheminée*; at lower right: *Daniel Marot fecit ams. 6ᵐ oust 1712*
Ecole Nationale Supérieure des Beaux-Arts, Paris

Many of Marot's designs for painted ceilings feature illusionistic architecture and scenes of figures peering over balustrades, inspired by René-Antoine Houasse's ceiling in the Salon de l'Abondance at Versailles. A domed opening towers over symbolic representations of the Four Continents in this ceiling design, and shaped cartouches with allegories of the Four Seasons ornament the corners.

DSS

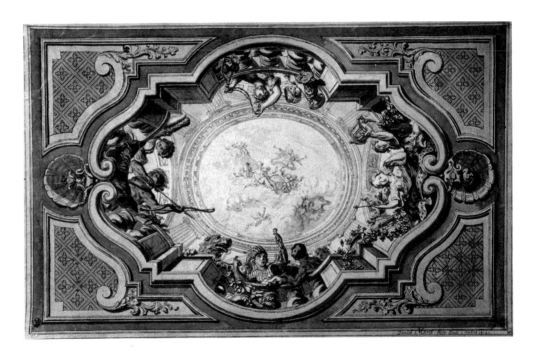

27 Design for Ceiling with the Four Continents

The Netherlands, 1712
Daniel Marot (1661–1752)
Pen and black ink; gray, pink, and green wash
31.1 × 42.7
Inscribed in pen and black ink at lower right: *Daniel Marot fecit Ams juliet 1712*
Lodewijk Houthakker Collection, Amsterdam

Exotically dressed figures representing the Four Continents, each accompanied by appropriate attributes, lean over the balustrade in this design for a painted ceiling; a view to the heavens is visible above. The thick scrollwork, shells, and diapered pattern at the corners are ornamental motifs especially favored by Marot. A large group of ceiling designs with similar painted decoration is also included in Marot's printed *Oeuvres*.

DSS

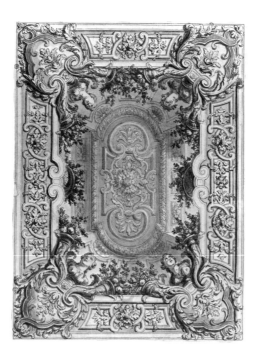

28 Design for Ceiling with Figures of Abundance

The Netherlands, c. 1712
Daniel Marot (1661–1752)
Pen and black and brown ink; blue, red, and gray wash
28.2 × 21
Ecole Nationale Supérieure des Beaux-Arts, Paris

Figures of Abundance and cornucopias of flowers adorn the corners of this ceiling design. The illusionistic effect of the baskets of flowers balancing on the edges of the cornice molding recalls a similar painted ceiling decoration depicted in Jean de Saint-Jean's print of a French closet (No. 143).
DSS

29 Design for Ceiling with Shield and Crown

The Netherlands, c. 1695
Daniel Marot (1661–1752)
Pen and black ink; pink, gray, and yellow wash
29 × 23
Inscribed in pen and black ink at lower center: *Corniche*
The British Architectural Library Drawings Collection, Royal Institute of British Architects, London References: Museum of London, 1985, no. 265; Royal Institute of British Architects, 1972, vol. L–N, 64

The shield and royal crown held aloft by the two putti in the center of this design suggest that the ceiling may have been planned for one of the king's smaller cabinets or dressing rooms at Hampton Court Palace.
DSS

30 Design for Marquetry Floor

Paris, c. 1682
Attributed to Pierre Gole (1620–1684)
Pen and wash
24 × 30
Inscribed at right center: *cheminée*; at lower left: *dessin du parquet de Marqueterie de / Cabinet dore de Monseigneur dons / L'Entresalle de la grande Aisle . . . 1688*
Musée des Arts Décoratifs, Paris
References: Thornton, 1978, 89, fig. 90; Lunsingh Scheurleer, 1980, fig. 10

Elaborate marquetried floors were rare in France, England, and the Netherlands during the William and Mary period, but they sometimes were made for small cabinet rooms or for the area surrounding the bed in the state bedchamber. Regular geometric parquet patterns, popular first in France and later in England, were more common. This design for an especially ornate inlaid floor is attributed to Pierre Gole, a Netherlandish craftsman who became cabinetmaker to Louis XIV. The floor was laid in 1682 for the Cabinet Doré at Versailles, where the Dauphin's collection of bronzes and gem-stone vessels were displayed on gilt-wood brackets; it was taken apart in 1688.

Gole produced some of the finest pieces of French furniture inlaid with rare woods, precious metals, ivory, and lacquerwork. His floral marquetry designs of the 1660s and 1670s were later widely copied by cabinetmakers in England and the Netherlands (see Nos. 102, 105). The strap-work, acanthus scrolls, shells, and floral ornament surrounding the crowned double *L*'s in this design are similar to motifs used by Daniel Marot, Gole's nephew by marriage, and are not unlike some of his projects for painted ceilings.

DSS

31 Design for Grotesque Ornament

France, c. 1680
Jean Berain (1637–1711)
Etching and engraving
38.6 × 24.3 (trimmed)
Cooper-Hewitt Museum, Bequest of Marian Hague,
1971-71-5

Many of Marot's published engravings for
grotesque ornament are composed of strap-
work, lambrequins, acanthus tendrils, and
fanciful creatures that are close cousins to
those peopling Jean Berain's designs. Marot's
early training under this French *ornemaniste*
in Paris remained a strong influence in his
work throughout his long career. Like
Berain, Marot created designs for a wide
variety of objects, ranging from furniture to
ceilings and from picture frames to pottery.
 DSS

 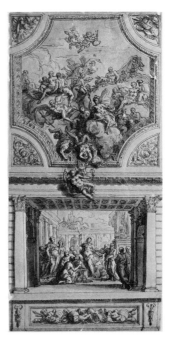

32 Design for a Candlestand

France, c. 1675
Jean Le Pautre (1618–1682)
Etching
29 × 21.8
Cooper-Hewitt Museum, Gift of the Council,
1921-6-108A
Reference: Thornton, 1978, 29, fig. 24

French ornamental prints published from
the 1660s to the 1690s had a great impact on
the development of the William and Mary
style in the Netherlands and England. Le
Pautre's engravings of the furniture and
decoration designed by Le Brun and others
for Versailles inspired countless imitations
by all manner of craftsmen in the North.
This design for a monumental guéridon, for
instance, may have been a source for Dutch
and English silver candlesticks from the
1690s with related molded figural stems (see
No. 67). The three-piece table-and-candle-
stand unit from which this guéridon might
have come was a form also emulated by
Northern designers and craftsmen. Marot
created a similar set for Het Loo, and many
other sets are listed in inventories from the
period (see No. 86).
 DSS

33 Study for Staircase Decoration,
 Hanbury Hall

England, c. 1710
Sir James Thornhill (1675–1734)
Pen and brown ink, brown wash
40.3 × 20
Cooper-Hewitt Museum, Gift of Mrs. Charles B.
Alexander, 1900-1-1
References: Wunder, 1962, 99–100, pl. 40; Gibbon,
1967, fig. 2; Victoria and Albert Museum, 1973, no.
70

Sir James Thornhill's design for the painted
decoration at Hanbury Hall, Wor-
cestershire, shows two scenes from Ovid's
Metamorphoses: on the ceiling, the Peace of
Lycomedes, and on the wall, Achilles Re-
vealing His True Identity in the Palace of
Lycomedes. The illusion of figures tum-
bling over the balustrade and the orna-
mented spandrels reveal lessons learned
from French painters working in England,
like Louis Laguerre, and from Marot's de-
signs for grand-stairway and ceiling decora-
tions. Thornhill, who went on to paint *The
Landing of William III* in the Painted Hall at
Greenwich, and other subjects in the Great
Hall at Blenheim Palace and on the cupola
of Saint Paul's Cathedral, was the last of the
great baroque painters working in England.
 DSS

The Silver Buffet

Silver and gold tablewares, arranged in impressive displays on sideboards or buffets, whether in royal palaces, churches, or domestic settings, were an important symbol of status and wealth during the late seventeenth century. William and Mary style silver, characterized by richly fluted and gadrooned surfaces, fine cast and applied ornament, and elaborately engraved coats of arms, was heavily influenced by skilled Huguenot silvermiths who emigrated to Holland, England, and the colonies and by the availability of prints showing the latest French fashions in silver forms and engraved decoration.

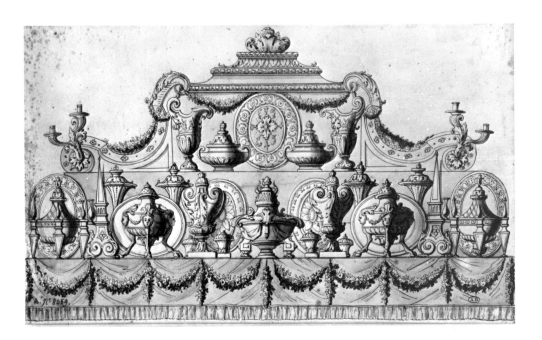

34 Design for a Buffet

Paris, c. 1700
Jean Berain (1637–1711)
Pen and wash
23.5 × 41.5
Musée des Arts Décoratifs, Paris
Reference: Thornton, 1978, pl. 229

Berain gives a detailed description of the arrangement of a lavish baroque buffet in this drawing. The draped and garlanded buffet table contains two shelves massed with an array of silver or gold vessels, some of which would have been used in serving and some solely for display. Included are seven large oval embossed basins or plates, two tall helmet-shaped ewers, and an assort-ment of tureens, vases, and other smaller vessels.

The lower tier of this buffet includes two burners, or cassolettes, with pierced lids, applied masks, and *pieds-de-biche*. The use of perfume burners to scent the air of dining rooms had spread from France to Holland and England in the late seventeenth century. Three cassolettes and nine pyramids, probably similar to the ones shown on this buffet, were listed in an inventory of the silver plate owned by William III in 1697 (Drossaers and Lunsingh Scheurleer, 1974, 1:419, nos. 149–54).

DSS

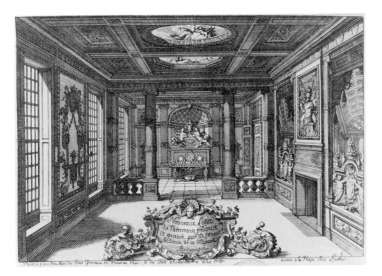

35 Design for Dining Room at Het Loo

The Netherlands, c. 1712
Daniel Marot (1661–1752)
Etching
18 × 26.5
Ecole Nationale Supérieure des Beaux-Arts, Paris,
Collection Le soufaché
Reference: Ozinga, 1939, pl. 5A; Pierpont Morgan
Library, 1979, fig. 2

Marot's design for the dining room at
William III's Het Loo Palace, shown on the
title page of his *Nouveaux Livre da Partements*,
features illusionistic wall paintings of ewers
and pyramids of fruit flanking the chimney-
piece. A buffet on the back wall is crowded
with platters and drinking vessels, and a
large cistern rests below.

 DSS

36 *The Passover Meal*

The Netherlands, 1725
Bernard Picart (1673–1733)
Pen and black ink, watercolor
14.9 × 20.9
Inscribed at lower left: *B. Picart fecit 1725*
Amsterdams Historisch Museum, Amsterdam,
Collection Fodor

The importance accorded the display of
silver, glass, and ceramic tablewares—even
in nonprincely settings—is shown in this
charming drawing of a Dutch family at its
Passover meal. The doors of a built-in buffet
open to reveal basins and ewers, can-
dlesticks, plates, and other vessels massed in
a manner similar to that seen in the Berain
design (No. 34). The wine cooler resting
below the table appears to be made of
wood, a more modest version of the silver
ones seen in grand aristocratic displays of
the period.

 DSS

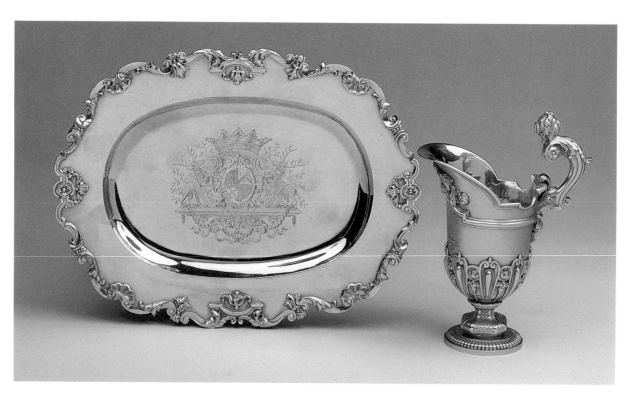

37 Ewer and Basin

London, 1701
Pierre Platel (active 1699–1719)
Gold
Basin: 19.7 × 27.3
Ewer: h. 17.8
The Duke of Devonshire and The Trustees of the
Chatsworth Settlement
References: Hayward, 1959, frontispiece; International
Exhibitions Foundation, 1979, no. 156; Grimwade,
1988, fig. 8

Helmet-shaped ewers with large matching basins were among the most elegant pieces of the baroque buffet. The grandest sets were fashioned from gold or from silver gilt and were often embellished with the engraved coat of arms of the owner. By the end of the seventeenth century, ewers and basins originally designed for washing the hands of diners had been rendered largely ceremonial in function by the growing use of forks at table.

Silver and gold helmet-shaped ewers were French in origin, deriving from contemporary faience models made at centers such as Rouen, and were popularized in England by Huguenot silversmiths such as Pierre Platel, the maker of this set. Platel was made a freeman of the Goldsmiths Company in 1699, after following William III's court to England as a page in 1688. His

exceptionally rare gold ewer, which follows the shape of an inverted helmet, has an open-scroll handle with a female herm and scrolled cut-card work at its base. The shallow basin bears the magnificently engraved arms of the first Duke of Devonshire at its center and a cast and applied border of scrolls, shells, and acanthus leaves. The superb engraving has been attributed to Blaise Gentot, who worked in England from the 1680s until about 1701 and who was also responsible for some of the plates in Jean Tijou's book of designs for ironwork (Nos. 223, 224) (Grimwade, 1988, 85).
 DSS

114

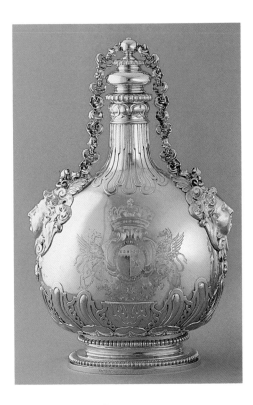

39 Salver

London, c. 1702
Maker unknown
Simon Gribelin (1660-1733), engraver
Silver gilt
7.62 × 31.7
The Duke of Devonshire and The Trustees of the
Chatsworth Settlement
References: Oman, 1978, fig. 87; International
Exhibitions Foundation, 1979, no. 155

38 Pilgrim Bottle

London, 1699
Pierre Harache the Younger (d. 1700)
Silver
52 × 33 × 30
The Provost and Fellows of Eton College, Windsor,
England
References: Hayward, 1959, 38, pl. 29; Murdoch,
1985, no. 330

Based on the shape of leather canteens carried by medieval travelers, the large silver and gold pilgrim bottles found on French, Dutch, and English baroque buffets were created purely for display. English examples were made mostly by Huguenot goldsmiths and were often included in the perquisite suites of silver plate issued to ambassadors and officers of state by the crown. They were fashionable only from the late seventeenth to the early eighteenth century. The applied masks, trefoil-link chains, and intricately molded knop, all characteristic Huguenot features, are joined in this pilgrim bottle by especially fanciful cut-card work. The arms (for the second Baron Arden [1756–1840] and his wife, Margaretta Wilson) were engraved in about 1802.

DSS

Henry Boyle, Chancellor of the Exchequer from 1701 to 1708, commissioned this magnificent salver to be fashioned from his seal of office, which had been rendered obsolete by the death of King William. The transformation of the large silver seals into objects for use and display was traditional in England; commemorative cups made from retired seals are known as early as the reign of Elizabeth I. By the end of the seventeenth century, however, it was more customary to have a seal incorporated into a large salver.

Designed for serving sweetmeats or holding glasses, salvers ranged from simple, round dishes of pottery or glass on a trumpet-shaped foot to high-status silver or gold vessels featured prominently on the sideboard buffet. Seal salvers such as this one were used purely for display and have remained in excellent condition.

Simon Gribelin, the leading Huguenot silver engraver of the William and Mary period, was responsible for the decoration of this salver, which includes not only the exchequer seal and the coat of arms and crest of Boyle, but also a fantastical web of scrolled foliage, figures, and trophies. A manuscript containing a collection of prints, proofs, and counterproofs for a large number of Gribelin's works (now in the British Museum) includes a proof for this seal salver.

DSS

40 *A New Book of Ornaments Useful to all Artists*

London, 1753–63, reprinted by John Bowles
(originally published 1704)
Simon Gribelin (1660–1733)
Engraving
19.8 × 16.3
Yale Center for British Art, New Haven, Connecticut,
Paul Mellon Fund
References: Oman, 1978, 73; Murdoch, 1985, no. 230

Silver decorated with engraved ornament
enjoyed great popularity in the late seven-
teenth century. Elaborate armorials and
scrolled ciphers graced large ceremonial
objects, and lively baroque foliage, strap-
work, and grotesques animated smaller
boxes, clocks, and watches.

Designs for engraved ornament pub-
lished by French artists such as Le Pautre
and Berain were copied by goldsmiths and
engravers throughout northern Europe.
Simon Gribelin's *A New Book of Ornaments
Useful to all Artists*, first published in 1704,
was aimed at jewelers, watchmakers, and a
broad audience of craftsmen. This title page
(from a later edition), with its classical urn
and plinth, billowing drapery, four putti,
and floral and acanthus foliage, illustrates
ornamental motifs that were easily adapted
not only by silver engravers, but also by
makers of boulle work (tortoiseshell inlaid
with metal), marquetry, or painted
ornament.

DSS

41 Title Page from *Nouveaux Livre d'Orfevrerie*

The Netherlands, c. 1712
Daniel Marot (1661–1752)
Etching
28 × 20
Ecole Nationale Supérieure des Beaux-Arts, Paris,
Collection Le soufaché

Marot's designs for silver published in his
Nouveaux Livre d'Orfevrerie ranged from
tableware to chandeliers to full-sized fur-
niture. Buffet pieces illustrated on this title
page include a covered jar and a large wine
cistern with a royal crest, lion's-head han-
dles, claw-and-ball feet, and a prominent
lambrequin border around the rim. Also
illustrated here are a mirrored sconce
framed with lively sculptural decoration, a
bracket or sconce, and a grotesque mask.
Although Marot's designs for silverware
were rarely copied exactly, his published
prints reached a great many craftsmen and
were adapted in a wide range of individual
ways.

DSS

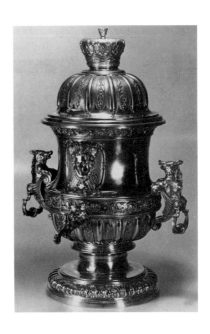

42 Design for Fountain and Wine Cooler

43 Wine Fountain

The Netherlands, 1710
Daniel Marot (1661–1752)
Pen and black ink, watercolor, black chalk
38 × 24
Inscribed in pen and black ink at lower left: *D. Marot fecit Ams. Nov^r 1710*; at lower center: *Basin deau / de Bord du Basin / assez large pour y posser des verres*
Rijksmuseum, Amsterdam

An elaborate wine fountain reminiscent of Marot's designs for garden fountains dominates the wine cooler built into this niche. While wine bottles are cooled in the basin below, glasses can be rinsed in the fountain pool above. Marot's inscriptions note the precise size and scale of the structure and also indicate that the rim of the fountain was to provide a space wide enough on which to rest glassware. A large ewer, a plate, and a pair of casters stand on the console to the right of the fountain as part of a larger buffetlike scheme.

DSS

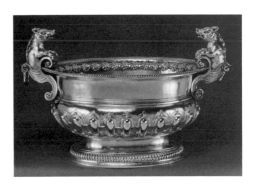

44 Wine Cooler

43 Wine Fountain
(see page 117)

London, 1728
Peter Archambo (active 1720–49)
Silver
70 × 50
The Worshipful Company of Goldsmiths, London

44 Wine Cooler
(see page 117)

London, 1701
Phillip Rollos (active from 1697)
Silver
38.1 × 64.8 × 38.1
The National Trust, Dunham Massey
References: Hayward, 1978, 32–39, pl. 2; Murdoch,
1985, no. 334; Glanville, 1987, 90, fig. 33

This wine fountain and cooler formed part
of the bountiful collection of silver plate at
Dunham Massey commissioned by George
Booth, second Earl of Warrington (d. 1758).
The cooler was purchased at the time of the
Earl's marriage, but the fountain was not
ordered until some twenty-six years later.
Although rococo design had begun to influ-
ence silver by the time the fountain was
made, the piece follows the style of the
earlier cooler, made by Phillip Rollos. The
fountain's handles take the form of demi-
boars, supporters of the Booth coat of arms,
and the cover is topped off with a large earl's
coronet. Its richly modeled shape and sur-
face ornament recall the designs of Daniel
Marot.

Most of the silver commissioned by the
second Earl of Warrington was fashioned by
Huguenot goldsmiths. Their familiarity
with the new styles from the court of Louis
XIV at Versailles and their superior training
in the various techniques required, such as
the handling of cast and applied ornament,
made their work highly desirable to wealthy
patrons of the William and Mary period.

DSS

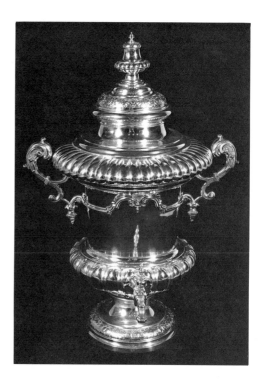

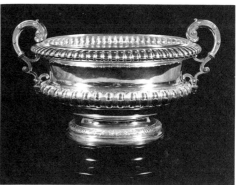

45, 46 Wine Fountain and Cooler

45, 46 Wine Fountain and Cooler

Amsterdam, 1729
Maker: IB
Silver
Fountain: 71.1 × 52 × 52
Cooler: 49.5 × 76.2 × 53.3
The Duke of Buccleuch and Queensberry, K.T.

Wine fountains and coolers en suite are rare in Dutch silver from the William and Mary period. At present only one other such pair is known (now at the Rijksmuseum, Amsterdam). Massive silver wine fountains were especially rare, even in England; they represented a substantial investment above and beyond the cooler, which was a more essential element of dining room service. Silver wine coolers, or cisterns, a form that developed during the baroque period, were filled with cold water and ice and used both for chilling wine bottles and for rinsing glasses, dishes, and cutlery. They often sat on the floor, under the buffet or sideboard table. A matching fountain, filled with water for rinsing glasses, was placed just above the cooler on the table.

Silver wine coolers and fountains were generally the largest pieces of a dining room buffet or sideboard and were designed to reflect the status of their owners. Wine fountains were usually given the form of a large urn or a covered cup, with handles, tap, and spigot. Coolers were made large enough to accommodate several bottles of wine and were often immense. To celebrate the arrival of Queen Mary from The Hague in 1689, William III ordered four wine coolers, each of which weighed more than 1,000 ounces (Hayward, 1959, 37). Fountains and coolers from the William and Mary period were often richly ornamented with cast and applied ornament, gadrooning, fluting, and armorial engraving or sculptural embellishments.

DSS

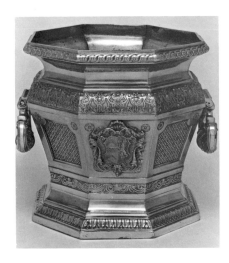

47 Wine Cooler

London, 1716
William Lukin (active from 1699)
Silver
H. 21
The Metropolitan Museum of Art, New York, Gift of Irwin Untermyer, 1968
Reference: The Metropolitan Museum of Art, 1977, 51, no. 80

Bearing the coat of arms of the famous prime minister Sir Robert Walpole (1676–1745), this wine cooler (one of a pair) is an especially fine example of William and Mary style silver. The overriding influence of French design is evident in its shape, ornament, and technique. Coolers designed to hold a single bottle were French in origin and, known as *sceaux à bouteille*, became more popular later in the eighteenth century, when they were also made in pottery and porcelain.

The cast and applied scroll handles and coat of arms and the carefully organized chased and engraved borders on this cooler would suggest the hand of a Huguenot goldsmith. William Lukin, whose stamp the cooler bears, may have employed Huguenot journeymen, or he may have sold the work of refugee goldsmiths under his own stamp, as was customary. English goldsmiths, worried about the competition from craftsmen trained in the French techniques and styles that were then gaining popularity in their own territory, made it difficult for Huguenots to join their guilds, hence French craftsmen were often forced to resort to roundabout means of obtaining work in England.

DSS

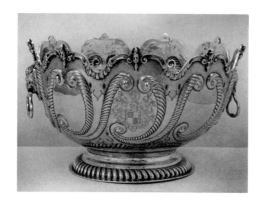 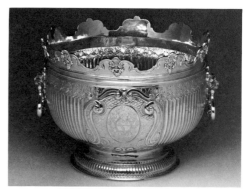

48 Wineglass Cooler, or Monteith

London 1695–96
Maker: CO
Silver
18.2 × 31.1
The Metropolitan Museum of Art, New York, Gift of
Irwin Untermyer, 1958
References: McNab, 1961, fig. 3

Reputedly named after a Scotsman whose cloak sported a similarly shaped border, monteiths—wineglass coolers with scalloped rims—were popular from about the late 1670s. On the tall, notched rim, six to eight wineglasses could be hung upside down from their feet to be cooled or rinsed in the ice water inside the bowl. Monteiths from this period were usually round, with a stepped foot and bail handles. Decorative motifs and techniques typical of both native and Huguenot goldsmiths are seen in this monteith; the basic shape is English, but the gadrooned border and cast and applied ornament around the upper rim and handle mounts show French influences. The rolling rhythm of the monteith's notched upper rim is emphasized by the repoussé border of interlacing scrolls around the sides of the bowl.

DSS

49 Wineglass Cooler, or Monteith

London, 1703
Samuel Lee (active from 1701)
Silver
24.7 × 34.9
Philadelphia Museum of Art, The Henry P.
McIlhenny Collection in Memory of Francis P.
McIlhenny

The monteith form was especially well suited to Marotesque ornament. Sculptural upper rims, armorial cartouches, scrolled handles, lion masks, gadrooning and fluting, as found on many of Marot's designs for silver, appear on the finest examples from the period. This monteith has a detachable rim so that it can also be used as a punch bowl.

DSS

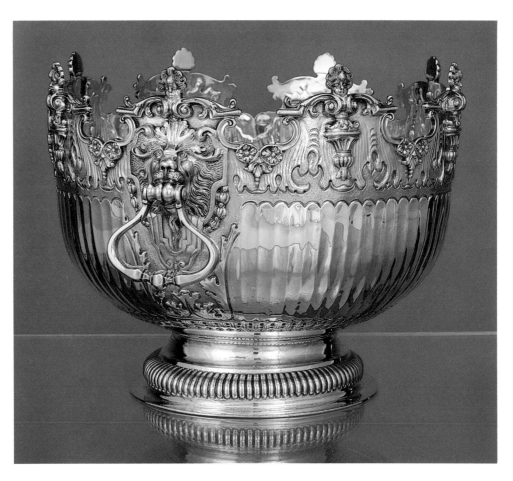

50 Wineglass Cooler, or Monteith

Boston, c. 1700–10
John Coney (1656–1722)
Silver with minute traces of original gilding
21.9 × 27.3 (lip) × 17 (base)
50 oz. 4 dwt.
Yale University Art Gallery, New Haven,
Connecticut, The Mabel Brady Garvan Collection
References: Buhler and Hood, 1970, 1:38–41, fig. 31;
Fales, 1970, 13–15, fig. 14; Hood, 1971, 65–66, fig. 51;
Ward and Ward, 1979, 140–41, fig. 146

Without question, the supreme American
achievement in the William and Mary style
is John Coney's monteith made for John
Coleman (1670– 1751), a wealthy Boston
merchant. (Coleman's arms are engraved
inside the bowl.) It is fully equivalent to
contemporary English-wrought monteiths.
One of many bowls to which it may be
compared is a monteith made by Anthony
Nelme of London in 1700 and now in the
collection of the Wadsworth Atheneum,
Hartford, Connecticut (Miles, 1976, no.
112). Such comparisons suggest that Coney
must have had firsthand knowledge of an
English monteith. Although none with
Boston histories have been identified, we

know for certain that colonists elsewhere in
America owned them and can conjecture
that Bostonians did, as well. William
Fitzhugh of Virginia, for instance, be-
queathed an English "Silver Moonteeth" to
his son Henry in 1701; it may be the one
made by Joseph Sheene of London in
1699–1700 that has descended in the
Fitzhugh family (Davis, 1976, 44).

Coney's monteith is a visual delight. In
it the silversmith demonstrates full mastery
of current baroque vocabulary. With its
sides encircled by fluting and its foot
similarly enriched by reeding, the body of
this vessel fairly shimmers. Its rim is a series
of architectural arches comprised of C- and
S-scrolls in patterns seen frequently in the
designs of Daniel Marot. It displays a tour-
de-force composition of cast cherub's heads,
rosettes, scrolls, and vases applied over a
chased ground of acanthus foliage. At either
side cast lion's heads hold the bowl's han-
dles. These are set against boldly chased
lambrequins, a distinctive baroque motif.
PMJ

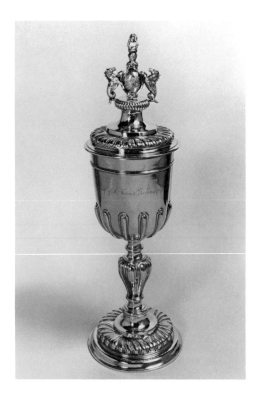

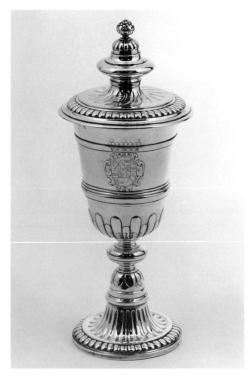

51 Standing Cup

London, 1705
Benjamin Pyne (d. 1732)
Silver gilt
57.1 × 17.7 × 17.7
The Worshipful Company of Pewterers, London
References: Hayward, 1959, pl. 1; Clayton, 1971, fig. 193

English silver standing cups with covers survived into the William and Mary period mainly as presentation pieces and church plate. Members of civic and guild organizations in England and Holland were important patrons of ceremonial silver, which could be enjoyed at banquets or, should the need arise, be melted down for cash.

This cup, inscribed *The Gift of Mr. Samuel Jackson Aug. ye 9th 1705*, is crowned with the arms of London's Worshipful Company of Pewterers. Three-dimensional cast and applied coats of arms, often including figural or armorial supporters, were particularly popular on important silver pieces made during the period. (They can also be seen in the carved ornament of architectural features, as in Nos. 19 and 14.) At about this same time, larger two-handled cups came into fashion, gradually replacing standing cups as favored presentation pieces.

DSS

52 Standing Cup

The Hague, 1694
Adam Loofs (c. 1645–1710)
Silver, silver gilt
29 × 11.2
Museum Boymans-van Beuningen, Rotterdam
Reference: Ter Molen, 1988, figs. 2, 3

Dutch patrons continued to commission standing cups as ceremonial vessels well into the eighteenth century. The three cartouches engraved on the sides of this cup contain an inscription and the coats of arms of Jean Deutz, an Amsterdam banker, and his wife, Maria Boreel. Although the shape of the cup is not French, its light bands of gadrooned and molded ornament juxtaposed with plain surfaces are close to Louis XIV style silver.

DSS

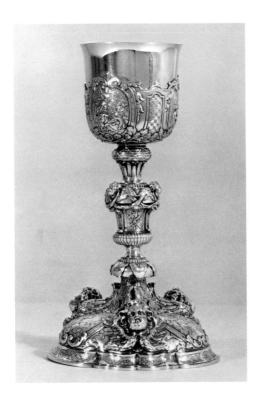

54 Standing Cup

Boston, 1700
Jeremiah Dummer (1645–1718)
Silver
19.37 × 11.11 (lip) × 10.95 (base)
Museum of Fine Arts, Boston, Anonymous Gift
References: Hood, 1971, 59, fig. 46; Buhler, 1972, 26–27, no. 23

53 Chalice

Utrecht, c. 1720
Nicolaas Verhaer (1685–1750)
Silver
31.7 × 11.4
The J. B. Speed Art Museum, Louisville, Kentucky
Reference: Sutton, 1986, 136, fig. 199

The church was a leading patron of silver plate in Holland, England, and America during the William and Mary period. Utrecht had been an important Dutch ecclesiastical center since medieval times and remained so through the seventeenth and eighteenth centuries.

The influence of highly ornate baroque church silver from centers such as Antwerp is evident in this chalice, made in Utrecht by Nicolaas Verhaer. Its richly sculptural ornamentation includes angels' heads and medallions depicting the Crucifixion, the Resurrection, the Adoration of the Lamb, and other scenes from the life of Christ. Although late in date, Marotesque details carried over from the William and Mary period are seen in the way the ornament is organized and in the gadrooned and lambrequin borders.

DSS

This cup, engraved *Ex dono/Mr. Joshua &/ Mrs. Hanna/Bangs to the Church of East-ham/1700*, represents the earliest dated use of gadrooning in American silver. The monumental cup made by John Coney for presentation by William Stoughton to Harvard College in 1701 is the second-earliest documented appearance of this most characteristic baroque decorative motif.

Dummer had significant foreign contacts as part owner of at least eleven ships between 1697 and 1713 and with two sons, William and Jeremiah, Jr., living in England and Holland during the late 1690s and the early 1700s (Ward, 1983, 167). It is not surprising, therefore, that his work shows the current taste in Europe and England. The swirled gadroons that encircle the lower third of the cup's bowl are effectively echoed in the swirled, incised reeds around the feet and complemented by the cast rayed collar below the baluster stem. These areas of rich geometric ornament alternate in typical baroque fashion with plain, unadorned surfaces. The baluster shape of the stem is characteristic of the era as well, as seen in the turned elements of American chairs and tables.

PMJ

55 Cup

Boston, c. 1700
John Coney (1656–1722)
Silver
8.57 × 5.79
Museum of Fine Arts, Boston, The M. and M.
Karolik Collection of 18th-Century American Arts
Reference: Buhler, 1972, no. 29

This cup is one of two made by Coney for
Mary Willoughby (b. 1676), granddaughter
of Francis Willoughby, who had served as
deputy governor of Massachusetts from 1665
to 1671. She married Thomas Barton in
1710, and the cup descended in their family
to this century.

The shape of the cup, a familiar one
from this era, is seen frequently in ceramics.
The simple form is made exceedingly ap-
pealing by its pleasing proportions and its
deft incorporation of ornament. The
gadrooned bands encircling the cup are of
graduated size, imparting a sense of vertical
movement to the object. This pattern is
mirrored in the graduated beading that
descends the cast handle.

PMJ

56 Tankard

Philadelphia, 1714
Johannis Nys (1671–1734)
Silver
18.4 × 19.6
Philadelphia Museum of Art
Reference: Philadelphia Museum of Art, 1976, 17,
no. 12

Little of the silver from Philadelphia's ear-
liest days of settlement has survived. This
city's first silversmiths, Cesar Ghiselin (c.
1663 - 1733) and Johannis Nys, were both of
French Huguenot ancestry. Ghiselin, of
Rouen, arrived in Philadelphia in 1681. The
Nys family came from Holland to New
York, where Johannes Nys was baptized in
1671. He trained there and then went to
Philadelphia, probably around 1695 (Phila-
delphia Museum of Art, 1976, 5, 8).

Nys's New York training is clear from
his use of a corkscrew thumbpiece and
applied leaf banding on this tankard, which
was made for Sarah and James Logan in
1714, just one month and a week following
their wedding. A cipher of their initials is
engraved on the front of the tankard. Its
form is typical of the era and suggests that
the engraver may have been familiar with a
published book of ciphers. The ornament
that encircles these initials also demonstrates
the engraver's knowledge of current designs
inspired by Daniel Marot and his contempo-
raries.

PMJ

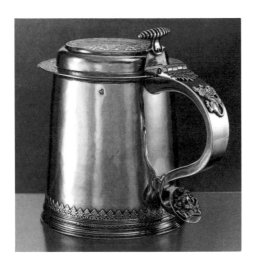

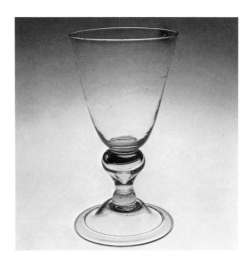

57 Tankard

New York, c. 1690–1700
Jacobus van der Spiegel (1668–1708)
Silver
19.5 × 12.7 × 14.6
Yale University Art Gallery, New Haven,
Connecticut, Gift of Spotswood D. Bowers and Mr.
and Mrs. Francis P. Garvan
Reference: Buhler and Hood, 1970, 19–22, no. 567

The tankard was an especially popular form
in colonial Boston, New York, and Philadel-
phia. In New York, silversmiths elaborated
this typically English drinking vessel, which
was not made in Holland, with Dutch-
inspired ornament. Van der Spiegel, like
other New York silversmiths, has placed a
base of stamped leaves (familiar in Dutch
beakers, for example) above a wide molded
baseband, itself decorated with an applied
meander wire. New York silversmiths, un-
like those in Boston, used corkscrew-type
thumbpieces, as Van der Spiegel has done,
although no specific Dutch source can be
cited. Both New York and Boston sil-
versmiths applied cast cherub's heads to the
ends of handles. Such heads, design ele-
ments common in England and on the
Continent at this time, were used in the
decoration of clock faces. Perhaps the most
striking feature of this tankard is its elab-
orately engraved cover, which in its fullness
seems Dutch-inspired. The cipher HWM is
for Hendrick (1673–1753) and Wyntje (Rhee
or Ray) Myer (b. 1654) who married in 1697.
A characteristically baroque coat of arms is
engraved on the front of the tankard. The
addition of pendent swags of fruit below the
shield is typical of New York engraving.
 PMJ

58 Goblet

England, 1690–1700
Colorless lead glass
27 × 14.4
Museum of Fine Arts, Boston, Gift of the
Seminarians
Reference: Museum of Fine Arts, Boston, 1982,
2:283–84, no. 278

This goblet has a history of ownership in
the Bennett family of Chester County,
Pennsylvania, from the eighteenth century
until recently. Its form, particularly the
bold baluster stem (a shape repeated in all
media during this era) set upon a large
domed foot, is typical of the late seventeenth
century. Its large scale is rare, however, even
among surviving glass examples in England.
Given its impressive size, we presume that
this glass—and others like it—would have
been used on ceremonial or grand occasions
and shared among a group of celebrants.
 The goblet is rarer still for its American
history of ownership. More important, this
goblet—along with the wineglass that de-
scended in the Sayward family of Maine
(Fig. 80)—offers evidence of the quality of
glass objects at a time when this fragile
medium, then fairly new to colonists, was
becoming highly popular for drinking
vessels.
 PMJ

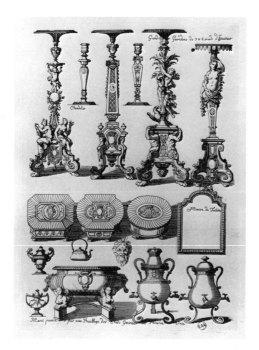

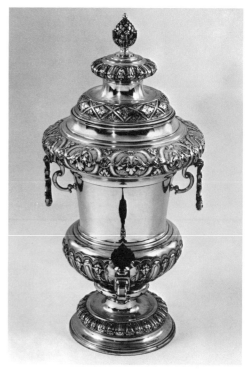

59 Designs for Silver

The Netherlands, c. 1712
Daniel Marot (1661–1752)
Etching
28 × 20.3
Ecole Nationale Supérieure des Beaux-Arts, Paris,
Collection Le soufaché

Illustrated in this print by Marot are silver
designs for dining rooms, bedrooms, and
state apartments. For the buffet, he shows a
wine cooler set on a base with female sup-
ports; two coffee urns, each with three taps;
a kettle; two urns; and two baluster-shaped
candlesticks. The "Miroire de Toilette" with
gadrooned border and the three boxes with
armorial decoration would have graced a
dressing table. The four sculptural "Grand
Gairidons," each about seven to eight feet
high, recall the silver candlestands made for
Versailles, and would have been used to
light the grandest state receiving rooms.

DSS

60 Coffee Urn

Leeuwarden, 1729
Andele Andeles (1689–1754)
Silver, ebony
41.7 × 20 (without tap)
Rijksmuseum, Amsterdam
Reference: Blaauwen, 1979, no. 111

Coffee urns first became popular, especially
in the Netherlands, during the William and
Mary period. Their basic form was bor-
rowed from larger wine fountains and
garden urns. The maker of this urn, Andele
Andeles, was one of the more important
silversmiths working in Leeuwarden, home
of the Frisian court. Andeles's style looks
toward The Hague, home of the other
Dutch court, where a balanced contrast
between plain and decorated surfaces pre-
vailed, as typified by the works of Adam
Loofs (Nos. 52, 67, 74). Although
Leeuwarden craftsmen were slower in
adopting French styles than their com-
patriots in The Hague, they were more
literal in their interpretations than craftsmen
in most other major Dutch centers.

DSS

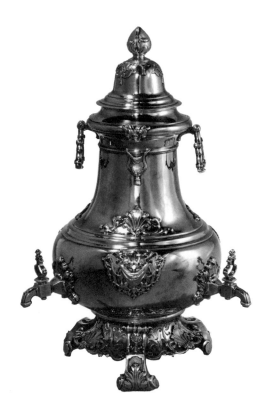

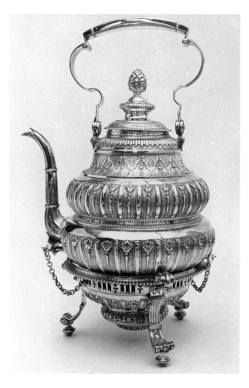

61 Coffee Urn

Amsterdam, 1733
Tijmon Suyk (1699–1754)
Silver
38.4 × 20.3
The Metropolitan Museum of Art, New York, Gift of
Mrs. Ruth L. Hoe Sterling, 1964, in memory of her
father, Robert Hoe, Jr., a Founder of the Museum
Reference: Blaauwen, 1979, no. 116

This spirited Dutch coffee urn relates
closely to the designs for three-spigot urns
with scroll feet shown in Marot's prints (see
No. 59). The applied drapery swags,
lambrequins, and tassel motifs are further
Marotesque flourishes derived from the
Louis XIV style, which remained popular
in Amsterdam silver of this date.

 DSS

62 Kettle and Stand

The Hague, 1707
Attributed to Richard Musseau
Silver, ivory
H. 29
Haags Gemeentemuseum, The Hague
Reference: Blaauwen, 1979, no. 94

Traditional Dutch form and French-inspired
ornamentation converge in this silver kettle
and stand to create a telling document of the
William and Mary style. Attributed to the
goldsmith Richard Musseau, it is a rare
example of Huguenot silver made in The
Hague. Kettles of similar shape are found in
Marot's designs (see No. 59). The stands for
kettles of this type contained either smoke-
less charcoal or spirit lamps for warming the
water.

 DSS

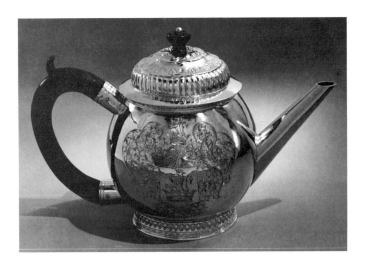

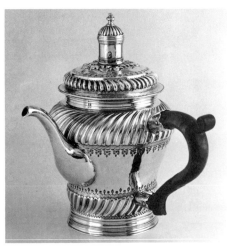

63 Teapot

New York City, c. 1700–15
Jacob Boelen (c. 1654–1729)
Silver
16.51 × 26.3
The Metropolitan Museum of Art, New York, Gift of
Mrs. Lloyd K. Garrison, in memory of her father,
Pierre Jay, 1961
References: Avery, 1930, 149, pl. 26; Hood, 1971, 72,
fig. 57; Safford, 1983, 20, fig. 20

This is the earliest known American teapot.
A pear-shaped one from about 1705 by
Kiliaen van Rensselaer in the New York
Historical Society and John Coney's pear-
shaped teapot of about 1710 in the Metro-
politan Museum of Art are its nearest rivals
in date. Coney's is the earliest yet identified
from Boston, although one appears in the
1701 inventory of William Stoughton, lieu-
tenant governor of Massachusetts. (It is also
worth recalling that Van Rensselaer, a New
Yorker, apprenticed in Boston with Jeremiah
Dummer.) The maker, Jacob Boelen, was
born in Amsterdam and brought to New
York as a young child (Fales, 1970, 190).

The globular shape of this teapot de-
rives from oriental ceramic prototypes.
Gadrooning and repoussé foliage ornament
the cover. A stamped baseband comprised of
interlaced diamonds makes a pleasing geo-
metric counterpoint to the cover's gadroon-
ing. (A similar baseband may be seen on the
Kierstede bowl, Fig. 74). Bands of meander
wire, common in New York decoration,
frame the upper rim of the body and the
base. In combination, this profusion of
ornament is typical of the best New York
silver of the era.

The teapot is further enriched by the
Philipse coat of arms and crest beautifully
engraved in a typical baroque format: a
shield flanked by lushly scrolling acanthus
leaves. The addition of pendant cornucopias
is a distinctively New York device.

PMJ

64 Chocolate Pot

London, 1697–98
Isaac Dighton (active 1697–99)
Silver, wood
19.7 × 19.7 (with spout)
The Metropolitan Museum of Art, New York, Gift of
George O. May, 1943
Reference: McNab, 1970, 58, figs. 40, 41

The introduction of chocolate from the New
World to England in the mid-seventeenth
century created a need for suitable vessels in
which to serve the fashionable new drink.
Chocolate pots were generally similar in
shape to coffee pots—pear-shaped or with
straight, tapering sides, with handles often
at right angles to the spout. Chinese por-
celains influenced the form of some early
examples, like this vase-shaped pot. Choco-
late pots were equipped with long stirrers,
inserted through a small aperture in the top
of the lid, for breaking up the thick choco-
late residue that settled at the bottom.

DSS

128

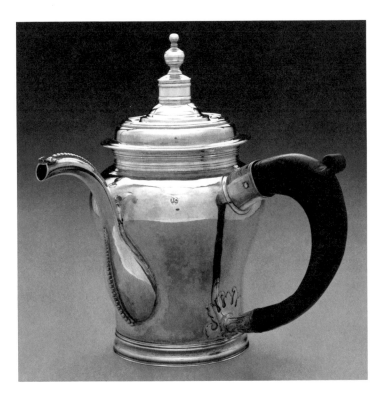

65 Chocolate Pot

Boston, c. 1701
John Coney (1656–1722)
Silver
20.48 × 9.21 (base) × 8.89 (lip)
Museum of Fine Arts, Boston, Gift of Edward Jackson Holmes
References: Hood, 1972, 74, fig. 62; Buhler, 1972, 59–61, no. 50; Fales, 1974, 88, fig. 85

This chocolate pot is engraved in semiscript on the bottom *The gift of William Stoughton Esquire/To Mrs. Sarah Tailer: 1701.* William Stoughton, lieutenant governor of Massachusetts, was an important patron of Boston silversmiths Jeremiah Dummer and John Coney. He commissioned a large two-handled cup in 1701, given to Harvard College just prior to his death, and made bequests to churches and relatives specifically for the purchase of plate. In this instance Stoughton bequeathed to his niece Sarah Tailer "as a particular rememberance of me twelve pounds to buy a bit of Plate" (Buhler, 1972, 60). Since the objects associated with Stoughton are of high quality and current design, it is tempting to conjecture that he was himself a trendsetter. (The teapot included in the inventory of his belongings after his death in 1701 is the earliest reference to this form in the colonies.)

John Coney is the first New England silversmith known to have made pots for chocolate and tea, drinks new and stylish in the late seventeenth and early eighteenth centuries. As he did with the small cup (No. 55), Coney has adapted a ceramic form, in this instance a Chinese vase, which was also employed by silversmiths in London, Leeds, Chester, Exeter, and Newcastle (Clayton, 1971, 62, fig. 124). Coney's use of ornament is appropriately restrained, limited to a cut-card shield at the lower juncture of the handle; graduated beading that outlines and encloses the spout on its upper and lower surfaces; and a complex crescendo of moldings that proceeds from the neck of the body to the finial. Similar patterns of moldings on furniture of the era likewise catch the light and engage the viewer's eye; such moldings are key elements in the formal dynamics of baroque objects.

PMJ

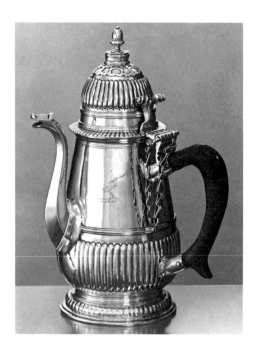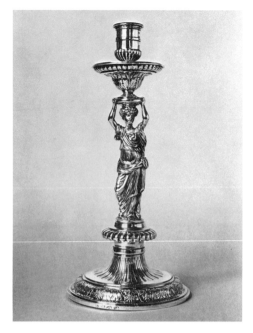

66 Chocolate Pot

Boston, 1700–1710
Edward Winslow (1669–1753)
Silver
24.3 × 7.9 × 10.3
Yale University Art Gallery, New Haven,
Connecticut, Gift of Mabel Brady Garvan Collection
References: Buhler and Hood, 1970, 1:56, no. 49;
Ward and Ward, 1979, 142–43, no. 149

Undoubtedly modeled on English proto-
types, this chocolate pot by Edward
Winslow relies on an alternation of plain and
richly gadrooned surfaces for its dynamic
ornamental vocabulary. An additional collar
of cut-card work adorns the domed cover.
Regrettably, the pot's original spout was
replaced by this faceted one in about 1740.
It is placed higher on the body than the
original one, whose joining place is now
covered by a shield-shaped plate. A vir-
tually identical pot by Winslow, with its
original spout, is in the Metropolitan Mu-
seum of Art (Safford, 1983, fig. 23).

PMJ

67 Candlestick

The Hague, 1687
Adam Loofs (c. 1645–1710)
Silver
28.6 × 13.4
Rijksmuseum, Amsterdam
Reference: Blaauwen, 1979, no. 87

The wide-reaching influence of French
court designs in the late seventeenth century
is reflected clearly in this candlestick, made
by The Hague goldsmith Adam Loofs.
Loofs, who had lived and worked in France
in the 1670s before returning to The Hague
to become Keeper of the Plate to William
III, would have been familiar with Louis
XIV style design.

Drawings and prints illustrating the
furnishings at Versailles also circulated
throughout Europe, providing up-to-date
information for goldsmiths, upholsterers,
woodworkers, and other craftsmen. Engrav-
ings such as that by Jean Le Pautre,
showing a monumental silver caryatid-sup-
ported candlestand (No. 32), may have
served as inspiration to goldsmiths in the
Netherlands and England.

Candlesticks with female figures as
stems, such as the one in the Art Institute of
Chicago attributed to Anthony Nelme, were
also made in London. The *W* marked on the
bottom of this candlestick may signify that
it belonged to the king.

DSS

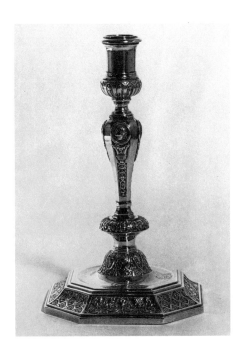 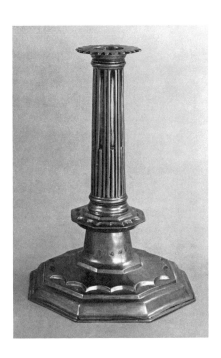

68 Candlestick

The Hague, 1727
Albert de Thomese (active 1708–53)
Silver
26 × 15.2
Haags Gemeentemuseum, The Hague
Reference: Blaauwen, 1979, no. 109

Influences from the court of Louis XIV are reflected in the design of this candlestick, made by Albert de Thomese, a goldsmith with French origins who worked at The Hague. The graceful baluster shape and applied decoration are characteristic of a period twenty to thirty years earlier. In silver, the William and Mary style continued to be popular for a long time in Holland and in the other provinces, as did the Louis XIV style in many French centers outside Paris.

DSS

69 Candlestick

London, 1686–87
Unknown maker
Silver
25.4 × 17.7
The Metropolitan Museum of Art, New York, Gift of Irwin Untermyer, 1968

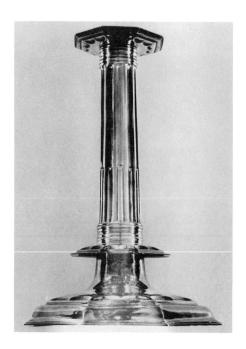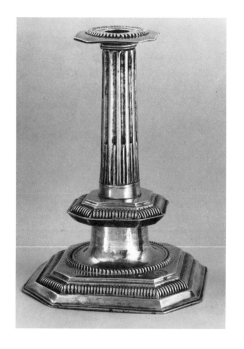

70 Candlestick

The Netherlands, 1701–2
Hendrick van Haeff (active 1695–1703)
Silver
20 × 13.5 × 13.5
Bestuur Godshuizen, Den Bosch, The Netherlands

The frequent movement of William III's court between England and the Netherlands introduced a number of new English forms to Dutch craftsmen of the late seventeenth century. Silver candlesticks with stems shaped as Doric columns—sometimes called monument candlesticks after Sir Christopher Wren's famous monument commemorating the Fire of London—were first made by London goldsmiths in the 1680s. Similar Dutch candlesticks, like the one made by Hendrick van Haeff, with its octagonal base, collar, and bobeche and its repeated scalloped borders, were based closely on English examples made some fifteen years earlier. Although relatively rare in the Netherlands, monument candlesticks were popular in the American colonies, especially New York and Boston.

DSS

71 Candlestick

Boston, 1695–1700
John Noyes (1674–1749)
Silver
23.5 × 16.19
Museum of Fine Arts, Boston, Gift of Miss Clara Bowdoin Winthrop
References: Buhler, 1956, 30; Buhler, 1972, 1:111–12, no. 90

This candlestick, made for Pierre Baudoin (later Bowdoin) and engraved with his crest and motto, is the William and Mary style variation of wrought columnar candlesticks. John Noyes's master, Jeremiah Dummer, in about 1680–90 made a pair of square, clustered-column sticks in the earlier baroque taste. Noyes, however, has fashioned a candlestick of stop-fluted columns, set on an octagonal base and fitted with an octagonal drip pan—both of which are enriched with reeding.

PMJ

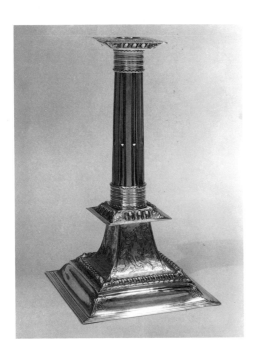

72 Candlestick

New York City, c. 1700–10
Cornelius Kierstede (1675–1757)
Silver
29.21 × 16.5
The Metropolitan Museum of Art, New York, Gift of
Robert L. Cammann, 1957
References: Fales, 1970, 109, fig. 107; Hood, 1971, 72,
fig. 56; Safford, 1983, 20–23, figs. 25, 26

This candlestick is one of a pair accom-
panied by a matching snuffer stand made by
Cornelius Kierstede for Johannes and Eliz-
abeth Schuyler of Albany, New York, who
married in 1695. The candlesticks and the
snuffer stand are among the most luxurious
objects made in the colonies in this era.

Born in New York City, Kierstede be-
longed to the third generation of his family
to reside in that city, following his paternal
grandfather's emigration from Saxony
(Naeve, 1987, 41). For his clients, Kierstede
fashioned silver in both Dutch and English
taste. His Dutch-inspired bowl (Fig. 74)
seems to have belonged to Theunis Jacobsen
Quick, a baker, and his wife, Vroutje. Like
Gerrit Onckelbag, Kierstede created an

English-style covered two-handled cup for a
member of the Van Cortlandt family (Fig.
75; Naeve, 43, fig. 1). His candlesticks made
for the Schuylers are of a form common in
English silver from the 1670s and 1680s.
Similar ones were also made in Holland.
The flat-chased chinoiserie decoration on
the candlesticks, however, is specifically
related, in both technique and motif, to
distinctively English ornament that appears
on numerous pieces of silver made in
England between 1670 and 1695. For exam-
ple, the figures Kierstede uses may be
compared in a general way with those on a
monteith made in London in 1688–89 that is
now at Colonial Williamsburg (Davis, 1976,
no. 32).

The gadrooning that enriches the can-
dle sockets, drip pans, and bases is the latest
element in the decorative vocabulary of the
candlesticks and is clearly characteristic of
the William and Mary style. Only
Kierstede's use of meander wire to decorate
the upper and lower moldings of the column
is possibly more Dutch than English in
spirit, although English silversmiths cer-
tainly employed this device, as a tankard of
1697–98 by Charles Overing will attest
(Miles, 1976, 43, no. 39). The frequent use
of meander wire is characteristic of New
York work, as distinguished from that of
Boston.

PMJ

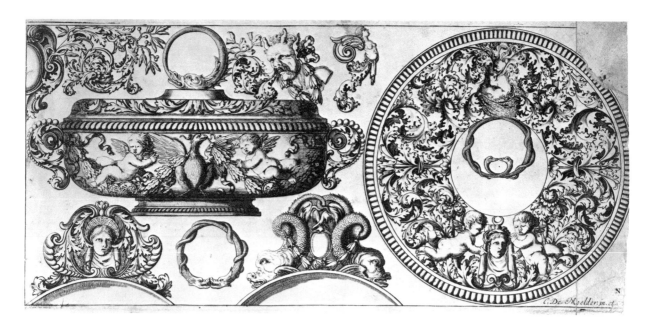

73 *Proper Ornaments to be Engraved on Plate*

London, 1694
C. de Moelder
Engraving
14.3 × 31.1
The Board of Trustees of the
Victoria and Albert Museum, London
Reference: Glanville, 1987, fig. 91

Printed designs for silver plate provided
London goldsmiths with information on
contemporary French and Dutch fashion.
Engraved and cast ornaments suitable for an
ecuelle, or tureen, rich in foliate and figural
detail, are illustrated in this print, which
closely follows French Louis XIV style
silver designs.
 DSS

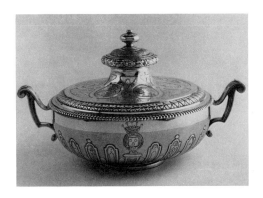 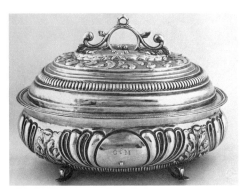

74 Ecuelle (Tureen)

The Hague, 1701
Adam Loofs (c. 1645–1710)
Silver
13.2 × 23.8
Haags Gemeentemuseum, The Hague
Reference: Blaauwen, 1979, no. 91

A very pure French style is represented by Adam Loofs's silver ecuelle. The coat of arms with three shells is that of Arnold Joost, Baron van Keppel, first Earl of Albemarle, a favorite of William III. The tureen was made for his marriage to Geertruid van der Duyn in 1701. Used mainly for serving individual portions of broth, ecuelles were also filled with sweetmeats and presented to nursing mothers. Having originated in France, some ecuelles were made in England by Huguenot goldsmiths, but very few are known from the Netherlands. Although not a Huguenot himself, Loofs showed a profound understanding for the serenity of French classical shape and ornament.

 DSS

75 Sugar Box

Boston, c. 1700
Edward Winslow (1669–1753)
Silver
14.6 × 17 × 21.6
Museum of Fine Arts, Boston, The Philip Leffingwell Spalding Collection
References: Buhler, 1964, 91, fig. 9; Buhler, 1972, 1:83–84, no. 69

Although rich in the ornament that is characteristic of baroque silver, this sugar box is the simplest of the five made by Edward Winslow, and perhaps the earliest (three of the others being dated 1702). Four of them have been known for some time: one in a private collection and one in the Yale University Art Gallery, both bearing the Winslow coat of arms; a third in the Winterthur Museum; and this one. A fifth has been recently discovered and is now on view in the Philadelphia Museum of Art.

 Regrettably, this box is missing its hasp (and hinge), which would have covered the boss where the initials *S* over *GM* are engraved. These initials represent the second owners of the box, Gurdon and Mary Saltonstall of Boston and New London, Connecticut, who were married in 1712. The original owners are unknown.

 The form of this sugar box and others similar to it is related to the mid-sixteenth century Italian cassone, which was given to newly married couples. The richer ornament on other boxes of this type—including a chivalric, sword-wielding horseman—has been cited as symbolic of courtship, marriage, and procreation (Museum of Fine Arts, Houston, 1987, 65).

 PMJ

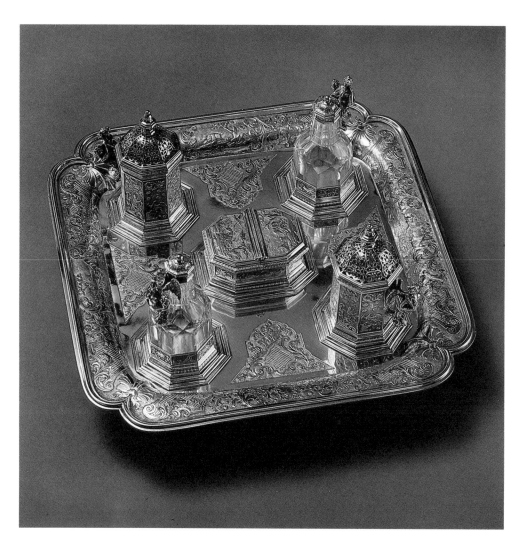

76 Cruet Stand

London, 1721–22
Paul Crespin (1694–1770)
Silver, glass
13.5 × 26 × 26
Colonial Williamsburg Foundation, Williamsburg,
Virginia
Reference: Glanville, 1987, fig. 29

Like miniature baroque palace pavilions
rising from parterred gardens, the richly
ornamented spice box, casters, and bottles
of this cruet set rest on a tray organized into
a careful symmetrical arrangement. The
individual components of the set are alive
with engraved, embossed, and cast orna-
ment, including four hunting scenes around
the rim of the tray, vignettes from *Aesop's
Fables* on the sides of the casters, and bold
winged-caryatid handles throughout.

The various silver and glass containers
for spices and sauces used at the table were
first organized into cruet stands in the late
seventeenth century. Although this set dates
from 1721, the goldsmith Paul Crespin,
whose parents had emigrated to London
with other Huguenots, was still working
very much in the French baroque idiom.
 DSS

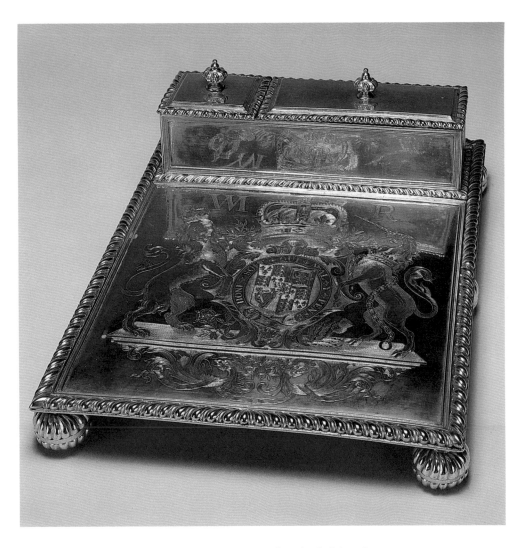

77 Caddinet

England, c. 1695
Maker: PR
Silver gilt
14 × 28.5 × 34.3
Private collection

Caddinets were rare in England and were used solely by royalty in the late seventeenth century. Taking the form of a rectangular tray with compartments at one end for cutlery and spices, they were topped with a napkin and placed before members of the royal family at state banquets. The first known English caddinet was used in 1661 at the coronation of Charles II, who may have seen similar pieces used at table during his years of exile on the Continent (see Oman, 1958).

Three caddinets, two silver and one silver-gilt, are listed in the 1697 inventory of William III's silver plate (Drossaers and Lunsingh Scheurleer, 1974, 1:417, nos. 114, 115). Two pieces made prior to William and Mary's coronation, in 1683–84 and in 1688–89, with arms added later, are presently in the English royal collections. This third silver-gilt caddinet, with its lavishly engraved royal coat of arms and heavily gadrooned borders, finials, and ball feet, is characteristic of full-blown William and Mary style presentation silver.

The monogram of William IV on the front of the box was added during that monarch's reign (1830–37), and the caddinet is thought to have been a gift from the king to his mistress, Mrs. Jordan. It has since passed by family descent to the present owner.

DSS

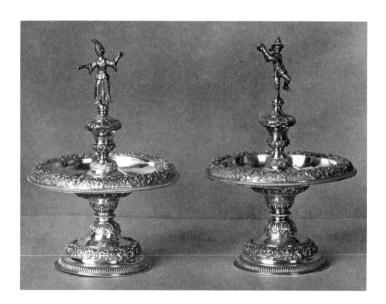

78 Pair of Salts

Leeuwarden, 1715–35
Johannes van der Lely (c. 1673–after 1749)
Silver
17.8 × 12.2 (each)
Rijksmuseum, Amsterdam

The continuing popularity of Louis XIV
style design and the strong influence of
Marotesque ornament in Friesland is evi-
dent in this pair of silver salts made in
Leeuwarden around 1715 to 1735. They
were crafted by Johannes van der Lely, a
member of the foremost family of local
goldsmiths. Rare in form, they include
gadrooned borders, floral and acanthus
bands, and dancing male and female
figures surmounting urn-shaped finials.

 DSS

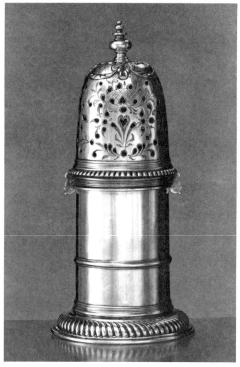

79 Caster

New York, c. 1700–1710
Bartholomew Le Roux (c. 1663–1713)
Silver
20.3 × 6 (lip) × 9.5 (base)
Yale University Art Gallery, New Haven,
Connecticut, Mabel Brady Garvan Collection
References: Buhler and Hood, 1970, 2:19, no. 565;
Hood, 1971, 72, fig. 58

This monumental caster was made by Bar-
tholomew Le Roux, a London-born silver-
smith of French Huguenot descent. Sets of
casters, customarily including a larger one
for sugar and a smaller pair for pepper and
mustard or for two kinds of pepper, were
made from the reign of Charles II onward.
A smaller, seemingly identical caster by Le
Roux, in a private collection, indicates that
the silversmith may have made such sets
(Buhler, 1956, 22, no. 206). Singly or in
sets, casters of such strong cylindrical form,
impressive scale and rich ornament suggest
an elegant style of dining in early New York.

 The caster, very clearly in the English
William and Mary taste, could be compared
with numerous contemporary English ex-
amples. Richard Biggs's caster of 1701 in the
Wadsworth Atheneum is noticeably similar
except that its foliate ornamentation below
the finial is applied cut-card work, while Le
Roux's is chased (Miles, 1976, 114, no. 141).

 PMJ

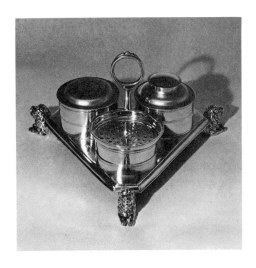

80 Cutlery

The Hague, 1674
Matheus Loockemans
Silver
L. 18.1, 18.3, 21
Haags Gemeentemuseum, The Hague
Reference: Haags Gemeentemuseum, 1967, no. 61

Full sets of cutlery—including knives, forks,
and spoons—were still relatively rare at the
time this set was made. The fashion for
matched eating utensils spread from the
court of Louis XIV to Holland and England
in the last quarter of the seventeenth cen-
tury. This set shows the kind of French-
style strapwork, scroll ornament, and masks
that were to become so popular in the
Netherlands.

 DSS

81 Inkstand

Boston, 1710–20
John Coney (1656–1722)
Silver
10.8 × 19.69
The Metropolitan Museum of Art, New York,
Bequest of Charles Allen Munn, 1924
Reference: Safford, 1983, 30–33, figs. 37–38

The only known American inkstand from
the William and Mary era, this example is
of an unusual triangular shape that has no
specific precedent. With its handle, the
form is reminiscent of cruet frames. Coney's
choice of three-dimensional lions as sup-
ports for the inkstand has both Dutch and
English precedents. Indeed, the English
inkstand that is probably the largest and
finest of the seventeenth century is one with
lion supports made in 1639 by London
silversmith Alexander Jackson and richly
decorated in the manner of Dutch sil-
versmith Christian van Vianen (Clayton,
1971, 10).

 A particularly intriguing comparison
can be made between the American ink-
stand and two English ones in the royal
collections, which also rest on cast lions.
Although inkstands were not restricted to
royal use, as were caddinets, they were
expensive appurtenances, indicative of
status. The wafer box of Coney's inkstand is
engraved with the Belcher family crest,
suggesting that it was made for Jonathan
Belcher, a wealthy Bostonian who became
governor of Massachusetts and, later, of
New Jersey. Ownership of such an object,
especially one with lion supports, might
have brought Belcher an aura of near-
royalty.

 PMJ

82 Pair of Pistols

Leeuwarden, c. 1705
Gerrit Penterman the Elder (active 1673–1720)
Walnut, steel, partly gilt
L. 51.6 each
The Walters Art Gallery, Baltimore
References: Pierpont Morgan Library, 1979, no. 78;
Hoff, 1978, 114– 15

Made in 1705 for the Frisian stadholder
Johan Willem Friso, the carved wooden and
gilt steel embellishments on this pair of
flintlock pistols is very much in the Marot-
inspired style of later Leeuwarden wood-
and metalwork. In addition to the stad-
holder's coat of arms, with ducal coronet
and lion supporters, the pistols are orna-
mented with classical figures of Victory,
Flora, and Terpsichore, and panels of ani-
mals and foliage in scrollwork frames.

 DSS

84 Case Watch with Alarm

London, c. 1690
Case marked *ALR* (probably Adam and Lewis
Romeau)
Movement by Nicolas Massy (or Massey) (1641–1698)
Silver, gilt brass, steel
Diam. 5.7
The Metropolitan Museum of Art, New York, Gift of
J. Pierpont Morgan, 1917

Like many other Huguenot watchmakers,
Nicolas Massy emigrated to London in the
1680s from the provincial town of Blois, a
center of French watchmaking. The case
may also be the work of Huguenot crafts-
men working in London. Small pocket
watches like this one were often embellished
with ornament derived from prints pub-
lished by designers such as Daniel Marot
and Simon Gribelin (see Nos. 40, 121, and
Figs. 84, 86).
 DSS

83 Traveling Clock with Alarm and
 Calendar

London, c. 1700–10
Joseph Paulet
Silver, silver gilt
22.9 × 10.2 × 6.4
The Metropolitan Museum of Art, New York, Gift of
Irwin Untermyer, 1964
References: Metropolitan Museum of Art, 1977, p.
8–9, pl. 10; Vincent, 1983, figs. 1, 7

Small metal-cased clocks, fitted with spring
balance, calendar, and free-swinging handle
at the top, were used by late seventeenth-
century and early eighteenth-century trav-
elers. The delightful pierced, engraved, and
repoussé silver case of this clock is covered
with decoration resembling the ornamental
prints published by Simon Gribelin. The
maker has been identified as Joseph Paulet,
a Huguenot craftsman working in London,
who produced a number of charming travel-
ing clocks and watches, in spite of his failure
to be accepted into the clockmakers' com-
pany.
 DSS

Furniture

Sculptural forms, rich surface ornamentation, and coordinated suites were all important characteristics of William and Mary style furniture. Skilled carvers, turners, and gilders were responsible for tables, stands, and the frames of chairs and stools. Marquetry craftsmen working in colored woods, ivory, tortoiseshell, and brass inlays embellished the surfaces of all kinds of furniture, most spectacularly the large cabinets decorated with floral bouquets and heraldic images. Matched suites of seating furniture and coordinated groupings, such as table, pier glass, and paired candlestands, were made in a wide variety of materials and finishes, from solid silver to dark, lustrous ebony.

85 Silver Mirror and Table

London, c. 1695
Andrew Moore
Silver
Mirror: 227.3 × 120.6
Table: 83.8 × 122 × 73.6
Her Majesty Queen Elizabeth II
References: Hayward, 1958, figs. I, II; Hayward, 1959, 59, pls. 84, 85A, 86; Oman, 1978, 64, fig. 70; Edwards, 1983, 307, 310, fig. 14, 319–20, fig. 23

This matching mirror and table, with their gleaming surfaces and rich sculptural details, are rare examples of royal silver furniture from the William and Mary period. Presented to William III by the Corporation of the City of London and made by the goldsmith Andrew Moore of Bridewell, they may once have been flanked by a pair of matching silver candlestands. The top of the table is engraved with a magnificent royal coat of arms with supporters and military trophies, and the four corners contain emblems of England, Scotland, Ireland, and France amid acanthus tendrils and cherubs. The initials of the unidentified engraver, *R. H.*, are signed on the central panel. The pineapple crowning the juncture of the stretchers under the table is one of the earliest uses of this popular decorative motif. The crest rail of the mirror is also crowned by a royal coat of arms with supporters, and an embossed band of flowers and fruit matches the frieze of the table.

Unlike earlier silver furniture, which was composed of thin sheets of metal laid over a wooden core, these pieces are of solid form. Silver furniture had been popular in French, Dutch, and English royal households during the previous decades but was less favored by the 1690s. A pair of silver andirons ornamented with cherub figures and the cipher of William III, also made by Andrew Moore in 1696, is part of the English royal collection, as well.

DSS

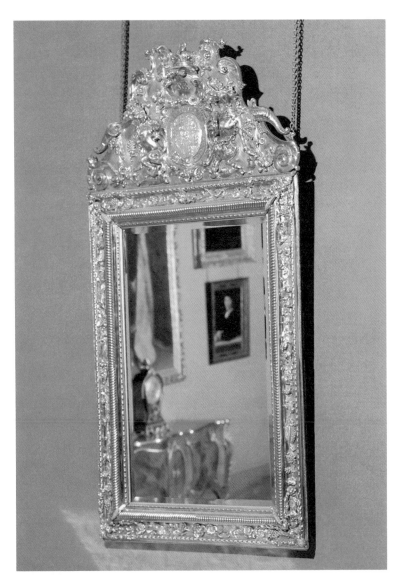

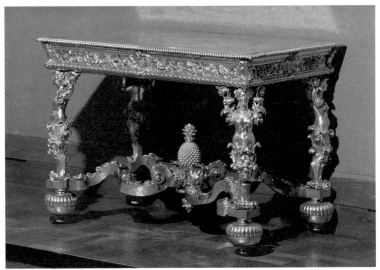

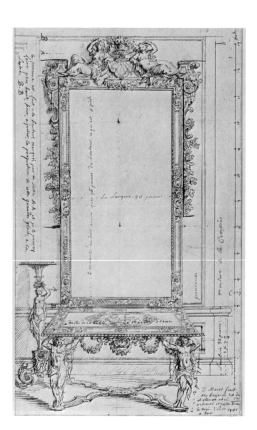

86 Design for Mirror, Table, and Candlestand

The Netherlands, 1700–01
Daniel Marot (1661–1752)
Pen and black and brown ink
40.4 × 24.5
Inscribed at lower right in pen and black ink: *D Marot fecit / ala Haye ce 28 dec. / 1700*, and in pen and brown ink: *et elle on est cé / acheveé et posse den / le mois d'oust 1701 / a Loo*; on the top of the table in pen and brown ink: *la dessus dela table est de marbre blanc;* at upper left margin in pen and brown ink: *le paneaux est, fait ala hauteur, marquér par la Lestre A A, et je le pouvray / faire plus, haut, pour, ajuster, La proportion de cette grande glace, a la / Lestre B B;* on verso: *1701 / table et miroire / doré pour Loo ce 17 sep., / sa sculpteur coute 400 fl*
Rijksprentenkabinet, Rijksmuseum, Amsterdam
References: Ozinga, 1938, pl. 8.; Smith, 1967, pl. 7; Liefkes, 1975; Thornton, 1978, fig. 51; Pierpont Morgan Library, 1979, no. 69

The suite of mirror, table and candlestand (presumably one of a pair) in this drawing was designed by Marot for Het Loo. The bold sculptural decoration and caryatid figures of all three pieces follow designs by Le Brun for the famous silver tables and guéridons lining the Grande Galerie at Versailles. A 1713 inventory for an antechamber in King William's apartments at Het Loo lists "a marble table with a square base, carved with figures and festoons, gilded; and two guéridons similarly carved, all with green covers; . . . a large mirror with gilded frame" (Drossaers and Scheurleer, 1974, 1:667, nos. 528, 530). The notes written on the drawing indicate that the marble top was white and that the whole suite was gilded. Other inscriptions provide notes concerning size—about thirteen feet tall—and scale, as well as directions for adjusting the surrounding wall panel to the tall mirror. Marot had been involved in the renovation of Het Loo for William III from 1686 and had provided designs for various interiors, staircases, and room arrangements, as well as for the gardens, pavilions, and decorative urns. A pair of gilded guéridons in the Rijksmuseum closely resembles the candlestand in this drawing (Fig. 14).
DSS

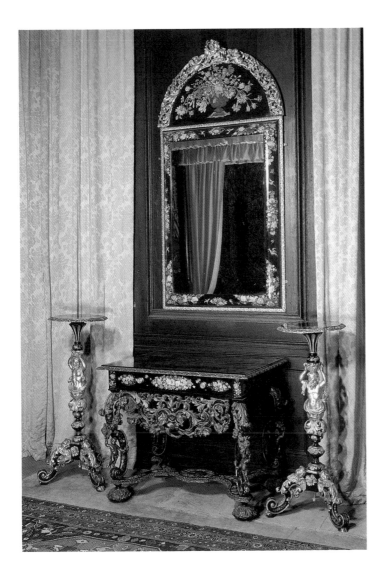

England, c. 1703
Attributed to John Guilbaud
Carved, painted, and gilded wood, glass
Mirror: 175 × 93 × 13: table: 84 × 106.5 ×66;
candlestands: 110 × 53
The Most Honourable The Marquess of Linlithgow,
Hopetoun House, Nr. Edinburgh, Scotland
Reference: Jackson-Stops, 1987, 120–121, pl. 14, fig. 2

The introduction of matching suites of furniture during the seventeenth century was consistent with the strong sense of unity so important to the baroque concept of interior decoration. This set of table, mirror, and paired candlestands represents one of the more impressive types of such matching suites. As well as having richly carved and gilded decoration, the pieces are "Japanned" on a black ground in imitation of oriental lacquer, but with floral garlands painted in a wholly European manner. In form, they relate quite closely to designs by Daniel Marot. The suite is attributed to the Huguenot John Guilbaud of "The Crown & Looking-Glass," Long Acre, London, who supplied two overmantel mirrors for Hopetoun House in 1703, and whose trade label states that he sold "all manner of Cabbinet work and Japan Cabbinets, Large Tables, Small suets of all manner of Looking Glasses, Pannells of Glasse, Chimney peaces and all sorts of Glasse Sconces." He is also likely to have been the "John Guilliband" who in 1690 made two writing desks "inlaid with flowers" for Queen Mary.

Sets of furniture of this kind were usually found in state bedrooms or dressing rooms, to judge by inventories of the period. They were invariably placed against the wall between two windows (hence the term "pier glass" and "pier table") so that in daylight hours the mirror would reflect those carrying out their toilet to the best advantage; candles set on the stands to either side would produce a similar illuminating effect after dark.

DSS

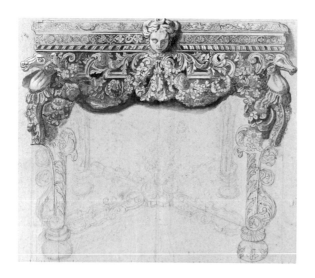
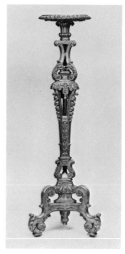

88 Design for Table

England, late 17th century
Pen and brown ink, gray and yellow washes, black
chalk on blue laid paper
45.7 × 54.7
Yale Center for British Art, New Haven, Connecticut,
Paul Mellon Collection

Probably representing a design for silver or
gilded wood furniture, this drawing shows a
table ornamented with a mask of Diana,
crowned by a crescent moon, and with
horse heads at the corners, perhaps sup-
porters of a family coat of arms. It may have
been designed en suite with a mirror and
candlestands and would have been appropri-
ate for a stylish bedroom, dressing room, or
closet.

DSS

89 Candlestand

England, c. 1701
Jean Pelletier (active in England c. 1690–1710)
Carved and gilded wood
155 × 56 × 48
Her Majesty Queen Elizabeth II

Tall candlestands, or guéridons, popular in
France, the Netherlands, and England,
were made to flank matching tables and
mirrors or were ordered in multiple pairs to
be placed against the walls or in the corners
of a room. Carved and gilded stands like this
one replaced the silver guéridons at Ver-
sailles, which were melted down in 1689.
Others were made of turned or carved
walnut, lacquered wood, marquetry, or
boulle work. A candelabrum, perhaps of
silver, gilt bronze, or brass, with glass
drops, would have been placed on top. Tall
candlestands went out of fashion in the
early eighteenth century and were replaced
mainly by wall sconces.

 The scrolled tripod foot and restrained
carved ornament of this candlestand reflect
the Louis XIV style designs carried to
England by Huguenot craftsmen like Jean
Pelletier, its maker, in the 1680s and 1690s.
Pelletier was in Amsterdam by 1681 and
later followed William III to England,
where he provided a number of carved and
gilded tables, candlestands, screens, and
mirrors for the royal palaces. This stand is
one of a pair from two sets made by
Pelletier for Hampton Court Palace in
1700–1701. Pelletier was also employed by
the Duke of Montagu, Master of the Ward-
robe and a devoted patron of Huguenot
artists, both at his house in Bloomsbury and
at Boughton.

 Similarities can be seen between this
candlestand and the "Grand Gairidons" in
Marot's print for silver designs (No. 59) and
the stand in Marot's drawing for candle-
stand, table, and mirror (No. 86).

DSS

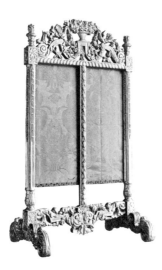

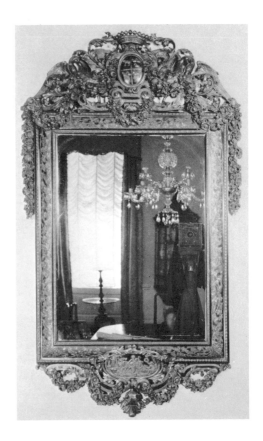

90 Sliding Fire Screen

England, c. 1690
Attributed to Jean Pelletier (active in England c. 1690–1710)
Carved and gilded walnut, damask
119.5 × 68 × 46
The National Trust, Knole (Sackville Collection)
References: Edwards, 1983, 2:58–59, fig. 4; *Knole*, 1982, p. 31– 32; Murdoch, 1985, no. 287

This carved and gilded fire screen is attributed to Jean Pelletier on the basis of another related example by him at Hampton Court Palace and a documented picture frame with almost identical carving at Boughton. The carved crest rail of this screen includes a vase of flowers surrounded by two birds holding garlands of flowers. Flaming urn finials crown the side columns, and the stretcher is formed of sculpted strapwork and acanthus. The screen sits on large scroll feet similar to those on contemporary candlestands, with which it might have been made en suite. Related carved detail can also be seen in mirror surrounds and picture frames from the same period.

Sliding fire screens, also known as *écrans à coulisse*, introduced in the late seventeenth century, offered a central leaf that could be adjusted to various heights according to the user's needs. Frames were made most often of turned or carved walnut, sometimes gilded, and the screens were covered with velvet, damask, or needlework. Several sliding screens are listed in the English royal accounts. An inventory of Kensington Palace from 1697 lists a "slidinge fire skreen, one side embroidered with silke" in the king's library (Lunsingh Scheurleer, 1960–62, 22). Others are listed with fringes of silver or gold.

DSS

91 Frame with Mirror

The Netherlands, c. 1680–1700
Johannes Hannart (d. 1709)
Boxwood, ebony, glass (modern)
167.7 × 99
The Metropolitan Museum of Art, New York, Gift of Irwin Untermyer, 1964
References: Metropolitan Museum of Art, New York, 1958, 79, pls. 344, 345; Metropolitan Museum of Art, New York, 1977, no. 185.

One of a pair made for two marriage portraits, this large frame is surmounted by a crest carved with a coat of arms, birds, flowers, acanthus leaves, and garlands. Its mate, now in the Rijksmuseum, has a cipher in place of the arms (Rijksmuseum, 1952, 262–63, no. 342). The panel at the base is carved with a scene of putti and sheep with wreaths and floral garlands, perhaps armorial in meaning, and also with the signature of the maker. Although originally designed to surround a painting, the frame shows similarities to designs by Marot for mirror frames with carved ornament extending beyond the rectangular edges at top, bottom, and upper sides (see No. 92). Born in Hamburg, Hannart became a master in 1683 and worked in Leyden and at The Hague. He is one of a group of sculptors who provided work for William's restorations at Het Loo.

DSS

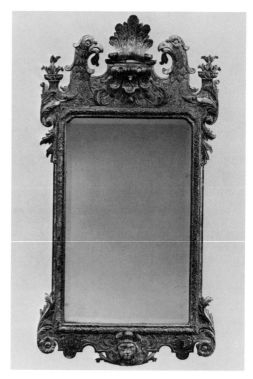

92 Design for Mirrors and Sconces

The Netherlands, c. 1712
Daniel Marot (1661–1752)
Etching
26.5 × 18.5
Ecole Nationale Supérieure des Beaux-Arts, Paris,
Collection Le soufaché

Illustrated in this print by Marot are two
large frames for mirrors, both with vigo-
rous carved ornament typical of his work.
The lion supporters of the coat of arms on
the frame at the top left and the large
acanthus scrolls, diapered backgrounds, and
female mask on the other frame are all
familiar motifs from Marot's vocabulary of
ornament. Two of the sconces illustrated
below, with polished, slightly domed backs,
are of a type especially popular in state
bedrooms from the period (see No. 127).
The third is backed by a plate of mirrored
glass, an especially reflective surface, and is
similar in design to the mirrored sconce in
the J. Paul Getty Museum (No. 126). The
Marotesque carved ornament of the English
gilded mirror (No. 93), reconfirms the im-
portance of his published prints in dis-
seminating Louis XIV style ornament.
DSS

93 Looking Glass

London, c. 1700–1710
Spruce, glass
142.8 × 74.9
The Henry Francis du Pont Winterthur Museum,
Winterthur, Delaware
Reference: Downs, 1952, fig. 242

This looking glass is believed to have been
presented to Pieter Schuyler of Albany
when he visited London in 1709. The
scrolled outline, with its upper central
element of a shell-like motif with pendant
lambrequins, and the mask in the lower
frame are typical elements in designs by
Daniel Marot and his contemporaries.

In addition to its original candle
branches, the frame seems to be missing
some decorative details below the mask at
the bottom.
PMJ

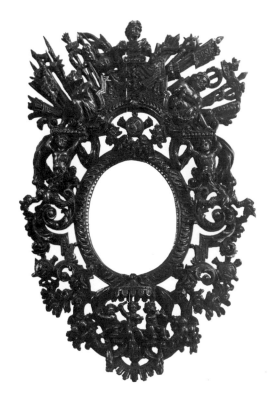

94 Design for Grotesque Ornament

The Netherlands, c. 1690
Daniel Marot (1661–1752), or a follower
Pen and ink
41.9 × 18.7
The Board of Trustees of the Victoria and Albert
Museum, London

In its vases, masks, and putti punctuating
leafy arabesques, this drawing, possibly of
etched or painted decoration for a looking
glass, reflects Marot's other designs for tall
vertical panels. The widespread popularity
of Marot's designs inspired a number of
imitators of his style, and this drawing may
have been the creation of one of these
followers.

 The production of large cast plates of
glass was first perfected in France only at
the very end of the seventeenth century, so
looking glasses were often made up of two
or more panes of silvered glass. The hori-
zontal band of decoration a quarter of the
way down in this drawing might have served
to hide the seam where two panes of glass
would meet.

 DSS

95 Frame

The Netherlands (?), early 18th century
Boxwood
32.4 × 21 × 2
The Metropolitan Museum of Art, New York,
Bequest of Irwin Untermyer, 1973

The bouquet of military trophies crowning
the top of this delicately carved frame was a
motif especially favored by William III, who
spent so much of his life at war with France.
The same motifs can also be seen in wall
paneling, tapestries, Delftware, and other
furnishings made for his houses (see Nos. 1,
35, 159). The strapwork with caryatid sup-
ports, the trio of putti, and the baldachin
surrounding the rest of the frame follow the
designs of Marot.

 DSS

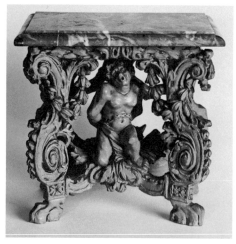

97 Model for Table

Dordrecht, The Netherlands, c. 1700
Hendrik Noteman
Terra-cotta
7.2 × 11.8
Museum Mr. Simon van Gijn, Dordrecht
References: Lunsingh Scheurleer, 1974, fig. 10;
Ruempol, 1982

Dutch carved furniture of the late seven-
teenth century combined a native tradition
for heavily sculptural forms with the new
taste for classical ornament spreading from
the court of Louis XIV in France.

Hendrik Noteman, who also carved
picture frames (see No. 96), sculpted this
model of a table in terra-cotta. Such models
were worked up for special commissions to
be submitted to patrons for approval. The
chained figure at the center of the large
volutes, garlands, and paw feet of the base
of this table probably represents Victory,
and the table may have been part of a larger
scheme of room decoration with specific
symbolic meaning. The table made from the
design of this model still exists in a Haarlem
collection (Lunsingh Scheurleer, 1974,
fig. 11).

DSS

96 Portrait of Hendrik Noteman

The Netherlands, 1698
Aert de Gelder (1645–1727)
Oil on canvas; carved and gilded oak frame
85 × 68.3; 103 × 85.5 × 10 with frame
Dordrechts Museum, Dordrecht
Reference: Ruempol, 1982

This portrait of Dutch sculptor Hendrik
Noteman, shown with a woodworking tool
and a carved bust in the background, was
painted by his friend Aert de Gelder. The
sitter's "antique" costume and the warm
colors of the canvas reflect de Gelder's
earlier training under Rembrandt. The oval
frame, with its restrained carving of lambre-
quins, sunflowers, tulips, and leaf orna-
ment, was made by Noteman himself, along
with a matching one containing the portrait
of his wife.

DSS

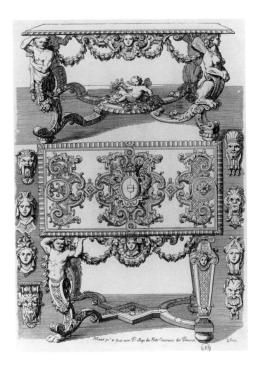

99 Dressing Table (Toilet Table)

Boston, 1705–20
Walnut and pine
77.4 × 85 × 50
Private Collection

98 Designs for Tables

The Netherlands, c. 1712
Daniel Marot (1661–1752)
Etching
28 × 20
Ecole Nationale Supérieure des Beaux-Arts, Paris,
Collection Le soufaché

Marot included these two designs for tables, one with its top tipped up to show the engraved ornament, in his *Nouveaux Livre d'Orfevrerie*. Based on the silver furniture designed by Le Brun for Versailles, tables like these were made of gilded wood and gesso in Holland and England, as well. A number of late seventeenth- and early eighteenth-century tables of very similar design are known, including a carved and gilded center table at Twickel Castle, Holland (Lunsingh Scheurleer, 1965, fig. 234). Its caryatid figures, garlands, scrolled legs, and putti resting on the crosspiece of the stretchers are closely related to the table design at the top of this print.

DSS

In New England the term most frequently used to designate this form, which emerged in the 1690s, was "toilet table." Such tables seem to have been made for ladies, who may have used them for writing as well as for dressing. The design of the table, with its cross-stretchers and the open central portion of its skirt, clearly allowed the lady to sit before it. Inventory references suggest that men in New England stood while they dressed, using dressing boxes that sat atop chests of drawers (Forman, 1987, 163–64).

Not all fine furniture from Boston in this era was veneered, as this table of solid walnut attests. It may have originated in the same shop as a dressing table in the Henry Francis du Pont Winterthur Museum (Acc. no. 58.574), with which it shares distinctive details of drawer construction and a skirt of virtually identical shape. Remnants of a painted surface that may have imitated oyster marquetry suggest that the Winterthur dressing table was once very fashionable-looking. The turned legs that grace this walnut table are among the most beautiful of New England and provide further evidence of an urban origin for this table. They are strongly related to the legs of a dressing table (with slate top similar to that of No. 175) with a history of ownership in the family of Thomas Hinckley (d. 1706), the last governor of Plymouth Colony prior to the merger with Massachusetts Bay Colony (Fairbanks and Bates, 1981, 66).

PMJ

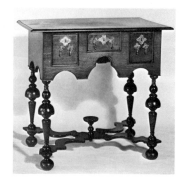

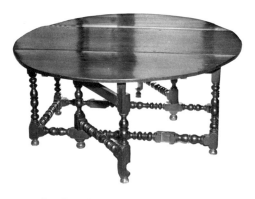

100 Dressing Table (Toilet Table)

Philadelphia, 1700–25
Walnut and pine
75.5 × 84.1 × 51.4
Philadelphia Museum of Art, Elizabeth S.
Shippen Fund
Reference: Nutting, 1928, fig. 391

In Philadelphia, cabinetmakers charac-
teristically executed case furniture in solid
walnut. The complex pattern of the legs
incorporating a differentiated cup turning is
typical of Pennsylvania work, as is the
absence of a vase turning below the flaring
columnar portion of the leg. (In New
England, a vasiform turning at the base of
the leg would be the rule.) Other Pennsyl-
vania characteristics include the separation
between drawers; the elaboration of the
widest point of turned elements with incised
lines; and the preference for pairs of brass
pulls on drawers. Only in Pennsylvania
furniture, moreover, do cross-stretchers as
complicated in outline as these appear.

 The cross-stretcher base is a design
innovation in baroque furniture that seems
to have French roots. Its pattern of C-
scrolls, which Marot designed for the con-
sole table at Het Loo (No. 86) is a common
one, variously rendered on American fur-
niture. The stretchers on this Pennsylvania
table suggest a two-dimensional interpreta-
tion of three-dimensional scrolling stretchers
such as those on the silver table by Andrew
Moore (No. 85). The circular stand, placed
where the stretchers cross, originally must
have supported a ceramic vase or bowl. It is
clear evidence that Americans, like their
English and Continental contemporaries,
used ceramic vessels as ornament. (The
turned finial on the Boston dressing table
[No. 99] is a wooden substitute for such a
ceramic vessel.)
 PMJ

101 Gateleg Table (Dining Table)

Massachusetts, probably Boston, c. 1700
Walnut
78.7 × 178.4 × 208.8 (open)
Pilgrim Hall Museum, Plymouth, Massachusetts

Undoubtedly one of the earliest American
gateleg tables, this example is also one of the
grandest in scale. Made of walnut, it was a
stylish, and expensive, table in its day.

 The legs and stretchers of the table
establish a complex rhythm of bold turn-
ings, whose unusually robust quality sug-
gests an early date. In characteristic New
England fashion, the dominant element of
the legs is a mirrored pair of vasiform
turnings. (On New York tables, by contrast,
a stacked sequence of vase-shaped elements
on the legs is usual.) Typical New England
turnings are slenderer, however, more akin
to those on the Bowdoin family gateleg table
at Historic Deerfield.

 Although this table traditionally has
been thought to have belonged to Governor
Josiah Winslow (1628–1680), it cannot have
been made this early. Instead, it must have
belonged first to Governor Isaac Winslow
(1671–1738), son of Josiah and uncle of
silversmith Edward Winslow III (see Nos.
66 and 75). He and Sarah Wensley, daughter
of Elizabeth Paddy and John Wensley, were
married in 1700 in Boston. It seems likely
that the table was made for the couple at
that time. The table remained a prized
possession, for upon her death in 1754,
Sarah Wensley Winslow bequeathed her
"great walnut table" along with four family
portraits to her son John Winslow.

 Fortunately, this table has been spared
restoration. It originally was fitted with two
drawers, one at either end. These rested on
long strips of wood nailed in place that are
still intact. Their elementary nature sug-
gests an early solution to the problem of
supporting a dovetailed drawer.
 PMJ

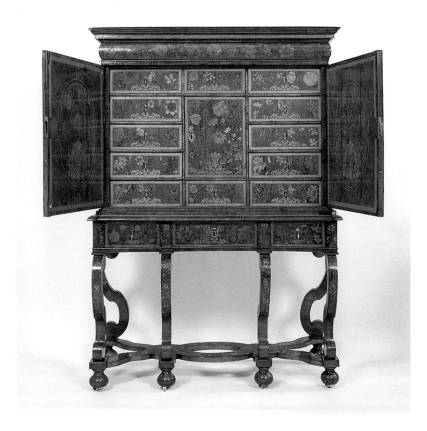

102 Marquetry Cabinet

Probably England, late 17th century
Oak, deal, walnut, other woods, bone
171.5 × 133 × 55.8
Cooper-Hewitt Museum, Bequest of Mrs. John Innes
Kane, 1926-22-43

Although simple rectangular cabinets deco-
rated with detailed inlaid pictures of vases of
flowers were probably first made in France
at the court of Louis XIV, they were most
likely ornamented by marquetry craftsmen
from the Netherlands. By the 1680s and
1690s they were also being produced in
Holland and England. The attribution of
such cabinets is not always clear, on account
of the frequent travel by marquetry artists
among the three countries. The cabinet-
maker Pierre Gole, for instance, one of the
originators of floral marquetry and an uncle
by marriage of Daniel Marot, moved from
the Netherlands to France to work for Louis
XIV in about 1640; his brother Adrian, also
a marquetry craftsman, worked for Princess
Mary in Holland; and his son Corneille
worked for William and Mary both in The
Hague and later in England.

Marquetry centers in the Netherlands
included the workshop of Jan Van Mekeren
in Amsterdam, Philippus van Santwijck at
The Hague, and Balter Gessing in Rotter-
dam. Similarities among the floral designs
produced at these shops and those created
by Gole and André-Charles Boulle suggest
a common design source, perhaps in some
instances engravings made after the flower
paintings of Jean-Baptiste Monnoyer (see
No. 106).

A frame with one long drawer, inter-
laced stretchers, and double-C-scroll legs
support this plain rectangular cabinet with
convex cornice molding. The two broad
doors reveal twelve small drawers and one
locked central compartment. Large panels of
bouquet-filled flower vases resting on plat-
forms and surrounded by acanthus scrolls
cover the outside of the cabinet, and the
drawers inside are faced with colorful inlaid
tulips, peonies, roses, carnations, lilies, jon-
quils, and sunflowers. The high quality of
the marquetry and certain constructional
details of the cabinet, combined with its
shape and overall proportions, suggest that
it may have been made by a Dutch crafts-
man working in England. (This photograph
was taken before recent restoration on the
cabinet.)

DSS

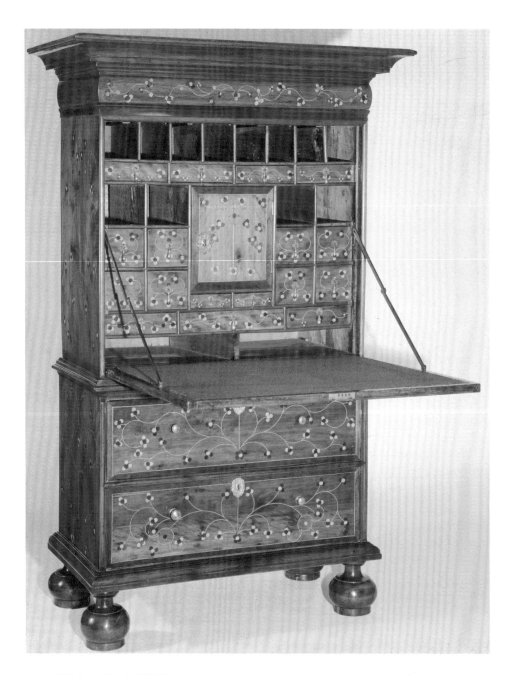

103 Fall-front Desk (Writing Cabinet)

Flushing, New York, 1690–1720
Red cedar, walnut, lightwood, tulip
169.5 × 86.4 × 106.7 (at cornices) × 55.9
Museum of the City of New York, Gift of Mrs. Elon
Huntington Hooker
References: Fairbanks and Bates, 1981, 58; Miller,
1956, no. 18

This desk, having probably originally be-
longed to Joris Brinckerhoff (1664–1729) or
Derick Brinckerhoff (1667–1778), both suc-
cessful farmers in Flushing, New York,
descended in the Brinckerhoff family. A
form popular in England in the seventeenth
century, it is also the form of the earliest
signed and dated piece of American fur-
niture, Edward Evan's desk of 1707, now at
Colonial Williamsburg (Fig. 77). The
Brinckerhoff desk is perhaps the most exu-
berant piece of American furniture from
this era. Its ornamental inlay of stylized
tulip-and-vine motifs is a reflection, though
distant, of the elaborate marquetry of Dutch
baroque cabinetwork, which was imitated in
England.

 PMJ

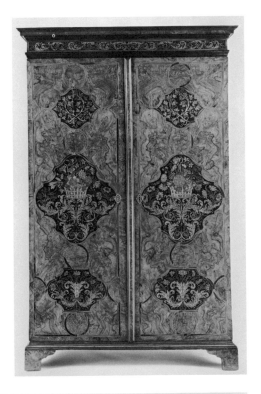

104 Armoire

Probably France, c. 1700
Oak, burl-walnut, and other woods
213.3 × 137.1 × 60.9
The Philadelphia Museum of Art, Gift of the Family
of Wharton Sinkler

Both the form and the rich use of floral and
arabesque marquetry decoration on the
doors of this tall cabinet recall the designs of
the French *ébéniste* André-Charles Boulle.
Brass, tortoise shell, and gilt bronze were
preferred for Boulle's arabesques, but the
swirling burl walnut veneers and multihued
inlaid woods used here create an effect
nearly as colorful, if not quite as sumptuous
as those materials. Garnitures of blue-and-
white oriental porcelains or Dutch Delft-
ware grouped on the tops of these flat-
topped cabinets, often on stepped shelves,
would have created an even more colorful
overall effect.
 DSS

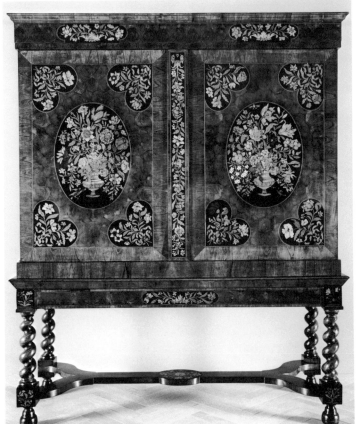

105 Marquetry Cabinet

The Netherlands, c. 1690
Oak, walnut, other woods, ivory
204.5 × 172 × 62.8
The Carnegie Museum of Art, Pittsburgh, Berdan
Memorial Fund, Ailsa Mellon Bruce Fund, Decorative
Arts Purchase Fund, and DuPuy Fund

Inspired by the flower paintings that had
been popular since the beginning of the
seventeenth century and by exotic new
colored woods imported from the Orient
and the New World, Dutch marquetry
artists were producing sumptuously detailed
decoration on cabinets by the 1680s. While
similar marquetry cabinets were made in
France, the Netherlands, and England, the
large size and rather square proportions of
this piece are typically Dutch.
 DSS

106 *A Bowl of Flowers and Perfume Burner*

England, c. 1692
Jean-Baptiste Monnoyer (1634–1699)
Oil on canvas
148.6 × 110.5 (178 × 127 with frame)
The Duke of Buccleuch and Queensbury, K.T.

This sumptuous flower painting by Monnoyer was part of a large set of overdoor and overmantel pieces (numbering about two dozen) executed for the Duke of Montagu's house in Bloomsbury during its decoration in the 1690s, probably under the supervision of Marot (Jackson-Stops, 1985, nos. 126, 127). Like other paintings in the series, it shows a large bowl filled with voluptuous flower blossoms surrounded by billowing folds of silk damask and fringed velvet. A classical Louis XIV-style gilt-bronze perfume burner, similar to the ones seen in Berain's buffet design (No. 34), sits in the foreground of the picture. The paintings were later moved to Boughton, the Duke's Northamptonshire seat.

Known as "Old Baptiste," Monnoyer was buried as a Protestant in London in 1699. He was probably trained in flower painting in Antwerp, worked under Le Brun at the Gobelins, and provided decorations for Versailles, Marly, the Grand Trianon, and other French royal residences. He had been brought over to England, along with other distinguished French artists, by the first Duke of Montagu. His broadly handled flower bouquets resemble contemporary Dutch marquetry patterns in furniture and the large tile pictures produced in Dutch potteries. A number of Marot's prints show designs for overdoors with scenes that are also similar to Monnoyer's paintings.

DSS

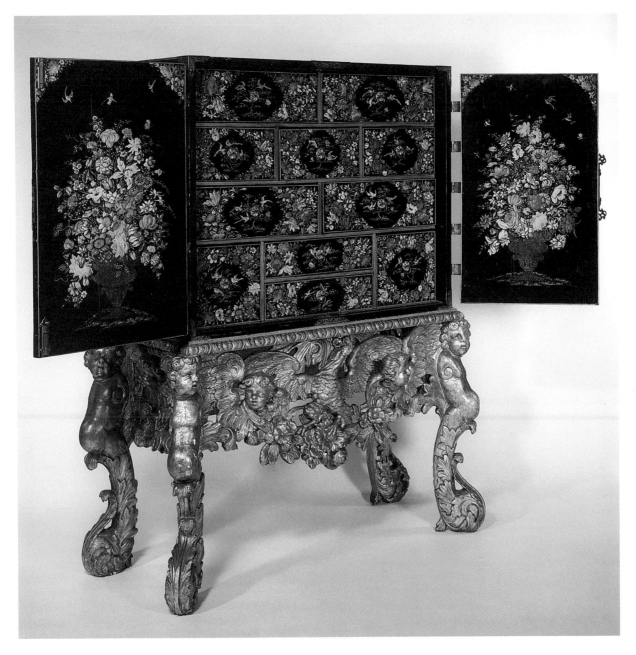

107 Cabinet on Stand

England, c. 1690–1700
Painted and silvered wood, brass mounts
161.8 × 104.7 × 59.6
The J. Paul Getty Museum, Malibu, California
Reference: Sassoon and Wilson, 1986, no. 264a

Dutch, English, and American cabinet-
makers all produced imitations of black-
ground oriental lacquer in the late seven-
teenth and early eighteenth centuries. John
Stalker and George Parker's *A Treatise of
Japanning and Varnishing*, published in
London in 1688, served as inspiration for
professionals and amateur craftsmen alike.

While some Western "japanned" pieces
closely followed oriental precedents, other
works like this chest were painted with
more traditional floral patterns. The carved
and silvered stand features a phoenixlike
bird with outstretched wings, putti, and
acanthus-scroll feet similar to those on
contemporary Dutch carved tables. The
engraved brass hinges, corner mounts, and
lock plate are based on oriental hardware.

 DSS

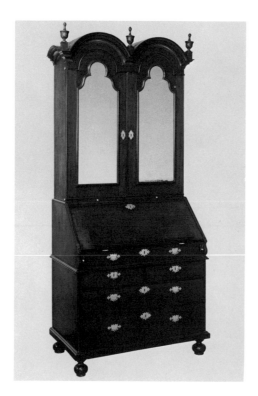

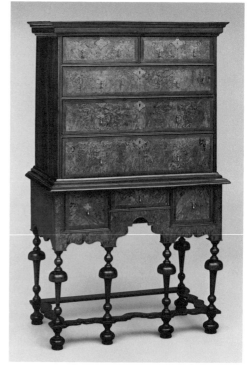

108 Desk and Bookcase

Philadelphia, c. 1720
Walnut and poplar
228.6 × 101.6 × 57.8; Depth, upper section: 29.8
Philadelphia Museum of Art, Gift of Mrs. John
Wintersteen
Reference: Philadelphia Museum of Art, 1976, 22–23

This desk, with its double-arch top, is a
unique example from Philadelphia but sim-
ilar to English desks of this era and to a
recently identified Boston one (Naeve and
Roberts, 1986, 51–53, fig. 38). English desks
of the form, both japanned, were owned in
Boston and New York (see Fig. 79). Further-
more, a japanned desk and bookcase, dated
1713, was made in London by William
Price, who immigrated to Boston in 1714. We
have yet, however, to discover an English
example with a Philadelphia history.

The maker of this desk has captured the
elegance of the form. The construction of
the desk is not the work of a London-trained
cabinetmaker, however. With the exception
of mitred dovetails that join the drawers, the
craftsmanship is surprisingly elementary for
such an elegant piece of furniture.

The desk appears to bear the signature
of its maker and a date (*D JOHN ⁶/₂₀*) written
in chalk script on the bottom of the book-
case section. It may be the work of David
John, son of Philip John, a joiner who
emigrated from Bristol, England. The feet
are modern replacements, as are the brasses.

PMJ

109 High Chest of Drawers

Boston, 1700–25
Walnut and maple veneered on pine; maple and pine
161 × 101.6 × 54.3
Museum of Fine Arts, Boston, Gift of Hollis French
References: Fairbanks and Bates, 1981, no. 56;
Randall, 1965, no. 51

A dynamic sense of movement enlivens this
high chest of drawers. Its shimmering ve-
neered surface is framed at the top and
bottom of the upper case by sequences of
stepped moldings. The drawers, surrounded
by a double-beaded molding, are bordered
by a double banding of veneered wood; the
fact that the grains in these bands run at
right angles to each other creates an illusion
of additional moldings. The overall result is
to entice the viewer's eye inward.

On the lower case the arched outline of
the skirt also suggests an interest in perspec-
tive reminiscent of Renaissance designs. The
arches are imitated in the stretchers that join
the legs; the stretchers become, in a sense,
shadows of the skirt. The legs form a
colonnade of balusters.

In Boston, high chests of drawers in
this style seems to have been made first by
the English-trained cabinetmaker John
Brocas. Once established as a fashionable
form, it continued in the colonies long after
it had lost favor in London, and was
modified to accommodate the succeeding
Georgian styles (so-called Queen Anne and
Chippendale).

PMJ

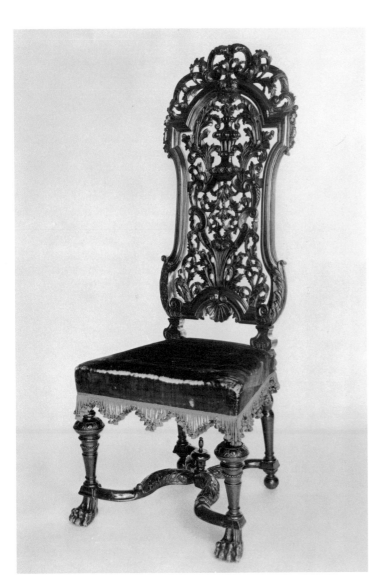

110 Side Chair

The Netherlands, c. 1690
Walnut, velvet-covered seat
139.1 × 57.2 × 48.3
The Metropolitan Museum of Art, New York, Gift of
Irwin Untermyer, 1964
References: *Catalogue of the Sallie A. Hert Collection*,
1949, lots 264–66; Metropolitan Museum of Art, 1958,
pls. 42, 43, figs. 65, 66

Although the tall, carved backs of Dutch
chairs of this type are apparently derived
from Marot's designs, no such chairs actu-
ally appear in his prints. Marot's chairs are
always upholstered, back and seat, and
usually trimmed with fringed borders. The
large suites of matching upholstered side
chairs, armchairs, and stools lined up
against the walls of Marot's rooms play an
integral part in the unified scheme of
decoration.

 Many variations on this type of chair
were made in the Netherlands and England
from around 1690 to 1700. This chair was
part of a set of at least six; two others from
the same set are presently in the William
Rockhill Nelson Gallery of Art and Atkins
Museum of Fine Arts, Kansas City.

 DSS

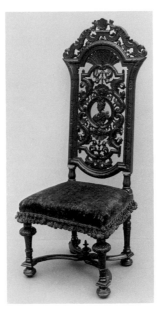

111 Side Chair

The Netherlands, c. 1690–95
Walnut, velvet-covered seat
137.8 × 53.3 × 45.7
The Metropolitan Museum of Art, New York, Hewitt
Fund, 1911

The tapering column legs and serpentine
stretchers of Dutch and English chairs like
this one follow contemporary French fash-
ion. Their high vertical backs carved with
Marotesque ornament are more Dutch in
character, however. Another side chair
carved with the same ornament is in the
collection of the Victoria and Albert Mu-
seum, London (Shearing, 1981, fig. 8).

 DSS

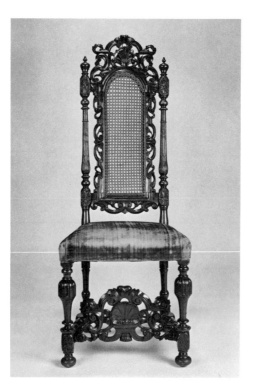

112 Side Chair

The Netherlands or England, c. 1690
Walnut, cane back, velvet-covered seat
131 × 52 × 45.5
Cooper-Hewitt Museum, Gift of Irwin Untermyer,
1950-4-1

Residual auricular ornament, popular earlier
in the seventeenth century, can be seen in
the carving of the back panel of this Dutch
side chair, although the rest of the chair
follows the latest fashions. Caned furniture,
light and comfortable, was adapted from the
Orient and became especially popular in
Holland, England, and America. Whereas
American chairs were usually caned on both
back and seat, English and Dutch examples
often combined caned backs with uphol-
stered seats.

DSS

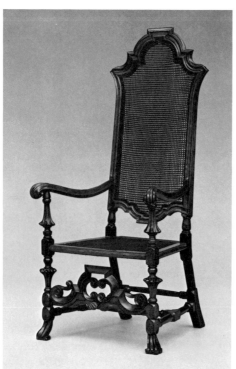

113 Armchair

London, c. 1700
Stamped *RS* and *CC* (initials of specialized carvers,
turners, or caners)
Walnut and cane
134.6 × 58.4 × 44.1
Museum of Fine Arts, Boston, Gift of a Friend of the
Department of American Decorative Arts and
Sculpture
References: Fairbanks and Bates, 1981, 70; Wadsworth
Atheneum, 1985, 124

Marked *X*, this armchair is from a presumed
set of twelve that descended in the pros-
perous Wyllys family of Hartford, Connec-
ticut, having belonged originally to Samuel
Wyllys (1632–1709) or Hezekiah Wyllys
(1672–1741). Its polyarched, molded crest
rail, flowing arms, and fluted baluster
shapes on the front legs and arm supports
clearly express the current style introduced
into England by Daniel Marot. A favorable
comparison can be made with a richly
upholstered, more elaborately ornamented
armchair made around 1700 by Thomas
Roberts for the Duke of Devonshire (now at
Hardwick Hall, Derbyshire; see Forman,
1988, fig. 150).

Chairs such as this one demonstrate the
level of sophistication in household furnish-
ings that style-conscious American colonists
achieved in this period. They also document
one principal means by which the William
and Mary style reached America: through
the importation of English furniture. The
caning on the chair was replaced in 1979.

PMJ

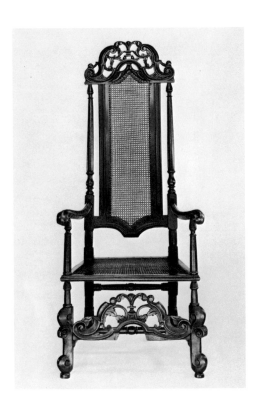

114 Armchair

Probably Boston, 1695–1710
Punched *I* with cross-serif (probably the initial of an
unidentified Boston caner working approximately
thirty years later)
American beech (*Fagus grandifolia*) and cane
142.3 × 63.6 × 68.6
Wadsworth Atheneum, Hartford, Wallace Nutting
Collection, Gift of J. Pierpont Morgan
References: Nutting, 1928, no. 1985

English cane chairs of this style were
imported in quantity to the colonies in the
1690s and represented the first type of cane
chair to express the classicizing rather than
floral baroque aesthetic. American-made
chairs in this style, however, are rare. This
armchair, virtually identical to English ex-
amples, is distinguished as American only
because the wood used is American, rather
than English, beech. It is probably the work
of a chairmaker who had recently immi-
grated to the colonies and chose beech
because he had used it to make similar
chairs in England. (William Hosley's study
of customs records dating between 1698 and
1710 [Public Record Office, Kew, Rich-
mond, Surrey] revealed a relatively low
value for cane chairs being shipped in
comparison to the value they were assigned
in Boston estate inventories. He, therefore,
has proposed that this and other chairs may
have been shipped from London unas-
sembled and then assembled and caned in
Boston.) Two side chairs in the Winterthur
Museum are so similar to this armchair that
they must have been made in the same
Boston shop. They are made of maple,
however, which New England chairmakers
had been using since the mid-seventeenth
century; the maker of this armchair must
have discovered maple to be a preferable
(and plentifully available) material and used
it for Winterthur's side chairs (Forman,
1988, 304).

The scrolls of the complex pattern on
the crest rail and the front stretcher are
disposed in the typical arching arrangement
associated with baroque designs. The stiles
and arm supports take their shape from
classical columns. The height of the chair,
the movement of its flowing arms, and the
out-turned, scrolled legs are suggestive of
Daniel Marot's published chair designs.
When in use, this armchair would have been
furnished with a plump cushion.

Minor restorations to this chair include
the carved fleur-de-lis on the front stretcher
and the feet just below the side stretchers.
The chair is painted black over a coat of
brownish graining.

PMJ

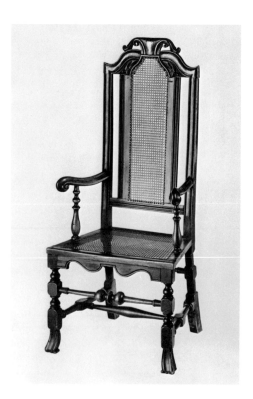

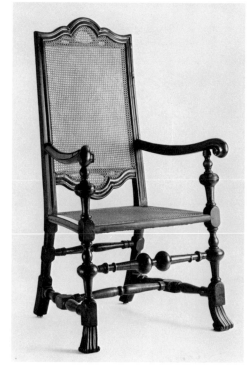

115 Armchair

Boston, 1720–35
Punched *I* with cross-serif on lower back rail
Maple and cane
128.91 × 59.37 × 41.59
Private Collection
Reference: Fairbanks and Bates, 1981, 70

This is one of five armchairs among approximately twenty-six chairs that form the largest group of related American cane seating furniture. Nineteen are marked on a rear stile or on the bottom back rail with a punched *I* with a cross-serif, presumably the initial of an unidentified Boston caner (see No. 114; Forman, 1988, 258, 265). Occurring noticeably later than Philadelphia chairs with molded stiles, they seem not to have been made much earlier than 1722, the date when Boston upholsterer Thomas Fitch began to produce leather-upholstered chairs with crook backs and molded, rather than turned, stiles.

Forceful, elegant forms derived from the fully developed late baroque in England, these examples are also the first American chairs to manifest the influence of oriental designs—in their double-ogee skirtboards and in the *ruyi* (a stylized mushroom, symbol of authority to the Chinese) central motif of their crest rails (Forman, 1988, 258).

Later additions of rockers have been removed, and the feet have been restored in their original conformation.

PMJ

116 Armchair

Probably Philadelphia, 1700–20
Black walnut (*Juglans nigra*)
112.1 × 58.1 × 41.2
The Henry Francis du Pont Winterthur Museum, Winterthur, Delaware, Gift of David Stockwell
References: McElroy, 1979, 65, fig. 1; Forman, 1988, 272–75

Philadelphia was founded during the era when the cane chair was becoming the most popular form of seating furniture in England, and most craftsmen who settled in Pennsylvania came directly from England. It is logical, therefore, that the earliest Pennsylvania furniture should be closely related to stylish English furniture of the day (Forman, 1988, 245). This cane armchair, with an unverified history of ownership, by Thomas Lloyd of Philadelphia would seem to support this reasoning. It is perhaps the American chair most closely related to designs by Daniel Marot—in its molded framing, scrolling arms, and bulbous baluster legs and arm supports. These balusters are made by gluing blocks

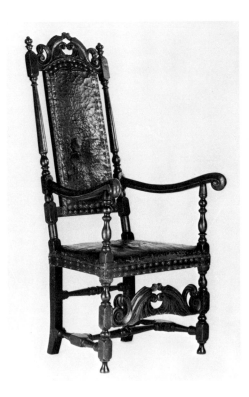

of wood to a narrower core of wood prior to turning, a typically English technique not characteristic of American work, although it was used in New England to fashion Spanish feet. Similar legs are found on a stool, now with an upholstered top (originally caned) at the Historical Society of Pennsylvania, in Philadelphia, although they are not common in Pennsylvania. The stool's history of having been among the furnishings of Stenton, James Logan's Germantown house, built in 1717, supports a Philadelphia origin for this splendid armchair.

The cane is a modern replacement, as is the right side stretcher. The lost sides of the two arm supports have been restored.

PMJ

117 Armchair

Boston, 1695–1710
American sugar maple *(Acer saccharum)*, red oak *(Quercus rubra)*, original Russia-leather upholstery
135.2 × 58 × 43.2
The Henry Francis du Pont Winterthur Museum, Winterthur, Delaware
References: Nutting, 1928, no. 1979; Fairbanks and Bates, 1981, 77; Cooper, 1980, 62, fig. 78; Forman, 1988, 308–10, no. 64

One of the earliest Boston-made leather-upholstered chairs, this armchair seems to have been modeled on Anglo-Dutch cane chairs (see Fig. 71) and is one of the highest-style chairs produced in the American colonies. Although no history of ownership for this chair is known, a virtually identical example is believed to have belonged to Richard Smith III (c. 1645–1720) of Smithtown, New York. Others, strongly related and also Boston-made, have New York histories of ownership, including one in the Henry Ford Museum, in Dearborn, Michigan, that seems to have belonged to Captain Pieter Schuyler (1657–1724), first mayor of Albany, and a side chair (Fig. 72) of nearly identical design, now in a private collection, that was owned by George Wilhelmus Mancius, a native of Holland who came to America and was minister of the Dutch Reformed Church in Albany. (The chair is stamped *MANCIUS* on the lower back rail.) These share specific New England attributes: distinctive arm supports, each consisting of a compressed baluster, an elongated baluster, a ball, and a grooved cone; lines scribed on the portion of the stile between the lower back rail and the seat; a collar combined with a capital on the columns of the stiles; and backward-raking rear feet. The fact that the chairs with histories are all from New York families offers verification of the lively trade with Boston, documented in the accounts of Thomas Fitch, Boston upholsterer. Indeed, with eleven chair-frame makers, eight carvers, and nine upholsterers working in Boston, this city must have dominated the furniture trade of New England in the first quarter of the eighteenth century (Forman, 1988, 314).

Approximately ¾ inch (1.9 cm) is missing from the bottom of the feet.

PMJ

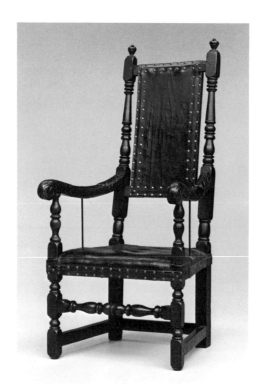

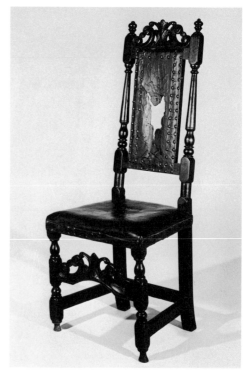

118 Armchair

New York, 1710–25
Maple, oak and original Russia-leather upholstery
120.6 × 60.3 × 45
Museum of Fine Arts, Boston, Arthur Tracy Cabot
Fund
References: Cooper, 1980, fig. 79; Fairbanks and Bates,
1981, 76; Forman, 1988, fig. 159

With its plain crest rail and turned front
stretcher, this armchair illustrates a prin-
cipal alternative to chairs of the same form
but with carved crest and stretcher. It is the
only surviving armchair of an important
school of New York chairmaking. Specific
characteristics of New York, as compared
with Boston, work include the complex,
turned stile having a short column with a
short baluster atop a longer baluster be-
neath; the flat-bottom cap above the longer
baluster; fat rings at the top and bottom of
the barrel-like turnings between the seat and
the lower back rail; rectangular rear and side
stretchers that enter the rear legs at the same
point; rear legs that extend straight to the
floor on the back side and are chamfered on
their front sides; and, for the turned front
stretcher the use of a piece of wood that is
thicker than the wood used for the leg so
that when the stretcher is fitted flush with
the front of the legs, it overhangs in the
back about ¼ inch.

 The chair is missing its small urn-
shaped feet; the iron tie rods bracing the
arms are nineteenth-century alterations.

 PMJ

119 Side Chair

New York, 1710–30
Maple, oak, and original leather upholstery
181 × 45.8 × 38.1
Albany Institute of History and Art, Albany, New
York, Gift of James Ten Eyck
Reference: Forman, 1988, 291, fig. 160

Although this chair represents a version of
the standardized leather chair produced in
quantity by Boston chairmakers in the first
quarter of the eighteenth century, it was not
made in Boston. It originated in a New
York chairmaker's shop; it thereby repre-
sents a third alternative available to New
Yorkers. They could purchase chairs made
locally but clearly Anglo-Dutch-inspired,
such as the preceding armchair; Boston-
made chairs in the English taste, which
were exported in some numbers to New
York; or, locally made chairs in the Boston
taste, like this one. Details indicating New
York rather than Boston manufacture in-
clude rings rather than incised grooves at the
base of the stiles' columns; the absence of
incised grooves on the barrel-like turnings
between the seat and the lower back rail; the
placement of both side and rear stretchers at
the same level; and the treatment of the top
edge of the upholstery on the chair back,
where the leather is pulled through a slit in
the straight (rather than arched) top back
rail and tacked to the back. Comparing this
chair with the Mancius family chair (Fig.
72) clarifies these differences.

 PMJ

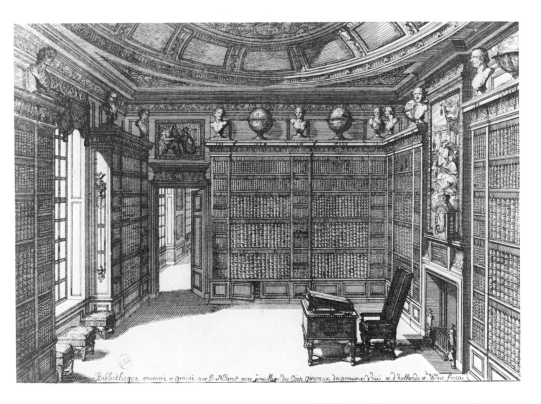

Bibliothèque *inventée, et gravée par D. Marot avec privilège des Etats généraux des provinces Unies et d'hollande et W.est Frise.*

120 William III's Library at Het Loo

The Netherlands, c. 1712
Daniel Marot (1661–1752)
Etching
17.3 × 27
Ecole Nationale Supérieure des Beaux Arts, Paris,
Collection Le soufaché
Reference: Thornton, 1984, fig. 100; Pierpont Morgan
Library, 1979, fig. 3

Busts like those on the bookcases of Marot's library are ubiquitous features of the classical baroque style. Recent research at Het Loo has indicated that the room was originally a porcelain cabinet planned for Queen Mary—hence its mirrored ceiling—and that it was adapted as a library for the king after her death in 1694 (Jackson-Stops, 1984, 1773). The Swedish royal architect Nicodemus Tessin, who saw Princess Mary's Audience Chamber at Honselaarsdijk in 1686, said, "The ceiling was covered with mirrors, so that the perspective was extended endlessly" (Upmark, 1900, 146).

According to the Het Loo inventory of 1713 (Drossaers and Lunsingh Scheurleer, 1974, 1:679), "De Bibliothek" contained "two pairs of globes, large and small" and was decorated with "two window curtains of green Italian taffeta, a lacquered Indian box for holding money and documents, and a new armchair with a cushion of red velvet, with gold silk fabric trimmed with lappets with a silver slipcover." This type of chair, comfortable and luxurious, was the ancestor of the wing chair. The barometer seen in the window bay, also mentioned in the inventory, still exists in a private collection in Holland.

LRS

Nouveaux Livre de Boites de Pendulles de coqs et Etuys de montres et autres necessaire au Orlogeurs. Invente par D. Marot Architecte. avec Privilege.

122 Clock

London, c. 1705
Thomas Cattell (active from 1679)
Ebony, silver, gilded brass
90.2 × 40 × 21
Mr. and Mrs. Glenn C. Randall

The scrolled volute sides, urn finials, and figural decoration of this rare English ebony-and-silver clock are reminiscent of both Marot's designs for bracket clocks and a group of timepieces made by Thomas Tompion, William III's most distinguished clockmaker. The clock shown here is fitted with an eight-day movement and signed by the maker (*Thomas Cattell, Londini Fecit*) on a cartouche just above the clock face on the front. An even more elaborate silver-mounted ebony clock with royal arms (now in the British Museum) was made by Thomas Tompion for William III, and another one, with figures of Christ and the four Apostles, for the king of Spain (The Time Museum, Rockford, Illinois).

DSS

121 Design for a Clock

The Netherlands, c. 1712
Daniel Marot (1661–1752)
Etching
27.7 × 18.5
Cooper-Hewitt Museum, Gift of Catherine Oglesby, 1958-120-9

Marot's highly sculptural design for a bracket clock owes much to the inlaid and gilt-bronze-encrusted timepieces of André-Charles Boulle. Shown on the title page of Marot's *Nouveaux Livre de Boites de Pendulles de Coqs et Etuys de montres et autres necessaire au Orlogeurs*, this clock case is framed by robust volute corner supports with caryatid figures and flaming urn finials, and is crowned by a high domed roof surmounted by a cherub. Acanthus tendrils, strapwork, and figural mounts enliven the surface. At the top and sides of the design, Marot includes schemes for the engraved ornament of smaller clock parts and cases, similar to those published by the Huguenot silver engraver Simon Gribelin (No. 40 and Fig. 86).

DSS

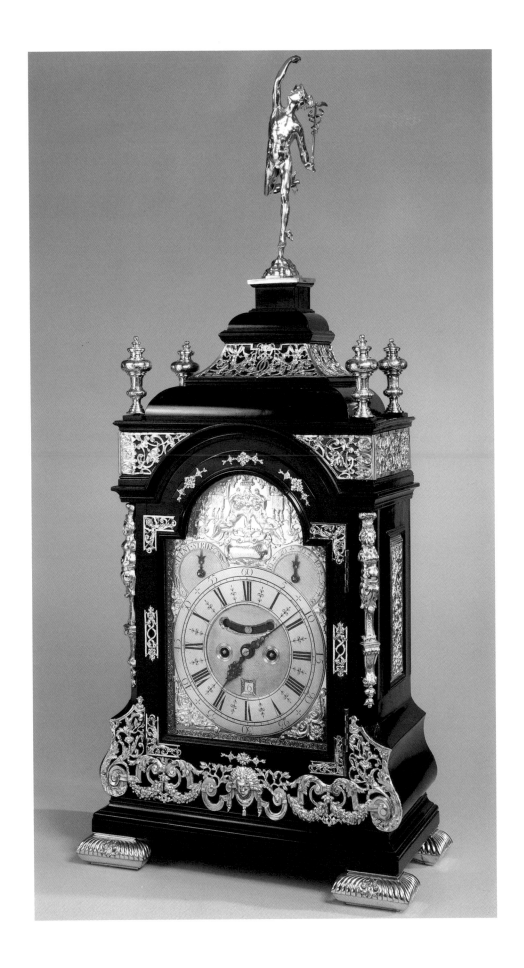

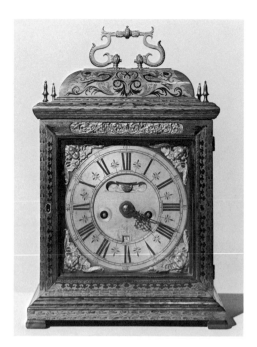

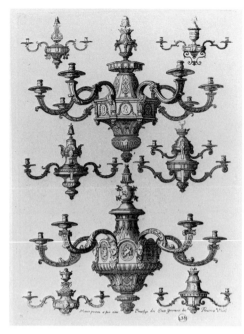

123 Clock

London, c. 1700
John Martin (active from 1688)
Inlaid satinwood
35 × 25 × 15
The Philadelphia Museum of Art, Gift of Mrs.
Francis P. Garvan in Memory of her Husband

English bracket clocks were popular furnish-
ings in fashionable libraries and closets from
the late seventeenth through the eighteenth
century. Designed to perch on wall brackets
or tabletops, they were usually veneered
with ebony, walnut, lacquer, or tortoiseshell
and were often ornamented with brass or,
more rarely, silver mounts. The inlaid ara-
besque patterns on the low-domed top of
this clock recall the brass-and-tortoiseshell
marquetry of André-Charles Boulle, whose
extravagant designs for clocks and other
furniture were an important influence on
cabinetmakers in Holland and England in
the William and Mary period and later.
Another clock by John Martin with related
inlaid ornament is in the Victoria and
Albert Museum, London.

 DSS

124 Design for Chandeliers

The Netherlands, c. 1712
Daniel Marot (1661–1752)
Etching
28 × 20
Ecole Nationale Superiéure des Beaux-Arts, Paris,
Collection Le soufaché

The pure Louis XIV style of these designs
for chandeliers shows Marot's familiarity
with styles popular at the French court,
where gilt bronze was a favored medium.
Marot's published designs for chandeliers
were adapted by Dutch and English crafts-
men, who worked most often in brass or in
carved and gilded wood.

 DSS

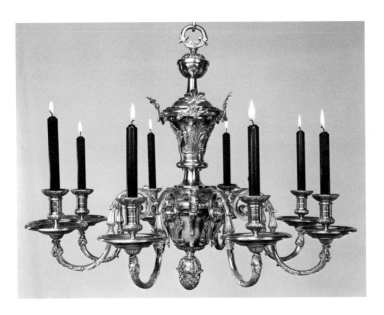

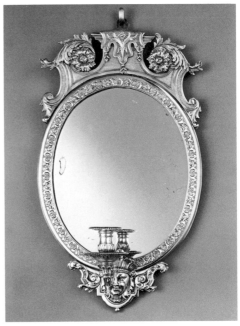

125 Chandelier

England, early 18th century
Gilded brass
66 × 76.2
Mr. and Mrs. Glenn C. Randall
Reference: Schiffer, 1978, 223

The fine cast and applied figural ornament
and the restrained classical design of this
English brass chandelier recall William and
Mary style silver made by Huguenot crafts-
men. The inscription around the upper
knob, *The Gift of Mrs. Anne Peers. Wife of
Chas. Peers Esq. 1762*, is of a later date.

 DSS

126 Sconce

Paris, c. 1700
Silver-plated bronze (stamped with crowned *C*),
mirrored glass
52.3 × 29.8 × 17.2
The J. Paul Getty Museum, Malibu, California

The lambrequin, mask, and scroll motifs
framing this French bronze wall sconce are
closely related to Marot's designs (see No.
92). Similar sconces made in Holland and
England during the William and Mary
period were more often fashioned from
silver but were also sometimes backed with
mirrored glass.

 DSS

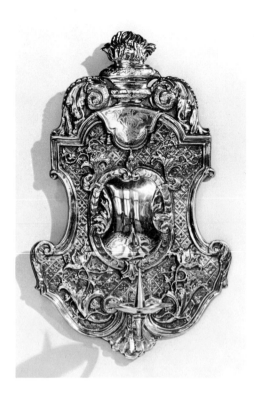 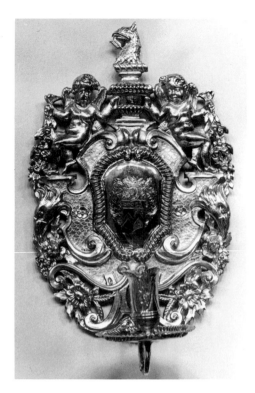

127 Sconce

Utrecht, 1719
Nicholaes Verhaer (c. 1685–1750)
Silver
39 × 23.8 × 14
Centraal Museum, Utrecht
Reference: Blaauwen, 1979, 104

Cartouche-shaped silver sconces, rarer in
Holland than in England or France, were
designed primarily for the walls of state
bedrooms. They were usually made in pairs
or larger sets. The shiny central boss and
scrolled-and-diapered border of this rare
example from Utrecht follow Marot's de-
signs for wall sconces (see No. 92).

 DSS

128 Sconce

London, 1702–3
John Fawdery (active 1695–1724)
Silver
28.9 × 17.4 × 12.7
The Metropolitan Museum of Art, New York,
Bequest of Mary Strong Shattuck, 1935
Reference: McNab, 1970, 55, fig. 31

The owner's arms are engraved on the
central boss of this English sconce, and the
Fowle family crest, a griffin's head pierced at
the throat by an arrow, crowns the top.
Sconces like these were cast in one piece,
except for the candle arm, and the ornament
was later finished by hand.

 DSS

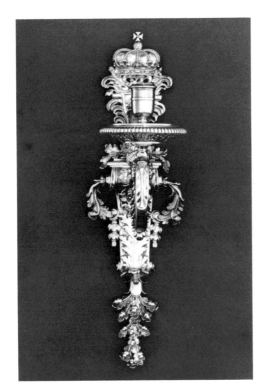

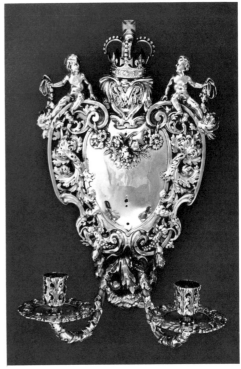

129 Sconce

London, 1700
Phillip Rollos (active London c. 1698–1704)
Silver
40 × 11.4 × 21.6
Colonial Williamsburg Foundation, Williamsburg,
Virginia
References: Davis, 1976, 17ff, no. 3; Pierpont Morgan
Library, 1979, no. 68; Edwards, 1983, 3:48, figs.
7A, 7C

The truss, or console, shape of this wall
sconce, the high quality of its cast and
applied ornament, and its close following of
Louis XIV style silver all mark it as the
work of a Huguenot goldsmith in London.
Originally part of the royal collection, it is
engraved on the outer face of the arm with a
royal crown and with the cipher *WR*, for
William Rex.

 DSS

130 Sconce

London, c. 1670
Unknown Maker
Silver
49.5 × 33 × 23.5
Colonial Williamsburg Foundation, Williamsburg,
Virginia
References: Davis, 1976, no. 2; Pierpont Morgan
Library, 1979, no. 67; Edwards, 1983, 3:48, fig. 7C

Originally part of a set of twelve made for
Charles II and richly embossed with the
loose floral sprays popular during the Resto-
ration period, this sconce has undergone
two major alterations. The holes in the
polished back plate suggest the original
placement of some sort of applied ornament,
perhaps armorial devices, probably removed
when William and Mary's cipher and royal
crown were added sometime between 1689
and 1694. The sconce was also converted
from a one-branch to a two-branch holder
by R. Garrard in the nineteenth century.
Four similar sconces are presently in the
English royal collection.

 DSS

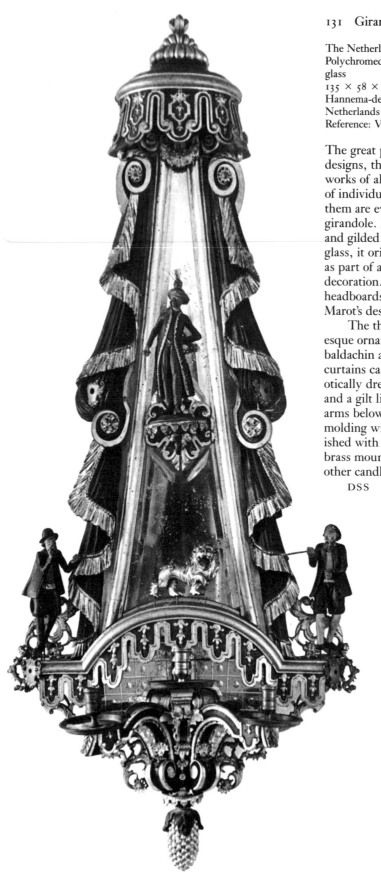

131 Girandole

The Netherlands, early 18th century
Polychromed and gilded limewood, gilded lead, brass, glass
135 × 58 × 38
Hannema-de Stuers Foundation, Heino, The Netherlands
Reference: Van der Feltz, 1979, 397–407, pls. 1–5, 8

The great popularity of Marot's ornamental designs, their wide-reaching influence on works of all kinds, and the amusing variety of individual interpretations inspired by them are evident in this enchanting Dutch girandole. Made of carved, polychromed, and gilded wood, and backed by mirrored glass, it originally may have been conceived as part of a larger scheme of mirrored room decoration. Wall panels, chimneypieces, headboards of beds, and even ceilings in Marot's designs were inset with mirrors.

The theatrical arrangement of Marotesque ornament on this girandole includes a baldachin at the top, draped and fringed curtains cascading down the sides, an exotically dressed Turk, two rustic musicians, and a gilt lion rampant. The three candle arms below are crowned by an arched molding with lambrequin valance and finished with a pineapple knop. Four other brass mounts along the sides may have held other candle arms.

DSS

132 Pair of Sconces

Boston, 1720
Ruth Read (paper work)
Wood, glass, silver, rolled paper, metal wire, feathers
59.5 × 22.7 × 23.8; 59.3 × 22.4 × 22.4
Cooper-Hewitt Museum, Bequest of Natalie K. Blair,
1952–14–4
References: Museum of Fine Arts, Boston, 1911, nos.
704, 705, pl. 24; Museum of Fine Arts, Boston, 1906,
nos. 171, 172, pl. 5; Bigelow, 1917, 295–96, fig. 197;
Nutting, 1921, 492–93; Nutting, 1928, nos. 2813, 2814;
Fales, 1970, no. 33; Pierce and Alswang, 1983, 36

Quillwork, or paper filigree, was popular in England and on the Continent from the late seventeenth century. Surviving New England examples, principally from Boston, all seem to date from the second quarter of the eighteenth century and hence are late expressions of a baroque phenomenon. The vase containing a burgeoning bouquet of flowers is a familiar motif in the second half of the seventeenth century, wrought in a variety of media. Here it is composed largely of strips of paper that have been rolled, assembled and sprinkled with bits of mica. The light of the candle would have illuminated this colorful composition while the glass on the front of the box would have reflected the candle's glow.

For many years these sconces and their original candle branches have been separated. The original candle branches are in the collection of the Henry Francis du Pont Winterthur Museum. The silver drip pans of these branches are engraved *RR/1720*, apparently for Ruth Read, neé Talcott, who married John Read in East Hartford, Connecticut, about 1699 and moved to Boston about 1720. Ruth Read may have executed the quillwork herself for her new Boston home, since quillwork, like embroidery, wax work, and painting on glass, was a skill taught to, and practiced by, gentlewomen in Boston. Prior to 1911 Thomas Read, their descendant, sold these sconces to Francis Hill Bigelow, who owned them at the time they were first published. The frames and candle branches, however, became separated. The frames with replaced branches were sold to Mrs. J. Insley Blair, who bequeathed them to the Cooper-Hewitt Museum in 1952; and H. F. du Pont purchased the branches in 1927 from the Brooks Read Gallery in Boston and gave them in 1951 to the Winterthur Museum.

I am indebted to Ian M.G. Quimby of the Winterthur Museum for bringing the history of these sconces to my attention.

PMJ

133 Pair of Wall Brackets

France, late 17th–early 18th century
Carved and gilded wood
27.3 × 22.3 × 11.1 (each)
Philadelphia Museum of Art, Bequest of R. Wistar Harvey

Ranging from simple pedestals to skillful sculptural ornaments carefully incorporated into comprehensive interior schemes, wall brackets were used for displaying clocks and oriental treasures. Many of Marot's designs feature profuse arrangements of wall brackets holding porcelain vases, cups, saucers, and figurines in porcelain cabinets.

DSS

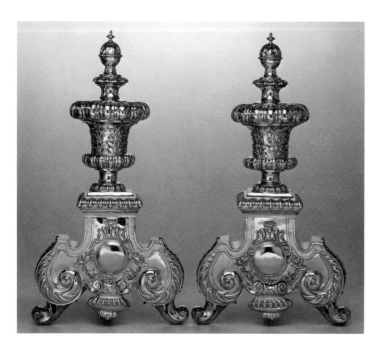

134 Pair of Andirons

London, 1697
Benjamin Pyne (d. 1732)
Silver, iron
H. 54.3
The Metropolitan Museum of Art, New York, Gift of Irwin Untermyer, 1968
Reference: Metropolitan Museum of Art, 1977, no. 56

Silver andirons were furnished as part of hearth sets, along with tongs, shovels, and fireboxes, for the most fashionable baroque interiors. While the broad, scrolled bases follow the shape of earlier English andirons, the elegant urn finials and fine cast and applied ornament of this pair point to the influence of Huguenot silver design. The maker of this set, Benjamin Pyne, not of French origin himself, may have employed refugee journeymen, or he may have had the work of another craftsman marked with his stamp.

Fireplace furniture made of silver was rarer than that of brass or bronze and would have been found only in the grandest of houses and palaces. After 1700, andirons decreased somewhat in popularity, as coal gradually replaced wood as fuel and the basket grate became more practical equipment. Bellows and poles for fire screens were also fashioned from silver.

DSS

135 Fireback

Possibly Saugus, Massachusetts, 1703
Possibly Saugus Ironworks
Iron
69.2 × 48.2
The Metropolitan Museum of Art, New York, Gift of
Mrs. J. Insley Blair, 1947

The outline of this fireback gives it a stylish character consistent with its 1703 date. Within the framework the maker has depicted a stone fortress with three towers, from which cannons point in three directions; at the second-storey level, all the cannons are directed straight out. Atop the central tower, with its classical doorway, stands a figure, presumably the commander in charge.

PMJ

136 Parquetry Panel from the Clark-Frankland House

Boston, Massachusetts, 1712
Various woods
88.9 × 87.6 × 7.5
The Society for the Preservation of New England
Antiquities, Boston, Gift of Mrs. Henry Warren

The Boston Merchant William Clark purchased land on Garden Court Street in Boston on December 10, 1711, where he built himself a fine three-storey brick mansion. Abbott Lowell Cummings, in comparing it to the Foster-Hutchinson House, which stood on adjoining property, describes it as "provincial in scale" but "more correct." He goes on to observe that "this house followed essentially in its schematic arrangement a precedent set by such a building as Coleshill in Berkshire, designed by Sir Roger Pratt and finished during the reign of Charles II" (Cummings, 1971, 10). Although the house was destroyed in 1833, it is depicted in a painting executed between 1712 and 1742 and owned by the Boston Society.

Two painted panels, possibly by John Gibbs (d. 1725), survive from the house. They are the earliest New England examples of the school of architectural landscape that developed in England in the seventeenth century. In addition, this section of parquetry wood flooring from the house survived demolition.

In 1831 the parlor of the house was described in *Miss Leslie's Card Game for Young People of Famous Boston Buildings:* "The floor of this room is tesselated, being composed, it is said, of fifty-two different sorts of wood, cut into small pieces and arranged in various but regular figures, so as to resemble handsome patchwork. In the center of the floor are the arms of the Clarke family, represented in the same manner by different pieces of wood. This was probably the most expensively finished in Boston" (cited in the archives of the Society for the Preservation of New England Antiquities).

PMJ

Upholstered Furniture and Textiles

After the architect, it was the upholsterer who held the most important role in the design and execution of William and Mary style interiors. Serving as interior decorator, the upholsterer provided matching suites of chairs, stools, daybeds, window curtains, and screens covered with silk damasks and velvets and finished with tassels, fringes, and galloons. Great state beds, the focal point of palace reception rooms and the masterpieces of the upholsterers' arts, were outfitted with testers, curtains, and headboards draped and festooned with richly embroidered and appliquéd fabrics.

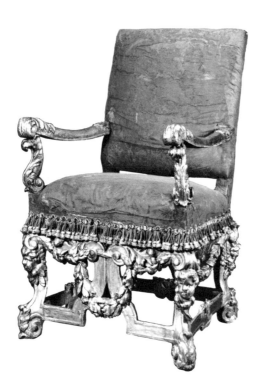

137 Armchair

England, c. 1693–95
Attributed to Francis Lapierre (d. 1717)
Gilded wood, silk damask and fringe
105.5 × 61 × 62
The National Trust, Knole (Sackville Collection)
Reference: *Knole*, 1982, 31

Carved, gilded, and covered with crimson silk damask and tassels, this handsome armchair from Knole forms part of a set of two chairs and six stools, probably originally made en suite with a state bed. The skillful sculptural details of cherub's heads, strapwork, and foliate garlands are French in character and resemble the carved design of contemporary side tables. The chair and its suite may have come to Knole as one of the perquisites of the sixth Earl of Dorset, who, as Lord Chamberlain to William III, was entitled to acquire for his own house articles of furniture and plate from the royal palaces (Jackson-Stops, 1977b). Alternatively, it may have been included among the items supplied directly to the duke by the Huguenot upholsterer Francis Lapierre, who is listed in bills at Knole from 1693 to 1695.

Lapierre is believed to have furnished the crimson-velvet and white satin upholstery for William III's state bedchamber at Hampton Court, as well as the silk damask beds for the Gentlemen and Grooms (Murdoch, 1985, 188). He worked for the Duke of Montagu and the Duke of Devonshire, and was employed at other country houses, including Melville House in Scotland, where he most likely provided the extraordinary state bed (now at the Victoria and Albert Museum).

DSS

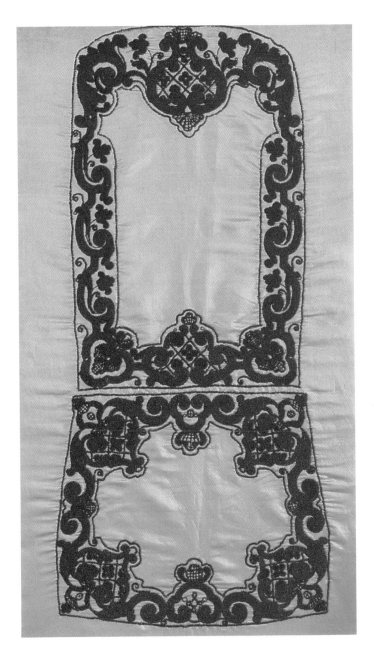

138 Chairback Cover

England, early 18th century
Yellow satin, red knotted silk cord
124.5 × 71
The Board of Trustees of the Victoria and Albert
Museum, London
References: Fowler and Cornforth, 1978, pl. 2;
Thornton and Tomlin, 1980, figs. 194–96; Tomlin,
1986, 50–51

A rare look at the brilliant colors of upholstery fabrics from the William and Mary period is afforded by this yellow satin chairback cover with its crimson couched and embroidered decoration. Stored away without having been mounted, it retains its original hues and textural details intact, unfaded by sunlight and unworn by years of use. The cover, along with its matching set of upholstered seating furniture and bed, was designed for a small sleeping chamber at Ham House, near London. A closely related fragment of an embroidered satin valance now in the collections at Colonial Williamsburg was probably part of the same suite.

DSS

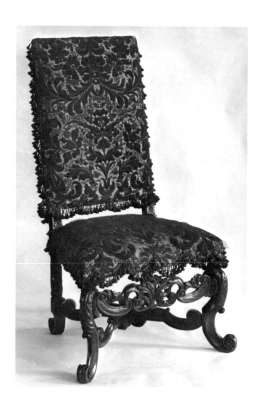

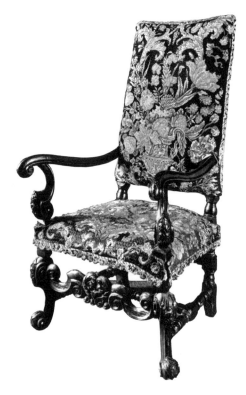

139 Upholstered Side Chair

The Netherlands, c. 1700
Walnut, cut velvet and fringe
120 × 70 × 70
Stichting Vrienden der Geldersche Kasteelen,
Arnhem, The Netherlands; Kasteel De Cannenburch,
Vaassen
References: Buurman, 1978

A rare example of a Dutch chair from the
William and Mary period that has survived
with its original upholstery, this side chair
was made for Kasteel Cannenburch in
Gelderland, the house of Johan Hendrik van
Isendoorn à Blois and his wife Margaretha
van Reede. As the owners of the chair were
part of the circle of the stadholder, it should
not be surprising that it resembles designs
by Marot (see No. 141). Its red and white
velvet fabric, trimmed with blue fringed
tassels, may have matched the bed curtains,
window drapes, portieres, and wall covering
of the room for which it was made.

DSS

140 Upholstered Armchair

England, c. 1690
Upholstery attributed to Rebekah Dufee and
Elizabeth Vickson
Ebonized wood, embroidered seat and back cover
127 × 66 × 78.7
Mr. L. G. Stopford Sackville
References: Jackson-Stops, 1978, p. 21; Thornton,
1978, fig. 192

Like the large sets of chairs lining the walls
in Marot's designs for bedchambers, this
armchair from Drayton House, Northamp-
tonshire, is one of six, made en suite with
the state bed, which were supplied by a
Huguenot upholsterer named Guillotin of
Castle Street, Soho, in 1701. As the form of
the chairs is distinctly earlier than this, with
scrolling "horsebone" ornament in the
Charles II style, it is likely that they were
re-covered to match the bed in 1701–2. The
needlework, with sumptuous vases and
flower bouquets that recall similar designs in
marquetry and overdoor paintings (see Nos.
102 and 106), is almost certainly by the
Huguenot embroiderers Rebekah Dufee and
Elizabeth Vickson, who are listed in the
Drayton House accounts as having provided
the curtains for the bed in the same years.

DSS

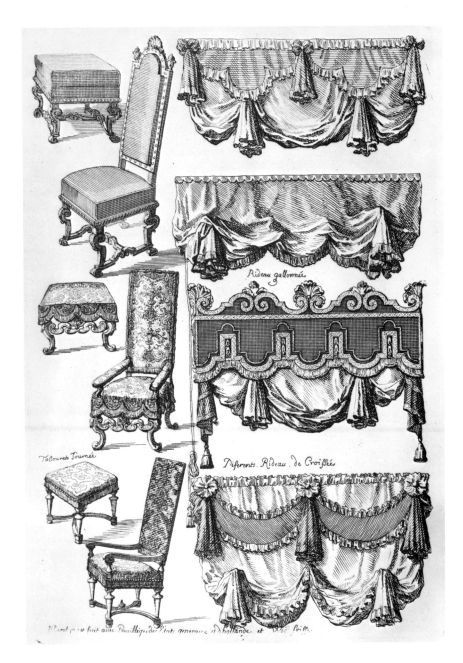

Rideau gallonneé

Tabouret Tourneé

Diferents. Rideau. de Croißée

141 Designs for Upholstered Furniture

The Netherlands, c. 1700
Daniel Marot (1661–1752)
Etching
27.4 × 18.6
Cooper-Hewitt Museum, Purchase, 1988-4-57

Various treatments for chair upholstery and
for valances, or pelmets, are shown in this
print by Marot. The covered chairs and
stools are the same kinds that line the walls
of his designs for state bedchambers; the
ruffled and gallooned valances with gathered
pleats, festoons, and swags were designed to
top off fashionable new curtains that could
be drawn up with strings. Similar valances
are also seen in Marot's projects for flying-
tester beds.

DSS

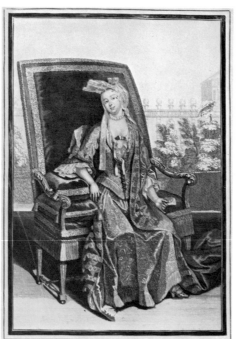

Paris, c. 1690
Jean Mariette (1660–1742), publisher
Etching and engraving
29.6 × 19.5
Cooper-Hewitt Museum, Purchase, Friends of the
Museum Fund, 1955-15-35

The Duchesse de Boüillon, dressed in layers
of brocaded, tasseled, and fringed clothing,
and sporting the tall, stiff lace headdress
popular at the time, sits on a commodious
French armchair or settee. Trimmed, like
the duchess, with fringe, galloons, and
tassels, the seat is furnished with two
cushions and supported by tapering column
legs with turned stretchers. Fringed or
gallooned borders were often used to mask
seams in upholstery fabric and the awkward
joinings between legs and seat.

 DSS

Madame la Duchesse de Boüillon.
A Paris Chez J. Mariette rüe St. Jacques aux Colonnes d'Hercules Avec Privi. du Roy.

143 *Femme de Qualité Deshabillée Pour le Bain*

France, 1686
Jean de Saint-Jean
Etching and engraving
38.2 × 39.7
Bibliothèque Nationale, Paris, Cabinet des Estampes
References: Thornton, 1978, fig. 304; Thornton, 1984,
fig. 73

A magnificent daybed with a tall, crowned
headboard and an unusual tufted and
fringed mattress dominates the fashionable
closet in this French print. While the bather
prepares to dip her foot into a giant wine-
cooler-like basin, the fragrant fumes wafting
from her tripod perfume burner are caught
in the draft of the opening door. The five-
piece garniture, bowls of flowers, and a
covered jar set above the projecting cornice
moldings of the room may represent painted
trompe l'oeil decoration of the sort favored
by Marot in some of his designs for ceiling
decorations (see No. 28).

 DSS

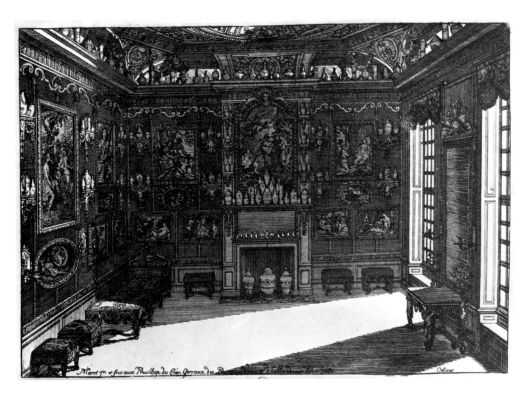

144 Design for Closet Decorated with Porcelains

The Netherlands, c. 1712
Daniel Marot (1661–1752)
Etching
18.8 × 27.9
Ecole Nationale Supérieure des Beaux-Arts, Paris,
Collection Le soufaché
Reference: Thornton, 1978, fig. 238

This engraving depicts a lavishly uphol-
stered picture-cum-porcelain cabinet of the
late seventeenth century. More than a hun-
dred pieces of porcelain are shown arranged
on brackets, over the mantel, in the fire-
place, and on the cornice. According to an
inventory taken in 1697, there were 193
pieces of porcelain and Delft in the Old
Bedchamber at Kensington Palace—ar-
ranged over the doorways, on pedestals,
under a table, and over the chimney. A wide
variety of shapes and sizes were used, from
tiny jars and figures placed over the fireplace
to large jars in the fireplace itself. So great
was the desire for masses of porcelain to
decorate a room that wooden or plaster-of-
Paris counterfeits were used in out-of-the-
way corners (Thornton, 1978, 384, note 32).
Delftware pieces that copied oriental origi-
nals were also used, although the Chinese
porcelains were always more prized.
William Montague, an Englishman who
visited Delft, recorded that "The People in
this City are rich, trade much to Sea, and
make much Porcelain, or Fine Earthen
Wares, to a great Perfection, tho' far short of
China, which they pretend to resemble"
(Montague, 1696, 24).

The pier table with caryatid legs, the
pier glass with attached candlestands, and
the stools were probably all carved and
gilded. Typical features of Marot's designs
include the classical head on the picture
frame above the mantel and the scrolling
strapwork under the cornice. The daybed
has the headboard with reverse-C-scroll
motif, tapering legs, and lappeted uphol-
stery typical of the Louis XIV style. Paned
hangings are arranged in panels or in strips
of fabric alternating with braid or fringe.
The luxurious fabrics used for the uphol-
stery would probably have matched with
the valances at the windows. The sym-
metrically arranged pictures and their uni-
form frames demonstrate the careful
planning of every detail of this interior.

LRS

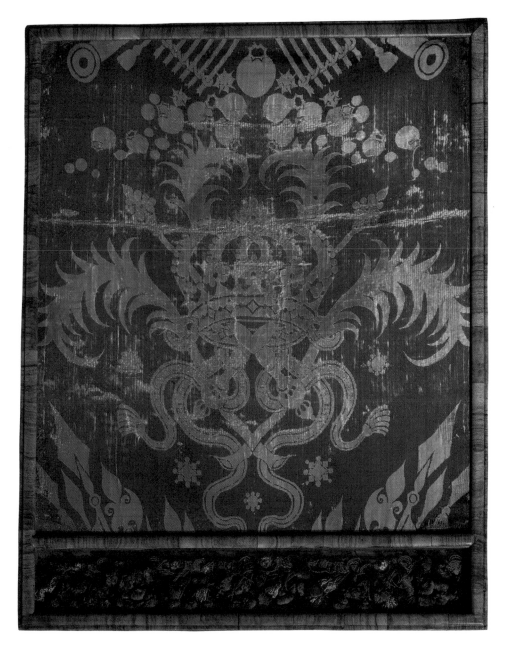

145 Silk Damask Fragment

England, 1700
Silk damask
75 × 58 × 4.5
Her Majesty Queen Elizabeth II
Reference: Digby, 1939, 248–53

The repeating pattern of this yellow and crimson damask fabric woven for William III features war trophies, a royal crown, William's Nassau motto, *Je maintiendray*, and the English royal motto. It was provided by the mercer John Johnson, whose initials were woven into the fabric on one of the cannons, along with the date, 1700. An unidentified monogram, *S. C.*, also woven into the pattern, may belong to the designer or master weaver of the fabric. According to Johnson's bill and to a related royal warrant, seventy-three yards of the damask, with matching silk fringe, were provided for the wall hangings, window curtains, armchair, and two small square stools for one of William's rooms at Hampton Court (Digby, 1939, 250).

DSS

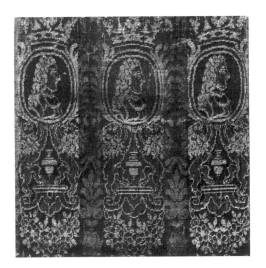

146 Patterned-velvet Fragment

France, early 18th century
Wool, linen, hemp
81.3 × 57.2 (loom width)
The Metropolitan Museum of Art, New York, Rogers
Fund, 1920

Woolen pile velvet, also known as *moquette*, *trippe*, *caffoy*, or *vallure*, was often employed as upholstery for seating furniture. The crowned portrait busts, lions, and garlanded pilasters in this fragment, originally a chairback cover, are woven in red, light green, and cream-colored wool with cream-colored linen on a dark green wool background.

DSS

147 Silk Damask Fragment

Probably France, late 17th–early 18th century
Gold silk damask
69 × 56.5
Colonial Williamsburg Foundation, Williamsburg, Virginia

Silk damasks were among the most expensive upholstery fabrics used in baroque interiors. The finest were made in Italy, but later centers in France and England included Lyon and Spitalfields, a suburb of London. The repeating pattern of this piece, formed by two faces of the same weave, features a baldachin and tasseled drapery swags.

DSS

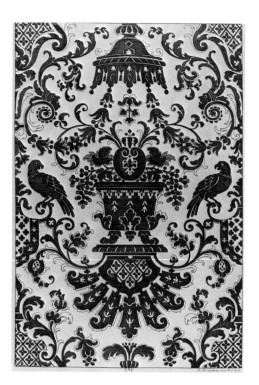

148　Design for Textile

The Netherlands, c. 1712
Daniel Marot (1661–1752)
Etching
27.8 × 18.4
Ecole Nationale Supérieure des Beaux-Arts, Paris,
Collection Le soufaché

149　Design for Textile

The Netherlands, c. 1712
Daniel Marot (1661–1752)
Etching
27.5 × 18.2
Ecole Nationale Supérieure des Beaux-Arts, Paris,
Collection Le soufaché

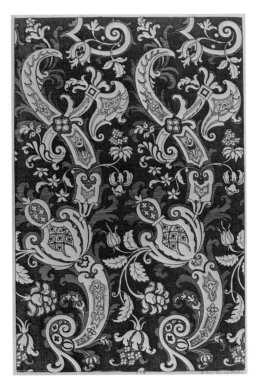

150 Design for Textile

The Netherlands, c. 1712
Daniel Marot (1661–1752)
Etching
28.5 × 18.7
Ecole Nationale Supérieure des Beaux-Arts, Paris,
Collection Le soufaché

Marot's acute attention to detail and his dedication to comprehensive schemes of decoration led him to provide designs even for the textiles with which his interiors were to be furnished. These designs for damask or printed fabrics show some of his own favorite motifs incorporated into traditional damask patterns. They exemplify the kind of rich textural patterns favored for the upholstery of seating furniture, state beds, window curtains, portieres, and wall hangings.

DSS

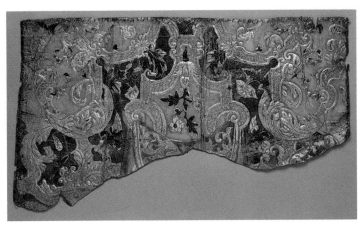

151 Leather Panel Fragment

The Netherlands, c. 1700
Leather, silvered, stamped, painted, and varnished
33.4 × 59.8
Cooper-Hewitt Museum, Gift of Eleanor Garnier
Hewitt, 1903–12–23

By the time that the English traveler William Montague reported seeing "Much Gilding and Carving; the first upon Leather with which they hang many of their Rooms" on his tour of Holland in 1696, gilt-leather wall hangings had already been popular for a century (Montague, 1696, 66–67). While earlier examples were heavily embossed, by the end of the century gilt leather patterns were flatter and more polychrome, a trend also seen in furniture and silver decoration of the period. The motifs on this fragment include lush scrolls of strapwork, acanthus, and drapery swags recalling Marot's designs for painted and carved decoration.

Because of its resistance to food odors, gilt leather was often used to panel walls in dining rooms. Princess Mary's Eetsaal at Dieren, for example, was covered with gilt-leather hangings with a white background (Drossaers and Lunsingh Scheurleer, 1978, 1:389; Thornton, 1978, 392). Suites of seating furniture were also upholstered with gilt leather.

Made from calfskin covered with tin foil, gilt leather was first embossed in wooden molds; the patterns thus created were painted in and then varnished. Gilt-leather panels were exported from the Netherlands, principally from centers at Amsterdam and Malines, to Europe and Scandinavia until the early eighteenth century.

DSS

152 Embroidered and Appliquéd Pilaster (One of a Set)

England, c. 1700
Velvet, damask, braid, canvas backing
274.3 × 40.6 × 5 (each)
The Viscount de L'Isle, V. C., K. G.

The high degree of skill in the art of the seventeenth-century upholsterer is evident in this rare pilaster, formerly at Cassiobury in Hertfordshire, designed to be hung against the wall in imitation of architectural ornamentation. The Ionic capital, fluting, and base are articulated in appliquéd and embroidered detail, closely imitating one of Daniel Marot's favorite forms of decoration (see No. 35).

DSS

153 *Woman on a Daybed*

France, 1686
Jean de Saint-Jean
Engraving
38.2 × 40
Bibliothèque Nationale, Paris, Cabinet des Estampes
References: Thornton, 1978, fig. 16; Thornton, 1984, fig. 66

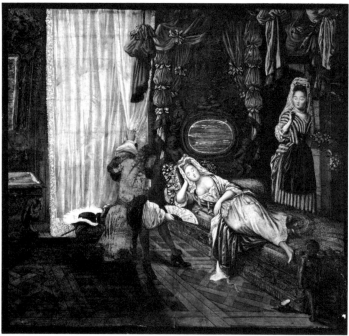

The richly appointed closet or small bed-chamber in which this fashionable French lady naps includes a parquet floor, a large carved table and looking glass, and a rather remarkable daybed with a flying tester and a mirror set into its headboard. Two beds of similar design from the Salon d'Amour and the Salon de Diane at Louis XIV's Trianon de Porcelaine had inset mirrors framed by papier mâché cherubs and were hung with extravagantly draped and swagged flying testers (Figs. 9, 10). Marot's designs for state beds with flying testers helped spread the fashion from France to England and Holland.

DSS

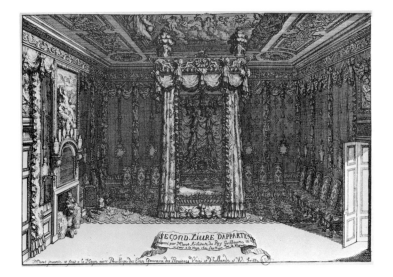

154 Design for State Bedchamber

The Netherlands, c. 1712
Daniel Marot (1663–1752)
Engraving and etching
19 × 28
Ecole National Supérieure des Beaux Arts, Paris,
Collection Le soufaché
Reference: Thornton, 1978, fig. 50

The draped and festooned cappings and
pilasters and the ruffled trim on the walls
and portieres of this chamber follow the
sumptuously upholstered dressings of its
state bed. A garniture of porcelains or
Delftware crowns a mirrored panel in the
mantelpiece, and two large jars and a potted
plant fill the fireplace. A floor covering with
a scalloped border sets off the bed area of
the room, in a manner similar to the carved
balustrades in French and English royal
bedchambers. This room, illustrated on the
title page of Marot's *Second Livre Dapparte-
ments*, may have been designed for William
III's Dutch residence, Het Loo (Royards,
1972).

 DSS

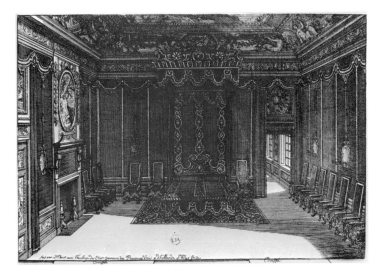

155 Design for a State Bedchamber

The Netherlands, c. 1712
Daniel Marot (1661–1752)
Etching
20 × 26.5
Ecole Nationale Supérieure des Beaux-Arts, Paris,
Collection Le soufaché
Reference: Thornton, 1978, fig. 95

A highly unified scheme of decoration
prevails in this design by Marot for a state
bedroom, where the valance and base ruffle
of the flying-tester bed are echoed in the
cappings of the wall hangings and in the
upholstered covers of the set of chairs lining
the walls. In addition to the portieres en
suite at the two doors, the room is also
furnished with an elaborate woven carpet
under the bed and overdoor paintings. The
tall vertical panels of the wall hangings are
outlined by decorative tapes that mask the
seams in the fabric. Cartouche-shaped silver
sconces with polished or mirrored back-
plates are hung from knotted and tasseled
cords at intervals around the walls.

 DSS

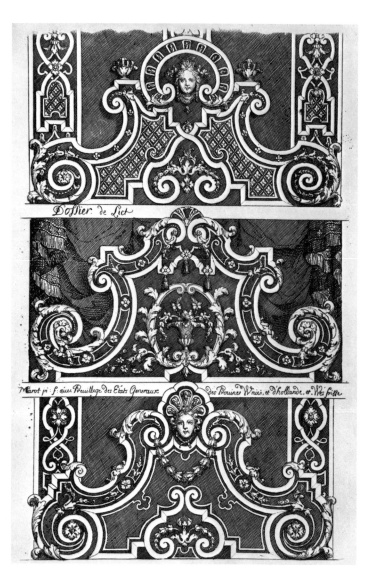

Doſſier de Lict

Marot jn f aue Peuillege des Etats Generaux des Prouines Vnies et dhollande et Wes friſe

157 Bed Valance

Boston, or Salem, Massachusetts, 1700–25
Linen warp and wool weft; watered, waived, and
figured; bound and decorated with braid and lined
with buckram (imported English materials)
31.7 × 523.2
Essex Institute, Salem, Massachusetts
References: Jackson, 1987, 138, pl. 7, fig. 123; Pierce
and Alswang, 1983, 39–40

In the colonies, as in England and Europe,
bed-hangings were the most expensive but
also the most desirable household furnishing
during the William and Mary period. Amer-
ican bed valances from this time are exceed-
ingly rare. The maker has used English
fabric and braids to fashion an English-style
valance. The patterns worked in braids
show marked similarities to Daniel Marot's
curtain designs published in 1700.

 We know from upholsterer Thomas
Fitch's accounts in the 1720s that he solicited
in his contracts with England drawn pat-
terns for bedhangings—an indication of
how American upholsterers attempted to
keep up with current London fashions
(Jobe, 1974, 28). We conjecture that the
same practice would have held true earlier in
the century as well.

 PMJ

156 Design for Headboards

The Netherlands, c. 1700
Daniel Marot (1661–1752)
Etching
27.5 × 18.9
Cooper-Hewitt Museum, Purchase, 1988-4-58

Marot's designs for the upholstered head-
boards of state beds are richly appliquéd
and embroidered affairs, very similar to
those of several English beds that remain
from the period (such as the Melville bed, c.
1695, Victoria and Albert Museum). The
scrolled volute contours are also reminiscent
of Marot's projects for high-backed garden
benches (No. 227).

 DSS

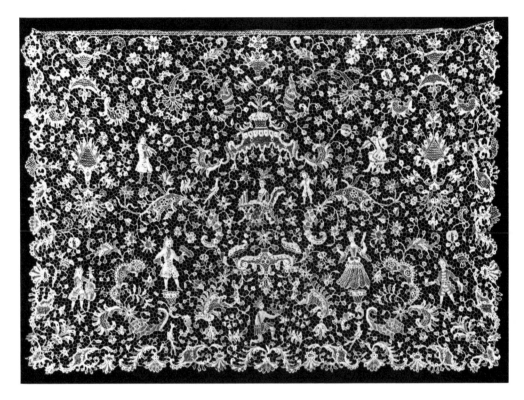

158 Lace Cravat End

Spanish Netherlands or France, c. 1700
Linen needle lace
29 × 41
Cooper-Hewitt Museum, Bequest of Richard C.
Greenleaf, in memory of his mother, Adeline Emma
Greenleaf, 1962–50–18B
References: Victoria and Albert Museum, 1973, no.
173; Sonday, 1982, fig. 15.

Following court fashions, William and Mary
both spent extravagant sums of money on
decorative lace trimmings (Bolingbroke,
1969, 11). The queen and her ladies wore
tall, stiff lace headdresses ornamented with
ribbons, diamonds, and long streamers,
while the king and courtiers sported ruffled
openwork shirt cuffs and flowing lace neck
scarfs. The charming, lighthearted motifs
worked into this fine cravat end include a
woman seated at an organetto, musicians,
birds, and floral and leaf tendrils. The
figures are similar to those found on gro-
tesque designs by Jean Berain and Daniel
Marot and to those worked into the decora-
tion of Delftware, silver, and marquetry
from the William and Mary period.

DSS

Delft

Dutch Delftware, inspired by porcelains imported from the Far East, was one of Holland's greatest gifts to late seventeenth-century decorative arts. Queen Mary's enthusiastic patronage of the Delft potteries in furnishing the royal residences in both the Netherlands and England resulted in some of the grandest examples of William and Mary style ceramics. The tin-glazed earthenwares produced in these factories, painted with blue and white and later with polychrome glazes, ranged from delicate tea wares to monumental flower vases standing over four feet high.

159 Bust of William III

Delft, c. 1690
The Double Flagon factory or the Metal Pot factory (Signed *LV* or *LVE*, for Louwys Victoorsz or Lambertus van Eenhoorn)
Tin-glazed earthenware
H. 42
Rijksmuseum, Amsterdam
References: Rijksmuseum, 1950, no. 480; Pierpont Morgan Library, 1979, no. 55; Lunsingh Scheurleer, 1984, no. 363

In this bust, William is portrayed as king of England, bearing a royal crown, with the *WR* cipher (for William Rex) painted below. A military trophy is also painted on the base, and he wears the extravagant lace neck scarf popular during the period. Related images of the king were carved in marble, such as a bust of William attributed to Honoré Pelle (No. 4) and another carved by Jan Blommendael (Mauritshuis, The Hague).

 DSS

160 Bust of Princess Mary

Delft, c. 1685
The Greek A factory (signed *SVE*, for Samuel van Eenhoorn)
Tin-glazed earthenware
H. 32
Rijksmuseum, Amsterdam
Reference: Lunsingh Scheurleer, 1984, no. 401

Mary's bust shows her as princess of Orange, wife of the stadholder William, wearing large baroque pearl earrings and a matching necklace. It was most likely commissioned before she moved back to England to become queen in 1689. Mary was a steady patroness of the Greek A factory in Delft, and continued to order flower vases, urns, and other wares from across the Channel. Her love of Delft and oriental porcelains is legendary, and many pieces survive from the collections she formed in Holland and at the English royal palaces.

 DSS

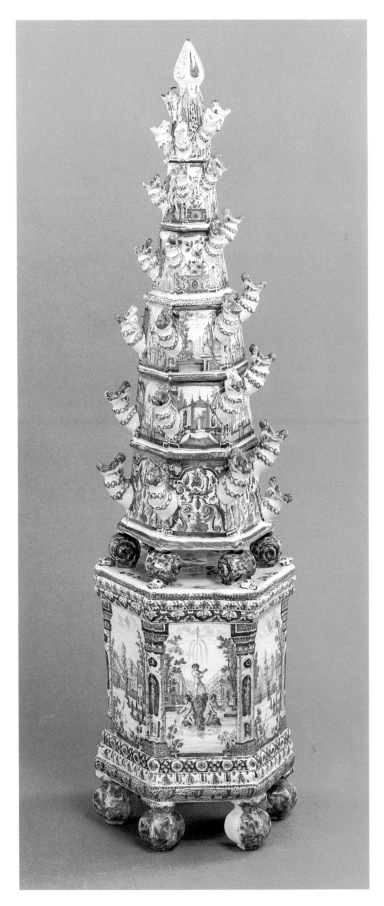

161 Flower Pyramid

Delft, c. 1700
The Greek A factory (signed *AK* for Adriaen Kocks)
Tin-glazed earthenware
133 × 35
Colonial Williamsburg Foundation, Williamsburg, Virginia
References: Kleyn, 1965; Pierpont Morgan Library, 1979, no. 57

Rich in architectural detail and sumptuous painted decoration, the monumental pyramid-shaped flower vases made at Delft for William and Mary and their court were fitting attributes to the grandest baroque interiors of the time. Standing over four feet tall, this pyramid vase is hexagonal in section and consists of a plinthlike base surmounted by six tiers of hollow units with spouts at the corners. Water is poured into each unit and cut flowers placed into the spouts to create a spiraling halo of fragrant blossoms. Panels of landscape and garden scenes framed by pilasters are painted around the base and on the sides of the spouted tiers.

A short-lived fashion, tall pyramid vases were probably first commissioned by Queen Mary after her move to London. Their shape may have been influenced by Mary's custom of stacking porcelains and Delftware in pyramidal shelves on top of chimneypieces. Although two flower pyramids are listed in the 1713 inventory of Het Loo, they were never as popular in the Netherlands as they were in England (Drossaers and Lunsingh Scheurleer, 1974, 1:658, no. 289). Their popularity waned after Mary's death in 1694.

Other examples of tall Delft pyramid flower vases exist at Hampton Court, Chatsworth, Dyrham, the Rijksmuseum, the Musées Royaux d'Art et d'Histoire (Brussels) and the Fine Arts Museums of San Francisco. Most were made at the Greek A factory and are signed *AK*, for Adriaen Kocks, its owner from 1687 to 1701 (Archer, 1975–76; 1976; 1984).

DSS

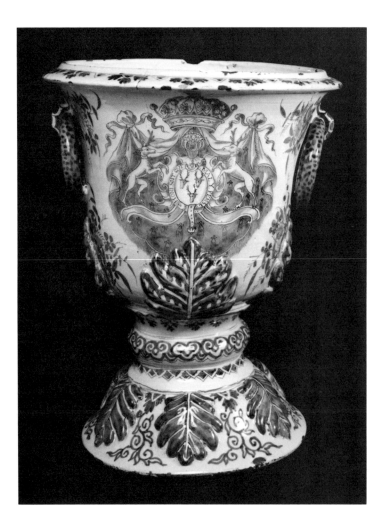

162 Urn

Delft, c. 1690
The Greek A factory (signed *AK*, for Adriaen Kocks)
Tin-glazed earthenware
48.5 × 39
The Duke of Devonshire and The Trustees of the
Chatsworth Settlement
References: Lane, 1949, fig. 7; Archer, 1976, fig. 5

The English aristocracy followed Queen
Mary's lead in ordering large urns and
flower vases from the potteries in Delft.
This one from Chatsworth bears the Caven-
dish coat of arms, an earl's coronet, and the
Order of the Garter, indicating that it was
made before the year 1694, when William
Cavendish was created first Duke of De-
vonshire. It is marked by Adriaen Kocks,
owner of the Greek A factory, which
supplied pottery to other English country
houses, including Castle Howard and Dray-
ton. Four other related urns are in the
collections at Chatsworth, and a set of six is
at Dyrham (Archer, 1975–76).

Drainage holes in the bottoms of these
urns suggest their use as planters. Potted
with orange, myrtle, or bay trees, they were
commonly placed in empty fireplaces during
summer months. Contemporary chimney
boards were painted with scenes showing
similar arrangements. The urn is very close
in shape and ornament to designs by Daniel
Marot for garden urns and for flowerpots in
painted overdoor decorations.

DSS

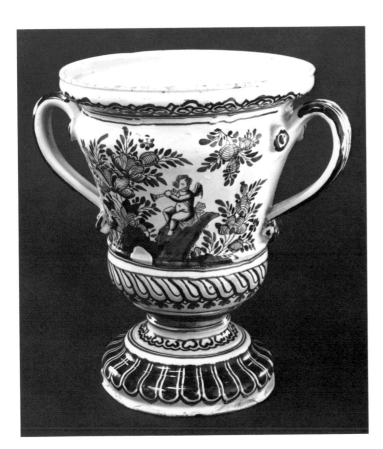

163 Urn

England, c. 1700
Tin-glazed earthenware
29.2 × 24.8
Colonial Williamsburg Foundation, Williamsburg,
Virginia

English delftware pottery followed Dutch examples in borrowing motifs from Oriental porcelains and adapting them to domestic tastes—sometimes with amusing results. On one side of this urn, probably used as a planter, an exotic species of duck stands on a rock in a chinoiserie landscape. Sitting in a matching landscape on the opposite side of the urn, however, is a very Western-looking putto blowing a trumpet.

The pot takes its shape from classical urns, and its painted gadrooned borders on foot and base relate closely to repoussé and cut-card borders on contemporary silver pieces. The blue cloud-scroll band around the lip of the urn is copied closely from Chinese porcelains.

Marot's *Nouveau Livre de vases et de Pots de Jardins* includes a group of two-handled urns similar to this one, planted with miniature trees and garden plants. Such pots were dispersed throughout formal garden parterres and were often brought inside to adorn empty summer fireplaces.

DSS

164 Tile

Delft, c. 1690
Probably the Greek A factory
Tin-glazed earthenware
62 × 62
The Metropolitan Museum of Art, New York, Gift of
Irwin Untermyer, 1964

165 Tile

Delft, c. 1690
Probably the Greek A factory
Tin-glazed earthenware
62 × 62
Rijksmuseum, Amsterdam, Lent by KOG

166 Tile

Delft, c. 1690
Probably the Greek A factory
Tin-glazed earthenware
62 × 61.5
Rijksmuseum, Amsterdam, Lent by KOG

167 Tile

Delft, c. 1690
Probably the Greek A factory
Tin-glazed earthenware
62 × 61.5
Rijksmuseum, Amsterdam, Lent by KOG

168 Tile

Delft, c. 1690
Probably the Greek A factory
Tin-glazed earthenware
31.2 × 61.5
Rijksmuseum, Amsterdam
References: Peelen, 1923; Lane, 1959; Fourest,
1980, 39

Like Louis XIV's short-lived Trianon de Porcelaine, built at Versailles for his mistress, Mme de Montespan, Queen Mary's Water Gallery was created as her own private retreat at Hampton Court Palace. While Louis's Trianon boasted exterior walls of faience painted like Chinese porcelains, Mary's Water Gallery contained an interior room completely lined with blue and white Delftware panels. A small building dating from Tudor times, originally serving as a landing station from the Thames, the Water Gallery was used by Mary as temporary lodgings while the palace was undergoing extensive renovations. The Water Gallery was remodeled under the supervision of Sir Christopher Wren and Comptroller of the Royal Works William Talman, and it was decorated with carvings by Grinling Gibbons and with furnishings designed by Daniel Marot. It was torn down soon after the queen's death in 1694.

The famous paintings of court beauties by Sir Godfrey Kneller hung on the walls of the main room, which opened out onto a balcony overlooking the river; other smaller chambers, or closets, were paneled with oriental lacquer, looking glasses, and marble. A "Delft Ware Closett" was decorated with Chinese porcelains and Delftware massed on wall brackets and chimneypieces and with large standing flower vases, pyramids, and urns. The Dairy was similarly furnished with Delftware milk pans and with a spectacular set of tiled wall panels to which these pieces belonged.

The tiles were designed by Daniel Marot and almost certainly made at the Greek A factory in Delft. Comparison with a set of vertical panels from Marot's published designs shows that four of these tiles come from quarter sections of the same set. The prints, published several years later, show distinct differences, perhaps reflecting the influence of the lighter French Régence style just coming into fashion in the early years of the eighteenth century. The same Marot designs were used for a set of wall panels painted for the second Duke of Montagu in about 1720 (No. 23).

Many of Queen Mary's pieces from the Greek A factory bear the *AK* mark, for Adriaen Kocks. Dealers in London also provided the Queen and other devoted collectors with abundant supplies of Chinese and Japanese porcelains and Dutch Delftware during this period.

The unmatched quality of the painting of these tiles and the many references to William and Mary appearing among their playful Marotesque ornamentation confirm their intended use in a court setting. Royal crowns, the intertwined ciphers of *W* and *M*, a bust of William, and an image of him on horseback join fanciful figures of Fame, Glory, Music, and imaginary creatures in a framework of columns, cornices, strapwork, billowing drapery, and foliate scrolls. The horizontal rectangular tile with urn, birds, acanthus scrolls, and diapered strapwork resembles designs by Marot for overdoor paintings.

Other tiles from this same series are at the Rijksmuseum, Amsterdam, the Victoria and Albert Museum, London, and the Kunstindustrimuseum, Copenhagen.

DSS

Chinoiserie

The exploration of the New World by seventeenth-century Europeans and the establishment of the Dutch and English East India Companies for trade with the Far East activated an enduring interest in foreign goods and customs that had great impact on the William and Mary style. The collecting of oriental lacquerware, Chinese porcelains, printed Indian fabrics, and rare natural specimens became the hobby of cultivated English and Netherlandish gentlemen. Craftsmen combined exotic motifs borrowed from Eastern wares—Chinese figures, dragons, and pagodas—with elements of baroque design to form highly original "chinoiserie" creations in the form of Delftware, lacquered furniture, and accoutrements for the tea table.

DSS

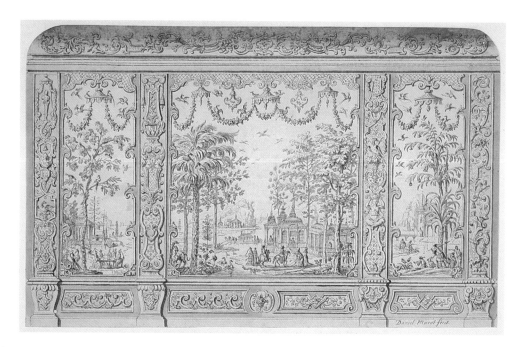

169 Design for Chinoiserie Wall Decoration

The Netherlands, c. 1720
Daniel Marot (1661–1752)
Pen and black ink, watercolor
29.3 × 47.9
Inscribed in pen and black ink at lower right: *Daniel Marot fecit*
Cooper-Hewitt Museum, Gift of the Council, 1911-28-213
Reference: Wunder, 1962, No. 45

Pseudo-oriental and European baroque motifs are joined in this wall design by Marot. The cornice decoration and pilaster and dado ornament—with alternative versions offered—are composed from familiar Marotesque strapwork, acanthus scrolls, and fanciful animals and figures. Three large panels show scenes of figures in quasi-oriental garb in exotic landscape settings: a tea-drinking scene on the left, a reception before a pagoda-like pavilion in the center, and a hunting and fishing scene on the right. Fantastic flora and fauna include a leopard and a camel standing under a gigantic pineapple tree, cranes, swans, and other colorfully plumed birds.

DSS

170 Chinoiserie Design

The Netherlands, c. 1690
Daniel Marot (1661–1752)
Pen and black ink, black chalk
27.9 × 15.5
The Board of Trustees of the Victoria and Albert
Museum, London

Marot's drawing relates closely to his pub-
lished prints with arabesque designs for tall
vertical panels—the same panel designs that
were used for the tiles for Queen Mary's
Water Gallery at Hampton Court (Nos.
164–168). Another chamber in the Water
Gallery was panelled with looking glasses,
perhaps engraved with decoration like this.
As in the panel designs, the left section of
this drawing is composed of a fanciful
framework of scrolls, columns, and architec-
tural features, interspersed with figures,
animals, and foliage. A vaguely oriental note
is struck here by the exotic costumes and
phoenixlike birds.

 DSS

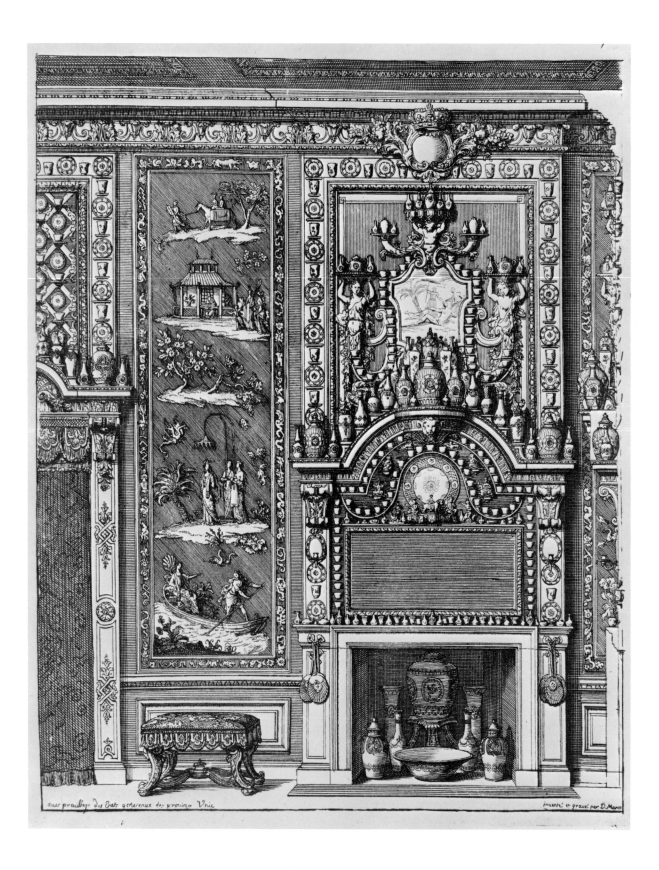

aues preuilege des Etats generaux des prouinces Vnie inuenté et graué par D. Maro

171 Design for Chimney Wall with
 Lacquered Panels and Porcelain

The Netherlands, c. 1700
Daniel Marot (1661–1752)
Etching and engraving
24.8 × 19.5
Cooper-Hewitt Museum, Purchase, 1988-4-48
References: Japan Society, 1986, fig. 13; Thornton,
1978, fig. 73

Since Holland was the most active European
country trading with the Far East during
the seventeenth century, it was natural that
the Dutch were among the first to use
lacquer paneling for room decoration.
Amalia von Solms, King William III's
grandmother, covered the walls of a small
room with oriental lacquer panels taken
from chests, cabinets and screens, and there
were many such rooms, or "lacquer cabi-
nets," in Dutch royal palaces. William
Montague, visiting Huis ten Bosch in 1695,
described "One closet of all true Indian
Japan, made of Cabinets or Chests taken in
pieces" (Montague, 1696, 42).

Marot combined oriental lacquer with
elements of the Louis XIV style, including
strapwork surrounding the doorways and
terms that form supporting shelves for
porcelain surrounding the overmantel pic-
ture.

Having so many pieces of porcelain and
Delft in one room was considered desirable;
Queen Mary had a total of 787 pieces of
porcelain at Kensington Palace, of which 154
were in her bedchamber alone. Specific
shapes in both porcelain and Delft were
ordered for placement inside the fireplace
during the summer. In the records of the
English East India Company "Chimney
flower pots" were mentioned. (Home Mis-
cellaneous Records, 1704, *Union*, series 12. I
am indebted to Dr. Julia B. Curtis for
sharing this reference.)

LRS

172 Tea-drinking Scene

The Netherlands, c. 1700
Gouache on paper
14 × 12.7
Private Collection
Reference: Thornton, 1984, fig. 94

The tea party, a ceremony borrowed from
the Orient but quickly adapted to European
fashion, is the subject of this charming
scene, painted on a fan leaf. Tea is being
drunk from blue-and-white cups and
saucers of oriental porcelain. The guests are
clothed in rich, brocaded fabrics and the
women wear tall, lacy headdresses called
fontanges that were popular at the time. The
walls of the room are equally well dressed,
with fitted verdure tapestries and heavy
drapes at the window. A symmetrically
arranged garniture crowns the large chest in
the corner, and another can be glimpsed on
the chimney mantel at the left.

DSS

NAMIDDAG LE APRESDINEE
Nu zich met Thee verfrist indien de hitte u plaegt
Zo raakt die hitte door een heter hitte aen 't koelen
Of koppt de koude vrel gaat t lijf met Lofte spoelen
Met zulk gezelschap dat Namiddaeg u behaegt
Theodorus Danckerts Excudit. P.v.d Berge Inv. Et Fecit.

173 *De Namiddag* (The Afternoon)

The Netherlands, c. 1700
Theodorus Danckerts, after Pieter van den Berge
Engraving
24.8 × 15.7
Museum Boymans-van Beuningen, Rotterdam
References: Museum Boymans-van Beuningen, 1978,
fig. 52; Thornton, 1984, fig. 95

European travelers to China had brought
back news of the drink called tea, but the
beverage did not reach England, by way of
Holland, until the 1650s, becoming steadily
more popular during the second half of the
seventeenth century. In this scene, a tea
party is taking place, with all the accouter-
ments necessary for tea service during this
period: cups, saucers, tea caddies, slop
basins, and teapots. Tea drinkers in the
seventeenth century did not expect these
pieces to be of the same shapes and mate-
rials. Not until the eighteenth century were
tea sets ordered as a matched set. Teacups of
this period were without handles. Tea
equipment is displayed on the hanging shelf,
called a *tablette* in France and a *theerack* in
Holland.

In a *porcelijncabinet* at the Binnenhof in
The Hague (Drossaers and Lunsingh
Scheurleer, 1974, 1:434), an "East Indian
tea-table" and an "East Indian cooking-stand
with all the requisites for making tea" are
mentioned in an inventory of 1700.

LRS

174 High Chest of Drawers

Boston, 1700–30
Signed *Scottow*
Maple, white pine
163.2 × 103.5 × 57.2
George M. and Linda H. Kaufman
References: Fairbanks and Bates, 1981, 131–32;
Flanigan, 1986, 50– 53, no. 17

In this era of classicism, a distinctly anti-
classical type of decoration was popular:
japanning, a painted and varnished Western
imitation of oriental lacquer. Japanned fur-
niture was popular in the colonies, as well as
in Holland and England. Inventory refer-
ences verify that Americans throughout the
colonies owned such stylishly decorated
furniture. In 1697 John Bank's Boston estate
included a "Jappan tabel and a chest of
drawers" (Forman, 1985, 20). Inventories of
1700 and 1701 show that John and Elizabeth
Tatham of Philadelphia owned a japanned
dressing box, looking glass, and other small
items (McElroy, 1979, 69). These may have
been English-made and imported to the
colonies, like the fine English japanned
desks and bookcases owned by the Bowdoin
family of Boston (now in the Detroit In-
stitute of Arts) and by Sir Danvers Osborn,
royal governor of New York (now in the
Metropolitan Museum of Art) (Fig. 79).

Within the William and Mary period,
however, American craftsmen began to ex-
ecute japanning. Stalker and Parker's *A
Treatise of Japanning and Varnishing* (1688) may
have provided instruction; craftsmen also
could have imitated imported japanned ob-
jects, or some may have learned the tech-
nique in England. William Price, who came
to Boston from London in 1714, for exam-
ple, is known to have made a japanned
bookcase signed and dated 1713, just the
year before (Forman, 1985, 21). The most
prolific Boston japanners, William Randle or
Randall (active 1715–39), Robert Davis (d.
1739), and Thomas Johnston (active
1737–1767), were born and trained in
England.

Of American japanned furniture,
clearly the earliest and most impressive
range of objects survives from Boston work-
shops, where more than a dozen japanners
were active in the first half of the eighteenth
century. Japanners also worked in New
York; both looking-glass frames and clock
cases survive from their shops. No Philadel-
phia-made japanned furniture has yet been
identified. One of only a few William and
Mary style japanned high chests of drawers,
this chest descended in the Cogswell-Dixon

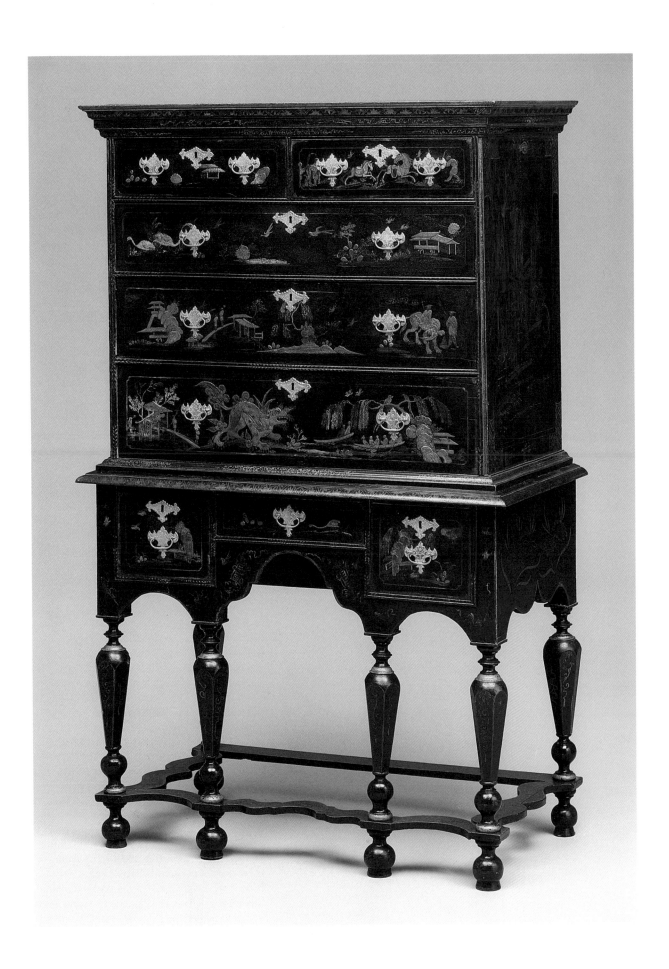

family of Boston, along with a companion dressing table, which is the only known American William and Mary style japanned dressing table. Each of its drawers is signed *Scottow* in chalk on the back. The Scottows were a family of Massachusetts furniture makers who worked in Boston in the late seventeenth and early eighteenth centuries.

As is characteristic of Boston japanning, the base paints have been applied directly over the wood. (In English and New York work, a layer of whiting was applied first.) Also typical of earlier American japanning is the way the chinoiserie decoration is set against a black background; later, in the 1740s, a tortoiseshell ground was more popular (Fales, 1974, 60). The most distinctive feature of this high chest, however, is the use of faceted legs, which are unique in American, though common in English, William and Mary furniture. An interesting English gaming table, of about 1700, with similar faceted legs descended in the Lord family and is presently owned by the Warner House Association in Portsmouth, New Hampshire.

PMJ

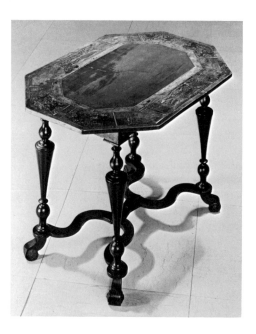

175 Tea Table

New York or Boston (base); Switzerland (top), 1700–15
Frame: soft maple, white pine, and white oak
Top: slate; Base: walnut and fruitwood inlay
68.6 × 88.9 × 62.2
Wadsworth Atheneum, Hartford, Connecticut, Wallace Nutting Collection, Gift of J. Pierpont Morgan
Reference: Nutting, 1928, figs. 1093, 1094

One of the rarest surviving forms from this era is the tea table. The Atheneum's may be one of only two American William and Mary style tables without drawers that the modern eye would identify as tea tables (the other is in the Winterthur Museum). Various small tables, with or without drawers, however, could have been used for the service of tea, as could some we today call dressing tables. We assume that a tea table would have been fitted with a practical slate top, but the fact that some dressing-table forms (Fairbanks and Bates, 1981, 66) and stretcher-based tables with single drawers (Nutting, 1928, figs. 1095, 1097) also have slate tops suggests a looser, rather than a stricter, designation of function, particularly at this time when drinking tea was a new social custom in America (see Nos. 63 and 199).

In 1961 Winslow Ames convincingly argued that tops such as the one on this table were made in Switzerland, brought to America, and fitted with locally made frames. How they came to America, we cannot demonstrate. Ames asserts, "They were probably shipped down the Rhine to Rotterdam and thence to a New England port" (Ames, 1961, 46–49). Slate tables began to appear in New England and New York inventories in the 1690s: the 1693 inventory of Thomas Pemberton, Boston, for example, lists a "Slate table," in his "Lower Roome"; and in 1699 Captain Christopher Goffe, mariner of Boston, had in his hall "1 slate table," and the estate of Frances Rombout of New York City included a "stone table and looking glass." (I am indebted to William Hosley for his comments about this table and for sharing this New York reference.)

Although all other slate-top tables are attributed to New England, the turnings and the cross stretchers of this table are closely related to those on a tea table in the Winterthur Museum thought to be from New York and, consequently, suggest a New York origin for this tea table. Recently, three missing bosses from the feet have been replaced (surviving originals served as models). A turned ornament originally stood at the crossing of the stretchers.

PMJ

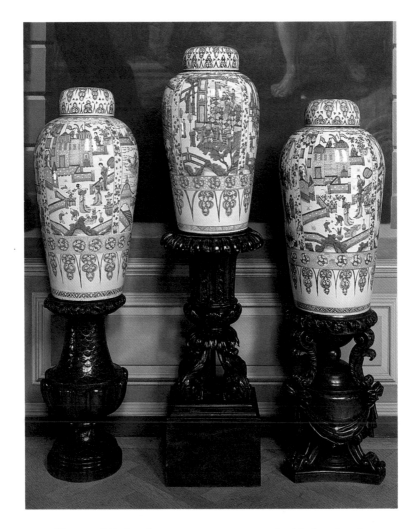

176 Vases and Pedestals

China, Kangxi Period (1662–1722) (vases)
England, c. 1695 (pedestals)
Vases: porcelain, painted in underglaze blue
Pedestal: mahogany
H. 168.9
The Lord Egremont
Reference: Jackson-Stops, 1977b, 358–66

Typical baroque motifs and ornamentation such as the fish-scale pattern, gadrooning, classical urn shape, C-scrolls, and swags found on these crisply carved pedestals, form a contrast to the Chinese vases they were made to support. The enormous size of these vases would have formed a striking element of baroque room decoration. The Dutchess of Somerset, who was Chief Mourner at Queen Mary's funeral in 1694, had in her dressing room at Petworth an elaborate arrangement of porcelain recorded in later eighteenth-century inventories, and these vases and pedestals are thought to have formed part of it (Petworth House Archives). We know that some of Queen Mary's ceramics at Kensington Palace were arranged on pedestals, since in the Kensington building accounts "8 scrowles for the pedestals of ye Gallery" were mentioned (Pay Books, May, 1693) and that when *The Fairy Queen* was first produced in 1692 "six pedestals of China-work [probably lacquer] rise from under the Stage; they support six large vases of porcelain" (Honour, 1961, 77).

 LRS

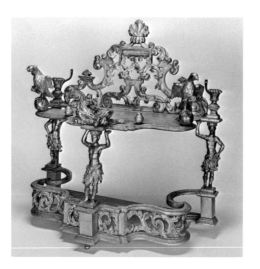

177 Etagère (Set of Wall Shelves)

England, c. 1700
Carved and gilded wood
60 × 61 × 35.5
The Viscount de L'Isle, V. C., K. G.

A reclining Turk and three caryatid figures
dressed in exotic feathered skirts and head-
dresses give this set of shelves an exotic
character, which might well reflect its origi-
nal contents. Such étagères were often filled
with rare treasures from the East, including
porcelain vases and figurines, teapots, lac-
querware, jade carvings, metalwork, rare
shells, and coral.

DSS

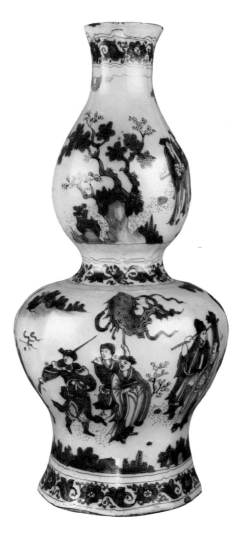

178 Double-gourd-shaped Vase

Delft, c. 1670–90
Tin-glazed earthenware
H. 40.3
Groningen Museum, Groningen
Reference: Jörg, 1984, no. 104

The double-gourd shape and refined
chinoiserie decoration of this vase are based
on Chinese Transitional porcelains. Other
pieces with comparable Chinese-inspired
decoration were signed by Samuel van
Eenhoorn, founder of the Greek A factory
and owner from 1674 to 1685.

DSS

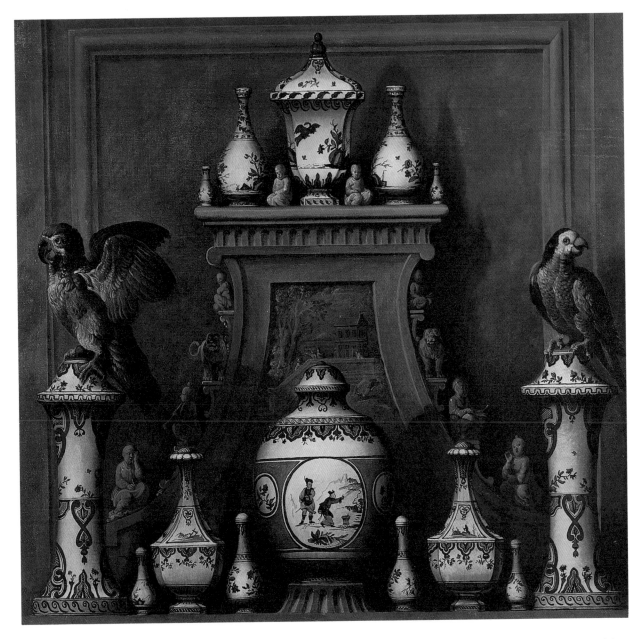

179 *Chimneypiece with Delftware*

The Netherlands, 1719
Pieter Jansz van Ruijven (1650/51–1719)
Oil on canvas
112 × 117
Amsterdams Historisch Museum
References: Jörg, 1984, fig. 10; Lunsingh Scheurleer,
1986–1987

The tiered arrangement of Delftware in this
trompe l'oeil painting relates quite closely to
several of Marot's prints for overmantels,
which he was fond of embellishing with
shelves and brackets loaded with porcelain
and Delftware. Even the shapes and
chinoiserie ornament of the pottery here
resemble those in Marot's prints. The late
date of this painting, designed to hang over
a fireplace, indicates the lasting taste for
Marotesque design in Netherlandish inte-
riors.

DSS

180 Teapot

Delft, late 17th century
Ary de Milde
Stoneware
12.75 × 17 × 14
Mrs. Richard Koopman

Typical of teapots made at Delft in imitation of Chinese Yixing wares (No. 181), which had been imported into Holland during the seventeenth century, this unglazed stoneware teapot has delicate flowers molded in relief on a globular body. Ary de Milde was one of the first of the Delft potters to produce red stoneware teapots, and he became the most prominent Dutch manufacturer of this ware. Such teapots would have been displayed along with Yixing pots in decorative arrangements of ceramics. During the early eighteenth century, when Chinese porcelain tea wares were brought into Europe in increasing quantities, these native ceramics were no longer in demand.

LRS

181 Teapot

China, late 17th century
Stoneware
H. 10
Emily Fisher Landau

In China, teapots from Yixing were favored for brewing tea, since they were held to retain the color, aroma, and taste of the drink. We know from the trading records of the Dutch East India Company that Yixing teapots such as this one were imported into Holland as early as the 1670s. (Lunsingh Scheurleer, 1974, 167). Many such reddish brown stoneware teapots were made specifically for the export market. They were copied by English potters, such as the Elers at Staffordshire, and by Dutch potters, such as Ary de Milde.

In Holland and England these pots would have been used for decoration as well as for brewing tea. Queen Mary's collection of porcelain and Delftware at Kensington included several "red teapotts" and "browne teapotts" (Lunsingh Scheurleer, 1960–62, 34, 38). These pieces were arranged in her apartments, along with other ceramics, as part of a decorative scheme. Thomas Bowery, an Englishman who visited Holland in 1698, described the "late Queen's Closett" at Honselaarsdijk as "all lined with China lacker[d] boards and the Mantle piece curiously adorned with Fine Red China ware" (Bowery, 1927, 55).

LRS

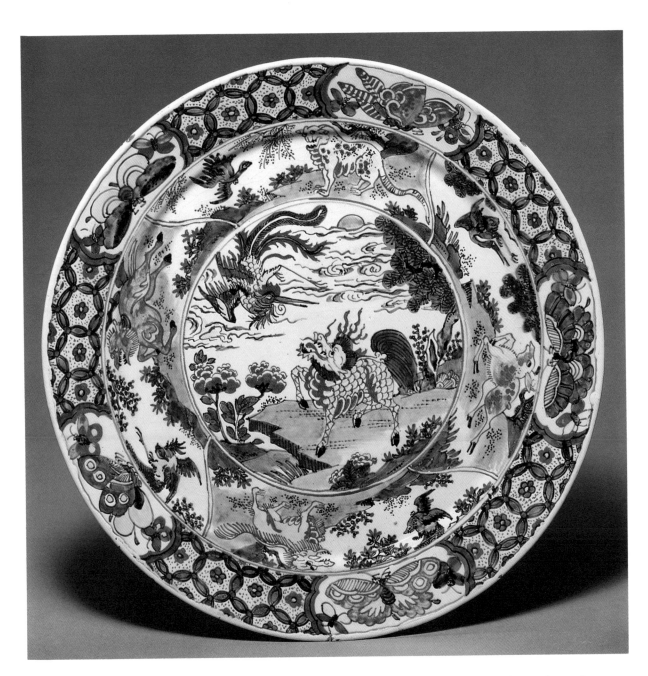

182 Plate

Delft, first quarter 18th century
The Rose factory
Tin-glazed earthenware
Diam. 26
The Metropolitan Museum of Art, New York, Gift of
R. Thornton Wilson, 1954, in memory of Florence
Ellsworth Wilson

Porcelains with polychrome decoration were imported from both China and Japan starting in the late seventeenth century. Delft potters were quick to imitate these exciting new wares, sometimes quite closely, as in this famille verte plate, where dragons, birds, insects, and floral borders are portrayed in dramatic green, manganese, iron red, blue, yellow, and black glazes. The Rose factory made a specialty of these richly colored wares, and several other plates with the same decoration are known, including those at the Rijksmuseum, Amsterdam, and the Museum Boymans-van Beuningen, Rotterdam.

DSS

183 Faceted Vase

Delft, c. 1680
The Greek A factory (signed *SVE*, for Samuel van
Eenhoorn)
Tin-glazed earthenware
20 × 11.5 × 11.5
Cooper-Hewitt Museum, Bequest of Walter Phelps
Warren, 1986-61-38
Reference: Warren, 1962, fig. 3

Other twelve-sided pieces like this faceted
vase were made at Delft, some of them
closed on top and used as wig stands. The
form may be borrowed from pewter flasks
with similar faceted sides. Samuel van
Eenhoorn, unlike other pottery owners, was
probably actively involved in the potting
and painting processes, and many pieces
painted with exquisite chinoiserie designs
are signed with his initials. The delicate
outlines (*trek*) and subtle shading of the
painting in this vase are characteristic of his
work.

 DSS

184 Ewer

Delft, c. 1700
The Greek A factory (signed *AK*, for Adriaen Kocks)
Tin-glazed earthenware
25 × 11.2 × 6
Cooper-Hewitt Museum, Bequest of Walter Phelps
Warren, 1986-61-45
Reference: Warren, 1962, fig. 7

Based on silver models, this elegant ewer
originally may have been accompanied by a
matching basin. Its fine chinoiserie decora-
tion of dragons, lambrequins, and stylized
floral and leaf borders reflects the high
quality of wares made at the Greek A
factory, one of Queen Mary's favorite sup-
pliers.

 DSS

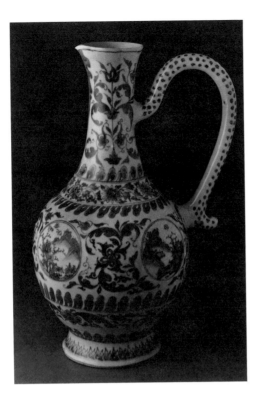

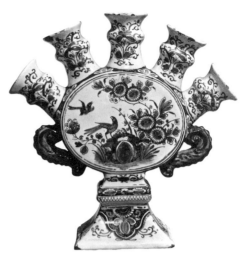

186 Five-spouted Vase

Delft, c. 1720
The Greek A factory (signed *PAK*, for Pieter
Adriaensz. Kocks)
Tin-glazed earthenware
20 × 20
The Brooklyn Museum, Museum Collection Fund

Fan-shaped flower vases with spouts for cut
blossoms, probably originating in Persia,
became popular in the Netherlands in the
late seventeenth century. Many different
forms of spouted flower containers, in
shapes ranging from pyramids to pagodas
and in a wide variety of sizes, were made at
the Greek A factory, including some of the
most extravagant examples made for Queen
Mary at Het Loo and Hampton Court
(Archer, 1976).

DSS

185 Ewer

China, Chongzhen period (1628–44)
Porcelain, painted in underglaze blue
H. 35.2
Professor N. R. Weiss

In 1635, representatives of the Dutch East
India Company gave the Chinese models of
European ceramic forms that they wanted
copied (Volcker, 1954, 37). Seventeenth-
century Chinese porcelains for export were
based on European models and were deco-
rated with Chinese motifs.

This ewer could have served as part of a
decorative arrangement of massed porcelain.
It is likely that even Queen Mary would
have had pieces of early seventeenth-century
date, since she may have inherited some;
Mary's father, James II, astonished the court
at Versailles by his knowledge of Chinese
porcelain (Beurdeley, 1962, 98). At
Hampton Court Palace today are 110 pieces
of oriental porcelain traditionally thought to
have belonged to Queen Mary. One of these
pieces is a bottle with decoration almost
identical to the decoration on this ewer
(Dillon, 1910, no. 21). A similar porcelain, in
the collection at Burghley House, dates
from this period (Burghley House, no. 148).
The band of stylized lotus petals is a motif
characteristic of the Chongzhen period; the
tulip motif at the neck may reflect Dutch
taste.

LRS

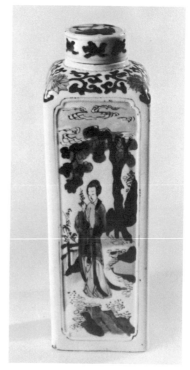

187 Bottle

Delft, c. 1690
The Greek A factory (signed *AK*, for Adriaen Kocks)
Tin-glazed earthenware
25.5 × 9.7 × 7.5
Cooper-Hewitt Museum, Bequest of Walter Phelps
Warren, 1986-61-63

Delftware bottles of rectangular form fol-
lowed the shape of contemporary glass
flasks; porcelain versions were also made for
export in China and Japan. The Chinese
figures, landscapes, and pavilions painted on
the four sides of this bottle are based on
Kangxi porcelain designs, although the
checkered floor tiles are a feature more
commonly found in Dutch interiors. A
similar bottle or tea caddy, also made at the
Greek A factory, is decorated with chinois-
eries and the crowned monogram of William
III (Musée National de Céramique, Sèvres).

 DSS

188 Square Bottle

China, Kangxi period (1662–1722)
Porcelain, painted in underglaze blue
24 × 9 × 9
Rijksmuseum, Amsterdam

Although square Chinese bottles made dur-
ing this period are generally believed to be
based on the shape of Dutch gin bottles,
this example tapers elegantly toward the
bottom in the manner of Chinese square
vases of the seventeenth century (Little,
1984, pl. 41). The elongated figure of a
woman and the landscape with pavilions are
typical motifs popular in the late Kangxi
period. Queen Mary had a "high square
bottle" (Lunsingh Scheurleer, 1960–62, 39)
in her collection at Kensington Palace.

 LRS

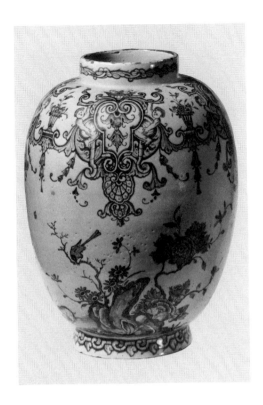

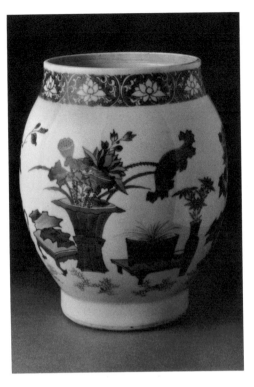

189 Jar

Delft, c. 1700
Tin-glazed earthenware
H. 21
The Brooklyn Museum, The Gamble Fund

Decorative motifs from East and West meet
in this Delft jar, where a lower band of
chinoiserie birds and flowers is topped by
an upper border of baroque scrolled car-
touches and cherubs. Probably originally
lidded, the jar has an ovoid form derived
from Chinese porcelain models.

 DSS

190 Jar

China, Chongzhen period (1628–44)
Porcelain, painted in underglaze blue
23.1 × 17.7
Mr. Peter A. Tcherepnine

The graceful shape and painted decoration
of jars such as this served as models for
Delft potters. The jar is decorated at the top
with a band of lotus meander in reverse, or
white-on-blue technique, and below is a
band of incised underglaze decoration. The
painting is carried out in a blue-purple,
typical of Chinese ceramics of the Transi-
tional period (1621–1683), that has been
called "violets in milk."

 LRS

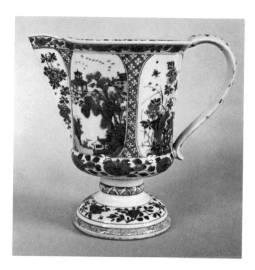

191 Ewer

China, Kangxi period (1662–1722)
Porcelain, painted in underglaze blue
20.5 × 14.5
Rijksmuseum, Amsterdam

This helmet-shaped ewer is a form ubiquitous in seventeenth century silver and ceramics from Europe. Probably introduced into China through wooden models supplied by the Dutch East India Company, the shape appears in Chinese ceramics by the 1630s. Here, the typical European form is decorated with Chinese designs. European ewers of this shape were made with matching basins; this piece is part of such a set, as was a Delftware ewer (No. 192) that echoes this form.

LRS

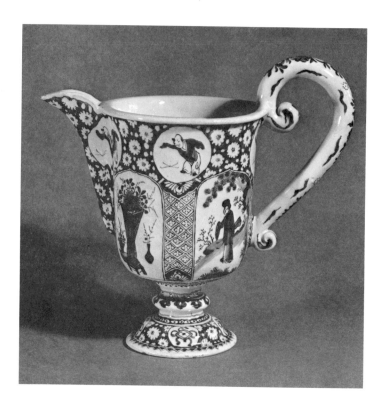

192 Ewer

Delft, c. 1690
Possibly the Greek A factory
Tin-glazed earthenware
23 × 25.4 × 13.8
Cooper-Hewitt Museum, Bequest of Walter Phelps Warren, 1986-61-53
Reference: *Catalogue d'une belle Collection*, 1908, no. 7

The magnificent monteith made to match this ewer is now lost, but both pieces were illustrated in a Dutch sale catalogue eighty years ago. Like its missing monteith, the ewer is painted with chinoiserie motifs—women, flower vases, and boys in reserves against patterned backgrounds of diaperwork and rosettes—in underglaze blue with dark outlines.

DSS

193 Figure of a Woman

Dehua, Fukien Province, China, late 17th–early 18th
century
Porcelain *(blanc de chine)*
32 × 16.5 × 11
Cooper-Hewitt Museum, Gift of Mrs. Howard J.
Sachs in Memory of Mr. Howard J. Sachs, 1977-48-8
Reference: Axel and McCready, 1981, 47

194 Figure of a Woman with Child

Dehua, Fukien Province, China, late 17th–early 18th
century
Porcelain (blanc de chine)
31 × 13.5 × 11
Cooper-Hewitt Museum, Bequest of Mary Hearn
Greims, 1927-5-45
Reference: Patterson, 1979, pl. 6

Blanc de chine figures made up an important
part of European collections during the
seventeenth century. It is difficult to date
such figures because the same molds were
used for extended periods. The inventory of
Queen Mary's collection at Kensington Pal-
ace mentions "two white figures being
women each with a child" (Lunsingh Sche-
urleer, 1960–62, 38). Such figures are known
in Dutch collections, notably that of Amalia
von Solms, King William's grandmother.
The inventory of her possessions from 1673
mentions "a woman with a child on her lap"
(Drossaers and Lunsingh Scheurleer, 1974,
1:309). These figures, both of Guanyin, the
goddess of mercy, offer a telling contrast:
one has the characteristic S-curve of pieces
made for the Chinese domestic market
(although such a piece could have been
shipped to Europe), while the other is stiffer
and less finely modeled, and is characteristic
of pieces intended for the export market.

Blanc de chine figures were imported into
Europe throughout the seventeenth and into
the eighteenth century. The 1704 records of
the East India Company contain a reference
to "large women with children two sorts."
(Home Miscellaneous Records *Aurengzeb*,
series 12; I am indebted to Dr. Julia B.
Curtis for sharing this reference.) The 1703
records show that an English ship "took in
. . . 22 baskets of white images" (Godden,
1979, 258).

A piece similar to the one on the left is
in the collection at Burghley House, which
dates to the same period (Burghley House,
no. 237).

LRS

195 Figure of a Woman on an Elephant

Dehua, Fukien Province, China; late 17th–early 18th
century
Porcelain (blanc de chine)
21 × 12.8 × 8.4
The Metropolitan Museum of Art, New York,
Purchased by Subscription, 1879

Blanc de chine pieces like this one were
sometimes gilded. Queen Mary's collection
of porcelain and Delftware at Kensington
Palace included "two elophant with
whomen on them in gold mantles" (Lun-
singh Scheurleer, 1960–62, 36). Two such
figures were arranged "over the doore goeing
into the Supping Roome" in the Old Bed-
chamber at Kensington Palace. They were
placed on either side of a large jar and
would have been striking against the wood
paneling in the room. A similar piece is in
the Staatliche Kunstsammlungen, Dresden
(Donnelly, 1967, fig. 86B).

 LRS

196 Guanyin

Delft, c. 1700
Tin-glazed earthenware
37.8 × 13.2
Municipal Museum Arnhem, The
Netherlands
References: Lunsingh Scheurleer, 1975, fig. 87; Jörg,
1984, no. 143

Delft potters produced their own idio-
syncratic interpretations of oriental por-
celain figurines. This exceptionally tall and
richly ornamented Guanyin is probably
based on the Chinese *blanc de chine* models
that were exported in large numbers to
Europe.

 DSS

197 Figure of a Chinese Sage

Delft, 1700–10
The Metal Pot factory (signed *VE* or *LVE*, for
Lambertus van Eenhoorn)
Tin-glazed earthenware
12.6 × 13.6 × 11.8
Municipal Museum Arnhem, The
Netherlands
Reference: Jörg, 1984, no. 142

Seated figures of smiling, pot-bellied sages,
probably based on the Chinese god of good
fortune, Budai, and known in the West as
pagods, were especially popular with Euro-
pean porcelain and Delftware collectors.
This one was made by the Metal Pot
factory, which specialized in statuettes of
this sort, and was probably based on a *blanc
de chine* model. Pagod figures were also
produced widely by porcelain factories in
Germany, France, and England later in the
eighteenth century.

DSS

198 Salver

Delft, c. 1700
The Metal Pot factory or the Double Flagon factory
(signed *LVE* for Lambertus van Eenhoorn or *LF* for
Louwijs Fictorsz)
Tin-glazed earthenware
7.2 × 22.2
Cooper-Hewitt Museum, Bequest of Walter Phelps
Warren, 1986-61-61

Both the form and the gadrooned edge of
this footed salver imitate contemporary sil-
ver models. Its exceptionally fine blue
painted decoration is typical of the mixture
of classical and oriental motifs found on
Dutch pottery of this period.

DSS

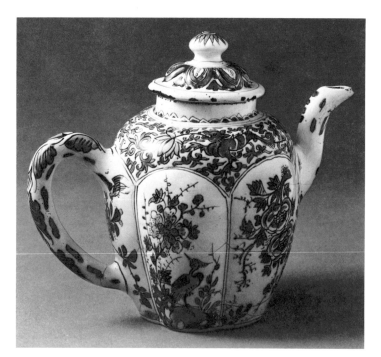

199 Teapot

Delft, 1686–1701
The Greek A factory (signed *AK* for Adriaen Kocks)
Tin-glazed earthenware
15.9 × 19.6
Pilgrim Hall Museum, Plymouth, Massachusetts
References: Museum of Fine Arts, Boston, 1982,
vol. 3

This teapot is believed to have belonged to
the Howland family of Plymouth in the late
seventeenth century. Documentary refer-
ences tell us that American colonists owned
ceramics, which they used and displayed on
top of chests and mantels. Few such objects
with period histories have been identified,
however. Nevertheless, objects like this tea-
pot offer clear evidence of the quality of the
Delftware owned by Americans.

 Elements in the design of the teapot are
predictably ones that may be seen in Amer-
ican-made objects, notably those of silver.
The cover is ornamented with molded and
painted gadrooning. The lobed sides of the
body contain flower and bird chinoiseries
loosely akin to those chased on Cornelius
Kierstede's candlesticks (No. 72). Finally, at
the lower edge of the neck appears a ring of
vertical leaves, very much like ones that
New York silversmiths applied to various
vessel forms.

 PMJ

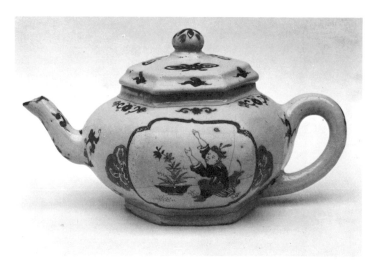

200 Teapot

Delft, c. 1680–92
The Young Moor's Head factory (signed *RIHS*, for
Rochus Jacobsz. Hoppesteyn)
Tin-glazed earthenware, polychrome decoration
H. 10
The Metropolitan Museum of Art, New York, Gift of
R. Thornton Wilson, 1950, in memory of Florence
Ellsworth Wilson
Reference: Lunsingh Scheurleer, 1984, no. 99

Hoppesteyn, a potter and owner of The
Young Moor's Head factory at Delft at the
end of the seventeenth century, was one of
the first to develop polychrome glazes in
imitation of imported Chinese and Japanese
porcelains. The charming painted decora-
tion on this hexagonal teapot includes
chinoiserie figures in shaped medallions on
the sides, with scroll and floral motifs
lightly dispersed around the body, handle,
spout, and cover. Its polygonal form, its
palette of blue, red, green, and gold, and its
relatively sparse ornament are somewhat
reminiscent of Japanese Kakiemon ware
imported from Arita.

 DSS

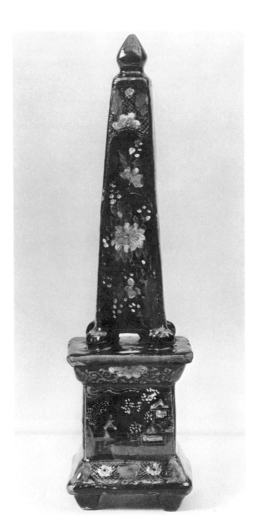

201 Obelisk

Delft, early 18th century
Tin-glazed earthenware, polychrome decoration
H. 19.7
The Metropolitan Museum of Art, New York, Gift of
R. Thornton Wilson, 1950, in memory of Florence
Ellsworth Wilson

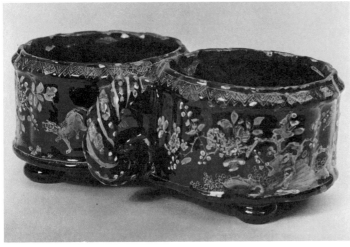

202 Cruet Stand

Delft, early 18th century
Tin-glazed earthenware, polychrome decoration
7 × 19
The Metropolitan Museum of Art, New York, Gift of
R. Thornton Wilson, 1950, in memory of Florence
Ellsworth Wilson

Chinese *famille noire* porcelains and Japanese
lacquer wares served as inspiration for Delft
pottery painted with black-glazed grounds.
Few examples of black Delft survive, on
account of expensive and unpredictable pro-
duction methods and the fact that the
pottery was made only at a limited number
of manufactories. Dating is often difficult.
Although they bear chinoiserie decorative
motifs, both of these black-glazed pieces
derive their shape from purely European
forms. The obelisk is similar to examples in
silver made for the sideboard buffet, while
the cruet stand, a recent addition to the
European table, was used to hold bottles
and containers for condiments.
DSS

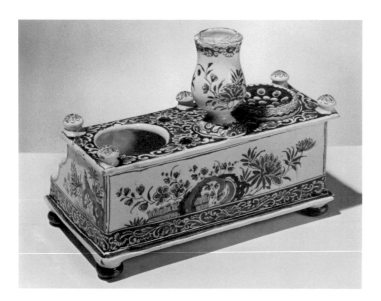

203 Inkstand

Delft, first quarter 18th century
The Greek A factory (signed *PAK*, for Pieter
Adriaensz. Kocks)
Tin-glazed earthenware, polychrome decoration
15.2 × 19.5 × 10.7
Philadelphia Museum of Art, Purchased: Joseph E.
Temple Fund

While under the ownership of Pieter
Adriaensz. Kocks and, later, his widow, the
Greek A factory specialized in Delftware
with decoration based on Japanese por-
celains from Arita. Chrysanthemums, styl-
ized rocks, birds, vases, and banded fences
are motifs commonly found on the poly-
chrome wares known as Kakiemon and
Imari. Like inkstands from the period made
in silver or pewter, this one contains a tray
for quills, inkwell, pounce pot, and
candleholder.

 DSS

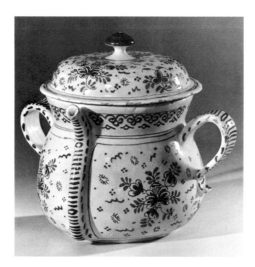

204 Posset Pot

Bristol, England, c. 1700
Tin-glazed earthenware, polychrome decoration
H. 18.5
The Brooklyn Museum, H. Randolph Lever Fund

English potteries at Southwark, Lambeth,
and Bristol produced polychromed wares
with chinoiserie decoration similar to, but
perhaps never quite as fine as, that produced
at the Delft factories. Some of the most
popular items made in the English potteries
were the large plates painted with portraits
of King William III and Queen Mary.
Posset pots, designed to hold a drink
concocted from hot milk curdled with ale or
wine and seasoned with spices and fruit,
were also made in glass.

 DSS

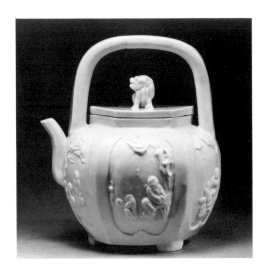

205 Ewer or Teapot

Dehua, Fukien Province, China, last quarter 17th
century
Porcelain (blanc de chine)
21.6 × 18.4 × 15.2
From the Collection of Richard L. Gray
Reference: Donnelly, 1967, fig. 60A

This pot was made in China, probably for
domestic use as a wine pot. The finial on
the cover represents a Buddhist lion; six
panels with sages seated in landscapes deco-
rate the sides. A similar piece is in the royal
collection at Hampton Court and is tradi-
tionally thought to have belonged to Queen
Mary (Dillon, 1910, no. 8), who had forty-
six "white pieces," as they were called, in
her collection at Kensington Palace.

LRS

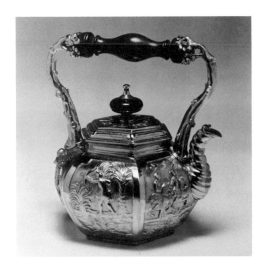

206 Teakettle

London, 1695
Pierre Harache (d. 1700)
Silver gilt
H. 19
The Burghley House Collection, Stamford, England
Reference: Burghley House, 1984, no. 17

An especially unusual example of
chinoiserie silver design is offered by this
delightful English silver-gilt teakettle. Its
hexagonal shape and branchlike handle de-
rive from Chinese *blanc de chine* pots (see No.
205), and its bamboolike spout was probably
inspired by Yixing stonewares. Details like
the rigidly molded polygonal lid and button
finial are strictly European in design, how-
ever. The six panels around the sides of the
teakettle are decorated with cast ornament
showing scenes of exotic and oriental figures
similar to those found in lacquer.

DSS

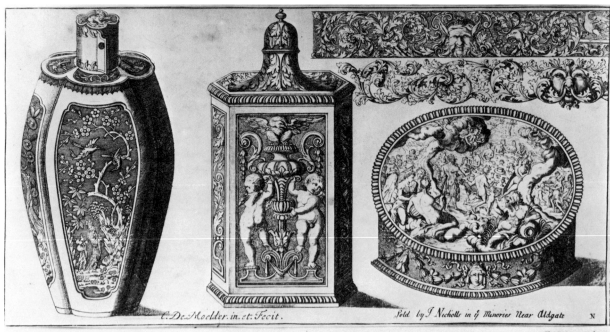

207 *Proper Ornaments to be Engraved on Plate*

London, 1694
C. de Moelder
Engraving
13.6 × 26.6
The Board of Trustees of the Victoria and Albert
Museum, London
References: Honour, 1961, 70; Glanville, 1987, fig. 233

De Moelder's book of silver patterns was one
of the first to include chinoiserie designs.
The high relief ornament shown here, based
on motifs found on oriental porcelains and
lacquer, was especially popular in English
and Dutch silver from about 1690 to 1720.

DSS

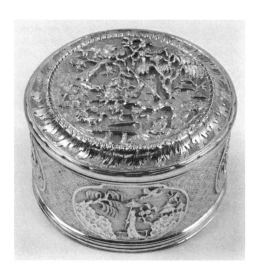

208 Box

The Netherlands, c. 1700
Silver
4.5 × 9
Museum Mr. Simon van Gijn, Dordrecht
Reference: Dordrechts Museum, 1975, no. 58

Chinese silver imported into the
Netherlands in the late seventeenth and
early eighteenth centuries also served as
inspiration for the relief patterns found on
some English and Dutch silver from the
period. Small boxes like this one—possibly
part of a toilet set—along with silver cups,
cane handles, and tea canisters, combined
European shapes with decidedly chinoiserie
ornament. A small silver box made in
London, with similar decoration of oriental
figures in relief, was given by Charles II to
his favorite, Nell Gwynn, in about 1685
(Honour, 1961, 70).

DSS

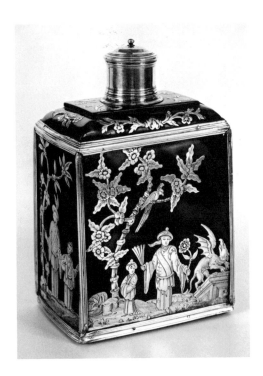

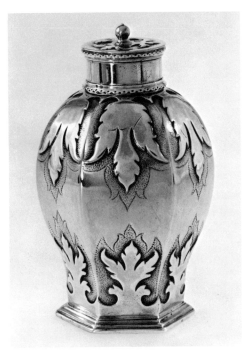

209 Tea Caddy

Zwolle, The Netherlands, c. 1700
Hendrik Voet (1654–1737)
Silver, tortoiseshell, wood
13.4 × 8.7 × 6
Rijksmuseum, Amsterdam
Reference: Blaauwen, 1979, no. 90

The fashion for silver ornamented with
oriental figures in exotic settings was among
the earliest manifestations of chinoiserie
taste. The fanciful scenes decorating the
sides of this tea caddy, formed of silver
inlaid into tortoiseshell, are reminiscent of
the earliest English chinoiserie designs en-
graved on silver in the 1660s. Hendrik Voet
and his brother Eusebius Willem made
several other tea caddies with similar de-
signs.

 DSS

210 Tea Caddy

The Hague, 1695
Silver
Unknown maker
9 × 4.9
Rijksmuseum, Amsterdam
Reference: "Keuze uit de aanwinsten," 1985, fig. 4

The tiny size of this canister reflects how
rare and precious a treat tea was considered
to be in the seventeenth century. A double-
sided lid served to keep any leaves from
escaping inadvertently. While its shape de-
rives from Chinese Yixing red stoneware, its
feathery cut-card ornament and molded foot
are based on Louis XIV style silver.

 DSS

TAB. VI.

211 *Wondertoneel der Nature*, by
Levinus Vincent

Amsterdam, 1706
Engraving by Romeyn de Hooghe (1645–1708)
Book: vellum, blind stamped
24.2 × 19
The Metropolitan Museum of Art, New York, The
Elisha Whittelsey Collection, the Elisha Whittelsey
Fund, 1958
Reference: Landwehr, 1970

A catalogue of an ideal collection of natural
materials and curiosities, this book features
chapters on botany, insects, shellfish, birds,
reptiles, corals, and stones. Educated gen-
tlemen of means often commissioned special
cabinets or small rooms for displaying such
foreign and exotic materials gathered from
around the world. The thirteen drawers of
the cabinet shown here, in Plate 6, are
carefully arranged with such natural won-
ders as seashells, bird specimens, turtles,
and rolled snake skins. Drawer no. 5, tipped
up to show its contents, displays scroll-like
patterns composed of buttlerflies, moths,
beetles, and other insects.
DSS

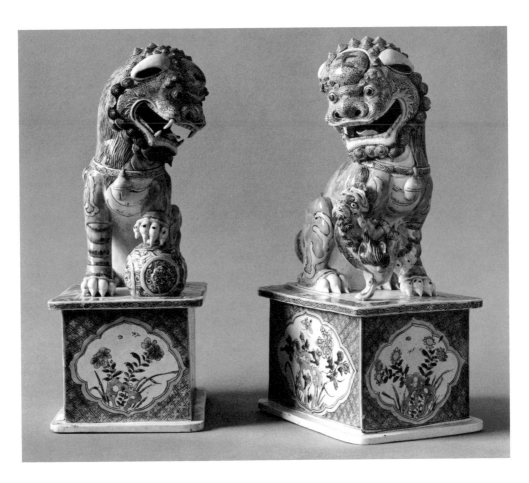

212 Pair of Lions on Pedestals

China, Kangxi period (1662–1722)
Porcelain painted on the biscuit with famille verte
enamels
36 × 14.6 × 20.7 (each)
Cooper-Hewitt Museum, Gift of Mrs. Howard J.
Sachs in Memory of Mr. Howard J. Sachs, 1977-40-1, 2
Reference: Lipson, 1981

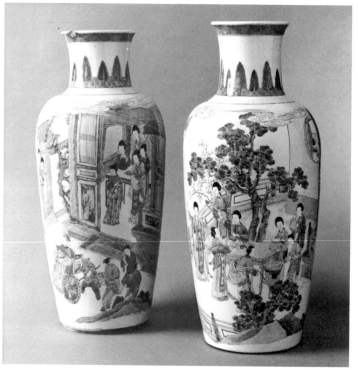

213　Two Vases

China, Kangxi period (1662–1722)
Porcelain with overglaze famille verte enamels
43.5 × 19.4; 42.5 × 19.4
Cooper-Hewitt Museum, Gift of Mrs. Howard J.
Sachs in Memory of Mr. Howard J. Sachs,
1977-48-13, 15

214　Vase

China, Kangxi period (1662–1722)
Porcelain with overglaze famille verte enamels
44.5 × 19.5
Cooper-Hewitt Museum, Gift of Mrs. Howard J.
Sachs in Memory of Mr. Howard J. Sachs, 1977-48-9

Porcelains with famille verte coloration first
appeared in European collections at the end
of the seventeenth and the beginning of the
eighteenth century. It was only during the
latter part of the seventeenth century that
polychrome wares began to be imported
into Europe in great quantities; previously,
the taste for blue-and-white wares had
predominated. Pieces such as those shown
here (Nos. 212–15) would have been rare
and costly in both the Netherlands and
England, and highly prized until the famille
rose palette gained ascendancy during the
late 1720s. The large covered jar would
probably have been used in a fireplace (as
shown in No. 171), while the lions and vases
might have formed a garniture on top of a
cabinet or on a mantel.

　　LRS

215　Covered Jar

China, Kangxi period (1662–1722)
Porcelain with overglaze famille verte enamels
55 × 35
Cooper-Hewitt Museum, Gift of Mrs. Howard J.
Sachs in Memory of Mr. Howard J. Sachs, 1977-40-8, 9

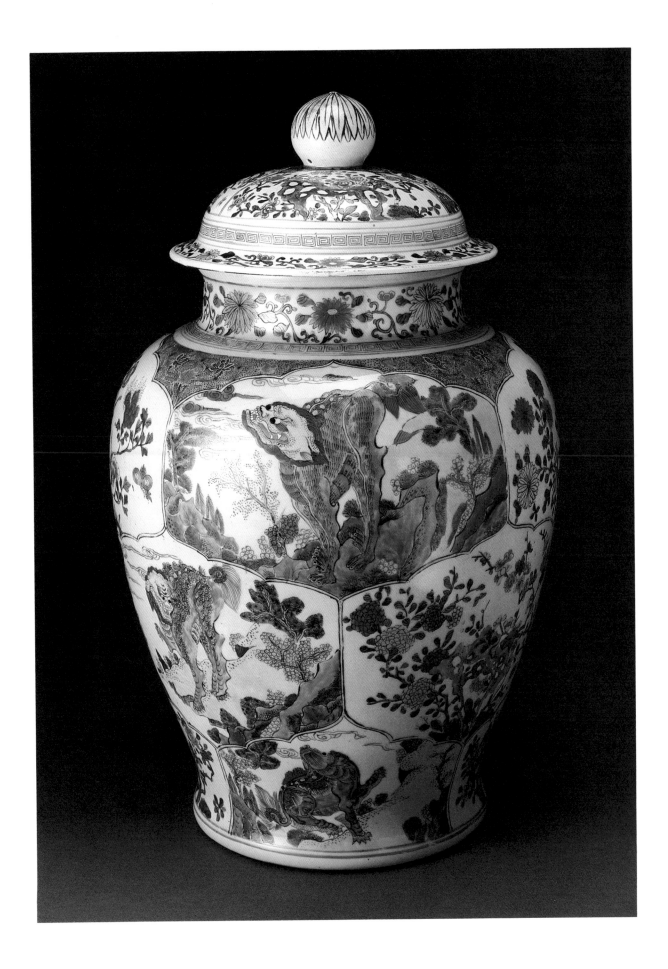

Gardens

William and Mary style gardens were influenced both by the French court and by Anglo-Dutch horticultural traditions. At Versailles, Le Nôtre's bold plan integrated palace and garden into a highly centralized plan radiating from the private chamber of the king to the state apartments, to the formal entrance, to the parterre gardens, to the fountain gardens, to the broad, tree-lined avenues, and finally to the wilderness beyond. Dutch flower beds filled with brilliant tulips and surrounded by networks of canals continued, along with traditional English mazes and topiaries, to be important elements of William and Mary style gardens in the late seventeenth century. Marot's designs for the layout, fountains, and pavilions of the gardens at Het Loo and De Voorst and for the Great Parterre or Fountain Garden at Hampton Court were echoed in such colonial outposts as the Governor's Palace in Williamsburg, Virginia.

216 A Bird's-eye View of Het Loo Palace and Gardens

The Netherlands, c. 1698
Romeyn de Hooghe (1645–1708)
Etching, second state
Four plates: 37.7 × 36.6 each
Rijksprentenkabinet, Rijksmuseum, Amsterdam
References: Hollstein, 1949, 9:127, no. 307; Landwehr, 1973, 341; Pierpont Morgan Library, 1979, no. 151.

The most advanced baroque court-style gardens in the Netherlands were created by William and Mary at Het Loo Palace in Apeldoorn, Gelderland. They were laid out between 1686 and 1695 according to designs provided by Daniel Marot. Le Nôtre's gardens at Versailles, where house, garden, and park were conceived in a central, unified scheme, served as inspiration for those at Het Loo—and in the rest of Europe—in the late seventeenth century. Peculiarly Dutch characteristics are manifest, however, in the arrangement of an outer framework of canals, smaller and more regularly shaped parterres and beds, and abundant plantings of tulips and other flowers.

Close to the house, under the king's apartments on the west side, were his private gardens, with parterres, a large fountain, and a bowling green. Opposite, on the east, the queen's gardens included an orangery, a grotto, an aviary, and extraordinary covered-arbor walks featuring hedges with clipped "windows" offering views of parterres and fountains in the adjacent garden.

On the north side of the house was a sunken garden with eight parterres decorated with seasonal flowers, marble urns, and pyramidal juniper trees. Also featured were a fountain with a statue of Venus, fountains with a celestial globe and a terrestial globe, and cascades with statues of Narcissus and Galatea. The upper garden included the King's Fountain, which shot water thirteen meters into the air, mazes, orangeries, and kitchen gardens; the park beyond contained an aviary, the Grove of Saturn, nurseries, ponds, canals, fish ponds, and a large reservoir.

Romeyn de Hooghe, a prolific etcher, produced a large number of prints illustrating the palaces, people, and special events at the court of William as stadholder and as king (see Nos. 9 and 230). Besides showing the buildings and gardens at Het Loo, this large etching also offers a glimpse of the daily activities surrounding a late seventeenth-century baroque palace: a visiting dignitary arrives in a coach at the forecourt gates; a procession of servants bearing food for the royal dinner leaves the kitchen wing on the right, bound for the central door of the main block; and courtiers, laborers, and others walk the garden paths and admire the waterworks.

A detailed guide to the Het Loo gardens is provided in *A Description of the King's Royal Palace and Gardens at Loo* (London, 1699), by Walter Harris, William's court physician. The gardens have recently been restored according to original plans.

DSS

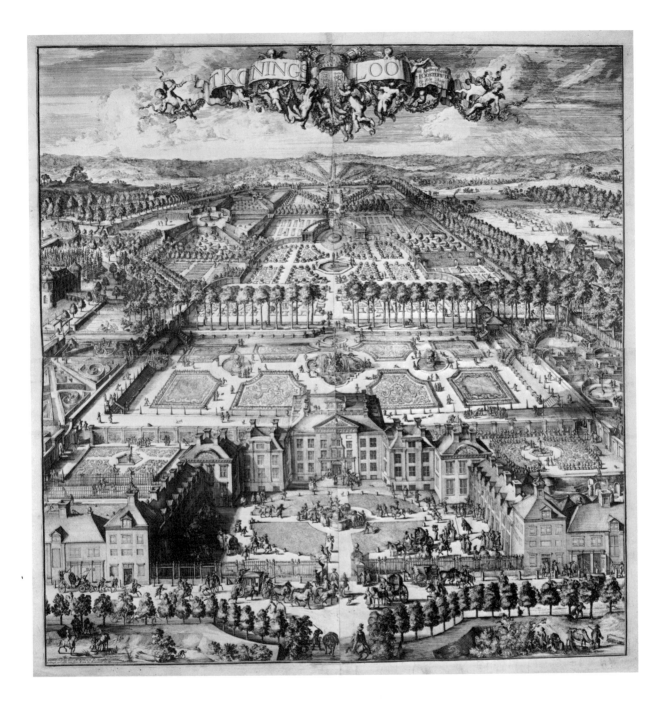

217 Design for a Tapestry or Painted Wall Hanging with Birds

The Netherlands, c. 1725–50
Daniel Marot (1661–1752) or Daniel Marot the Younger (1695–1769)
Pen and black ink, watercolor
19.6 × 33.3
Inscribed in pen and black ink at lower center: *Daniel Marot fecit*
Cooper-Hewitt Museum, Gift of the Council, 1911-28-308

The enchanting songs, brilliant colors, and lively movement of prized species of foreign and domestic birds added important sensual components to elaborate baroque gardens. The collecting of rare and exotic birds and other animals had been popular since ancient times, and the grandest seventeenth-century gardens featured special menageries and aviaries to house them. The famous menagerie at Versailles was one of the most popular parts of that park.

Walter Harris, in *A Description of the King's Royal Palace and Gardens at Loo* (1699), tells of the "Voliere, or Fowl-Garden" in the northwest corner of the park, entered through blue-and-gold painted wrought-iron gates. Inside was a fountain for the use of "divers sorts of fowl," two summerhouses with screened windows that opened onto aviaries containing "curious Foreign or Singing Birds," and several other houses for "Ducks, Pigeons, Poultry etc.," with openings that allowed the fowl to enter and exit freely.

The arrangement of the colorful plumage of Marot's garden fowl calls to mind contemporary sartorial splendor at court, where a conspicuous neck scarf, lacy ruffles down the breast, long winged coat-tails, and tall cockadelike wigs were popular during the late seventeenth and early eighteenth centuries.

DSS

218 Title Page: *Vases de la Maison Royalle de Loo*

The Netherlands, c. 1700
Daniel Marot (1661–1752)
Etching and engraving
25.1 × 19
Cooper-Hewitt Museum, Purchase in memory of Mrs. John Inness Kane, 1944-36-20

The curving columned arcade in the background of this print relates closely to the two "Semicircular Galleries or Porticoes" (Harris, 1699, 47) in the Upper Garden at Het Loo, each forty paces long and about six yards wide, with a balustraded gallery on top. According to Harris's description, they were decorated inside with paintings of "Gods and Goddesses at length in Fresco," thirteen in each gallery. This portico and its mate originally joined the main house to flanking wings. They were moved to the garden during renovations by Jacob Roman, architect to William III.

The scene illustrated in the central panel of the garden vase shown here represents the story of Pan and Syrinx from Ovid's *Metamorphoses*. The nymph Syrinx escaped the advances of the satyr Pan by being transformed into a bunch of reeds. Pan was so charmed by the sound of the wind rushing through the reeds that he created the first reed flute. The composition of the scene relates closely to a print by Jean Le Pautre and to the decorations by Le Brun for garden urns at Versailles, with which Marot would have been familiar. The broad scrolled and diapered tripod base and rich sculptural details of the vase, however, reveal Marot's own exuberant form of baroque classicism. A large fountain designed by him for the gardens at De Voorst also included a figural group of Pan and Syrinx. Marble garden urns designed by Marot still ornament the gardens of the Het Loo Palace today.

DSS

233

The Netherlands, c. 1712
Daniel Marot (1661–1752)
Etching
28.5 × 20.5
Ecole Nationale Supérieure des Beaux-Arts, Paris,
Collection Le soufaché
References: Lane, 1949, no. 17

The Great Fountain Garden, or Great
Parterre, to the east of Hampton Court
Palace, was designed by Daniel Marot and
built within the large semicircular area
created by the goose-foot arrangement of
avenues laid out for Charles II (Lane, 1949;
Jellicoe, 1986, 242-44). Work on the garden
probably started in 1689, when the diarist
John Evelyn reported that "a spacious
garden with fountaines was beginning in the
park at the head of the canal." Activity was
halted after the queen's death but resumed
after the fire at Whitehall Palace four years
later. The semicircular area was divided into
eight irregularly-shaped *parterres de broderie*
(embroidered parterres), each with plantings
in patterns of exuberant baroque scrolls and
strapwork, bordered by dwarf box and
punctuated with pyramids of yew and
globes of bay and holly. Walking paths
winding through the parterres were inter-
spersed with thirteen fountains, and the
garden was bordered on the palace sides by
a tall wrought-iron gate by Jean Tijou and
on the park side by double avenues of lime
trees.

 This print from Marot's *Oeuvres* shows a
segment of his plan for the Great Parterre
Garden. The parterres de broderies are
strikingly similar to his designs for appli-
quéd and embroidered upholstery fabrics on
state beds and seating furniture. Marot may
also have contributed designs for the Privy
Garden and the Wilderness at Hampton
Court. Among his published prints are
designs for many different kinds of garden
ornament, including not only parterres, but
also bosquets, labyrinths, fountains, statues,
urns, furniture, pavilions, trelliswork, and
arbors.

 The Great Parterre was altered dras-
tically after the death of William III, when
Queen Anne, who reputedly disliked the
smell of boxwood, ordered the parterres
filled in with grass and removed all but one
of the fountains.

 DSS

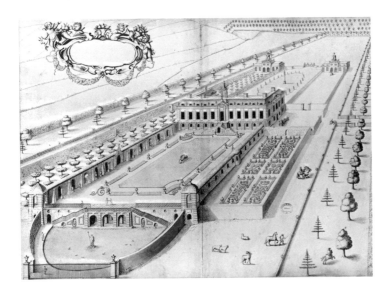

220 A Bird's-eye View of a Proposed Trianon at Hampton Court

England, 1699
William Talman (1650–1719)
Pen and black and red ink, gray and blue wash
52 × 74
The British Architectural Library Drawings
Collection, Royal Institute of British Architects,
London
References: Harris, 1960; Harris, 1982, 37, fig. 55;
Whinney, 1955

Louis XIV's Grand Trianon in the park at
Versailles created a new kind of royal
abode—part garden pavilion and part mini-
palace—a private retreat for the king and a
small group of friends and family, away
from the crowds at the palace and the
formal restrictions of court etiquette. This
example was soon followed by kings and
princes all over Europe, including William
III, who commissioned William Talman to
design a similar hideaway just across the
Thames from Hampton Court Palace.

The Hampton Court Trianon gardens,
as proposed in this drawing, would have
been essentially Dutch in character, laid out
in a long, rectangular enclosed plan and
enriched with parterres and topiary. The
great stairway leading up to the terrace
parterre, the loggias, the corner pavilions,
and the garden benches, obelisks, and statu-
ary provide stong architectural emphases.
DSS

221 Longitudinal Section of a Proposed Trianon at Hampton Court

England, 1699
William Talman (1650–1719)
Pen and black ink, black and gray wash
52 × 74
The British Architectural Library Drawings
Collection, Royal Institute of British Architects,
London
References: Harris, 1960; Harris, 1982, 37, fig. 56;
Thornton, 1984, fig. 60; Whinney, 1955

William Talman, Comptroller of the Royal
Works from 1689 until 1702, worked with
Daniel Marot on such projects as Hampton
Court and Kensington Palace. Marot's influ-
ence on Talman can be seen in some of the
articulation and decoration of the rooms
seen in this cross-section of the Trianon.
The corner chimneypiece in the state bed-
room and the mantelpiece with inset oval
mirror in the small closet next door are
similar to designs in Marot's *Oeuvres* (see
No. 18). Sadly, Talman's plans for William's
Trianon were never realized, since the king
died in 1702, after a riding accident in
Bushy Park.
DSS

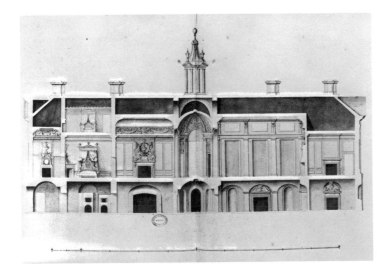

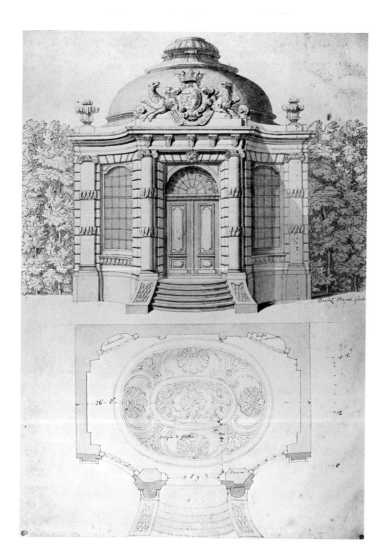

222 Design for a Garden Pavilion

The Netherlands, 1712
Daniel Marot (1661–1752)
Pen, black and brown ink, pink wash
51.7 × 35.6
Inscribed in pen and black ink at center right: *Daniel Marot fecit*; in graphite below: *1712+*; in pen and ink lower section: *chemineé / buffet ou armoire / couple de platre / Greque pierre*
Ecole Nationale Supérieure des Beaux-Arts, Paris
Reference: Ozinga, 1939, pl. 44

Large sculptural coats of arms rising from cornice moldings feature in several other designs by Marot for houses from the 1710s to 1730s, including the Wassenaer-van Obdam House, Kneuterdijk, The Hague, for which this garden pavilion may have been commissioned (No. 14).

The interior plan of the pavilion shows an octagonal chamber topped by a plaster-work ceiling recalling Marot's parterre designs. With its chimney and buffet, or armoire, built into the back corners and its large convex windows on the front side, this handsome pavilion would have afforded a most charming spot for garden dining or afternoon tea.

DSS

223 *A New Booke of Drawings* (Plate 19)

London, 1693
Jean Tijou (active 1689–1712)
Michiel van der Gucht (1660–1725), engraver
Etching and engraving
27.4 × 39.4
Cooper-Hewitt Museum, Gift of the Council,
1921-6-410
Reference: Harris, 1960, no. 24

A New Booke of Drawings, published in London by the French ironsmith Jean Tijou in 1693, contained his designs for ironwork gates, balconies, staircases, and panels, including many that were actually executed at Hampton Court and at other large country estates. Several factors were responsible for a surge in the use of decorative ironwork in England in the late seventeeth century; most important were the expansion of iron production, the perennially damp climate, and the introduction of French tastes in highly decorated formal state rooms and in garden settings.

DSS

J. Tÿou. In. et del: P. P. Bouche. sculp:

15.

224 Design for an Ironwork Gate, Plate 15 from *A New Booke of Drawings*

London, 1693
Jean Tijou (active 1689–1712)
Peter Paul Bouche (active 1646–1693), engraver
Etching and engraving
33 × 21
The Board of Trustees of the Victoria and Albert Museum, London
References: Harris, 1960, no. 20; Jackson-Stops, 1971, vol. 2, fig. 2

One of Tijou's works at Burghley was described by Celia Fiennes as a "door of iron carv'd the finest I ever saw, all sorts of leaves flowers figures birds beast wheate in the carving" (Jackson-Stops, 1971, 1:182). Other works for English houses included gates and balustrades for Chatsworth and Drayton, where Tijou collaborated with the architect William Talman. His greatest iron-work masterpieces, however, were created for Hampton Court, where he worked from 1689 until 1700 and where he designed and executed the balustrades to the King's and Queen's staircases, a gateway, and the screen to the Fountain Garden. Plate 19 (No. 223) shows the monumental gates for the east front of the palace. A strong architectural framework is enlivened by luxuriant, flow-ing acanthus foliage, and the upper edge of the gates is defined by a lively rhythm of urns, scrolls, volutes, and a magnificent crowned cipher. French sources are evident in the design of the gate in Plate 15, which shows similarities to gates made by Luchet at Versailles in 1678 (Jackson-Stops, 1971, 1:183).

Tijou's book of ironwork designs was the first one published in England, and it influenced a whole new school of British blacksmiths who continued to work in and around London and in other parts of the country into the eighteenth century. The book was sufficiently popular outside En-gland to have inspired a pirated version by Louis Fordrin in Paris: *Livre de Serrurerie de Composition Angloise, Contenant plusieurs Des-sins pour les Maisons Royales, etc., Lesquels ont été executé à Londres* (Harris, 1960, 4).

DSS

225 Section of the Communion Rail from St. Paul's Cathedral

London, c. 1706
Jean Tijou (active 1689–1712)
Wrought iron
68.6 × 185.4 × 2.5
The Dean and Chapter of St. Paul's Cathedral, London

At St. Paul's Cathedral, working under the direction of Sir Christopher Wren, Tijou's works included the sanctuary screen, a guardrail to the landing of the Geometrical Stair, and gates to the north and south chancel aisles. This section of ironwork from his communion rail features a cock, acanthus leaves, and sprigs of laurel inter-spersed within a framework of scrolls and volutes. When the rail was completed in 1706, Tijou was paid a total of £260. It was moved from its original position to the choir entrance in the middle of the nineteenth century.

DSS

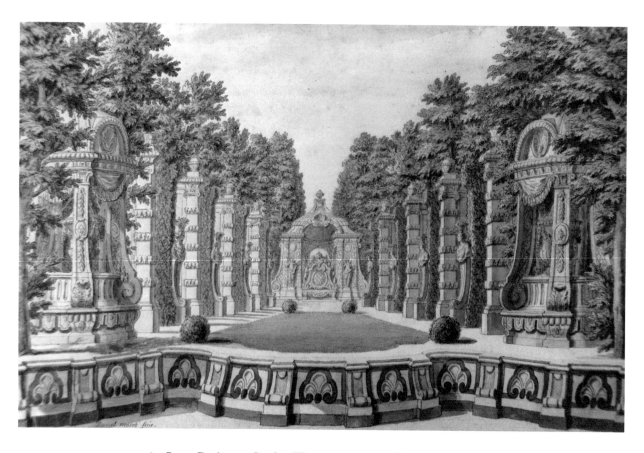

226 Stage Design or Garden Theater

The Netherlands, c. 1730
Daniel Marot (1661–1752)
Pen and black ink, watercolor
30.5 × 47.8
Inscribed in pen and black ink at lower left: *Daniel Marot fecit*
Lodewijk Houthakker Collection, Amsterdam

Garden and theater have been closely associated since the Renaissance, when ancient Roman amphitheaters were transformed into small green theaters and featured prominently in Italian villa gardens. In northern regions, where weather was more severe and unpredictable, the outdoor theater developed more as a garden folly. Some of the grandest baroque palace gardens did, however, include special garden theaters, such as the one designed by André Le Nôtre at the Tuileries. At Versailles, temporary stages were set up in different parts of the gardens, incorporating plantings, fountains, and pavilions into court pageants and ballets.

Gardens sometimes featured permanent theatrical embellishments, such as painted murals that made flat end walls look like vistas stretching off into the far distance. Artificial garden settings were also created for indoor theaters. Set designers copied the long axial perspectives afforded by garden avenues to create dramatic backdrops for the pastoral plays popular in the late seventeenth century.

Marot created plans for garden theaters for at least two Dutch estates, at Huis ten Bosch and Meer en Berg. This scene shows a heavy debt to the theater designs of the Bibiena family, as well as many very characteristic Marot features, such as the large scrolled volutes and lambrequin borders of the pavilions and the tall-backed garden bench. A related drawing is in the Bibliothèque Nationale, Paris (Ozinga, 1939, pl. 57B).

DSS

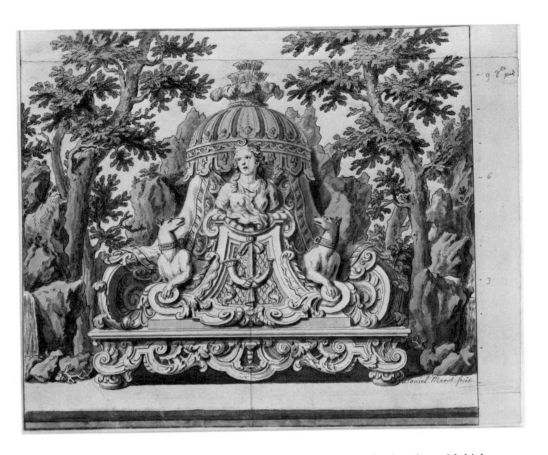

227 Design for a Garden Bench

The Netherlands, 1725–50
Daniel Marot (1661–1752)
Pen and black ink, watercolor, black chalk
27.1 × 34.9
Inscribed in pen and black ink at lower right: *Daniel Marot fecit*
Rijksprentenkabinet, Rijksmuseum, Amsterdam
Reference: Hijmersma, 1980, fig. 4

Large wooden garden benches with high, carved backs were first designed by Daniel Marot in the late seventeenth century. Planned as integral parts of a comprehensive garden scheme, which included the overall layout, parterres, plantings, fountains, and pavilions, they were usually placed against walls or tall hedges or in shallow niches or pavilions. The bench in this imaginative design is ornamented with a bust of Diana, two muscular dogs, and a hunting trophy.
DSS

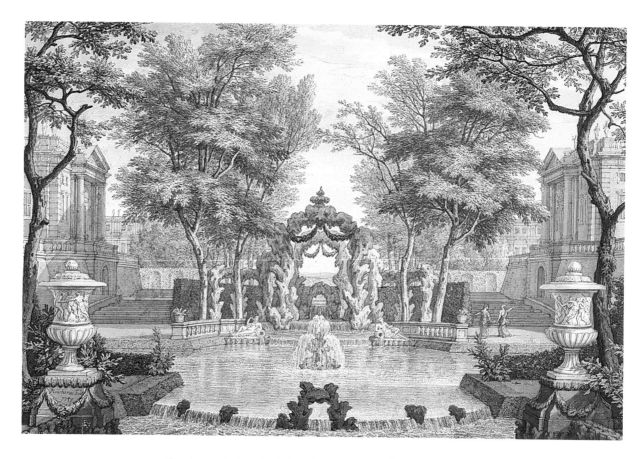

228 Garden with Classical Buildings

The Netherlands, 1743
Isaac de Moucheron (1667–1744)
Pen and brown ink, watercolor
22.2 × 32.7
Inscribed in pen and brown ink at lower left:
Moucheron Fecit / 1743
Cooper-Hewitt Museum, Gift of The Port Royal
Foundation, Inc., 1986-8-1

Isaac de Moucheron's travel in Italy during
the 1690s and his familiarity with the work
of Claude Lorrain (1600–82) are reflected in
the arrangement of classical architecture,
urns, statuary, and distant landscape vistas
in these drawings (Nos. 228 and 229). His
close association with Daniel Marot, who
had published a series of similar park scenes
in his *Oeuvres*, is also evident.

The drawings, which belong to a series
and are all dated 1743, show the sort of
idealized garden and park scenes that had
been popular since the middle of the seven-
teenth century and continued to be fashion-
able in the Netherlands well into the
eighteenth century. The cool blue and green
tones and the fabulous rocaille formations
are characteristic of rococo design in the
1740s.

DSS

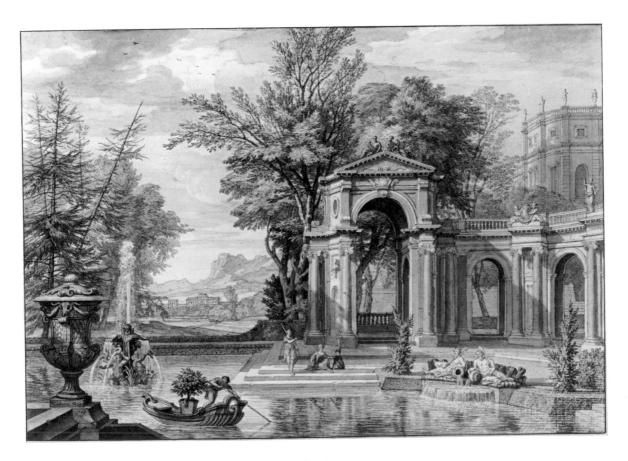

229 Imaginary Italianate Garden Scene

The Netherlands, 1743
Isaac de Moucheron (1667–1744)
Pen and brown and gray ink, watercolor, over faint
traces of black chalk
23.2 × 34
Inscribed in brown ink at lower left: *Moucheron Fecit /
1743*
Pierpont Morgan Library, New York, Purchased on
the von Bulow Fund, 1982–91

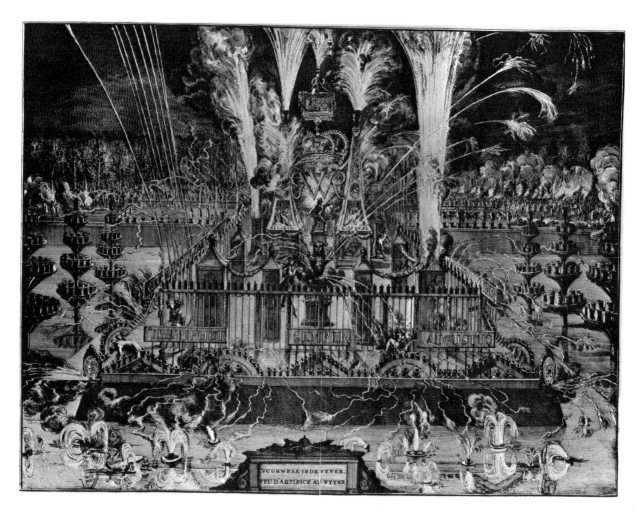

230 Plate 13 from *Komste van Zyne Majesteit Willem III Koning van Groot Britanje, enz in Holland*, by Govard Bidloo

The Hague, 1691
Etching by Romeyn de Hooghe (1645–1708)
32.5 × 43.2
Mr. Gervase Jackson-Stops
References: Hollstein 1949, 9:125, nos. 168–185; Landwehr, 1970, 172-177

In 1691, William III journeyed from England to Holland to attend a council on the state of the war against France. It was an opportunity for the city of The Hague to mount a spectacular celebration in his honor. Romeyn de Hooghe was commissioned to design the temporary structures marking the route of the king's progress through the city. There were several triumphal arches elaborately decorated with painting and sculpture. At the market square, a circular wall, painted with scenes of William's military triumphs and ornamented with sculptured trophies, incorpo-

rated one of the arches and enclosed two obelisks. A fusillade saluted the king at the city hall, which was illuminated for the occasion. The climax of the festivities, however, was the fireworks display on the Vyver, a body of water in the center of the city. The apparatus for the fireworks, which was, of course, consumed in the process of the evening's display, was adorned with William's monogram, patriotic mottoes, and phrases praising the ruler.

The festival was commemorated in a luxurious, 127-page volume published in Dutch in 1691 and in French the following year, with a text describing each aspect of the celebration. De Hooghe, the faithful pictorial recorder of the important events of William's life, provided the etched illustrations, including a frontispiece and fourteen plates.

EED

Bibliography

Agates, Crystaux, Porcelaines, Bronzes, et Autre Curiosités dans Le Cabinet de Monseigneur le Dauphin à Versailles, 1689 (manuscript on microfilm).

Ames, Winslow. "Swiss Export Table Tops." *Antiques* 80 (July 1961): 46–49.

Archer, Michael. "Delft at Dyrham." *The National Trust Yearbook* (1975–76), 12–18.

———. "Dutch Delft at the Court of William and Mary." *International Ceramic Fair and Seminar* (1984), 15–20.

———. "Pyramids and Pagodas for Flowers." *Country Life* 159 (1976): 166–69.

"An Armorial Tapestry made for Dutch William." *Connoisseur* 91 (1933): 136–37.

Ashmolean Museum. *Eastern Ceramics and Other Works of Art from the Collection of Gerald Reithinger.* London: Sotheby Parke Bernet, 1981.

Avery, C. Louise. *Early American Silver.* New York: The Century Company, 1930.

Axel, Jan, and Karen McCready. *Porcelain: Traditions and New Visions.* New York: Watson-Guptill Publications, 1981.

Bérard, André-Denis. *Catalogue de toutes les estampes qui forment l'Oeuvre de Daniel Marot, Architecte et Graveur Français.* Brussels: A. Mertens, 1865.

Beurdeley, Michael. *Porcelain of the East India Companies.* London: Barrie & Rockliff, 1962.

Bigelow, Francis Hill. *Historic Silver of the Colonies and Its Makers.* New York: The Macmillan Co., 1917.

Blaauwen, A. L. den, ed. *Nederlands zilver/Dutch silver 1580–1830.* Amsterdam: Rijksmuseum, 1979.

Bolingbroke, Judith M. *William and Mary Fabrics.* Leigh-on-Sea, England: F. Lewis, Publishers, Ltd., 1969.

Bowery, Thomas. *The Papers of Thomas Bowery. Part I: Diary of a Six Week's Tour in 1698 in Holland and Flanders.* The Hakluyt Society, 2nd series, 58. London, 1927.

Buhler, Kathryn C. *American Silver 1655–1825 in the Museum of Fine Arts, Boston.* Boston: Museum of Fine Arts, 1972.

———. *Colonial Silversmiths, Masters & Apprentices.* Boston: Museum of Fine Arts, 1956.

———. "The Nine Colonial Sugar Boxes." *Antiques* 85 (1964): 88–91.

Buhler, Kathryn C., and Graham Hood. *American Silver, Garvan and Other Collections in the Yale University Art Gallery.* New Haven and London: Yale University Press, 1970.

The Burghley House Preservation Trust. *Burghley House, Stamford* (catalogue of Chinese and Japanese porcelains) n.d.

———. *Burghley House, Stamford* (catalogue of silver). 1984.

Buurman, D. J. G. "Tien stoelen, ca. 1700, en twee wandtafels, 2de kwart 18de eeuw, afkomstig van Kasteel de Cannenburch, Vaassen." *Vereniging Rembrandt* (1978), 37–40.

Catalogue d'une belle Collection de Faience de Delft. Sale cat., Frederick Muller & Cie, Amsterdam, April 28, 1908.

Catalogue of the Sallie A. Hert Collection. Sale cat., Parke-Bernet, New York, November 28, 1949.

Clayton, Michael. *The Collectors' Dictionary of the Silver and Gold of Great Britain and North America.* New York: The World Publishing Company, 1971.

Clinton, Lisa. *The State Bed From Melville House.* Masterpieces Series. London: Victoria and Albert Museum, 1979.

Cooke, Edward S., Jr. "The Warland Chest: Early Georgian Furniture—Boston." *Maine Antiques Digest* 15:3 (1987):11c–13c.

Cooper, Wendy A. *In Praise of America, American Decorative Arts 1650–1830.* Exh. cat. New York: Alfred A. Knopf, 1980.

Cummings, Abbott Lowell, "The Domestic Architecture of Boston, 1660–1725." *Archives of American Art Journal* 9 (1971) 1–16.

Davies, John D. *English Silver at Williamsburg.* Williamsburg, Va.: The Colonial Williamsburg Foundation, 1976.

Dee, Elaine Evans, and Guy Walton. *Versailles: The View From Sweden,* Exh. cat., New York: Cooper-Hewitt Museum, 1988.

Digby, G. F. Wingfield. "Damasks and Velvets at Hampton Court." *Connoisseur* 103 (1939): 248–53.

Dillon, Edward, M. A., comp. *Catalogue of the Chinese and Japanese Porcelain and of the Delft Fayence at the Palaces of Hampton Court and St. James.* London, 1910.

Donnelly, P. J. *Blanc de Chine.* New York: Frederick A. Praeger, 1967.

Dordrechts Museum. *Dordrechts Goud en zilver.* Exh. cat. Dordrecht: Dordrechts Museum, 1975.

Downs, Joseph. *American Furniture: Queen Anne and Chippendale Period, 1725–1788.* New York: Viking Press, 1967.

Drossaers, S. W. A., and Th. H. Lunsingh Scheurleer. *Inventarissen van de Inboedels in de Verblijven van de Oranjes 1567–1795.* The Hague: Martinus Nijhoff, 1974.

Edwards, Ifor. "Ironwork Master of St. Paul's." *Country Life* 129 (1961): 386–87.

Edwards, Ralph. *The Dictionary of English Furniture.* London: Barra Books, Ltd., 1983 (second revised edition 1954, reissued).

Erkelens, A. M. L. E. "Delfts aardewerk op Het Loo." *Nederlands Kunsthistorisch Jaarboek* 31 (1980), 263–72.

Evelyn, John. *Diary and Correspondence of John Evelyn.* Ed. from original manuscripts at Wotton by William Bray. London: 1850–52.

Fairbanks, Jonathan L., and Elizabeth Bidwell Bates. *American Furniture 1620 to the Present.* New York: Richard Marek, 1981.

Fales, Dean A., Jr. "Boston Japanned Furniture." *Boston Furniture of the Eighteenth Century.* Boston: The Colonial Society of Massachusetts, 1974.

Fales, Martha Gandy. *Early American Silver for the Cautious Collector.* New York: Funk & Wagnalls, 1970.

Fiennes, Celia. *The Journeys.* Ed. by Christopher Morris. London: 1947.

Flanigan, J. Michael. *American Furniture from the Kaufman Collection.* Washington D. C.: National Gallery of Art, 1986.

Forman, Benno M. *American Seating Furniture 1630–1730.* Exh. cat., New York and London: W. W. Norton, 1988.

———. "The Chest of Drawers in America, 1635–1730: The Origins of the Opened Chest of Drawers." *Winterthur Portfolio* 20 (1985): 1–30.

———. "Furniture for Dressing in Early America, 1650–1730: Forms, Nomenclature, and Use." *Winterthur Portfolio* 22 (1987): 149–64.

Fourest, H.-P. *Delftware, Faience Production at Delft*. New York: Rizzoli, 1980.

Fowler, John, and John Cornforth. *English Decoration in the 18th Century*. London: 2nd ed. Barrie & Jenkins, 1978.

Gibbon, Michael J. *Hanbury Hall*. London: Country Life for the National Trust, 1967.

Girouard, Mark. "The Smythson Collection of the Royal Institute of British Architects." *Architectural History* 5 (1962).

Glanville, Philippa. *Silver in England*. New York: Holmes & Meier; London: Unwin Hyman, 1987.

Godden, Geoffrey A. *Oriental Export Market Porcelain and its Influence on European Wares*. London: Granada, 1979.

Grimwade, Arthur. "The Master of George Vertue, His Identity and Oeuvre." *Apollo* 127 (1988): 83–89.

Haags Gemeentemuseum, *Haags zilver uit vijf eeuwen*. Exh. cat., The Hague: Haags Gemeentemuseum, 1967.

"Hampton Court." *Wren Society* 4 (1927).

Hardy, John, and Gervase Jackson-Stops. "The Second Earl of Warrington and the 'Age of Walnut.'" *Apollo* 108 (1978): 12–23.

Harris, John. *English Decorative Ironwork*. Chicago: Quadrangle Books Inc., 1960.

———. "The Hampton Court Trianon Designs of William and John Talman." *The Warburg and Courtauld Institutes Journal* 23 (1960): 139–49.

———. *William Talman, Maverick Architect*. London: George Allen and Unwin, 1982.

Harris, Walter. *A Description of the King's Royal Palace and Garden at Loo*. London: 1699 (reprinted The Hague: Staatsuitgeverij, 1985).

Hayward, J. F. "The Earl of Warrington's Plate." *Apollo* 108 (1978): 32–39.

Hayward, J. F. *Huguenot Silver in England 1688–1727*. London: Faber and Faber, 1959.

———. "Silver Furniture." *Apollo* 67 (1958): 153–57.

Hijmersma, Herbert J. "Een wijle van rust in de buitensael, een gebeeldhouw de tuinbank naar ontwerp van Daniel Marot." *Nederlands Kunsthistorisch Jaarboek* 31 (1980): 279–84.

Hoff, Arne. *Dutch Firearms*. London: Sotheby Parke Bernet, 1978.

Hollstein, F. W. H. *Dutch and Flemish Etchings, Engravings, and Woodcuts*. Amsterdam: Menno Hertzberger, 1949.

Home Miscellaneous Records. East India Office Library, London. (Shipping records.)

Honour, Hugh. *Chinoiserie, The Vision of Cathay*. New York: Harper and Row, 1961.

Hood, Graham. *American Silver, A History of Style, 1650–1900*. New York: Praeger Publishers, 1971.

Hornor, William MacPherson. *Blue Book, Philadelphia Furniture, William Penn to George Washington, with Special Reference to the Philadelphia-Chippendale School*. Philadelphia: 1935.

Howard, David, and John Ayers. *China for the West*. London and New York: Sotheby Parke Bernet, 1978.

International Exhibitions Foundation. *Treasures from Chatsworth, The Devonshire Inheritance*. Introduction by Sir Anthony Blunt. Exh. cat. International Exhibitions Foundation, 1979.

Jackson, Linda Wesselmann. "Beyond the Fringe: Ornamented Upholstery Trimmings in the 17th, 18th and Early 19th Centuries." *Upholstery in America and Europe from the Seventeenth Century to World War I*. New York: W. W. Norton, 1987.

Jackson-Stops, Gervase. "The Building of Petworth." *Apollo* 105 (1977): 324–33.

———. "Daniel Marot and the 1st Duke of Montagu." *Nederlands Kunsthistorisch Jaarboek* 31 (1980): 244–62.

———. *Drayton House*. London: privately pub., 1978.

———. "English Baroque Ironwork-I, The Sources of Tijou's Designs" and "English Baroque Ironwork-II, The Influence of Tijou." *Country Life* 149 (1971): 182–83 and 262–66.

———. "Furniture at Petworth." *Apollo* 105 (1977): 358–66.

———. "Huguenot Upholsterers and Cabinetmakers in the Circle of Daniel Marot." In *Huguenots in Britain and Their French Background 1550–1800*, edited by Irene Scouloudi. London: 1987.

———. "The Palace of Het Loo, The Netherlands, II." *Country Life* 176 (1984): 1770–74.

———. "Petworth and the Proud Duke." *Country Life* 153 (1973): 1870–74.

———. "Purchases and Perquisites: The 6th Earl of Dorset's Furniture at Knole," parts I and II. *Country Life* 161 (1977): 1495–57 and 1620–22.

———. "William III and French Furniture." *Furniture History* 7–8 (1971): 121–26.

———, ed. *The Treasure Houses of Britain: Five Hundred Years of Private Patronage and Art Collecting*. Exh. cat., National Gallery of Art, Washington, D. C. New Haven and London: Yale University Press, 1985.

Jellicoe, Sir Geoffrey, et al., eds. *The Oxford Companion to Gardens*. Oxford and New York: Oxford University Press, 1986.

Japan Society. *The Burghley Porcelains*. Exh. cat., New York: Japan Society, 1986.

Jessen P. *Das Ornamentwerk des Daniel Marot*. Berlin: Ernst Wasmuth, 1892.

Jobe, Brock. "The Boston Furniture Industry 1720–1740." *Boston Furniture of the Eighteenth Century*. Boston: The Colonial Society of Massachusetts, 1974.

Jörg, C. J. A. *Interaction in Ceramics, Oriental Porcelain and Delftware*. Exh. cat., Hong Kong: The Urban Council, 1984.

Kane, Patricia E. *300 Years of American Seating Furniture*. Boston: New York Graphic Society, 1976.

"Kensington Palace." *Wren Society* 7 (1930).

Kerr, Rose. *Chinese Ceramics: Porcelain of the Qing Dynasty 1644–1911*. London: Victoria and Albert Museum, 1986.

"Keuze uit de aanwinsten." *Bulletin van het Rijks-museum* 33 (1985): 266–75.

Kimball, Fiske. *The Creation of the Rococo Decorative Style.* 1943 New York: Dover Publications, Inc., 1980 (reprinted).

Kleyn, J. de. "Een paar Delfts piramiden in Colonial Williamsburg (U. S. A.)." *Vrienden van de nederlandse ceramiek* 40 (1965): 15–22.

Knole, Kent. Rev. ed. London: The National Trust, 1982.

Lady Lever Art Gallery, Port Sunlight. *Catalogue of Foreign Paintings, Drawings, Miniatures, Tapestries, Post-Classical Sculpture and Prints.* Liverpool: Merseyside County Council, 1983.

Landwehr, John. *Romeyn de Hooghe as Book Illustrator.* Amsterdam: A. L. Van Geudt, 1970.

———. *Romeyn de Hooghe the Etcher, Contemporary Portrayal of Europe, 1662–1707.* Leiden and Dobbs Ferry, N.Y.: 1973.

Lane, Arthur. "Daniel Marot: Designer of Delft Vases and of Gardens at Hampton Court." *Connoisseur* 123 (1949): 19–24.

———. "Delftse tegels uit Hampton Court en Daniel Marot's werkzaamheid aldaar." *Bulletin van het Rijksmuseum* 7 (1959): 12–21.

Liefkes, F. "Twee gueridons in de stijl van Marot." *Bulletin van het Rijksmuseun, Amsterdam* 23 (1975): 102–4.

Lipson, Karin. "Where Can You See . . .?" *Antiques World* 3 (1981): 94–96.

Little, Stephen. *Chinese Ceramics of the Transitional Period: 1620–1683.* New York: China Institute in America, 1984.

———. "Chinese Porcelain of the Chongzhen Period 1628–44." *Oriental Art* 29 (1983): 159–80.

Lo, K. S. *The Stonewares of Yixing.* London and New York: Sotheby's Publications, Hong Kong University Press, 1986.

Lunsingh Scheurleer, D. F. *Chinese Export Porcelain: Chine de commande.* New York: Pittman Publishing Corporation, 1974.

———. "Daniel Marot en een schoorsteenstuk door Pieter van Ruyven (1650/51–1719)." *Antiek* 21 (1986–87): 446–48.

———. *Delft, Niederländische Fayence.* Munich: Klinkhardt & Biermann, 1984.

———. *Delfts Blauw.* Bussum: Dishoeck, 1975.

Lunsingh Scheurleer, Th. H. "Documents on the Furnishing of Kensington House." *The Walpole Society* 38 (1960–62): 15–58.

———. "The Dutch and Their Homes in the Seventeenth Century." *Arts of the Anglo-American Community in the Seventeenth Century.* Winterthur Conference Report, ed. by Ian M. G. Quimby. Charlottesville, Va.: The University of Virginia Press, 1974.

———. "Een Hollands kabinet versierd met 'blom-werk.'" *Bulletin van Rijksmuseum* 4 (1955): 85–90.

———. "The Low Countries." In *World Furniture,* 72–75. Secaucus, N.J.: Chartwell Books, 1965.

———. "Pierre Gole, ébéniste du roi Louis XIV." *Burlington Magazine* 122 (1980): 380–94.

———. "Stadhouderlijke lakkabinetten." In *Opstellen voor H. van de Waal.* Amsterdam and Leiden, 1970.

McElroy, Cathryn J. "Furniture in Philadelphia: The First Fifty Years." *Winterthur Portfolio* 13 (1979): 61–80.

McNab, Jessie. *English Silver.* Collector's Blue Books. New York: Walker and Company, 1970.

———. "The Legacy of a Fantastical Scot." *The Metropolitan Museum of Art Bulletin* n. s., 19 (1961): 172–80.

The Metropolitan Museum of Art. *English Furniture, with Some Furniture of Other Countries, in the Irwin Untermyer Collection.* Cambridge, Mass.: Harvard University Press, 1958.

———. *Highlights of the Untermyer Collection of English and Continental Decorative Arts.* New York: The Metropolitan Museum of Art, 1977.

Miles, Elizabeth B. *English Silver.* Hartford, Ct.: Wadsworth Atheneum, 1976.

Miller, John. *The Life and Times of William and Mary.* London: Weidenfeld and Nicolson, 1974.

Miller, V. Isabelle. *Furniture by New York Cabinet-makers.* Exh. cat., New York: Museum of the City of New York, 1956.

Montague, William. *The Delights of Holland.* London: John Sturton, 1696.

Mulliner, H. H. *The Decorative Arts in England 1660–1780.* London: 1923.

Murdoch, Tessa, *The Quiet Conquest: The Huguenots 1685–1985.* London: Museum of London, 1985

Museum Boymans-van Beuningen, *Thema Thee.* Exh. cat., Rotterdam: Museum Boymans-van Beuningen, 1978.

Museum of Fine Arts, Boston. *American Church Silver.* Boston: Museum of Fine Arts, 1911.

———. *American Silver.* Boston: Museum of Fine Arts, 1906.

———. *New England Begins: The Seventeenth Century.* Exh. cat., Boston: Museum of Fine Arts, 1982.

The Museum of Fine Arts, Houston. *Marks of Achievement: Four Centuries of American Presentation Silver.* Exh. cat., New York: Harry N. Abrams Inc., 1987.

Naeve, Milo. "Dutch Colonists and English Style in New York City: Silver Syllabub Cups by Cornelius Kierstede, Gerrit Onckelbag, and Juriah Blanck, Jr." *American Art Journal* 19 (1987): 40–53.

Naeve, Milo M., and Lynn Springer Roberts. *A Decade of Decorative Arts: The Antiquarian Society of The Art Institute of Chicago.* Chicago: The Art Institute of Chicago, 1986.

Nutting, Wallace. *Furniture of the Pilgrim Century.* New York: Bonanza Books, 1921.

———. *Furniture Treasury.* New York: Macmillan Publishing Co., 1928.

Nygren, Edward J. "Edward Winslow: Sugar Boxes: Colonial Echoes of Courtly Fare." *Yale University Art Gallery Bulletin* 33 (1971): 38–52.

Oman, Charles. "Caddinets and a Forgotten Version of the Royal Arms." *Burlington Magazine* 100 (1958): 431–5.

———. *English Engraved Silver 1150 to 1900.* London: Faber and Faber, 1978.

Ottema, Nanne. *Friesche Majolica.* Leeuwarden, 1920.

Ozinga, M. D. *Daniel Marot. De Schepper van den Hollandschen Lodewijk XIV-Stijl.* Amsterdam: H. J. Paris, 1938.

Patterson, Jerry E. *Porcelain*. New York: Cooper-Hewitt Museum, 1979.

Pay Books for Kensington, March 1689–March 1695 (manuscript). Public Record Office, Kew Gardens, London.

Peelen, Ida C. E. "Versiering op tegels naar ontwerpen van Daniel Marot." *Oudheidkundig Jaarboek* 3 (1923): 163–66.

Philadelphia Museum of Art. *Philadelphia: Three Centuries of American Art*. Philadelphia: Philadelphia Museum of Art, 1976.

Phillips, John Goldsmith. "An Armorial Tapestry." *Bulletin of the Metropolitan Museum of Art* 31 (1936): 122–24.

Pierce, Donald C., and Hope Alswang. *American Interiors: New England and the South, Period Rooms at the Brooklyn Museum*. New York: The Brooklyn Museum, 1983.

The Pierpont Morgan Library. *William & Mary and Their House*. Exh. cat., New York: The Pierpont Morgan Library, 1979.

Randall, Richard H., Jr. *American Furniture in the Museum of Fine Arts*, Boston. Boston: Museum of Fine Arts, 1965.

Rijksmuseum. *Catalogus van Meubelen*. Amsterdam: Rijksmuseum, 1952.

———. *Delfts Aardewerk*. Amsterdam: Rijksmuseum, 1955.

———. *De Stadhouder-Koning en zijn tijd, 1650–1950*. Exh. cat., Amsterdam: Rijksmuseum, 1950.

Rosenberg, Jacob, Seymour Slive, and E. H. ter Kuile. *Dutch Art and Architecture 1600–1800*. The Pelican History of Art. 3rd ed. Harmondsworth, Middlesex: Penguin Books, 1977.

Royal Institute of British Architects, *Catalogue of the Drawings Collection of the Royal Institute of British Architects*. Farnborough, England: International Publishers Ltd., 1972.

Royards, C. W. *Het Loo*. The Hague: 1972.

Ruempol, Alma. "De beeldsnijder Hendrik Noteman, zijn vrienden en zijn werk." *Dordtenaar*, April, 24 1982.

Schiffer, Herbert. *The Brass Book*. Exton, PA: Schiffer Publishing Ltd., 1978.

Shearing, Graham. "By Appointment to the House of Orange." *Connoisseur* 206 (1981): 280–83.

Safford, Frances Gruber. *Colonial Silver in the American Wing*. The Metropolitan Museum of Art Bulletin 41 (1983).

Sassoon, Adrian, and Gillian Wilson. *Decorative Arts: A Handbook of the Collection of the J. Paul Getty Museum*. Malibu, Calif.: The J. Paul Getty Museum, 1986.

Smith, Robert, "Five Furniture Drawings in Siena." *Furniture History Society* 3 (1967): 1–15.

Sonday, Milton. *Lace in the Collection of the Cooper-Hewitt Museum, The Smithsonian Institution's National Museum of Design*. New York: Cooper-Hewitt Museum, 1982.

Stainton, Lindsay, and Christopher White. *Drawing in England from Hilliard to Hogarth*. London: British Museum Publications, 1987.

Sutton, Peter C. *A Guide to Dutch Art in America*. Washington D.C.: The Netherlands-American Amity Trust Inc., 1986.

Ter Molen, J.R. "Adam Loofs, zilversmid van de Koning-stadhouder." *Antiek* 22 (1988): 518–26.

Thacker, Christopher. *The History of Gardens*. Berkeley and Los Angeles: University of California Press, 1979.

Thornton, Peter. *Authentic Decor: The Domestic Interior 1620–1920*. New York: Viking, 1984.

———. *Seventeenth-century Interior Decoration in England, France and Holland*. New Haven and London: Yale University Press, 1978.

Thornton, Peter, and Maurice Tomlin. *The Furnishing and Decoration of Ham House*. London: The Furniture History Society, 1980.

Tomlin, Maurice. *Ham House*. London: Victoria and Albert Museum, 1986.

Upmark, G. "Ein Besuch in Holland, 1687; Ans der Reise schilderungen des schwedischen Architekten Nicodemus Tessin d. J." *Oud Holland* 18 (1900): 15–152.

Van der Feltz, A. C. A. W. "Belangrijke meubelen uit het tijdperk van Stadhouder-Koning Willem III." *Antiek* 13 (1979): 397–407.

"[George] Vertue's Note Books," *The Walpole Society* 20 (1931–2).

Victoria and Albert Museum. *An American Museum of Decorative Art and Design: Designs from the Cooper-Hewitt Collection, New York*. Exh. cat., London: Victoria and Albert Museum, 1973.

———. *The Orange and the Rose: Holland and Britain in the Age of Observation 1600–1750*. Exh. cat., London: Victoria and Albert Museum, 1964.

Vincent, Clare. "Paulet London: The Signature of a Huguenot Emigré Clockmaker?" In *Studien zum europischen Kunsthandwerk: Festschrift Yvonne Hackenbroch*, 217–77. Munich: Klinkhardt & Biermann, 1983.

Volker, T. *Porcelain and the Dutch East India Company 1602–1682*. Leiden: E. J. Brill, 1954.

Wadsworth Atheneum. *The Great River: Art and Society of the Connecticut Valley 1635–1820*. Exh. cat., Hartford: Wadsworth Atheneum, 1985.

Ward, Barbara McClean. "The Craftsman in a Changing Society: Boston Goldsmiths, 1690–1730." Ph.D. diss., Boston University, 1983.

Ward, Barbara McLean, and Gerald W. R. Ward, eds. *Silver in American Life*. Exh. cat., Boston: David R. Godine, in association with the Yale University Art Gallery and the American Federation of Arts, 1979.

Warren, Walter Phelps. "Introduction to Dutch blue and white." *Antiques* 82 (1962): 258–61.

Whinney, M. D. "William Talman." *Journal of the Warburg and Courtauld Institutes* 18 (1955): 123–39.

Wunder, R. P. *Extravagant Drawings of the Eighteenth Century*. New York: Lambert-Specter, 1962.

Photo
Credits

Colophon

Courts and Colonies: The William and Mary Style in Holland, England, and America was set in Janson, a "Dutch" typeface named for Anton Janson (1620–1687), but most likely first cut by Nicholas Kis (1620?–1702). Kis was a Hungarian who probably apprenticed with Dirk Voskens in Holland and later worked in Leipzig. Kis and William III (1650–1702) died in the same year.

This book was set by Trufont Typographers, Inc., and was printed and bound by Meriden-Stinehour Press on paper made by the Mohawk Paper Mills.

Courts and Colonies was designed by Nathan Garland.